GUILD
HALL
OF EAST HAMPTON

To Jim and Margot —
with many thanks to
Jim for starting the ball
rolling at Abrams. —
Best
Eng W.

END PAPER.
Dan Budnik.
Cedar Point. 1975. Color.
GH Art Collection.
Gift of the artist, 1979.

Publication of this book was made possible by the thoughtful contributions
of several Guild Hall friends.
Robert B. Menschel, who originally suggested that Enez Whipple write the history of Guild Hall,
has, with his wife, Joyce, been a major supporter from the beginning;
as have Daniel and Joanna Rose.
Miki Denhof, designer of the book, has made an extraordinary contribution of her talent.
In addition, special gifts for the project were made by Eloise Spaeth,
Elizabeth Jewett (in memory of her husband, John Jewett), Mr. and Mrs. A. R. Landsman,
Claus and Helen Hoie, Lillian Braude, William A. Dreher, Robert and Teddy Greenbaum,
Alan Patricof, Muriel Siebert and an anonymous donor.

Special thanks to Henry Korn, Executive Director of Guild Hall since
September 1993, for his extraordinary help in launching
the book and supervising the final
stages of production.

GUILD HALL

OF EAST HAMPTON

BY ENEZ WHIPPLE

Designed by
MIKI DENHOF

Edited by
CHERYL MERSER

Consultant
JASON EPSTEIN

Photographic research by
MARGOT DOWLING

AN ADVENTURE IN THE ARTS
THE FIRST 60 YEARS

Harry N. Abrams, Inc., Publishers

During World War II, Guild Hall, having concluded its first decade, sought a director to plan and guide its future. The new director, Enez Whipple, arrived in 1943; she would remain for almost forty years through the celebration of Guild Hall's 50th anniversary.

The director took a fledgling center which had neither staff nor endowment and built it into a major year-round community arts center.

As author of this book, which covers the years 1931–1991, Enez Whipple describes all the *other* people who played a part in building Guild Hall—the actors, artists, benefactors, composers, dancers, musicians, poets, teachers, writers, volunteers and staff.

The author's account is incomplete for she leaves unwritten the role of her vitality and vision as the inspirational catalyst who motivated the many participants who appear on the pages of the book.

On behalf of the many thousands who have over the years supported and enjoyed Guild Hall and participated in its services, we salute Enez Whipple, that talented lady whose passion for Guild Hall has so enriched our lives.

Copyright © 1993
by Guild Hall of East Hampton, Inc.
All rights reserved.

Published by Guild Hall of East Hampton, Inc.
158 Main Street, East Hampton, N.Y. 11937

Guild Hall of East Hampton
is a non-profit organization with a
New York State Board of Regents
Educational Charter

Distributed in 1994 by Harry N. Abrams, Incorporated,
New York. A Times Mirror Company

ISBN 0–8109–3384–5 (Abrams)

Library of Congress Catalog Card Number: 93-79013

Produced by Folio Graphics Co. Inc./New York

Printed in Hong Kong

CONTENTS

To my husband, Warren (Whip),
who introduced me to Guild Hall and
has held my hand ever since

ACKNOWLEDGMENTS

First I wish to acknowledge the help of three people who worked most closely with me on the long journey of producing this book:

Miki Denhof for her outstanding artistry in designing the book, for her considerable assistance in selecting the photographs, for her sensitivity in keying them to the text; and for her advice and encouragement from the very start of the project.

Cheryl Merser for her warm, friendly guidance and very special expertise as editor.

Margot Dowling for her thoroughness and good-humored patience in serving effectively as photo researcher.

I also thank:

Jason Epstein, vice-president and editorial director of Random House, for his invaluable help in steering the course of this Guild Hall publication.

Robert Farrell, professor of archaeology, medieval studies and English at Cornell University, for reading the early drafts of the manuscript and making highly valued suggestions.

Phyllis Braff, art critic for the *New York Times*, for special editorial help on the visual arts section of the book, as well as for her kind services in selecting the art works for the chapter on the art collection.

Charles Brock, for his generous gift of legal assistance through the law firm of Carter, Ledyard and Milburn; and to

Thomas Bardo of that firm for his extraordinary work and wise counsel (so cheerfully given) on all legal technicalities relating to the book.

Helen Rattray, president of the *East Hampton Star*, for her kind permission to use innumerable quotations from the newspaper, and photographs from *The Star*'s archives; and to staff members Kate Skinner Kerr and Sheridan Sansegundo for their courteous help in researching photographs.

Robert Greenbaum, chairman of the Guild Hall Board of Trustees, for his considerable help in expediting the publishing of the book.

Robert Menschel who originally suggested that I write this book, for his continuing interest and support of the project.

Joy Gordon, executive director, and the Guild Hall staff for their always willing assistance in dozens of important ways. Special thanks to Sandra Beckman Morell, Christina Mossaides Strassfield, Tracy Bashkoff, Amy Eller, Robin Hatch, Marietta Badami, Adrienne Kitaeff, Pam Calvert, Brigitte Blachere, Katie Meckert, Serena Seacat, Robert Long, Eleanor Shaw, Norman Plitt, Chuck Gerner, John Donnelly, L. Kenneth Byrd, Arthur Fisher, John Mazynieski and others.

Beth Gray and the staff of the East Hampton Library for their courteous and prompt help in locating obscure background material; in particular Dorothy King, librarian for the Long Island Collection, who gave unstintingly of her time; and Elizabeth Sarfati, and others at the front desk.

The many photographers who generously made their work available for reproduction; in particular Tessa Namuth Papademetriou and Peter Namuth for permission to reproduce Hans Namuth's photographs of artists; and to others who went out of their way to be helpful: Kathryn Abbe, Rameshwar Das, Frances McLaughlin Gill, Jay Hoops, Noel Rowe, Phyllis and Jonathan Reed, Philippe Montant and Sandra Weiner.

Eve Adams for supervising the early stages of production.

The keepers (past and present) of the Guild Hall archives (a principal source of information): Dorothy Osborn, June Dunnet, Louise Conklin, Marie Olssen, Billie Kalbacher, Margaret Berglund, Sandra Beckman Morell, among others.

Stanley Drate of Folio Graphics for his friendly interest and special concern in supervising the printing of this book.

All those who shared their reminiscences about Guild Hall in taped interviews; and Ruth Garraway who transcribed the tapes so meticulously.

I also thank the many others who helped in various, important ways: Paul Amaden, Barbara Mahoney Brooks, John Bucher, C. H. Clemans, Chuck Close, William Dreher, Rae Ferren, Mary Gardner, Paul Goldberger, Mildred Granitz, Helen A. Harrison, Sherrye Henry, Helen Hoie, Morton Hunt, Anne Jackson, Gillian Jolis, Clark Jones and Enid Roth, Douglas Leeds, Beatrice Mathes, Mary Newlin, Patricia Osborne, Doris Palca, George Plimpton, Josephine Raymond, Paul Rickenback, Rosemary Sheehan, Judith Sneddon, Sue Steele, Wilson Stone, Robert Ullman, Robert Vetault, Lee Walter, Jerold Weitzman, William Woolfenden, Helen Mann Wright, and others whose names I may have omitted inadvertently.

Last but not least, my husband, Warren (Whip), whose mellow humor and unfailing confidence in the project lifted me over the hurdles of discouragement encountered along the way.

E.W.
September, 1993

". . . A great deal of East Hampton still looks
the way it did when the first sketching parties began to come out
from New York in the 1870s. And part of Guild Hall's job is
to speak for that continuity; not too loudly—
people around here don't care to be preached to—
but with a poetic insight that gets through to any sensitive visitor."[1]

John Russell

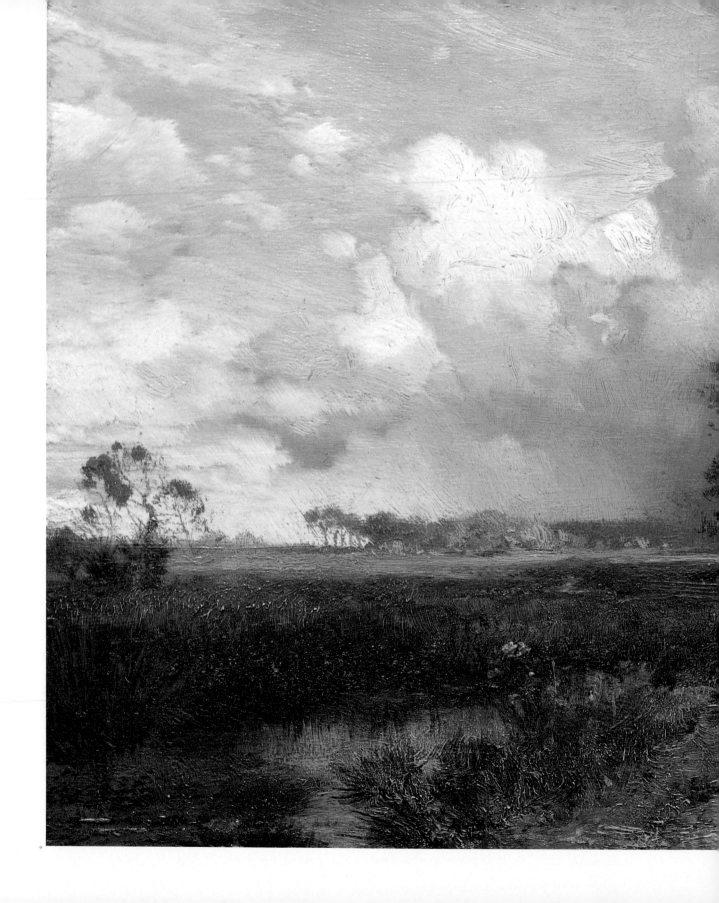

Thomas Moran. Approaching Storm, East Hampton, Long Island (c. 1880). Oil. GH Art Collection. Purchase, 1991.

Henri Cartier-Bresson.
East Hampton, 1968.
B/w photograph. Gift
of the artist, 1977.

PREFACE

When Guild Hall opened in 1931, I was in Syracuse dreaming about a career in the arts—unrealistically, it seemed, particularly since the country was in the depths of the Great Depression. I had never heard of East Hampton, much less its fledgling arts center. My interests were in theater, music, art and literature. It seemed inconceivable that I would find a job encompassing all these interests. Guild Hall would be the place where my love for the arts would be fulfilled.

I came to the directorship of Guild Hall by a circuitous route. After stints in newspaper work and teaching, I moved to East Hampton to join my husband, Warren (Whip) Whipple, in 1941. That year, Mrs. Lorenzo E. Woodhouse, Guild Hall's preeminent benefactress, had arranged for Anne Poeller, director of the Four Arts in Palm Beach, to return for her second summer as director of Guild Hall. However, at the last minute, Mrs. Poeller was unable to come and Mrs. Woodhouse asked Whip, who had been involved in the arts programs at Guild Hall, to take over as director. At my urging, and with my promise to help out, he accepted.

That summer was memorable. Henry T. Leggett, an elegant bachelor of considerable stature and one of William Merritt Chase's first art students at Shinnecock Hills, was chairman of the Art Committee. With Whip, he arranged outstanding exhibitions that year—among them, an exhibition of J. M. W. Turner's watercolors sponsored by Mrs. Dwight Davis as a benefit for the American-British Art Center "so that art shall not perish from democracies at war." Unbelievable as it may seem, the price range in that exhibition was $75 to $250 and only one painting sold.

I was impressed that summer by the work being done by the Rollins School of Acting, which gave performances in the theater. Imaginative and sensitive to the times, Leighton Rollins presented a show in the ominous summer of 1941 called *A Point of View*, which revealed remarkably prescient views of the escalating war.

Other offerings were shaped to meet the spirit of the time. Louise Maunsell Fields, a proper white-gloved lady, abandoned her usual literary topics and talked about air raids and the urgent need to pull down our dark window shades at dusk. Main attraction of the season was a lecture by William L. Shirer, author of *Berlin Diary*, just back from Germany. A

public address system was set up in the galleries so that the overflow crowd could listen to his somber analysis of the events abroad.

When Whip stepped down as director after two summers because of other commitments, Mrs. Woodhouse asked me to take his place. I had come to know this gracious lady well. I admired her spirit of adventure in creating this multifaceted center, and I shared her fervent hopes for broadening its role in the year-round community. Her goals became my goals. From 1943–46 I served officially as summer director, but winters, on my own, I devoted my time to encouraging activities that blended the arts with community programs on many levels. I took on the year-round directorship in 1947. By this time the winters were almost as busy as the summers.

Those were years of growth and change—exhilarating, challenging, sometimes stormy, but never boring. All my training came together— undergraduate and postgraduate work at Syracuse University and practical studies in museum and theater management—to help me guide this unique center.

I felt I had a privileged position from which to watch abstract art take hold, and theater to turn occasionally experimental, sometimes controversially so. I met scores of talented people and marveled at the leaders in every artistic field who always seemed, somehow or other, to turn up in our village and our small cultural center. I saw films that would become classics shown for the first time at Guild Hall; I saw the Guild Hall art collection grow to include works by many of our preeminent artists; and I made lifelong friends among the staff, trustees and committees with whom I worked. I retired at the end of 1981, having seen Guild Hall through its spectacular year-long 50th anniversary celebration. For nearly 40 years, Guild Hall had been the center of my life.

Guild Hall couldn't have happened just anywhere. It needed the kind of land and seascapes that could seduce artists; it needed a city like New York nearby to nourish it; and, most of all, it needed the dedicated people who have made it the exemplary cultural center it is today.

Because of my long association with Guild Hall, I was asked to write a history of it. In so doing, I've tried wherever possible to tell the story through the transcribed accounts of the "players" themselves, having interviewed on tape dozens of people who had been involved in our center in dozens of ways—from trustees to film stars. These reminiscences are to my mind the most vivid way to actually "feel" this cultural history taking place. Naturally, some crucial voices are missing; over the course of 60 years, many of our "players" have moved away or died. But these "ghosts" of Guild Hall still give the place its special character, and I've tried to give them their due here as well.

What I hope comes through in these essays is how deeply the people of East Hampton care about their cultural center and how Guild Hall made a valiant effort to involve all of the artistic community, and the community as a whole, in the broad-ranging events it has presented.

Enez Whipple

GH ARCHIVES
Enez Whipple (1973).

GUILD HALL:

THE DREAM,
THE REALITY,
THE EARLY
PLAYERS

INTRODUCTION

When Guild Hall first opened its doors on Wednesday, August 19, 1931, curiosity more than anything else was what attracted the thousand or so local and summer residents who crowded into the new galleries and theater set at the corner of Main Street and Dunemere Lane in East Hampton. The summer residents came to hear the dedication speeches and to witness the moving tribute to philanthropist Mrs. Lorenzo E. Woodhouse, who was largely responsible for conceiving this new center for the arts. The local residents may have been drawn more by the building itself, with its graceful central theater balanced on either side by handsomely designed exhibition galleries. At least one of the old-time residents was unimpressed enough to wonder why the "damn fools" had built the structure, however beautiful, on land that was sure to flood. Perhaps he remembered, as did Elizabeth

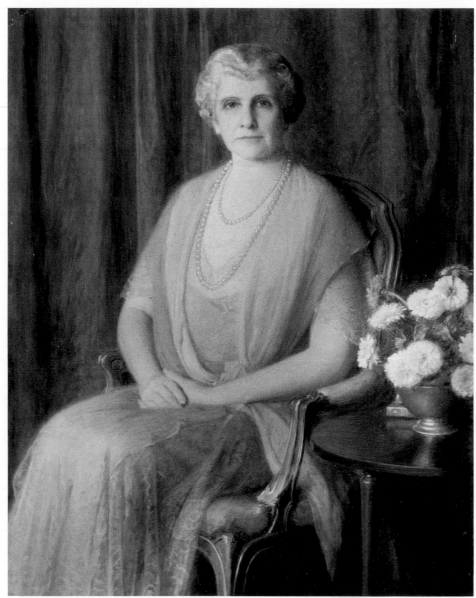

Albert Herter's oil portrait of
Mrs. Lorenzo E. Woodhouse, philanthropist
and founder of Guild Hall (c. 1931).

Cartwright, a student at Clinton Academy in the 1860s, that Sam Miller's yard (the site chosen for Guild Hall) would sometimes get so filled with water that Sam had to use a rowboat to get to his barn; and at recess the boys would take the girls rowing over there.[1]

It's easier to see now than it must have been at the opening ceremonies that Guild Hall's inception marked the end of one era for East Hampton and the beginning of another. In much the same way that the arrival of the Long Island Rail Road as far east as nearby Bridgehampton, in the early 1840s, had linked New York City and East Hampton geographically, now Guild Hall would establish the cultural link between the two.

Guild Hall's opening led to a new cultural prominence for East Hampton and, at the same time, provided a natural showcase for the people in the arts who had found their way to the East End of Long Island since the 1870s and have continued to do so ever since. Guild Hall would also come to reflect and anticipate the arts as they evolved in our part of the world, a role that would earn us praise but also controversy, and inspire us to redefine Guild Hall's role with each passing era.

Along with triumphs, we've had our share of hard knocks — which was inevitable perhaps for an institution born out of a spectacularly generous initial gift, but not nurtured by an endowment fund. Opening as it did in the Great Depression, Guild Hall had to adapt to the changing fortunes of our founders and early benefactors. Community support, both financial and in hours and hours of volunteer labor, has kept us alive in the ensuing years. We've also done our best to meet other challenges: profound changes in social values, the emergence of new and radically

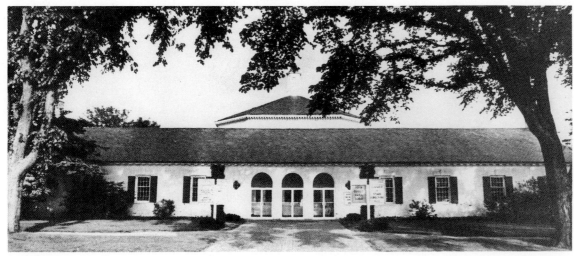

GH ARCHIVES
Guild Hall of East Hampton.

different art forms, the transformation of our village from rural to sophisticated suburban and charges from some segments of the community that Guild Hall is elitist.

Because Guild Hall was, to our knowledge, the first cultural/community center in the country to combine a theater, museum and com-

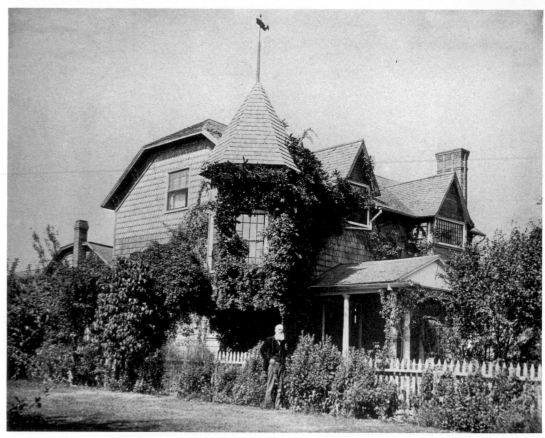

Thomas Moran in the garden of
"The Studio,"
Main Street, East Hampton
(after the turn of the century).*

*The Tile Club and the
Milliner of Bridgehampton,*
an 1878 charcoal drawing
by Charles Stanley Miller.

munity meeting place under one roof, we were, from the start, an experiment in combining disciplines; one art form would be the thematic and aesthetic catalyst for another. There was no formula back then to assure that such an experiment would work, though this interdisciplinary approach to the arts is now followed all over the country.

What makes Guild Hall work year after year is what makes East Hampton unique: an abundance of extraordinarily talented people. Drawn to the area by the sea-distilled light, the richness of the landscape and the beauty of the beaches, artists and writers and actors and directors have settled here not merely to escape the city but to find the solace and inspiration to work. In that sense, they are not so different from the farmers and fishermen for whom the region has provided a livelihood, generation after generation, and who remain as fiercely independent as the artists in their midst. At its best, Guild Hall is more than a theater and museum for its community; it is a meeting place and a melting pot, where those worlds mingle and find expression, the better to understand and appreciate each other as they celebrate the world they share.

Guild Hall's history encompasses us all.

At the root of the Guild Hall family tree is Thomas Moran, the landscape painter to whom the main gallery is dedicated.

Often credited as the first artist to "colonize" the village, Moran

in fact followed his friends, members of the so-called New York Tile Club, after they made their first exuberant—and now legendary—visit to the village in 1878.

Moran and his wife, Mary Nimmo, one of America's foremost etchers, settled for good in East Hampton a few years later, having bought the property across from Goose Pond, now called Town Pond, and facing the South End Cemetery across Main Street, not far from the plot that would later house Guild Hall. The Morans built their romantically exotic house, now a National Historic Landmark, in 1884. The combination studio-parlor became a salon for local gentry and visiting artists. (Lucky visitors were treated to a ride in Moran's Venetian gondola, said to have belonged to Elizabeth Barrett and Robert Browning; George Fowler, a Montauk Indian, would pole the gondola around Hook Pond.)

From then on, Moran was the catalyst for the community of artists who began to set up their year-round homes in the area as well.

A lively article in *Scribner's Magazine* in 1878 publicized an excursion to East Hampton that summer by the Tile Club, an informal fraternity that drew together a number of famous painters and introduced the region to a whole new set of trendy readers. The article depicted the artists, dressed incongruously for the country in velveteen suits and berets, setting up their easels by wide, open meadows and at the edge of the sea; the sight of these dandies was surely as puzzling to East Hampton residents as it was enticing to readers.

The fifty-five paintings and sketches in the first exhibition to open Guild Hall half a century later would depict the spectrum of work of Tile Club members and their followers.

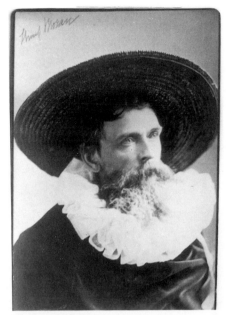

Thomas Moran
dressed in costume for a
tableaux vivant (c. 1886).*

Thomas Moran's Venetian gondola on Hook Pond.
George Fowler, Montauk Indian at the pole.
Seated: Ruth and Mary, Moran's daughters.

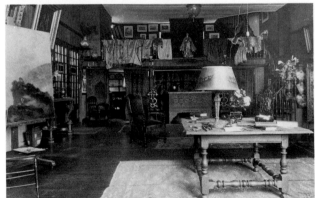

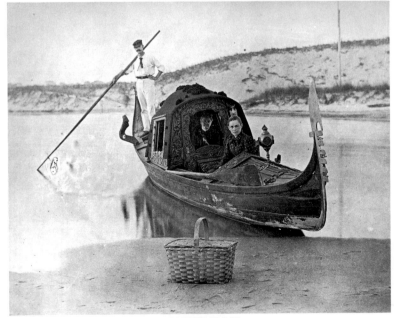

COURTESY OF THE MARINER'S MUSEUM. NEWPORT NEWS, VA.

JOHN REED

Artists Elizabeth (Boots) and Condie Lamb
in the Moran studio that they bought in 1948. It was
designated a registered national landmark in 1966.

With the turn of the century, more outsiders began to find East Hampton. Prosperous city people began building fashionable "cottages" along the dunes, bringing with them all the stylish accoutrements of New York City, a hundred miles or so away. While hanging on to its heritage as a fishing and farming region, the area began acquiring an aura of glamour from the summer residents—sometimes welcomed by the year-round residents, sometimes not.

One summer favorite was matinee idol John Drew, known as "the aristocrat of the theater" for the dashing way he epitomized the social graces. During the 30 years he summered in East Hampton, having built his house and matching miniature bathhouse on Lily Pond Lane in 1902, he officiated at everything from the Fourth of July parades to the fashion shows at the Ladies' Village Improvement Society fairs. (This latter role was particularly apt, as he made something of a fashion statement himself: In 1910, according to *The East Hampton Star*, he was considered the best dressed man in America and, later, he singlehandedly set the vogue for men in brightly-colored patterned shirts.) When he died in 1927, the whole town mourned, even flying the flag at half-mast. Four years later, the small but elegant theater at Guild Hall would be named in his honor.

Much later still, when Guild Hall was celebrating its 50th anniversary, one newspaper article summed up the ongoing vibrance of this "whimsical place of dreams and imagination": "More stars have performed in this beautiful little picture box of a theater than in any other theater in America. Its list of players reads like a who's who of stage, screen, concert and dance stars. . . ."[3]

In the years leading up to the founding of Guild Hall, you might also have seen the humorist Ring Lardner at the Maidstone Club watching Helen Wills play tennis. Then as now—and following the lead of such poets as Walt Whitman and William Cullen Bryant—writers found in the area their working haven.

Lardner and sportswriter Grantland Rice had bought neighboring four-acre tracts on the East Hampton dunes in 1927 and built summer homes for their families that winter. The houses were later damaged by storms and relocated some distance behind the dunes.

Their growing writers' colony also included the drama critic Percy Hammond, the humorist and storyteller Irvin S. Cobb (whose major complaint about East Hampton was that he was kept awake at night by a robin "stomping across the lawn") and John N. Wheeler, the late president of the North American Newspaper Alliance, whose business, he said, was "selling other men's brains."

The Hammonds had turned up in East Hampton first; the Lardners were in Great Neck and thought the group should settle there. Ever democratic, they met one weekend at the Maidstone Arms to look East Hampton over, then repeated the drill the next weekend in Great Neck. Great Neck lost, and they all moved farther east to join the Hammonds.

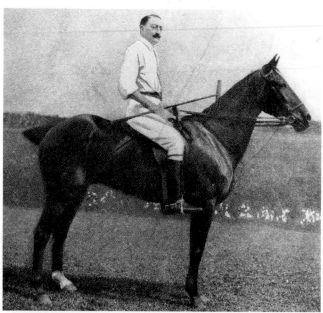

GH ARCHIVES
John Drew, matinee idol and equestrian, in East Hampton (c. 1930).

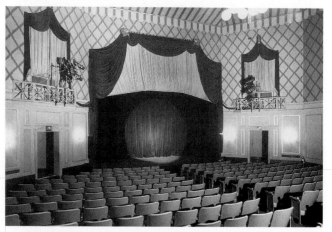

GH ARCHIVES
Interior of the John Drew Theater, named in memory of the actor.

In contrast to some of the earlier and more flamboyant activities associated with the artists, these writers lived relatively quiet lives in East Hampton. Yet their presence was felt—in the literary status they conferred on the village, in the East Hampton datelines wired all over the country, in the columns and stories they published, extolling the pleasures of the bucolic life they found living and working among the dunes.[4]

Echoes of their presence have been felt by succeeding generations of writers who have found their own inspiration in the East End and made their indelible imprint on the history of Guild Hall. Readings and openings of plays by local playwrights have taken place almost from the first; later, the theater would stage public forums on contemporary issues by leading writer-residents and lively (if sometimes acrimonious) debates on the changing role of literary forms.

Clinton Academy, the first accredited high school in New York State, had been built on Main Street in 1784 and later remodeled to serve as a community center. An auditorium was added during the remodeling, for basketball, traveling shows like *Uncle Tom's Cabin*, hometown minstrels and even exhibitions and art classes. In 1921, however, it was decided that Clinton Academy be restored to its original state and converted into a museum.

Local philanthropists Mr. and Mrs. Lorenzo E. Woodhouse financed this project, knowing that the restoration of the academy would leave the village without its meetingplace. The need for a replacement, an interdisciplinary community center that would heighten the importance of the arts and serve in addition as the village's meeting hall, was clear. Because of Mr. Woodhouse's failing health, the concept and realization of the project fell largely to Mrs. Woodhouse.

Almost 10 years later, on September 26, 1930, *The East Hampton Star* reported that, "A long cherished hope of art lovers here may soon be realized, in the erection of a little theater and an art museum on the former J. G. Thorpe property, the old Samuel Miller homestead, at the corner of Dunemere Lane and Main Street. That corner property was sold last fall, to a buyer who wishes to remain anonymous, and who has now given the tract, which is 161 × 200 feet, approximately, for the purpose of founding a permanent art gallery here. . . .

"The donor of this very valuable property has made a very wonderful and public-spirited gift to East Hampton," the article continued. "It now remains to be seen whether the building plans will materialize. This must be worked out by the formulation of a group of people interested in the project; by forming committees, to go ahead with the work, which, it is hoped, may be done this winter so that the building will be ready for use next June or July."

Miraculously close to the hoped-for schedule, Guild Hall would open the following August.

GH ART COLLECTION
Childe Hassam's etching of
Helen Wills on the
Maidstone Club court (1928).

COURTESY OF C. FRANK DAYTON
The old Samuel Miller farmhouse, originally
on the site where Guild Hall now stands.
To the left: Thomas McCann's meat market, where
the Charles S. Dewey Wing is now situated.

Aymar Embury, II,
architect of Guild Hall
(c. 1931).

The anonymous donors were, of course, the Woodhouses.

Lorenzo E. Woodhouse's uncle, Lorenzo G., had built his East Hampton house on Huntting Lane in 1894 and, while visiting him, the younger Woodhouses fell in love with the town; a few years later they designed their own estate, The Fens, to be built just across the street.

Once installed, Mary Woodhouse plunged into East Hampton society—and philanthropy—with her characteristic and lifelong zeal. Even following her husband's death in 1934 after a long illness, she continued her work. By the time of her own death in 1961, at the age of ninety-six, she could count among the Woodhouse public gifts, in addition to the restoration of Clinton Academy and Guild Hall itself, the East Hampton Free Library, the Emergency First-Aid Center (later called the Neighborhood House) and her beautiful Japanese water garden at the foot of Huntting Lane, now known as the Nature Trail. In Palm Beach, where she spent her winters, she was no less active. She was a founder there of the Four Arts, and gave to that organization a splendid oriental garden.

A modest woman, Mrs. Woodhouse refused the founding trustees' suggestion that the cultural center she had conceived be named in her honor. She preferred the idea that Alfred D. Bell had proposed, which revived the "guild" concept of Medieval Europe, wherein professional guilds looked after the standards and interests of members of their professions. His idea was that the center, which would express the standards and interests of like-minded citizens devoted to the arts, be called Guild Hall.

Aymar Embury II, who had earlier designed the East Hampton Free Library across Main Street, was the architect. His wife, the distinguished landscape artist Ruth Dean, would design the sculpture garden that now bears her name.

Embury's vision was of an unadorned, long, brick structure with a classic yet unpretentious triple-arch entrance, gracefully in keeping with the colonial character of Main Street. The foyer would serve as the entrance to both the theater (often compared to a "jewel box") and the two galleries, each with a Georgian fireplace designed with panels to set off portraits hanging above.

The artist Childe Hassam, who had been unable to attend the planning meeting, had some questions about the use of the building that everyone was so enthusiastic about and wrote to the committee on October 4, 1930:

"Having made an engagement to go over to the National [golf course] this afternoon, it will prevent my attendance at the meeting to formulate plans for the exhibition of pictures—permanently and for short periods. Thus, in addition to the beautiful library, the old town will have its opportunity to be represented in all the arts.

"One might exclaim, 'Who would ask for more!' But there is more . . . On the other side of this shining shield is, How are you going to use it?

"But it might appear churlish of me to speak of pitfalls, so I will not do so but wish you success in your very praiseworthy undertaking."[5]

From the *Star*, November 17, 1930: "At 11 o'clock Tuesday morning, a momentous meeting was held at the East Hampton Free Library, when a representative gathering from the whole village formally accepted, in the name of East Hampton, the gift of the site for the proposed new social and artistic center, and also the gift of $100,000 toward its building and upkeep, from Mr. and Mrs. Lorenzo E. Woodhouse. . . ."

At the end of the meeting, after a discussion of the plans, Mrs. Hamilton King made a motion that a rising vote of thanks be given Mrs. Woodhouse for her vision and generosity. "The rising vote," the paper reported, "was a solemn and impressive moment."

Childe Hassam's letter to Mrs. Hamilton King and Nelson C. Osborne, regarding building plans for Guild Hall (1930).

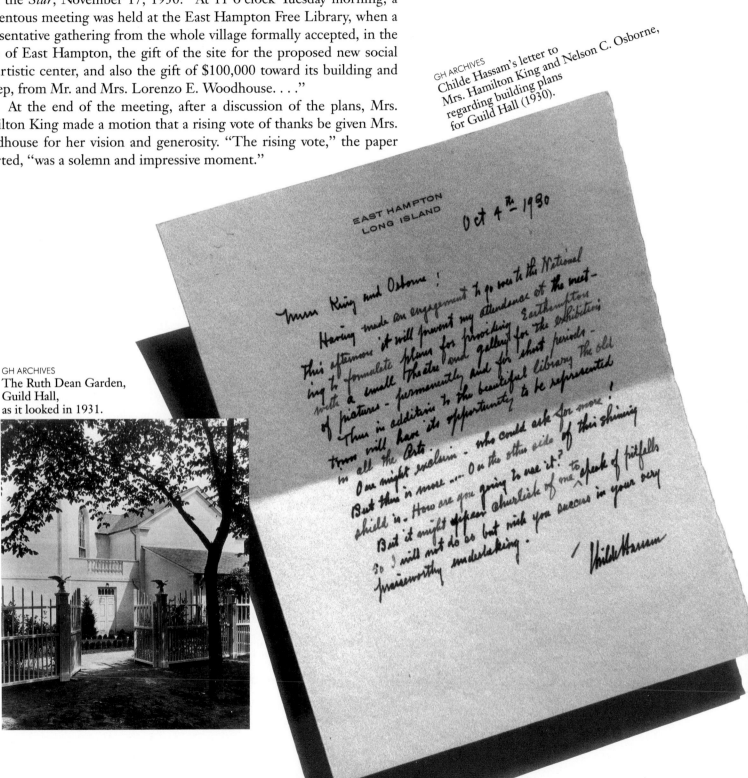

The Ruth Dean Garden, Guild Hall, as it looked in 1931.

Samuel Hedges, president
of the East Hampton Historical Society,
spoke at the Guild Hall opening
ceremonies, August 19, 1931.

At the start of the new year, construction was already under way; Frank B. Smith had been chosen as the builder. In February, a committee was set up to raise donations from the community in order to complete the project. Practical considerations aside, the committee, which was chaired by I. Y. Halsey, also felt that "the psychological fact is that we all cherish and enjoy things most that have been earned." The fundraising would make subscribers feel truly a part of their own community center.

By March, more than $10,000 had been raised; eventually, more than 200 families would "buy a brick" to secure the needed funds. Construction proceeded throughout the spring; the date for the dedication ceremonies was announced early in August.

In awed tones the *Star* wrote of the August 19, 1931 opening: "East Hampton has never known a celebration like that on Wednesday, when Guild Hall was formally opened to the public, from 5 to 7, with a beautiful dedication ceremony, followed by tea, viewing a unique art exhibition, and dancing."

Mrs. Woodhouse was given an ovation when she walked down the aisle toward the front row of the theater. Behind her the theater was filled to overflowing; people were standing in the aisles and crowded around the open doors. The boxes had been given over to local organizations—the Village Board, the Ladies Village Improvement Society, (L.V.I.S.), the Mothers' Club, the Business Men's Club and the clergy. The program opened with composer-conductor Victor Harris and Philip James playing a four-handed accompaniment to baritone Willard Frey's singing.

The dedications themselves were in a quieter, more solemn spirit, simple and moving. As president of the Historical Society, Samuel C. Hedges, also representing the generations of families that were East Hampton's earliest settlers, was first to speak. Summarizing the address, the *Star* reported that he spoke of the early settlers, coming over 275 years ago, to choose this spot as their abiding place and of their simple arts, the weaving and design, then how with new people a new conception of beauty had been brought to East Hampton. "East Hampton," he said, "is grateful."

Childe Hassam, introduced as
"the renowned Impressionist and summer resident since 1898,"
rose to dedicate the North Gallery to his old friend Moran.
Otis Skinner, a luminary of the stage, then dedicated
the theater to his late friend John Drew.

Drew's ten-year-old grandson, John Drew Devereaux, accepted on his grandfather's behalf with an aplomb that befitted his ancestry—it was his

first appearance at the John Drew theater. Upon accepting a silver bowl commemorating the occasion, which was presented to her by William A. Lockwood, Mrs. Woodhouse expressed her own gratitude: "All I can say," she told the assembled group, "is I thank you from the bottom of my heart."

Guild Hall was now free to explore its carte-blanche charter, emblazoned in gold on its facade: "The purpose of Guild Hall is to cultivate and encourage a taste for the arts through the presentation of drama and music, to provide galleries for the display of objects of artistic or historic interest, to furnish a meeting place for committees and organizations of this village, to promote and encourage a finer type of citizenship."

One of Guild Hall's charter members was the sculptor Maude Sherwood Jewett, who had kept a summer studio in East Hampton since 1910. It was she, in fact, who organized the appropriate and highly acclaimed opening exhibitions entitled (a bit wordily), "A Retrospective Exhibition from the Work of the Tile Club and Their Followers Who First Discovered the Picturesque Qualities of East Hampton—1877–1895."

The next year, however, Guild Hall weathered its first controversy over "Six Contemporary Painters," a show organized by the College Art Association and scheduled by Guild Hall's art chairman, Josiah P. Marvel, who was also a director of the Brooklyn Museum. Many visitors to the show, as well as some critics, found the works by Morris Kantor, Alfred Maurer, Max Pechstein and other "moderns" profoundly disturbing, describing them with such words as grotesque, brutal, erotic, jarring.

When some people went so far as to complain to the board, Jewett wrote to the *Star* (September 20, 1932) in defense of the exhibition: "Frank criticism of the pictures is welcomed and appreciated but when objections as to the advisability of having such an exhibition are raised, I feel they should be answered. . . . Guild Hall was built for the advancement of all the arts. . . . Whether we like it or not we can certainly admire the courage and the independence of the Modernists in their efforts to express the soul of Nature rather than just its outer garment. . . . I think if anyone will go to the exhibition and quietly become acquainted with [the work] he will feel that these pictures reveal a deep understanding of the heart of the universe and help to blaze the trail to Progression in the art world."

The next outcry occurred in 1939, when Marvel booked what he thought was an ideal show for Guild Hall, selections from the Index of American Design, watercolor renderings documenting American decorative arts objects from the colonial period through the nineteenth century. It came through Roosevelt's New Deal WPA arts project. WPA? To the board of trustees, dominated at the time by members of the staid Maidstone Club, permitting this show to run was tantamount to linking arms with the Socialists. Letters and wires flew back and forth. Marvel resigned in protest.

COURTESY OF CAMILLA JEWETT
Arnold Genthe's photograph of Maude Sherwood Jewett, sculptor, and Guild Hall's first Art Committee chairman. (c. 1934).

1931

C. Douglas Woodhouse, son of
Mr. and Mrs. Lorenzo E. Woodhouse, who served briefly
as vice-chairman of the Guild Hall board.

Madeline Edwards as a young girl
at the tea house in Mrs. Woodhouse's
Japanese Water Garden on Huntting Lane,
now the Nature Trail. (c. 1913).

Childe Hassam's etching of Guild Hall (1931).

The pine-paneled Moran Gallery
as it looked in 1931.

. . . . and as it looks today.
The new Spiga Gallery can be seen through
doorways either side of the fireplace.

Or Jewett's letter might have run in the *Star* again in the summer of 1949, perhaps, to answer the outcry against Jackson Pollock's "drip paintings" in the first of the annual artists-of-the-region invitational exhibitions.

For the most part, however, Jewett's forthright sentiments have held firm. Guild Hall remains an institution as dedicated to the advancement of all the arts today as it was the day it opened, though pockets of resistance will always exist.

In a feature article celebrating the 50th anniversary of Guild Hall in 1981, Michiko Kakutani wrote in *The New York Times* of some of the artists with ties to Guild Hall who had "helped redefine American—and twentieth-century—art": Willem de Kooning, Jackson Pollock, Lee Krasner, James Brooks, Adolph Gottlieb, Franz Kline, Roy Lichtenstein, Alfonso Ossorio, Larry Rivers and James Rosenquist were, she wrote, leading members of this "wonderfully uncommon . . . community of talent."

Kakutani went on to list many other residents "who also happen to be prominent cultural figures who have participated in Guild Hall activities: Cy Feuer, Betty Friedan . . . Robert Alan Aurthur, Elia Kazan, Sidney Lumet, Dwight Macdonald, Frank Perry, George Plimpton, Irwin Shaw, Peter Stone and Charles Strouse have assisted with its film festivals; David Ignatow, Kenneth Koch, Peter Matthiessen, Willie Morris, Howard Moss and . . . Jean Stafford have given readings there; and Gwen Verdon, Bob Fosse, Cy Coleman, Phyllis Newman, Betty Comden and Adolph Green have appeared at the John Drew Theater. . . ."[6]

All of these talented and committed people, and dozens more, found their way first to East Hampton and then, almost inevitably, to Guild Hall. Along with a great number of talented, long-time residents, many of them with roots going back to colonial times, they have enabled Guild Hall to find, in turn, its own way. The story of Guild Hall is their story.

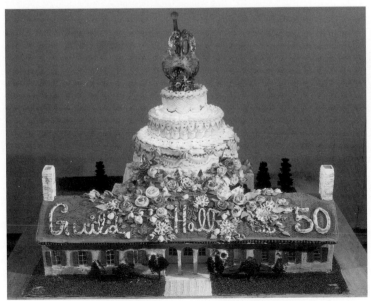

NOEL ROWE. GH ART COLLECTION
Larry Rivers created this four-foot-wide birthday cake sculpture for display in the foyer during Guild Hall's 50th anniversary (1981).

1991

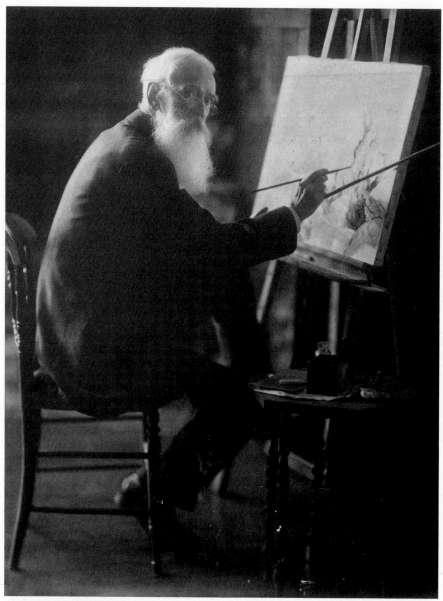

Thomas Moran in his
Main Street studio (1915).

INFLUENCES OF THE REGION

In a *Star* article, October 24, 1935, Ruth B. Moran, daughter of the artist Thomas Moran, wrote evocatively of her memories of the late 1880s, when a group of artists would congregate nightly in the Moran studio on Main Street to "start up their pipes," listen to Mary Nimmo Moran (Moran's wife) "sing Scotch songs to break your heart" and fill the big square room "with good studio talk: quarrels as to what is Art!" Remembering those days when she was a young girl, she wrote: "I see them all—the long roster of men and women who came and took away with them on canvas, copper or paper, the essence that was old East Hampton—to scatter it over the cities and towns in art exhibitions everywhere; and more than that, to go on loving it; its whirling mills, its silvery, silent beaches, its watery marshes and bays; its goose pond,

willows and green; not French, nor German, nor English—just American; just East Hampton. And have we not today the same spirit? Our studios are still busy—artists painting; always painters, here in East Hampton—always."

Is it any wonder, then, that Guild Hall has been inspired over the years to create theme and subject shows revealing the way generations of artists up to the present have interpreted the magical ambience of this eastern tip of Long Island?

How fitting that the exhibition marking the opening of Guild Hall in 1931 should be "the Tile Club and Its Followers," arranged by Maude Jewett, herself an artist. Art critic Carlyle Burrows in the *New York Herald Tribune*, August 23, 1931, singled out William Merritt Chase for special praise: "His Shinnecock painting tells a story of a neighboring country-side of grass-grown dunes, of a quiet picnic by the sea. No one since Chase's time seems to have caught so well the mood of this especial bit of seaside or has painted it so well . . ."

Some years later, James Abbe, Jr., a specialist in nineteenth-century American art, suggested we take another look at those early artists and so, in 1969 under his direction, we mounted a large, well-researched exhibition called "East Hampton: The American Barbizon—1850–1900." The title was inspired by an April 1883 article by Charles Burr Todd in *Lippincott's Magazine*, which described the charms of East Hampton and how congenial it was for artists. All of this Todd likened to Barbizon, a country region near Paris, where Corot, Millet, Rousseau and others sought to escape the rapidly encroaching industrialization of the city, and to find in the simple rural scenery a truer inspiration for pencil and brush. This show filled both of the large galleries with its 135 works, including a moody Samuel Colman of a pastoral Main Street in 1880, a George Smillie depicting a local meadow and an 1887 Winslow Homer of fishermen in dories.

In looking back, Abbe commented, "In presenting this show, we were in the vanguard of revival of interest in this nineteenth-century work. We had help from some serious scholars like Nelson White and good cooperation from the Metropolitan and other museums. The art historian Ron Pisano acknowledged later that our pioneer work on this exhibition had helped inspire him to write his book *Long Island Landscape Painting*."

FRANCES McLAUGHLIN GILL
At the opening of
"East Hampton, the American Barbizon"
(1969): James Abbe, Jr., guest curator;
and Robert Montgomery, actor
and East Hampton resident.

For the summer show in 1953 the theme was "The Sea Around Us," and that same year the critic James Thrall Soby, in his foreword for the annual artists of the region show, focused on the indirect stimulus of the East Hampton landscape on such abstract artists as James Brooks, Jackson Pollock and Willem de Kooning, who were all represented in the exhibition. He wrote: "Too much is always made of the detachment of modern artists from surrounding reality. The best of them, on the contrary, whether abstract or not, are susceptible to suggestions from the tangible world

which they transpose to their own high uses. Because the twentieth-century painter's retina looks inward does not mean that he no longer sees out . . ."

"A Sense of Place" in 1972 again dealt with how the artist is moved by the physical world around him. "Light, air, color, form, weather, fields, sky, water—is at the heart of my work," Jane Freilicher said of her *Landscape at Water Mill*. And Julian Levi described his work thus: "After twenty-five years of exposure (visual) to East Hampton, let me affirm that my painting has been intimately shaped by what I have seen and experienced . . . I have reached for those symbols of the environment . . . impressions well concealed but nevertheless in which certain concrete objects intrude themselves—channel-markers, breakwaters, buoys, the tides . . ."

"Light of the South Fork" in 1979 was more specific. It illustrated the ways in which the quality of the light had influenced four contemporary area artists (Robert Dash, Paul Georges, John MacWhinnie and Jane Wilson) and four photographers (Dan Budnik, Jay Hoops, Hans Namuth and Susan Wood). Dash described it as "the wettest light in the world," while Wilson said, "Coming back from Europe there is a layer of American light on the horizon. One enters it abruptly at the edge of Long Island . . . It is silvery and candid, deceptively optimistic like a Henry James heroine . . ." Namuth remarked that photographers breathe the light as other people breathe the air, and MacWhinnie said that the clear, soft light coming through his huge barn window in *Studio* "brought the outdoors into the painting, suffusing everything, flattening and integrating the figures without robbing them entirely of their substance."

"En Plein Air—The Art Colonies of East Hampton and Old Lyme—1880–1930," curated by Helen A. Harrison in 1989, was one of two exchange exhibitions (the other was with Provincetown) that examined seaside art colonies in relation to each other. The selections Guild Hall sent to Old Lyme (mainly from our collection), were reminders of the appeal of the local scene in works like G. Ruger Donoho's *Woodhouse Water Garden*, Childe Hassam's *Adam and Eve Walking Out on Montauk in Early Spring* and William Whittemore's *Autumn in Old East Hampton*.

More recently, in 1991, Guild Hall presented "East Hampton, the nineteenth-Century Artist's Paradise" in which guest curator Katherine Cameron evoked the birth of East Hampton as an artist's "paradise," combining works from the collection with such rarely displayed examples from private collections as William Merritt Chase's *Main Street, East Hampton* and Bruce Crane's *Farm Landscape*.

Even as the potato fields and stretches of dunes are losing their pristine beauty, this part of the world continues to attract artists. Are they influenced, as were their predecessors, by the physical qualities of the area? Not necessarily, according to Helen A. Harrison, curator of "Arrivals," a 1983 exhibition focusing on such newcomers as Lynda Benglis,

Connie Fox, Robert Richenburg, Dan Welden and Joe Zucker. In the catalogue, she said several have noted "that the light, water and other topographical features affect their work, either directly or obliquely. Others value the region less for its landscape than for its atmosphere; as one artist put it, 'the attention and energy given to and generated by the artistic community.' " For whatever reasons, East Hampton is still a magnet.

Committed from the first to showing a cross-section of East End artists, Guild Hall mounted its first annual artist members' exhibition in 1938; the sole criterion has always been membership in Guild Hall.

Although subject to criticism from time to time, this traditional open show remains to this day the one opportunity during the year when an artist can show without being invited or subjected to a jury of selection. What gives the exhibition its excitement is the mix of prestigious area professionals showing next to those less well known and hoping to be discovered. Strangely enough, over the years the show has to an extent juried itself. Amateurs, for the most part, have dropped out, wisely deferring display space to those who are more accomplished. Beginning in 1963, the Best in Show winner was given a one-person show the following year. Ray Prohaska was the first to be so honored, followed by (among others) Athos Zacharias, Francesco Bologna, Theo Hios, Perle Fine and Elizabeth Strong-Cuevas.

The conservatism that marked the early history of Guild Hall reigned as well in the art community of the day. The trustees were members of the socially elite Maidstone Club, with token representation from

AREA ARTISTS AT CENTER STAGE

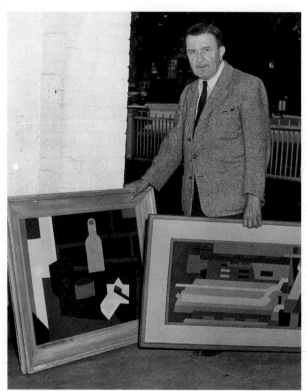

DAVE EDWARDES
Niles Spencer with his entries for the third annual "Artists of the Region" exhibition (1951).

GH ARCHIVES
At the opening of the 1952 "Artists of the Region."
Participating artists: Lee Krasner,
Robert Motherwell, Willem de Kooning.

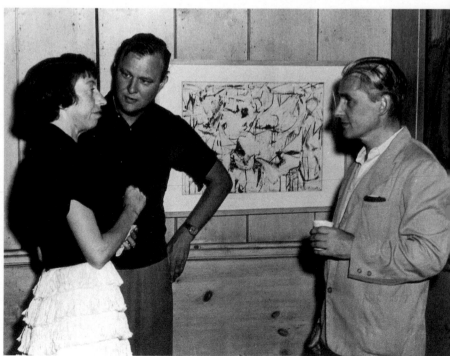

Exhibiting artists Buffie Johnson
and Theodoros Stamos at the opening
of the 1952 regional.

DAVE EDWARDES

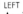

LEFT
At the opening of the 1956
invitational regional:
Gitou Knoop, exhibiting sculptor;
Barbara Hale; Manette Loomis,
chairman.

FAR LEFT
Carlo Grossman, of the exhibition
committee, with the jury for
"Long Island Painters" (1967):
Alan Stone, Seth Sieglaub,
Carroll Janis.

WILLIAM BOONE

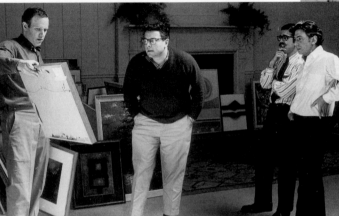

JOHN REED

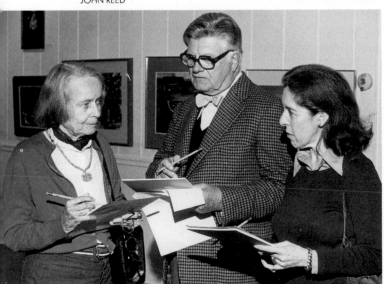

PHILIPPE MONTANT

JAY HOOPS

Warren Brandt, Fay Lansner and William Woolfenden
served as judges for the 1980 members' exhibition.

Betty Parsons, Ray Prohaska, Cynthia Navaretta: Judges
for the 39th annual artists' members exhibition (1977).

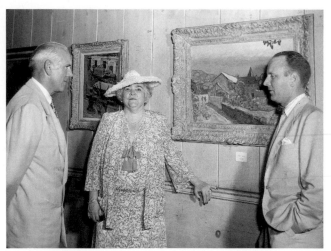

Edward Moran, chairman of the Art Committee;
and Martha Burke, with E. Coe Kerr
of Knoedler Galleries, at an opening in 1948.

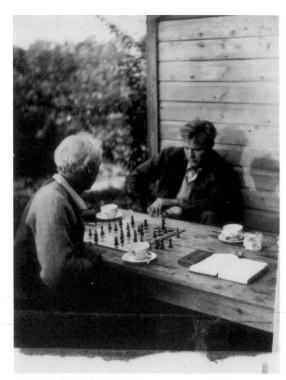

Max Ernst and
Robert Motherwell playing chess
in Amagansett in 1945.

the year-round community. The artists who lived and showed here at that time were also in large part socially well connected and traditional in their thinking. It is perhaps not surprising that at first they did not open their arms to the avant garde artists who begin arriving in the early '40s.

Nevertheless, some of us recognized the significance of the new art and felt strongly that if Guild Hall was to represent the community of artists, we should certainly include these newcomers in our shows. It was Rosanne Larkin, then chairman of the Art Committee, and the fiery Harriet (Happy) Macy, Guild Hall trustees and rebels in their own social set, who persuaded the reluctant board to go along with our plan for a regional invitational show that would represent a true cross-section of the artists working here and would, as it turned out, become an important annual tradition. The first, in 1949, was called "17 Artists of Eastern Long Island." With board permission, the committee removed the staid memorial oil portraits and most of the furniture from the galleries to install recent work by Jackson Pollock and Lee Krasner as well as Balcomb Greene, Lucia, Ray Prohaska, Julian Levi, Nat Werner and others. Members of the art community as well as the "old guard" turned out for the opening. Although some of the reserved hostesses looked askance at Pollock's painting encrusted with cigarette butts and other trash, the *Guild Hall News* reported that the exhibition was "an overwhelming success from every standpoint." What is more, it stated, "Attendance at the preview was one of the largest on record and the crowds attending the exhibition daily were further evidence of the increasing interest in contemporary art being created in this area . . . During the first four days of the show, six paintings and one piece of sculpture were sold."

When Mrs. Woodhouse, who was not in residence in East Hampton that summer, heard that her portrait had been removed from over the mantel, she was so indignant that she asked to have it shipped immediately to her home in Palm Beach. Only when she was assured that the removal was temporary did she relent.

The next summer Larkin bowed out as chairman and the artist John Little carried out her mission to include more of the new artists, organizing our first all-abstract exhibition, "Ten East Hampton Abstractionists," with works by Pollock, Krasner, Robert Motherwell, Buffie Johnson and others. Not surprisingly, it was controversial among the more conservative members of the board. Motherwell, then living in East Hampton, wrote in the guest column in the *Guild Hall News* (August, 1950) an eloquent piece on modern art, which read in part:

> . . . What the public means by art is representation of an object that it can recognize: The closer the resemblance and the more it looks like the object— say, a baby's face—the greater the work of art, in its estimation. Especially a portrait in which the sitter is made to appear more elegant than in life.
>
> What an artist means by art the public cannot experience without long training and an adventurous mind. Rhythms, beat, sequences, orchestration, order—as in music or poetry—some of the qualities that make art what it is,

these are not easy to recognize until one has been saturated in them for years.

If the public does not "understand" modern painting, neither does it understand the basis of any important painting of the past. Why this should be is a social problem; an American education is entirely in words and numbers. In compensation, the public has invented its own arts, baseball, popular music, movies, radio, television, newspaper and comic strips, whose premises are such that a person without culture can understand them, as well as everyone else. What is inexcusable is the public's hostility toward those few persons interested in something else . . .

Even when "the public" seemed to be trying to understand the new art, they were sometimes rebuffed. For instance, at one regional opening, Phyllis Wheelock, the effusive wife of the poet John Hall Wheelock, who was serving as a hostess, tried to put Pollock at ease by telling him how much she admired his painting. Pollock responded with a loud "Bullshit!" that resounded through the gallery and shocked his own friends as much as it did the lady herself.

Josephine Little, wife of the artist John Little, who was helping to install an off-season exhibition, remembers with amusement the time that Mrs. Woodhouse, who had an intense dislike for modern art and wasn't afraid to say so, arrived unexpectedly at Guild Hall. The director, to avoid an unpleasant head-on collision, apologetically closed the gallery door on the "offensive art" until the grande dame was safely out of the building.

On yet another occasion, in 1954, the ultra-conservative chairman of the board contronted Larry Rivers in the foyer as he was delivering his almost life-sized nude sculpture of the poet Frank O'Hara for an invitational show. He was so shocked that he yelled as he pointed to the door-

LAWRENCE LARKIN. GH ARCHIVES
Rosanne Larkin, chairman of the 1948 Art Committee, removing a roast from her old coal stove in the Georgica Woods studio, where she and her husband Larry often entertained artists at "kitchen" dinner parties (c. 1949).

DAVE EDWARDES
Members of the Art Committee
(c. 1952):
Eloise Spaeth, chairman;
Harriet (Happy) Macy;
Ms. Kneeland Green; Ellen Barry;
Gina Knee; Denise Delaney.

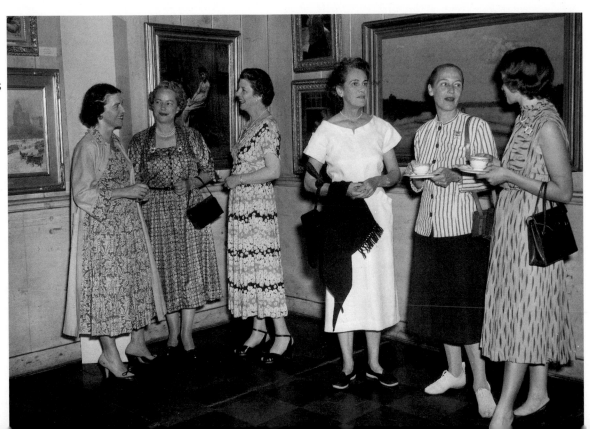

Arthur Byron Phillips' portrait
of the actress Nell Robinson
(egg tempera, 40″ × 30″) shown in the
1978 exhibition, "Aspects of Realism."

way, "Young man, get that thing out of here!" Rivers obliged and wasn't seen again at Guild Hall for quite some time, even after apologies.

Nevertheless, the regionals continued each year to growing appreciation among some art lovers and grudging tolerance by others as we pursued our course with determination. Along with "the regulars," we sought out artists new to the region. One such relative newcomer to the area, Willem de Kooning, showed three large canvases from his new "Women" series in 1953. Other artists new to Guild Hall in the '50s were John Graham, Paul Brach, Franz Kline, Jacques Lipchitz, David Hare, Louis Guglielmi, Grace Hartigan, Miriam Schapiro and August Mosca.

Eloise Spaeth became a board member in 1950 and was soon appointed chairman of the Art Committee. Energetic, imaginative and outspoken, she would serve as trustee and officer for many years and would become the guiding force in building the art collection. Spaeth was a bulwark of support in the controversial '50s. On the one hand, the Abstract Expressionists were beginning to complain that we were not exhibiting their work exclusively during the prime summer season. On the other hand, in 1955 a group of summer residents circulated a petition protesting Guild Hall's showing of abstract art. A forceful Spaeth told the board: "Do we have a right to close our doors to our regional artists because they paint abstract? Carlyle Burrows of the *New York Herald Tribune* was here last Sunday and told Enez Whipple, our director, that of all the summer museum programs from Maine on down, ours has been the most interesting and vital. Do we want to be judged by a pro who knows his business or by those self-appointed critics who don't know anything about art but 'know what they like?' Do you want to take the easy way and not show anything that's been painted since 1910 . . . or do you want to roll up your sleeves and prepare for a little controversy?" The petition was turned down unanimously.

Sometimes themes were introduced in the regionals to heighten their appeal. Often they developed in unexpected ways. One night, for example, Lee Krasner was sitting around with some artist friends and commented that she was bored to death with the eternal youth cult, all those shows around New York that were glorifying the young with titles like "Artists Under Thirty." Someone said, "So why not artists over 60?" That was the genesis of our 1973 exhibition "21/60" (21 artists over 60 years of age, who were then at the peak of their careers). It was an idea that instantly appealed to the news media, attracting unprecedented press and TV coverage for a Guild Hall exhibition. Ilya Bolotowsky, Adolph Gottlieb, Esteban Vicente and Adja Yunkers were among the "oldsters" only too happy to prove that they were still in top form.

Another variation on the annual regionals was "Aspects of Realism" (1978) with works by Arne Besser, Chuck Close, Audrey Flack, Ian Hornak, Howard Kanovitz, Arthur Byron Phillips and others.

Co-presented with the American Association of University

Women, "Women Artists of Eastern Long Island" was the regional in 1979. Alice Baber, for whom the library in the Leidy Gallery would later be named, was one of the artists represented and also served on a related panel with Perle Fine, Fay Lansner and Buffie Johnson. Art critic Phyllis Braff was the moderator.

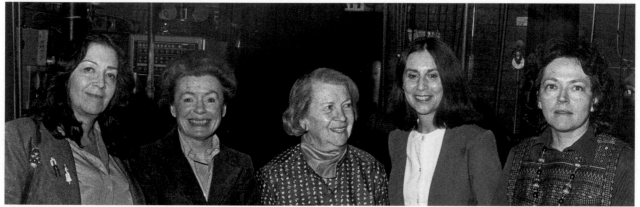

"Women in the Arts" panelists: Fay Lansner; Buffie Johnson; Perle Fine; Phyllis Braff, moderator; Alice Baber (1979).

"Portraits Real and Imagined" followed in 1980 with, for example, John MacWhinnie's "real" portrait of Fairfield Porter alongside Larry Rivers' "imagined" portrait of Stravinsky incorporated in a box-like construction, with music as an added element.

In celebration of Guild Hall's 50th anniversary in 1981, the regional was a year-long presentation of in-depth exhibitions—celebrations, really—of the work of several major artists associated with our community from late in the last century to the present.

As one of the great legends of East Hampton, Thomas Moran was the obvious choice for the opener, "Thomas Moran: The Search for the Scenic." Moran, with his wife, Mary Nimmo Moran, the distinguished etcher, was—as has been noted previously—the first to build a permanent studio-home in East Hampton. It soon became the center of the East Hampton art world of their day; their salon lasted until Mary contracted typhoid fever in 1899, when the soldiers were at Montauk recovering from the Spanish-American War, and died from it. Moran's daughter Ruth subsequently devoted the rest of her life to her father and to the documentation and preservation of his art and his studio records, which were important to American art history.

Even though Moran made many sketching trips to locations far from East Hampton, he always returned to the village he loved with a passion. In 1902, legend has it, when the Sea Spray Inn was being moved from the business section to Main Beach, he sat all day in front of his Main Street house with a shotgun across his knees, vowing he would shoot if the movers broke off so much as a branch of any tree in his view.

For the anniversary show, guest curator Phyllis Braff—who, as a result of her work would become America's leading authority on Moran—chose three of the artist's favorite scenic themes: the American West, East

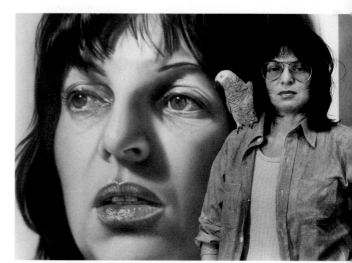

Audrey Flack (with Albert on her shoulder) and self-portrait (1974).

Hampton and Venice, revealing through loans from museums and collectors across the country the artist's greater concern with pictorial emotions than with pictorial records.

To highlight the Moran exhibition, there was a special celebration at Moran's old studio, which Condie and Elizabeth (Boots) Lamb, both artists, had bought in 1948 after Ruth Moran's death. Throughout the snowy afternoon, in an atmosphere reminiscent of the studio's salon days, guests enjoyed listening to the actor Day Tuttle read from Moran's favorite authors—Shakespeare, Browning, Longfellow—followed by music and refreshments with the Lambs as hosts. The celebration would turn out to be presciently fitting as, after her husband's death, Boots and her son, David, gave the historic landmark studio to Guild Hall, along with a fund to help maintain it. It was one of the most generous gifts ever made to Guild Hall.

The second show in the 1981 anniversary sequence celebrated another beloved East Hampton master, Childe Hassam, who first came to the village in 1898 to visit artist friends. In an interview many years later, he claimed that he had actually been diverted to East Hampton by the Spanish-American War. His usual summer haunt, a hotel off the coast of New Hampshire in the Isles of Shoals, was strategically exposed to the war and he decided to come to East Hampton instead. The village worked a kind of spell on the painter who, with his wife, Maud, subsequently returned regularly; in 1919 they bought their own house which still stands on Egypt Lane. (From then on, Hassam, like all newcomers, began to complain whenever he sensed the village losing its unique character to modern times and progress!)

Though he subsequently traveled widely and painted in other places, Hassam particularly loved interpreting the simplicity and character of his adopted village: "I have always felt," he wrote in a preface to a catalogue for an exhibition of his work at Guild Hall in 1932, "that to spare a fine old tree and salvage fine old houses, such as I portray in my etchings . . . constitutes one of the highest forms of a civilized people's aim." On his seventy-fourth birthday, in October 1933, the *Star* recorded his usual daily swim through the breakers alone. It was too cold to swim the following year, and that winter he became ill. In the summer of 1935 he had himself brought by ambulance to East Hampton from Manhattan because that was where he wanted to die—which he did, that August.

Hassam's affection for East Hampton came through clearly in the 50th anniversary exhibition, which was selected and organized by Stuart P. Feld. It benefited from the extensive research Feld had done as author of the definitive Hassam catalogue raisonné. Such evocative works as *July Night*, depicting Hassam's wife at a Japanese lantern-lit Fourth of July party on Egypt Lane, crystallized his love of the region for a new generation of art lovers.[1]

"Krasner/Pollock: A Working Relationship,"[2] the third of the an-

JAY HOOPS
Judith Wolfe, staff curator; with Stuart Feld, guest curator of "Childe Hassam: 1859–1935" (1981).

niversary exhibitions, was curated by the noted art critic and writer Barbara Rose.

If there had been a cutoff point when one generation of artists gave East Hampton over to a new generation, it was with the arrival in 1945 of artist Jackson Pollock, who would become known as the most influential artist of his time, and his wife, Lee Krasner, also considered a pioneering New York School abstractionist.

In the August 8, 1949 issue, *Life* magazine called Pollock, then age thirty-seven, "the shining new phenomenon of American painting." Others did not pass the mantle so enthusiastically. *Life*'s sister publication, *Time*, said of Pollock that same year: "A Jackson Pollock painting is apt to resemble a child's contour map of the Battle of Gettysburg."

The task of nurturing and tending Pollock, whose hard drinking ways alternated with periods of sobriety, fell largely on his wife and sometimes prevented her from devoting full time to her own work. Nevertheless, their partnership was artistically productive and they were honest critics of each other's work.

In the 1981 exhibition, Barbara Rose explored the powerful interaction of the two artists in comparative works from the '30s to the time of Pollock's death in 1956. In the catalogue essay she wrote: "This exhibition is meant to illustrate that theirs was, above all, a working relationship for both, that the richness of their lives and feeling for each other spilled over into the work they produced together." Krasner remarked later that it was the first time their work had ever been shown together.

A native of the Netherlands who emigrated to America in 1926, Willem de Kooning, together with his wife, the painter, teacher and writer Elaine de Kooning, moved to Springs, East Hampton, from Manhattan in 1963. However, he had begun working on the East End earlier, and "Willem de Kooning: Works from 1951–1981"—the final anniversary exhibition, spanned those earlier years as well. Guild Hall's staff curator Judith Wolfe organized the show.

Like the other artists in the anniversary series, de Kooning felt a special love for the area. He enjoyed riding his bike along the roads that led to the bayside, soaking up the scenery and light. He once told Harold Rosenberg that working in the country affected his painting enormously: "When I came here," he said, "I made the color of sand—a big pot of paint that was the color of sand. As if I picked up sand and mixed it. And the gray-green grass, the beach grass and the ocean was all kind of steely gray most of the time . . . indescribable tones."[3] De Kooning was seventy-seven at the time of the exhibition. He told Judith Wolfe that the subject most interesting to him was what he was currently planning to do. "It's not going to be easy," he said. "Just because you're getting old, it doesn't mean you're getting any better. But I have a feeling I can do it better now." And that seemed to be the case. As was pointed out in the catalogue introduction, "De Kooning is not an artist to rest on his laurels. His cre-

WILFRID ZOGBAUM
Lee Krasner and Jackson Pollock in Springs (1949).

COURTESY OF ALEXANDER B. BROOK
Alexander Brook at the wheel of his Rolls Royce. Jackson Pollock seated next to him. Lee Krasner and unidentified man in back seat (c. 1946).

Elaine de Kooning (1946).

ative energy and output continue undiminished and the new works burst with inventiveness and spontaneity."

As a long-standing trustee of and friend to Guild Hall, artist Jimmy Ernst served informally, and brilliantly, for many years as our liaison to the art community. His spirit was as generous as his ideas were expansive, and in 1980 he came up with a new way for us to express our commitment to showing area artists. His concept, which was presented in 1982, was to be called simply "Poets and Artists," and he described the intent "to pay decent attention to a group of human beings [poets] . . . a minority honored in some societies, feared and oppressed in others, but barely perceived in this nation, whose pride is the free spirit." Ernst felt that since the aims of the poets and the artists are essentially the same, the poets should be up there with the artists on the gallery walls.

Lillian Braude, art collector and sponsor of poets, was invited to curate the show. The poets and artists chosen were paired off, by mutual consent, and two rules were established up front: The canvases had to be five feet by seven feet in order to make the display look like pages of a book, and part of the poetry had to appear directly on the canvas. The

At the opening of his show in 1981, Willem de Kooning autographs a catalogue for Andrew Malone as his daughter, Lisa de Kooning, looks on.

Thomas M. Messer, director of the Solomon R. Guggenheim Museum, at the opening of the de Kooning exhibition.

result was a provocative exhibition of forty-three collaborations by such teams as poet Kenneth Koch and artist Larry Rivers, Norman Rosten and Herman Cherry, H. R. Hays and Gerson Leiber, Harvey Shapiro and Syd Solomon, Michael Heller and Claus Hoie, Claire White and Sheila Isham. One artist commented rather poetically, "Hands alone don't make a painting. Having eaten at the poet's table, I feel the work is as much his as it is mine." Another reacted more directly: "It was a helluva lot of fun."

By the time of the 1985 show, "Walls—The Artist as Philosopher and Poet," the regional theme exhibition had become a much anticipated tradition. In this one, Rae Ferren, Guild Hall's associate curator, who conceived and organized it, gave the artists leeway to interpret the theme in any way they chose. "The artists found the idea tempting and challenging," said Ferren. "Some thought along introspective lines—walls of mind and soul as in Susan Yardley Mason's *Interior Folly*, a three-dimensional piece where the viewer peered through a window in a wall at objects revealing her hidden thoughts. Some works, like Frank Wimberley's and Nick Micros' free-standing pieces, were architectural and concerned with texture; a few were historical—inspired by, say, the Wall of China or the Wailing Wall; Rocco Liccardi's *Once Upon a Time* was an emotional expression—man's pollution of the oceans as a wall to future generations. Accompanying statements were often expressed in poetry. The exhibition, like the works themselves, was an experiment."

Before the danger of vandalism became a reality in the mid-80s, we regularly showed sculpture outdoors. The welcoming Ruth Dean Garden, off the Woodhouse Gallery, became the setting for annual exhibitions of sculpture, nearly all by area artists. For a number of years, Arline Wingate, herself a sculptor, planned these shows, occasionally assisted by guest curators, notably Phyllis Braff and Toni Borgzinner. Daily visitors, along with intermission crowds from the theater, could enjoy works by Jane Wasey, Day Schnabel, Ibram Lassaw, Louis Trakis, Wilfrid Zogbaum, Hubert Long and others.

Here again there was room to vary the theme. "Color in Sculpture," for example, was curated by Braff in 1967. The following year the theme dealt with motion. The painter-sculptor Ronnie Stein had made a study of the technical aspects of electrically powered fountains and drew up guidelines for the artists invited to create works especially for "Fountains by Eleven Sculptors," a very popular show, as it turned out. Children were especially attracted to it. A *Newsday* reporter was on hand one day to observe "a five-year-old boy who said, 'Look, Mommy, blood!' as he raced around Alfonso Ossorio's fountain—a stone eyeball oozing red water from its orange pupil. 'See, see, the children love it,' said the smiling creator, pouring Kodak photo solution on his fountain. 'This is not a put-on.' Ossorio continued as an awestruck woman whispered, 'He must be kidding,' as she went past. 'My fountain is part of the world today, glazed with a common denominator—blood!'"[4] Esther Gentle's rectangular-

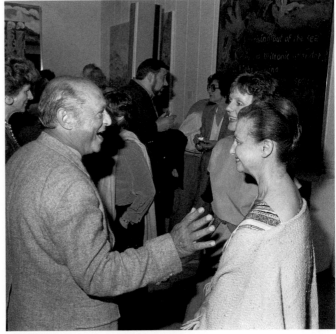

NOEL ROWE
At the opening of "Poets and Writers" (1982): Jimmy Ernst; Anabelle Hebert, Guild Hall director; and Lillian Braude, chairman of the exhibition.

SANDRA WEINER
Alfonso Ossorio with his entry for "Fountains by Artists" (1968).

43

A prankish bather takes a shower
in Esther Gentle's entry for
"Fountains by Sculptors" (1968).

Wilfrid Zogbaum placing his work for
"Sculpture in the Garden" (1958). Other exhibiting sculptors:
Ibram Lassaw, Louis Trakis, Hubert Long, Arline Wingate,
exhibition chairman; and Day Schnabel.

shaped fountain, too large for the garden, was displayed on the front lawn. The *Star*'s photographer caught a bather returning from a swim at Main Beach as he stepped inside it for a shower.

As in the previous instance, Guild Hall has occasionally displayed a piece or two of sculpture in front of the building, and no one has ever questioned Guild Hall's right to do so; not until 1988 when, as William Dreher, then chairman of the board, explains it, "We had placed two pieces out front, a Bill King and an Albert Price (both conveyed domesticity), which provoked letters to the *Star* from people involved with the Village Preservation Society saying the pieces were out of character with the historic district (which includes Guild Hall) . . . We were soon confronted by the village Design Review Board saying we were violating the ordinance governing the historic district, which rules that you can't change anything visible from the street without their permission. Although we felt this was a First Amendment issue involving rights of free expression (furthermore, the ruling referred to changing a building or things attached to a building—not free-standing objects), we did remove the pieces, which were part of our art collection, and met with the review board to establish the point that we had a right to exhibit, but that we didn't simply wish to lay down the gauntlet and deny the authority of the board. We agreed to some guidelines regarding size and frequency of showing sculpture on the lawn, but decided that if we found the constraints too limiting, we would go back and restate our case." Some members of the artists' community accused Guild Hall of knuckling under to unfair pressure; others thought Guild Hall was simply practicing good public relations.

The surprise of the 1970 summer season was a far-out variation on the regionals—a "happening," in keeping with the times, created by William (Bill) King and dubbed "The Wandering Regional." A community-wide gallery emanating from Guild Hall, it included art, music, dance, film, poetry . . . all with a twist.

"With Guild Hall's blessing," says King, "we redefined the regular regional. It was wide open. Artists would prepare exhibits and events to take place anywhere in the region during the 10-day period. The Guild Hall galleries would be used only for the display announcements (fanciful and imaginative) and maps . . . We wanted to show some of the unbelievable creativity and complexity of this bunch of people living here. There were about forty events! There was sculpture at Georgica Beach, a Rich and Poor House Tour that Dwight Macdonald and I ran (we thought this would be a good way to show East Hampton on a tour in cross-section for a change). We wound up at a yardman's one-room shack—wood stove and kerosene thing to cook on . . . Wayne Barker collected all the discontinued paints from the hardware stores for a community mural on the barrier fence where Bank of New York was being built. There was Arles Buchman's 'Painted Weed Garden,' (marvelous), Jeanette Saget's narcotics pro-

test, 'Soul Searching,' where everyone put messages in helium-filled balloons to the souls of young people lost to drugs and let them loose into the sky." Ernestine Lassaw remembers that she and Bill's wife, Annie, dreamed up 'Edible Art Works,' one of the most original events. "The artists all made marvelous things—there was Bill's alligator meat loaf, a beautiful gelatin fish, Nivola's bread sculpture of a female nude . . . People were supposed to just walk around them like you were at an art show and then eventually (when we rang a bell) take a small taste. But they were like vultures—everything was gone in two minutes. Whish!"

To celebrate the bicentennial year in 1976, we presented one of our most ambitious and comprehensive shows to date: a survey tracing the development of the East Hampton art colony from 1870 to the present, "East Hampton Artists: A One-Hundred-Year Perspective." Phyllis Braff, curator of the Nassau County Museum and East Hampton resident, served, as she often had, as guest curator with the aim of illuminating each historical segment to help the viewer understand the appeal of the town for different groups at different times. She divided the show into "generations" of artists: Artists arriving ca. 1870–1900 (the Tile Club et al); those arriving 1900–45 (Hassam, Albert and Adele Herter, William and Helen Whittemore, Maude Jewett, Max Ernst, Fernand Leger, Hilton Leech . . .); those arriving 1945–65 (Pollock, Krasner and other Abstract Expressionists); and the newcomers, who arrived from 1965–76 (James Rosenquist, Larry Zox, Claus Hoie, Ian Hornak . . .). The art critic, John Russell, observed in the *Times*: "It is only in East Hampton that there is a hundred-year tradition, still in being, of the introduction of good, new blood into a colony of artists that holds together in a spirit of mutual tolerance. That is what makes the exhibition so fascinating. Newcomers such as Audrey Flack and Howard Kanovitz and Robert Gwathmey are part of a continuum that shows no signs of coming to an end and has included over the last 100 years many of the greatest names in American Art."[5]

A few years later, in 1979, we honored Victor D'Amico, probably this country's most innovative and influential art educator, who said about art: "It is my belief that the arts are a humanizing force and that their major function is to vitalize living . . . to help man find his self-respect and to enjoy this greatest natural endowment, the power to create.[6] From the mid-50s he had been director of the so-called "art barge" on the bay at Napeague, first for the Museum of Modern Art and, after 1972, for the independently chartered Victor D'Amico Art Institute.

The challenge in presenting "Victor D'Amico: 50 Years of Humanizing the Arts," organized by Theodora Gavenchak and Doris Lerman, was to find a way to illuminate D'Amico's career, which included, most importantly, education directorship at the Museum of Modern Art for many years. James Tilton designed an ingenious "tunnel" that led visitors through a labyrinth of audio and visual experiences—continuous

KATHRYN ABBE
Arles Buchman with David and Beth Rattray in her "Painted Weed Garden," one of the imaginative events in the "wandering" regional (1970).

PHILIPPE MONTANT
Victor D'Amico at his "art barge" at Nappeague (1979).

45

At the opening of "Recent Work by Three Sculptors". Participant Philip Pavia with Harold Rosenberg and John Ferren (1968).

A BROADER VIEW

Geoge Constant, who was honored in a one-man show in 1976.

slide presentations, photographic blow-ups, models of his teaching devices, student art work and memorabilia to reveal the full scope of D'Amico's career.

One-person shows, one of the major ways we've celebrated artists of the region, have always held an important place in Guild Hall programming. We've averaged two a year from the first one in 1931, a show of Hamilton King's work. Some have been major surveys. Among those honored in one-person exhibitions were James Brooks, John Ferren, George Constant, Balcomb Greene, John Little, Robert Gwathmey, Ibram Lassaw, Abraham Rattner, Alfonso Ossorio, Moses Soyer, Joe Wilder, Peter Lipman-Wulf, Larry Rivers, Chuck Close and Eric Fischl.

At least once every year Guild Hall has looked beyond the community for subjects or themes of broad appeal, including, where appropriate, artists of our region. For example, "A Historical Survey of American Art," the first exhibition Eloise Spaeth organized for us (1951), was a remarkable achievement in terms of both quality and scope. "When I think back," Spaeth says, "I wonder how we did it, and on the unbelievable budget of $700, including insurance! In the first section, we had Hicks' *Peaceable Kingdom.* That whole primitive section, or most of it, was borrowed from the Brooklyn Museum. For the colonial period, we had artists like Smibert and Copley, borrowing from the Met and other museums and galleries; we managed to obtain truly distinguished examples for every single period. We had beautiful examples of Eakins and Homer. And we moved up

Robert Gwathmey at the opening of his 1984 exhibition, with his wife, Rosalie (left); trustee Robert S. Greenbaum and his wife, Teddy.

Abraham Rattner (left) and Joe Wilder at the opening of Rattner's major survey show and Wilder's show of recent works (1977).

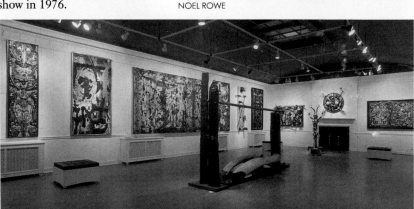

Section of the installation for "Alfonso Ossorio: 1940–1980" (1980).

to our own time, 1950, with Jack Levine, Stuart Davis, Edward Hopper, Theodoros Stamos and Jackson Pollock. It was a show to be proud of."

Undaunted by the work and planning, Spaeth went on to produce another major show worthy of a much larger museum in 1954, "Contemporary Religious Art." With help from her husband, Otto, who had been president of the Liturgical Society of America, Spaeth brought together stellar examples of art, stained glass and architectural models of houses of worship by Marcel Breuer, Percival Goodman and others.

"American Printmaking (1670–1968)" was the cover story of the July/August 1968 issue of the magazine *Art in America*, written to coincide with a survey show of the same title at Guild Hall that summer. "Behind the current period of achievement in American print-making stand three centuries of effort that are rarely accorded attention," the magazine stated, by way of introduction. "Redressing the score, Donald H. Karshan here presents the full scope of graphics in this country. A major survey exhibition based on this article is being presented at Guild Hall, East Hampton, one of the pioneer cultural centers in this country." Karshan curated the show for us. Our board chairman, Charles S. (Bud) Dewey, who helped with the original arrangements, chartered a private plane to bring in the rarest item in the show—the first woodcut made in America, John Foster's portrait (c. 1670), *Mr. Richard Mather*. One of the contemporary artists represented was Larry Rivers, whose original silkscreen print was inserted in the magazine as a gift to readers.

During Manette Loomis's tenure as chairman of the Art Committee, from 1956–61, she was determined "to give local people who didn't travel to New York the chance to see great works of art from the past." An artist of conservative bent herself, and with a gift for meticulous organization, she wove such European masters as Bruegel and Monet, and Americans like Cassatt, O'Keeffe and Homer into such crowd-pleasing theme shows as "Five Centuries of Flowers in Art," "Pleasures of Summer" and "Of Art and Nature." With guidance from art historians Ida Rubin and Margaretta Salinger, these shows were many months in preparation. And Loomis's installations were visually beautiful. For one, Vetault Florists installed a splendid garden in the center of the Moran Gallery; for another, Loomis displayed the works in period furniture settings.

"American Folk Art" (1964) broke all previous attendance records at 14,000 visitors. For this, Alice Kaplan, collector, trustee and later president of the American Federation of Arts, and Katherine Perkins, an artist and collector, combed local attics and antique shops and borrowed extensively from museums, the Garbisch and other important private collections to assemble the finest examples available. Nothing was too much trouble, it seemed. For example, in order to remove the nine-foot copper Indian weathervane from the Museum of Folk Art in New York, a large window had to be removed and the figure taken out feet first; the committee also managed to find the only remaining Killingworth images, life-

Patricia Osborne and Anita Zahn at the exhibition "Contemporary Religious Art" (1954).

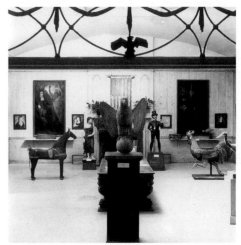

View of the exhibition "American Folk Art" (1964).

sized performing figures powered by a water wheel, made in the 1890s by Clark Coe, a farmer in Killingworth, Connecticut.

Reviewing the range of exhibitions over the years, one is reminded over and over again of how rich we are in "people" resources in this community. For example, Ruth and Paul Tishman, who have a summer home in East Hampton, made the 1974 show, "Sculpture of Black Africa," possible by lending from their collection, which is considered one of the finest of its kind in the world. Warren Robbins, then director of the Museum of African Art in Washington, DC, created a dramatic installation for the Tishman show, which featured major sculptures from the sub-Sahara region and rare Akan gold pieces.

We've avoided for the most part traveling shows, preferring to personalize ours for the community. Sometimes, however, a loan show seems made to order. "Five Distinguished Alumni: An Exhibition Honoring the Franklin Delano Roosevelt Centennial" (1982) came to us from the Hirshhorn Museum in Washington. Fortuitously, four of the "alumni" who had worked on FDR's Federal Project during the '30s were from our own region: James Brooks, Willem de Kooning, Ibram Lassaw and Ilya Bolotowsky. (The fifth was Alice Neal). For our presentation, we paid special homage to Bolotowsky who had recently fallen accidentally to his death down an elevator shaft.

The 1984 show, "Ordinary and Extraordinary Uses: Objects by Artists," was probably the first exhibition ever devoted exclusively to contemporary Western artists' objects. As former editor of *Crafts Horizons*, art critic Rose Slivka, guest curator, knew how to find some remarkable examples—a stool by Constantin Brancusi, a decoupage bureau by Athos Zacharias, a knife-and-fork set by Salvador Dali, a chess set by Man Ray, a wine bottle with label by Saul Steinberg, a toaster by Alexander Calder. "Not intended for production or sale," Slivka wrote in her catalogue essay, "these objects express private attitudes, unexpected quirks of habit, eccentricities of form that gave them special significance within an artist's oeuvre and personality . . ."

The Gershwin Festival, planned by Judith Sneddon, then Guild Hall's executive director, for the summer of 1986, was a good example of how a complex like Guild Hall, combining art galleries and a theater, can give full expression to a theme. The exhibition, "Ira—the Words, George—the Music," curated by Helen A. Harrison, filled the Leidy Gallery, surprising visitors with paintings by the Gershwin brothers (many people had not realized that they were also artists). There were original music manuscripts, photographs and memorabilia (a cigarette lighter, for instance, which provided the show's title, inscribed: "To Ira The Words From George The Music"). The theater, for its part, presented a spectacular Gershwin series arranged by Jay Hoffman and included: *The Theatrical Gershwins*, a revue of their Broadway and operatic works; *The Classical Gershwins*, covering chamber works; *The Popular Gershwins*, performed by

GH ARCHIVES
Alice Kaplan and Katherine Perkins, curators of "American Folk Art" (1964).

JAY HOOPS
At the opening of "Sculpture of Black Africa from the Collection of Paul and Ruth Tishman." The collectors are shown with Warren Robbins (left), director of the Museum of African Art, Washington, DC, who designed the show (1974).

Dick Hyman and the Perfect Jazz Repertory Quintet; and *The Cinematic Gershwins,* highlighting "An American in Paris" and "Rhapsody in Blue," introduced by Sheldon Harnick.

To inaugurate the 1987 renovations of the galleries, funded through the National Endowment for the Arts Advancement II Grant, Guild Hall presented two grand exhibitions, one local in scope and the other national. Showcased in the Woodhouse Gallery was "American Masters—Landscapes from the Phillips Collection," including works by Milton Avery, William Glackens, Edward Hopper, Albert Pinkham Ryder, among others; and in the Moran Gallery, "Works of Art from East Hampton Collections," selected by a committee headed by Eloise Spaeth.

One of the most anticipated exhibitions in recent years took place in 1990. Conceived and curated by Helen A. Harrison and involving nearly eight years of intermittent planning, "East Hampton Avant Garde: A Salute to the Signa Gallery, 1957–1960" paid tribute to East Hampton's first vanguard commercial gallery and its founders, John Little, Alfonso Ossorio and Elizabeth Parker. In putting the Signa show together, Harrison set a Herculean task for herself by deciding to include only works that had actually appeared in the Signa Gallery. Fortunately, she had Ossorio, Signa's unofficial record keeper, to help her sift through his files. Harrison said, "He saved everything, thus providing excellent documentation." However, tracking down artists, owners and the works presented many problems—the prohibitive cost of shipping long distances, unwillingness to lend, the fragility of the work. "But I enjoyed doing the detective work," Harrison said. "It made a strong show, stronger than I at first realized was possible. There was a type of energy that came from this generation of artists that was very sincere, very authentic. They were interested in the aesthetics of what they were doing rather than the marketing, promoting and career-building that is such an important part of today's art world."

"Aspects of Collage" (1991) was yet another way of exploring a theme broadly, while including many area artists in it. Staff curator Christina Mossaides Strassfield, assisted by associate curator Tracey Bashkoff, showed how fifty-one artists had used the medium in various ways. For example, Strassfield pointed out in her introductory essay in the catalogue, "A number of artists, such as Franz Kline, Lee Krasner, John Little and Jorg Madlener, whose work stems from the first and second generation Abstract Expressionist movements, created collages by cutting up their abstract paintings, drawings and watercolors, and rearranging the components to create a new abstract composition." Romare Bearden, Joseph Cornell, John Day, Max Ernst, Arnold Hoffmann, Jr., Helen Hoie, Sheila Isham, David Porter, David Salle, Miriam Schapiro, Julian Schnabel, Saul Steinberg and Andy Warhol were among the artists represented

NOEL ROWE
Helen A. Harrison,
staff curator 1982–88.

NOEL ROWE
George Gershwin:
Self Portrait in Top Hat
lent by Mrs. Arthur Gershwin for
the exhibition "Ira—the Words,
George—the Music" (1986).

49

who chose to demonstrate how collage can be considered one of the most innovative mediums of the twentieth century.

"A View from the Sixties: Selections from the Leo Castelli Collection and the Michael and Ileana Sonnabend Collection," curated by distinguished art historian Sam Hunter, was a focal point in Guild Hall's 60th anniversary celebration (1991). Initiated by Guild Hall's Museum Committee chairman, Robert S. Greenbaum, this landmark exhibition of thirty-eight Pop, Minimal and Conceptual works came from a duo who helped shape a decade marked by dramatic growth and change in American art. Shown together for the first time and considered the most important of its kind in private hands, the collection had links to the East End of Long Island through Leo and Ileana Castelli who, before their divorce, were prominent post–World War II members of the East Hampton art community; and through some of the artists represented—Roy Lichtenstein, Dan Flavin, Andy Warhol and Jim Dine, who are or have been area residents. Joy Gordon, Guild Hall's executive director, said in the catalogue foreword, "As a window on our recent past the exhibition offers an amazing view . . . For anyone who looked seriously at art during the 1960's, the works . . . when viewed in our galleries will no doubt cause what the English writer Margaret Drabble has called, 'a shiver of history.'" *The New York Times* praised the show as one of the best Guild Hall had ever presented.

NOEL ROWE
Moran Gallery installation for
"A View from the Sixties: Selections from
the Leo Castelli Collection and the Michael and
Ileana Sonnabend Collection" (1991).

Rogert S. Greenbaum,
chairman of the Museum Committee,
with collector Ileana Sonnabend at the opening
of "View from the Sixties" (1991).

ELIZABETH GLASGOW

ELIZABETH GLASGOW
Artists John Chamberlain and
Dan Flavin at the opening of
"A View from the Sixties" (1991).

NOEL ROWE
Christina Mossaides Strassfield,
staff curator (1989–) and Tracey Bashkoff,
associate curator-registrar (1990–).

JOHN REED
Arnold Hoffmann, Jr., was also
represented in the collage show.

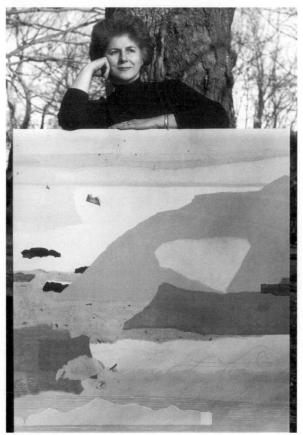

CLAUS HOIE
Helen Hoie, artist
and Guild Hall trustee, showed in
"Aspects of Collage" (1991).

EMPHASIS ON EDUCATION

John Lonero and Ralph Carpentier preparing models for the installation of "Seventeen Fish of Eastern Long Island and How They Are Hunted" (1959).

Until the late '50s, very few exhibitions took place outside the summer season. But then, with a year-round staff in place (albeit minuscule: director, part-time secretary and custodian), we began thinking of ways to develop shows that would have special meaning to the year-round community. Given the dictates of Guild Hall's New York State Educational Charter, we also wanted exhibitions that would supplement the curriculums of area schools. Since we are a combination museum-theater, we could explore themes in a particularly lively way. Until funding opened up in the early '70s through federal, state and county agencies, we had to rely almost exclusively on the resources within our community—fortunately, a community generously endowed with ideas and talent.

One of the first of what would become a long tradition of interdisciplinary presentations was a Latin American Festival in 1958. Chairman of the exhibition was Rhoda Dawson, an artist, who was delighted to find all the resources she needed at hand in the community.

H. R. Hays, the writer, and his wife, Juliette (Julie), an art historian who had traveled and researched extensively in Latin America, were generous participants, lending a great many artifacts (rare pre-Columbian pieces, costumes, utensils and folk art they had collected over several years). Jack Lenor Larsen, the well-known designer who had been studying Latin-American textiles, showed his contemporary designs along with some of the folk art that had inspired them. A nice touch were the flags of the republics, made by the high school Latin-American Club.

To flesh out the theme, there were talks by Bridgehampton resident Carlos Videla, feature speaker for the Voice of America; slide programs by Charles and Eunice Juckett, educators and travel writers; music from Evans Clark's rare Latin American record collection; and documentaries by local filmmakers.

Almost immediately after this festival, we were talking with artist Ralph Carpentier about other ways of involving the community in Guild Hall, and he came up with the idea of an exhibition about the fishing industry. Appropriate as the idea was, Carpentier met some initial resistance from the fishermen ("Well, Guild Hall, you know, that's for the summer folk, not us . . ."). Once convinced, however, "they came out in full force," says Carpentier. "I couldn't believe the kind of help I got, from fisherman to educators, the summer people, poets, writers and musicians—everyone got involved. We even published a cookbook."

The concept evolved into "Seventeen Fish of Eastern Long Island and How They Are Hunted," presented in 1959. The exhibition, nearly a year in the works, filled all three galleries and overlapped into the theater for events related to the theme. Carpentier recalls, "Eddie Sherrill must have put a dozen models into that exhibit. There were certain 'holes' where we were missing this or that vessel, and he'd say, 'Oh, I can build one!' Ted Lester made a model of a pound trap, Johnny Collins a model of a lobster boat. Nettie Rattray lent whaling gear and other artifacts from the collection of her father, E. J. Edwards.

"For the opening, Jennie Lester got the wives of the fishermen to put together wonderful deviled clams, chowder, fish-cakes—the spiked punch was something! I remember at the opening seeing Maidstone types with their arms around these fishermen, all having a swell time. It was great fun."

The success of this show led directly to the founding of the Town Marine Museum in Amagansett. Carpentier gives Jeannette Rattray credit for that. He said, "In her *Star* editorial she said it was one of the finest events that had ever taken place in the village, that the displays should somehow be kept together. Why not a museum devoted to the subject?" One thing led to another. The Town took over the property of the Navy in Amagansett, and the buildings were the perfect site. Rattray pushed the East Hampton Historical Society to take over the management. Carpentier was engaged to design and install the exhibits, many of which he took intact from the Guild Hall show. As with "Seventeen Fish" the entire community helped out and, seven years later, in 1965, the new museum opened with great fanfare.

Another exhibition that struck the heart of the community was "The Long Island Indian," the first ever presented on the thirteen tribes of the island. It was mounted in 1972 with Gary D'Amario as chairman. Artifacts—old maps, baskets, wampum, implements—were supplied by the Museum of the American Indian in New York, the New York State Archaeological Society, the East Hampton and Long Island historical societies and private collectors. The Accabonac Indian dancers stomped and chanted on stage in several repeat performances and the story of a Montauk princess's kidnapping was enacted in a multi-media presentation.

But the pièce de résistance, the display that drew busloads of schoolchildren from Nassau and Suffolk counties each day, was the huge wigwam that Red Thunder Cloud had constructed of saplings and rushes. We suffered considerable anxiety, though, as the opening of the show drew near. Red Thunder Cloud couldn't be found, and the raw materials lay in a heap in the gallery. As it turned out, he had been off somewhere for a few days tracking down hides for the wigwam's interior display. He finished on time, of course, and he and his wife even found time to make the traditional pounded-corn samp and sassafras tea for the opening.

Guild Hall picked up this theme again in 1991, focusing this time on "The Montauk: Native Americans of Eastern Long Island," expertly researched and curated by Dr. Gaynell Stone.

In 1973 we embarked on a series of exhibitions in collaboration with the American Association of University Women; this partnership led to some shows of special educational value. The first was "Chinese Arts and Culture," with Ruth Wolkowska as project chairman and Helen Busch as exhibition chairman. Loans of scrolls, costumes, porcelains, ivory and jade came from many sources. We led off with a talk by long-time trustee Robert T. Elson, then acting bureau chief of Time, Inc., in Hong Kong. Dancers from the New York Chinese School, fresh from an appearance at

PHILIPPE MONTANT

Harriet Gumbs talking with students at "Shinnecock Arts and Crafts" (1976).

JAY HOOPS

Rae Ferren (right), staff curator for the exhibition "A Glimpse of Life in the Middle East," with Irma Fraad, consultant; John Carswell, adviser; and Mokhless Al-Hariri, exhibiting photographer (1978).

Frederick Stover with Kathleen Mulchahy
and her historic dolls' house. Christmas exhibition (1972).

N. Sherrill Foster,
director of the exhibition
"Lifestyles East Hampton: 1648–1976"
with some of the artists who created
the settings: Jody Berke, Francesco Bologna,
James Tilton (1976).

Lincoln Center, performed folk dances, and Chung 'Hsiang Chao demonstrated calligraphy.

This excellent exhibition ran at a time when we were asking for some local support through the public school budget in recognition of the many services we were supplying to students. Despite enthusiastic recommendations by John B. Meeker, supervising principal, and faculty members, we were defeated by a narrow margin by a coalition of senior citizens fearful of higher taxes. We weren't helped either by one senior citizen who rose to his feet at a school board meeting and condemned Guild Hall as unworthy of support because it was spreading the doctrine of Chinese communism! Nevertheless, we managed to close the festival on a happy note, celebrating the Chinese New Year, the beginning of the Year of the Ox, with a special "hot pot" prepared by celebrated food authority Craig Claiborne, long recognized for his generosity to Guild Hall—and author, with Virginia Lee, of a just-published book on Chinese cookery.

It seems appropriate here to mention Frederick Stover who, throughout the '60s and '70s was part of nearly all these exhibitions, becoming a much-loved fixture at Guild Hall. A distinguished former Broadway scenic designer and head designer for ABC-TV, Stover retired to East Hampton and found in Guild Hall the perfect outlet for his creative energies, designing the installations for most of the educational exhibitions. Perhaps the community remembers him best for the spectacular annual Christmas holiday shows he loved to create and which varied each year: "Symbols of Christmas," and "Trees of Many Nations" among them. He set a standard that still resonates.

Both the north and south forks of the island have many people of Polish descent, and it was to this group that we addressed our Polish Arts Festival in 1977. We found all the resources we needed right at home in the form of scholars, historians and craftspeople, who helped put together an exhibition of contemporary fine art and folk art. In spite of the worst blizzard in years, the Polish communities turned out in record numbers for the opening to see the Folk Dance Company from New York and hear an all-Chopin recital by Jan Gorbaty. They were fortified for their return trip to Riverhead and points farther west by Polish ham and mounds of traditional delicacies made and served by hostesses in traditional costumes.

"Lifestyles East Hampton, 1630–1976" was a major undertaking in celebration of the bicentennial year. This winning concept, carried out by N. Sherrill Foster and assisted by Peter Dohanos, James Tilton, Francesco Bologna, Jody Berke and a host of others, took thirteen East Hampton residents from four centuries of our history and depicted the characteristics of their life and work in theatrical settings complete with artifacts and

memorabilia. Among the settings were Lord John Gardiner's living room in the manor house, Gardiner's Island (1730); a corner of the old Dominy woodworking shop (1810); an afternoon tea scene in the Woodhouse's Elizabethan-style playhouse on Huntting Lane (1930); and the twelve-foot "sharpie" and fishing gear of bayman Milton Miller (1937). Continuous slide shows by photographers Kathryn Abbe, Sandra Weiner, Anne Schwartz and Dorothy Beskind covered contemporary lifestyles. Most popular of the complementary events was an "Up and Down Main Street" tour with costumed village residents enacting on location the history of our village.

Theater and museum collaborated very successfully in 1986 to produce "Carousels." It drew in the whole community. Children, to say nothing of adults, came in great numbers to see the colorful carousel animals from the Charlotte Dinger Collection and to watch carvers Gerry Holtzman and Jim Beatty demonstrate the art of figure carving. To round out the theme, Kelly Patton created and directed for the Young People's Theater Workshop *The Runaway Carousel*, a joyous experience for hundreds of children, on and off stage. There had to be a real merry-go-round, of course, and Guild Hall director, Judith Sneddon, had one installed in the parking lot behind the Dewey wing. As she recalls, "The carousel was supposed to be for children. I'll never forget one Saturday when I was working in my office, watching it go 'round and 'round, and there were all these middle-aged and older couples with great grins on their faces, having the time of their lives." And all this in November and December!

NOEL ROWE
Installation for
"Art of the Carousel" (1986).

PHILIPPE MONTANT
"Lifestyles" setting for
"Mrs. Lorenzo E. Woodhouse—
Patron of the Arts" (1976).

ARTISTS FOR GUILD HALL

Just as Guild Hall has tried to nurture and reflect the interests of the many artists living among us, so have the artists done much for us in return. We've received generous gifts of art works from them to our collection; and bequests from artist Tito Spiga for the new permanent collection gallery and from the estate of artist Alice Baber for the library named for her. All along, many of our artists have found Guild Hall a congenial place to gather, helping with ideas and installations and giving moral support to one another and to us.

Perle Fine (1972)

Robert Dash (1970s)

Ian Hornak (1974)

Jack Lenor Larsen and Ingeborg ten Haef.

John Opper

Herman Cherry as "Odalisque" (1968)

56

Claus Hoie (1972)

Elizabeth Strong-Cuevas (1981)

Gerson Leiber (c. 1976)

William Tarr (1981)

David Porter (c. 1968)

Harlan Jackson (1970s)

Hans Hokanson (1980)

Haydn Stubbing (1970s)

Josh Dayton

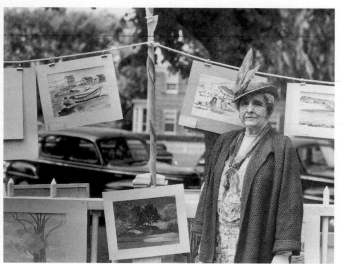

Mrs. Lorenzo E. Woodhouse
at the "Clothesline Art Show" (1947)

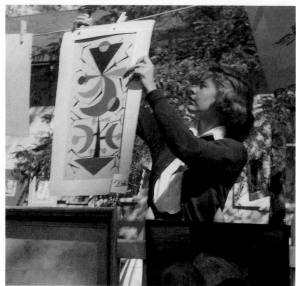

Lynn Chase, Clothesline chairman (1953).

The "Clothesline Art Show," instituted in 1946, became a favorite tradition and fund-raiser, drawing the entire community into the excitement of art. The show features art for sale clipped gaily to clotheslines strung around Guild Hall, fueling the eternal hope that a prescient art-lover can manage to buy for a song a masterpiece by next year's master. The artists always give fifty percent of the proceeds to Guild Hall. The price range in the early years was $5 to $25; now it is $40 to $650. The first "Clothesline" netted $400 for Guild Hall and the 1991 one, $56,580.

In the early days you'd see Mrs. Woodhouse in one of her famous hats inspecting the work. Today it's a lively and casual crowd, but the scrutiny is no less intense.

It's not only the buyers who come away satisfied. At the "Clothesline" in the summer of 1948, for example, a number of paintings were placed along the picket fence. As it happened, Buddy Ebson, who was playing in the theater that week in *Honest John*, and his little dog were inspecting the show when the dog chose a watercolor on which to relieve himself, ruining the painting. One of the salesladies suggested to Buddy that the only fair thing to do was to buy the painting, which he did. When the artist returned at the end of the day to pick up her unsold paintings, she was thrilled to discover that she'd made her first sale ever to a famous stage and movie actor!"

In a break from tradition in 1966, the "Clothesline" featured in the theater an auction of art contributed by well-known artists. Dorothy Vetault and Charlotte Markowitz, co-chairmen, succeeded in getting donated works from such artists as Fairfield Porter, James Brooks and Willem de Kooning. De Kooning's didn't bring the preset minimum price, and he generously donated it to the Guild Hall Art Collection.

That same year, a "Children's Clothesline Show" was held across the street on the porch of Clinton Academy. The young Patti Osborne,

E. Ingersol Maurice's
watercolor of the 1952 show.

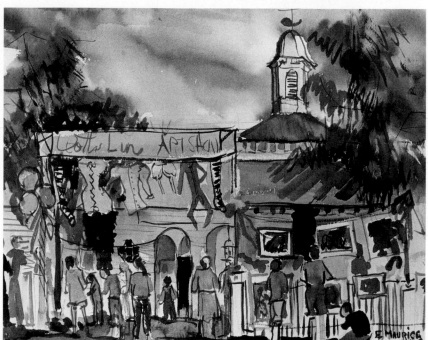

58

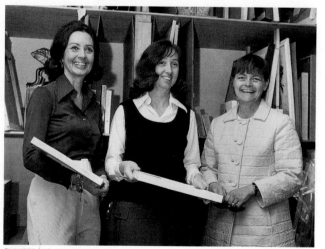

Picasso poster—
Clothesline raffle prize.

Clothesline chairmen (1967):
Dorothy Vetault, Charlotte Markowitz, Josephine Little.

JOHN REED

KATHRYN ABBE
Cliff Robertson and Dina Merrill
with their purchases (1970s).

PHILIPPE MONTANT

PHILIPPE MONTANT
Committee chairmen in 1974:
Shirley Cummings, Laurelle Fallon, Jean Dayton.

Sam Norkin, noted theater
caricaturist, "catches"
Tillie Delehanty at the
1978 Clothesline Show.

Mr. and Mrs. Charles J. Osborne's daughter, took her entry seriously, submitting an essay to the *Star* along with her sketch: "I want to be an artist when I grow up. I will be very fames and I will paint a painting like this (sketch) only better. I will paint the very best painting in the world. I will win a meddle an a blue ribbon and a red ribbon and an art galory . . . I will paint (a painting) for Guild Hall and one for the bank and one for President Jonson . . ."

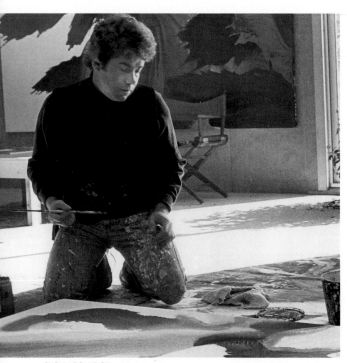

William Durham, instigator of the Artists in the Hamptons Auction to benefit Guild Hall (1975).

Artist William (Bill) Durham, who had often shown at Guild Hall, was, like so many of his friends, distressed to find in 1975 that Guild Hall was having financial problems. At the time, we were faced with $80,000 in unexpected expenditures in order to comply with changes in the New York State building code for places of public assembly.

"The night the seed was planted," Durham recalls, "I was sitting in Chez Labbat with a number of artists, all probably having one-too-many drinks, and somebody was talking about Guild Hall's troubles . . . and we thought, Why don't we do something about it?"

The idea they came up with was a fund-raising auction of works donated by artists. And next day Durham began calling around to see if people would be interested. "One of the first I talked to was Bob Gwathmey and he was a little hesitant, but then he said, 'Yeah, it sounds good.' Then it just started growing from there on . . ."

"We were so excited that the artists had come to *us*," says Helen Hoie, a trustee who immediately became involved. "When I talked to Bill, I thought he meant a local auction, but he said, 'Oh, no. This is important. This should be at Parke-Bernet in New York.'"

The auction would turn out to be the most successful money-making event Guild Hall had ever seen, but between that night at Chez Labbat and the time of the auction itself, everything that could have gone wrong did in fact seem to go wrong.

Hoie accepted the chairmanship; George and Freddie Plimpton, moved by the spirit of the artists, were delighted to be co-chairmen. The artists' committee consisted of Durham, Jimmy Ernst and Robert Gwathmey, assisted by Ernestine Lassaw and Elaine Benson Kaufman.

Hoie recalls, "Eloise Spaeth and I went in to Parke-Bernet to see what kind of arrangement we could make. We explained that the artists were giving their work. They said that since it was a charity auction, they would supply the place and auctioneer and forego their usual commission. They gave us a date, September 18, and said they'd send a contract. This was in May, so we knew we had to work fast. We met with the artists' committee. Bob Gwathmey, a champion of artists' rights, made the point that it would be a hardship for some of the artists to give their work outright and would we consider, in certain cases, giving them a third. We agreed but felt if we offered it to some, we should offer it to all and sent out a letter to the participants to that effect.

"Everything was fine until we got the contract (by this time it was July 1!) that specifically stated that to qualify as a benefit auction, the works had to be donated outright. It was a terribly embarrassing position for us. An emergency meeting with the artists was scheduled to explain the misunderstanding; Jimmy Ernst agreed to break the news that the auction was off unless the artists were willing to go back to the original plan of giving 100 percent. There were some pretty fiery debates, but in the end only four withdrew." Letters flew off to the *Star* and one artist, whose feelings were hurt because he wasn't included, accused the artists' committee of being "a clique within a clique." Nevertheless, plans for the auction proceeded with ninety artists participating (the maximum number Parke-Bernet recommended). In the catalogue, art critic Harold Rosenberg reminded artists and art lovers of the reason behind the auction: "To artists, Guild Hall is more than just a community center and an attraction for summer visitors. It has been an institution where artists in all modes have been quickly made to feel at home during the years since the war. To many, the Guild's exhibition galleries provided important opportunities to become better known. Some have been given one-man shows when they needed them most. In addition, paintings and sculptures have been given the setting of creations in other arts and intellectual activities: plays, films, poetry readings, lectures, panel discussion. The artists' solidarity with Guild Hall rests on the firm ground of enthusiastic participation in its past and its future."

In the end, the auction cleared $92,300. The artists had saved the day! Durham was pleased because "it cemented the artists behind Guild Hall." In recognition of their generosity, we gave lifetime memberships to all contributors and used part of the proceeds to install a new lighting system in the galleries, the better to show the artists' work.

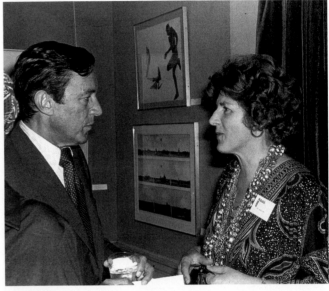

JAY HOOPS
Helen Hoie greets Mike Wallace, correspondent for "Sixty Minutes," at the Parke–Bernet auction (1975).

Following page. Some of the 90 artists who participated in the Artists of the Hamptons Auction.
PHOTOGRAPH BY JAY HOOPS

Front row: Esteban Vicente, Tania, David Porter, Howard Kanovitz, Jimmy Ernst, Hans Hokanson, Ralph Carpentier, Ian Hornak. Second row: Fay Lansner, John Day, Maurice Berezov, Perle Fine, John Little, Ronnie Chalif, Della Weinberger, Arnold Hoffmann, Jr., Allen Leepa, Abraham Rattner, Frank Scott, Esther Gentle. Standing: Tony Rosenthal,

Syd Solomon, William Durham, Ibram Lassaw, Philip Pavia, Robert Skinner, George Constant, George Griffin, Polly Kraft, John Opper, Hubert Long, Alexander Russo, Jo Anne Schneider, Claus Hoie, Helen Hoie, Ian Woodner, Sydney Butchkes, Calvin Albert, William Barrett, Ray Parker, Kyle Morris, Peter Busa. Top row: Joe Wilder, Warren Brandt.

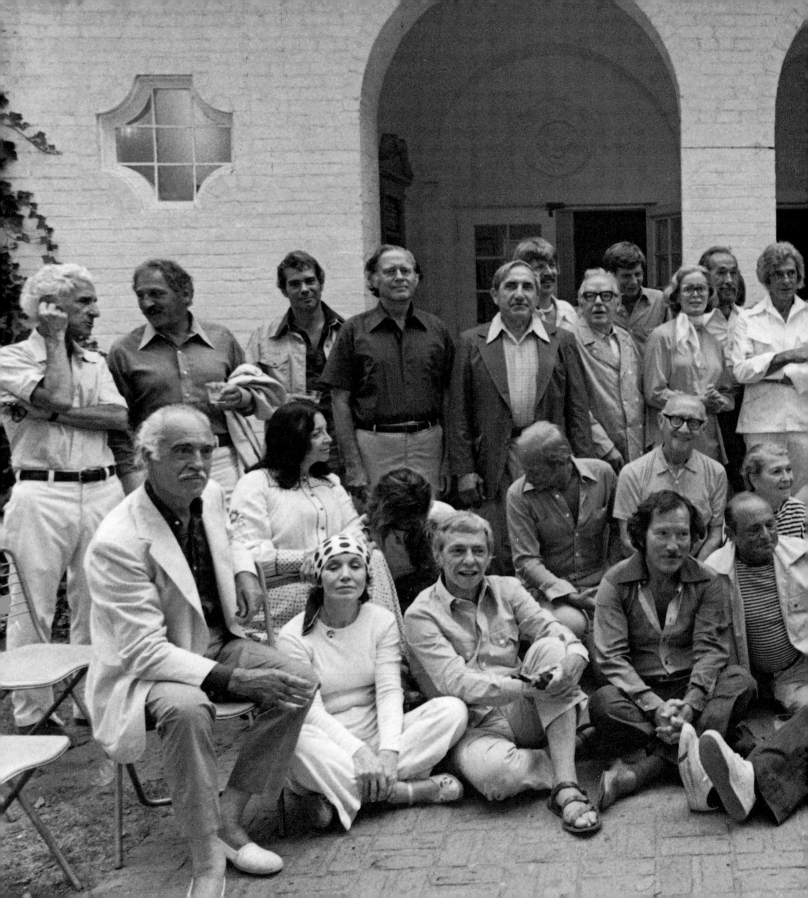

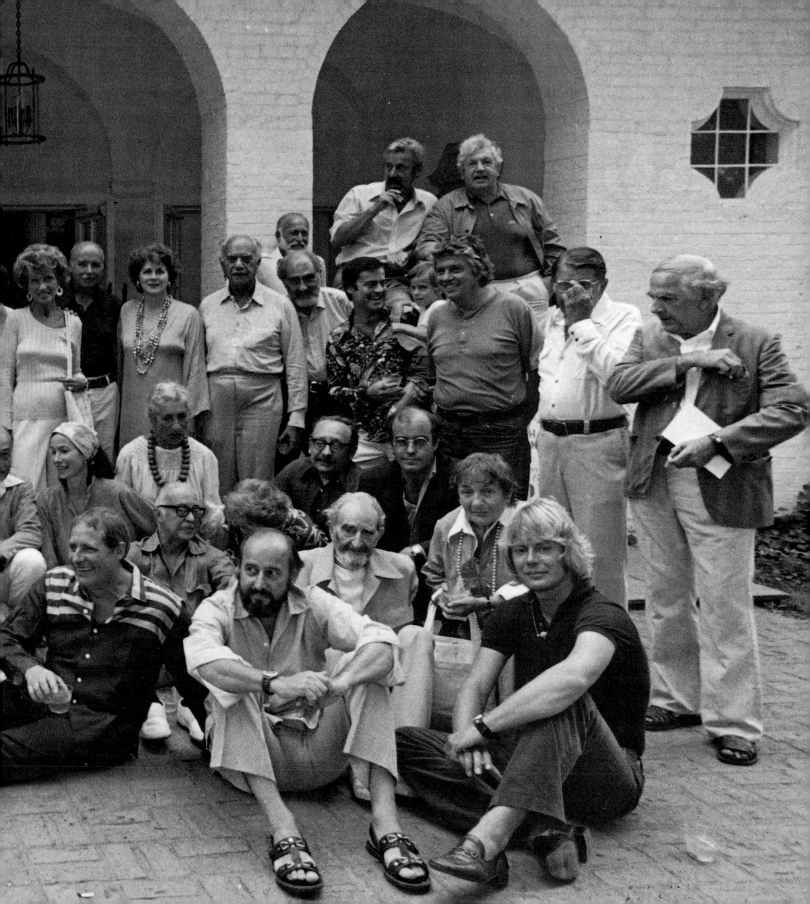

Miki Denhof's logo design
for the 50th anniversary
of Guild Hall.

Saul Steinberg's poster
Admiral Perry Speaking English to the Japanese.

Miki Denhof, like Hoie, has been devoted to Guild Hall for many years. A graphics and editorial designer for Condé Nast publications, who served at different times as art director for *Glamour* and *House and Garden* magazines, she first came to East Hampton in the mid-50s and recalls how she became interested in what we do. "The first exhibition I ever saw at Guild Hall made a great impression on me. It was in 1956 and it was called "Five Centuries of Flowers in Art." I was amazed that in a small village like East Hampton one could see these wonderful paintings by Bruegel, Corot, Van Gogh, Chagall . . . And the concerts, the films—well, all of it gave me so much pleasure I thought that giving my design talents was a way of giving something back."

Denhof more than gave of her design talents: She virtually transformed the look of our exhibition catalogues, programs and brochures; designed the Guild Hall logo and stationery still used today; and created graphics for most of the artists' posters.

Of all the catalogues she designed, her favorite, she says, was that for "Lifestyles East Hampton, 1648–1976." "Through the old maps and documents, the wonderful material, I was able to give the catalogue a real sense of place—as East Hampton was, as it is."

In 1978 we presented "Miki Denhof: A Retrospective—35 Years of Editorial and Graphic Design," which encapsulated her remarkable career. Alexander Liberman, with whom Denhof had been working at Condé Nast since 1945, said of her, "She is always able to blend the classic tradition with the most avant garde thinking, and she has really made art direction into something that goes beyond layout."[7] Even after receiving Guild Hall's Friend of the Year award, Denhof didn't stop giving of her time and talents. Most recently, she designed this book.

Artists have been generous to Guild Hall in other ways, too; for instance, the very successful Artists' Posters series, which has netted approximately a half million dollars for Guild Hall since it was initiated in 1970 as a project of the new museum shop. Saul Steinberg generously provided the image for the first poster, called "Admiral Perry Speaking English to the Japanese," and signed a limited edition of a hundred, thus setting a pattern continued almost immediately by Adolph Gottlieb with "Guild Hall Is for Everybody" and followed by a long line of other artists.

Janet Grossman and Gina Beadle, members of Dennis Davis's first shop committee, deserve credit for conceiving the poster project and producing the first two, but it was Helen Hoie who saw its great potential and for nearly twenty years has made it the most dazzlingly successful feature of the shop. "It was a challenge," says Hoie, "and I loved working with the artists and supervising the printing process to assure top quality. We've done posters by Lichtenstein (he signed 200 for us); Botero; Paul Davis designed two; Jimmy Ernst (that was for the Phoenix Theatre season); Jane Freilicher, Balcomb Greene, Larry Rivers, James Rosenquist,

Robert Gwathmey, Warren Brandt, Will Barnet . . . more than thirty in all."

Oscar Weinberger, Guild Hall's treasurer through those years, speaks glowingly of Hoie's contribution: "Without Helen there wouldn't have been an ongoing poster project. She had the dedication to carry it through, the eye for the kind of art work that would sell, and she had the merchandizing ability besides. Look what she did! She got Evelyn Farland of Poster Originals to cover all the printing costs in exchange for half the poster run. Everything was clear profit for Guild Hall."

Willem de Kooning's poster
East Hampton Garden Party.

Evelyn Wechsler, chairman of the benefit
"Auction with Action" (1981) against a background
of Guild Hall posters. Donald Karas (left),
Robert Wechsler (right).

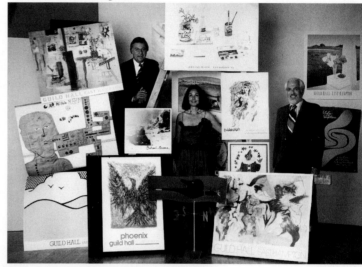

NINA KRIEGER

Larry Rivers' poster The Wall.

Fernando Botero's poster
Still Life with Watermelons.

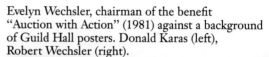

The handsome "tabletop" cookbook *Palette to Palate*, published by Times Books, was yet another artists' collaboration for Guild Hall. "It was the first time, " says Jean Kemper Hoffmann, who edited it, "that I had ever seen an artists' cookbook developed in quite the way we did it. From each artist there was not only a recipe, but also an illustration, and a statement and photograph of the artist. It was Rosemary Sheehan's idea and it was her persistence which was largely responsible for its being. Over 200 artists contributed."

As one might expect, the book was filled with imagination and humor. Costantino Nivola described cooking swordfish steaks outdoors between layers of pine boughs; Esteban Vicente extolled garlic as the reason for the longevity of Spaniards ("What is due to garlic? Franco was able to stay in power for forty-five years!") His recipe was Sopa de Ajo (garlic soup) using twelve cloves, no less; and he illustrated it with a beautiful drawing of a garlic bulb. Warren Brandt, an artist who "loves to paint, loves to cook and loves to eat," came up with Chicken and Clams (Poor Man's Paella). Ingeborg ten Haeff said she gathered her ingredients for Spring Salad on walks—dandelion leaves, wild violets, wild onions. And Syd Solomon offered his recipe for Morning-After Blintzes. Jimmy Ernst talked about artists' appetites saying, "My grandfather told me, 'In my time, mothers watching their children playing outdoors might suddenly yell at them, "Hey, kids, hide your sandwich—there's an artist coming up the street!" ' " His recipe was for good old-fashioned apple pie and his drawing, Mona Lisa with an apple for a head.

Unforgettable was the book-signing party when all the artists made their specialties and spread them out for the crowd. William Tarr, the sculptor, who works mostly in metal, was the star of the party. He came in his welding outfit, complete with goggles and asbestos gloves, set up his equipment in the garden off the Woodhouse Gallery and made his Acetylene Kabobs, threading the vegetables and meat on skewers and playing his torch over them. It was a glorious event, as were so many others that brought together the artists and people of our community.

Warren Brandt's self-portrait
for the artists' cookbook
Palette to Palate (1978).

THE ART COLLECTION

When the trustees of the Archives of American Art honored Eloise Spaeth in celebration of the thirtieth anniversary of the Archives Art Tours, [8] the writer Wilfrid Sheed reminisced in the program about his fifty-year friendship with Spaeth, and the summer of 1950, when he was a young man visiting the Spaeths at their East Hampton home: "Among the random things I remember from that summer is my surprise at finding an American household in which the name Jackson Pollock was not considered an automatic joke. As I recall, *Life* had just run a spread making fun of this ridiculous man and his fraudulent methods, and that was pretty much the national consensus. So it was invigorating to hear a new point of view and to realize that art was an adventure that could be happening right now and, better yet, just down the street."

BERNARD ROSENTHAL
Cube. 1972.
7½ feet × 7½ feet. Corten steel.
Gift of the artist, 1972.

In his tribute, Sheed referred to Eloise Spaeth as an art lover—"and I mean *lover*, not just 'fancier,' not just 'patron.' "

Spaeth and her husband, Otto, were renowned collectors who enjoyed sharing their treasures with others. They once removed the seats from a Greyhound bus and installed storage racks for paintings to create the "Spaethmobile," so they could bus their collection nationwide to small museums whose borrowing power was limited.

Spaeth's greatest contribution to Guild Hall was the development of the art collection, which has now grown to include more than 1,500 works, becoming one of the finest small, regional art collections in the country. Nationally recognized, Spaeth also served as chairman of the American Federation of Arts Traveling Service for fifteen years, before becoming a trustee of the Archives of American Art and commissioner of the National Collection of Fine Arts–Smithsonian Institution.

The intent of a collection was built into the structure of the original Guild Hall plans. The minutes from the board meeting of November 7, 1930, have Hildreth King on the record, discussing a collection: "The smaller of the two galleries [now the Woodhouse] will be for permanent exhibitions. It has been suggested that one example from every artist who has lived here might be included."

Mrs. Woodhouse and her friends did indeed start a small collection in the 1930s of works by early artists who'd lived in the region—Arthur Quartley, G. Ruger Donoho, Thomas Moran, Arthur T. Hill, Childe Hassam, among others. However, there was no long-range plan and no storage space for the collection to grow beyond the wall space of the gallery. What was more, the Great Depression was deepening and money was scarce; further collecting virtually stopped during World War II.

It was not until the '50s, and after Eloise Spaeth joined the board, that, surrounded as we were then by some of the most notable figures in contemporary art, we turned to collecting again in earnest, with the aim of concentrating on artists of the region. Though the problems hadn't changed, the board approved of the effort, and the Guild Hall Art Acquisitions Committee was formed in 1957, with Eloise Spaeth as chairman. Serving with her were Julian Levi, artist; Robert B. Hale, curator of the American Wing of the Metropolitan Museum of Art; and James Thrall Soby, trustee and staff member of the Museum of Modern Art.

Spaeth held the post as chairman with distinction, until 1990, when the committee was absorbed into the reconstructed Museum Committee. During the '60s, we proceeded to collect with caution, acquiring only a few carefully selected works. It was not until 1970, when the new Dewey Wing with climate-controlled art storage vault and processing facilities was added that, as Spaeth herself put it, "We could really get down to the serious business of collecting."

Spaeth's vision inspired a renewed interest in the collection and was a stimulus to the artists as well. Many responded by donating paintings,

others reduced prices; and dealers, almost without exception, waived their commissions to see the collection grow. Given the ongoing need for operating funds to finance exhibitions, theater and special events, there was no surplus in the Guild Hall budget to earmark for the collection. At first, even the costs of conservation came from funds raised by the committee.

The art critic Harold Rosenberg was one of the chief supporters of our goal to focus the collection on artists of the region. When we received our first National Endowment for the Arts matching grant for purchases ($20,000 with the match), we asked him to head a committee to select the work. Incredibly, he and his committee of artists came up with paintings, prints and sculptures—some of them major works—by Ilya Bolotowsky, Willem de Kooning, Paul Georges, Adolph Gottlieb, Lee Krasner, William King, Kyle Morris, Costantino Nivola, Charlotte Park, Hedda Sterne, Esteban Vicente. Most artists accepted token sums, giving in return works of great value.

In 1978, after Rosenberg's death, we presented in his honor an exhibition of selections from the collection. We said of him in the catalogue foreword:

> He looked at the work of art and, while it may not have been a masterpiece, he had the wish to comprehend and the vision to look beneath the surface, to try to understand what the artist was striving for. Personal predilections were put aside; his mind was open. While he discounted the slick with a raise of those massive eyebrows, he often sympathized with the awkward, recognizing a potential talent as others turned away from it. Most of all, Harold Rosenberg was a practical man. He realized that our paltry yearly funds had little purchasing power, that we are dependent on the generosity of donors, dealers and the artists themselves. Whenever possible he encouraged those who could to help us in achieving our goal.

Rosenberg also encouraged us to collect the young and lesser-known artists. Alfonso Ossorio and Herman Cherry, artists who served on the Acquisitions Committee at one time or another, were of the same mind and, thanks to their suggestions, we acquired works by Jeffrey Parsons, Josh Dayton, Robert Rustmann and other emerging talents. The policy has continued. Under one program in the '80s, for instance, the Republic National Bank of New York, through Walter Weiner, now a Guild Hall trustee, sponsored an invitational exhibition of new talent. Under staff guidance, the bank purchased one work for our holdings and two more for the bank's own collection.

Apart from generous gifts of works from artists and collectors, and certain donations of money specifically for the collection—notably the $30,000 Elaine Dannheisser Fund—the main source of income through the years has been the annual "Art in the Home" and "Artists Studios" tours. Through de-accessioning works not relevant to our regionally oriented collection, we've also made further funds available.

"We're all too aware of the gaps that exist in the collection," Spaeth said in 1985. "Yes, we've missed some jewels along the way. Yes, we wish

HEDDA STERNE
Portrait of Harold Rosenberg.
1964.
Oil. 64″ × 45″.
Gift of the artist
in memory of
Harold Rosenberg, 1981.

we could have given more support to artists through purchasing, but at the time we were not in a position to do so. I'm terribly sick of hearing people say, 'What! You could have purchased Pollock's *Blue Poles* for $2000?' I remind them that at the time *Blue Poles* would have had to be folded up and put in a hot attic along with stage props." Besides, $2000 was a lot of money in the '40s. The entire Guild Hall operating budget was only $11,000 in 1945!

Yet vis à vis the collection, Guild Hall has been lucky, too. There were, for example, the 1970 "windfall" gifts of major paintings and sculptures by such artist-donors as James Brooks, John Little, Ibram Lassaw and Conrad Marca-Relli; we received these just under the wire before the government eliminated tax deductions for work donated by artists to nonprofit organizations. "Our print holdings," says Spaeth, "enriched by the Enez Whipple Print and Drawing Collection, presented as a tribute to her from the artists of the region at the time of her retirement in 1981, are an asset any museum would be proud of, and we have the beginnings of a fine photographic collection." After the 1977 show, "Photography in the Hamptons: A Survey of Historical and Contemporary Camerawork," some of the participants chose to give their prints for the collection: Henri Cartier-Bresson, Andre Kertesz, Gjon Mili, Inge Morath, Elliott Erwitt and others.

Considering the small size of its staff, Guild Hall has managed to sustain a modest art loan program. For ten years, beginning in 1973, we circulated mini shows to schools, universities and libraries on Long Island. In 1979, we circulated "The East Hampton Art Colony" (selections from the collection) to museums in the South. In the mid-80s, Guild Hall organized two important exchange shows with similar organizations— "Crosscurrents," with the Provincetown Art Association and Museum in Massachusetts, and "En Plein Air," with the Florence Griswold Museum in Old Lyme, Connecticut. Our collective aim was to foster a wider appreciation of the museums' collections outside their own communities.

As the Guild Hall collection grew, so did the need for a special place for showing it. The answer to this dream came when Tito Spiga, an East Hampton artist and collector who died in 1988, left not only his personal collection, including paintings by his companion, Ted Carey, but the rest of his estate as well to be liquidated to create a new gallery at Guild Hall. He had specified that the gallery be given over to showing the collection.

The new Spiga Gallery, named in his memory, is located to the north of the Moran Gallery in what formerly had been the art storage vault. The opening was held on October 13, 1990. By then the collection had grown to include works by hundreds of artists associated with the East End of Long Island. The public can at last enjoy the collection more fully.

NOEL ROWE

Eloise Spaeth (1982).

PHILIP PAVIA
Lorenzetti. 1974.
Carrara marble. 25″ × 8¼″.
Anonymous donor, 1975.

WILLEM DE KOONING
Untitled. 1974.
Oil. 41¼″ × 30″.
Purchase, 1987

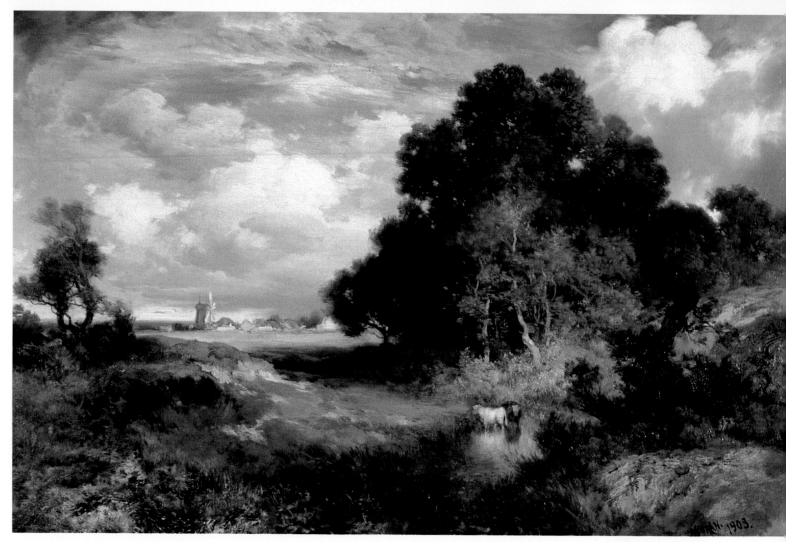

THOMAS MORAN.
Midsummer Day,
East Hampton, Long Island. 1903.
Oil. 14″ × 20″.
Purchase, 1992.

ADOLPH GOTTLIEB
Untitled #67. 1967.
Acrylic. 20″ × 15″.
Purchased with the aid
of the National Endowment
for the Arts, 1972.

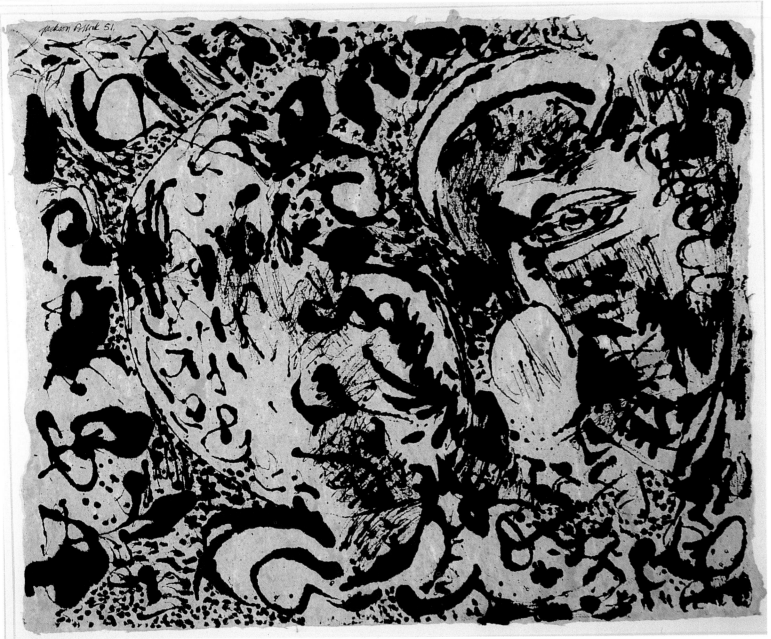

JACKSON POLLOCK
Untitled. 1951.
Ink. 18″ × 21½″.
Gift of Mr. and Mrs.
Valentine E. Macy, Jr., 1959.

LARRY RIVERS
Summer Pregnancy. 1977.
Acrylic. 60″ × 56″.
Purchase. Elaine Dannheisser Fund.
1979.

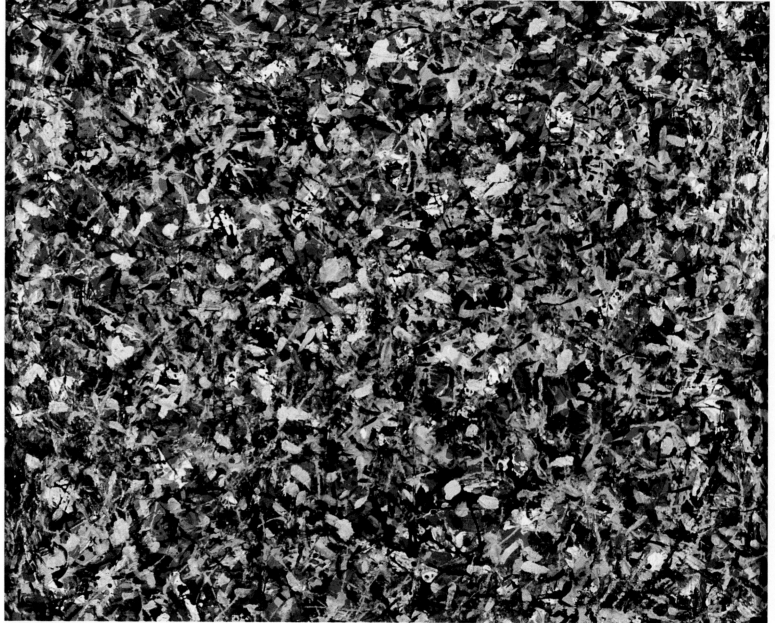

LEE KRASNER
Shattered Color. 1947.
Oil. 22″ × 26⅛″.
Gift of Rosanne and
Lawrence Larkin, 1961.

IBRAM LASSAW
Caryatids V. 1969.
Various metals. 19¾″ × 10¼″.
Gift of the artist, 1969.

ROY LICHTENSTEIN.
Bull # V. 1973.
Lithograph/linecut.
Printed in two colors. 27″ × 35″.
Purchased with the aid of
funds from the National
Endowment for the Arts with
matching support from the
Elaine Dannheisser Fund, 1979.

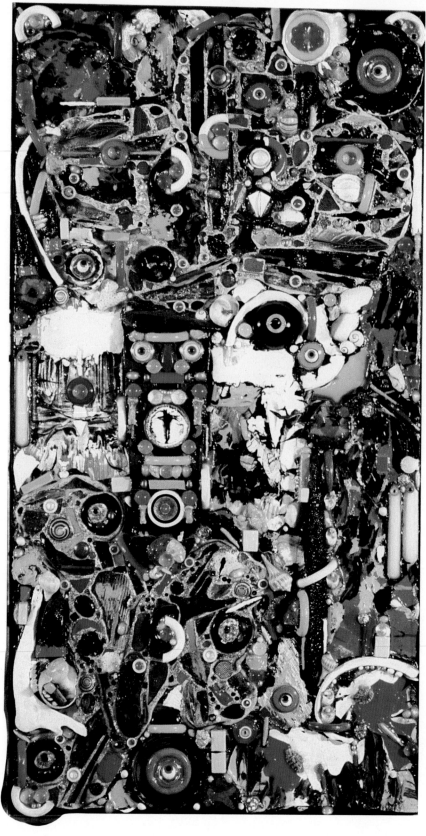

ALFONSO OSSORIO
Compatriots. 1967.
Collage. 49″ × 25″.
Gift of the artist, 1969.

CHILDE HASSAM
Little Old Cottage on Egypt Lane,
East Hampton. 1917.
Oil. 32¾″ × 45½″.
Gift of Mrs. Chauncey B. Garver
in memory of her great-uncle and great-aunt,
Mr. and Mrs. Childe Hassam, 1967.

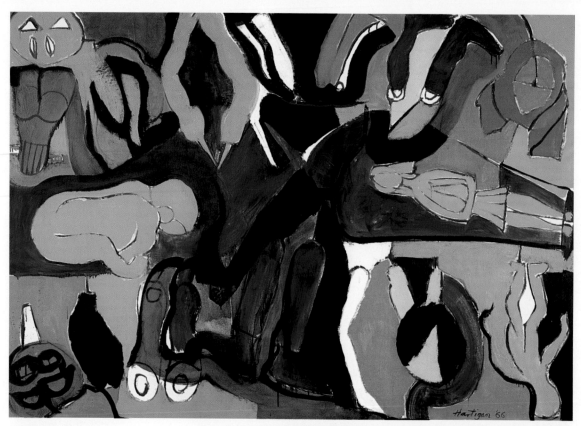

GRACE HARTIGAN
Hobby Shop Human. 1966.
Oil. 58½″ × 82″.
Gift in memory of
Martha Jackson by her son,
David Anderson, 1981.

JAMES BROOKS
Floxurn. 1955.
Oil. 64″ × 59″.
Gift of the artist, 1970.

JOHN FERREN
The Approach. 1959.
Oil. 50″ × 55½″.
Promised gift of
Rae Ferren, 1974.

ROBERT GWATHMEY
Still Life. 1973.
Oil. 29″ × 45″.
Gift of the Tyson Foundation
supplemented by Guild Hall
Purchase Fund, 1973.

JANE FREILICHER
Water Mill Landscape. 1963.
Oil. 70″ × 80″.
Gift of the artist, 1969.

ILYA BOLOTOWSKY
Light Blue Tondo. 1977.
Acrylic. 37″ diam.
Gift of Grace and
Warren Brandt, 1981.

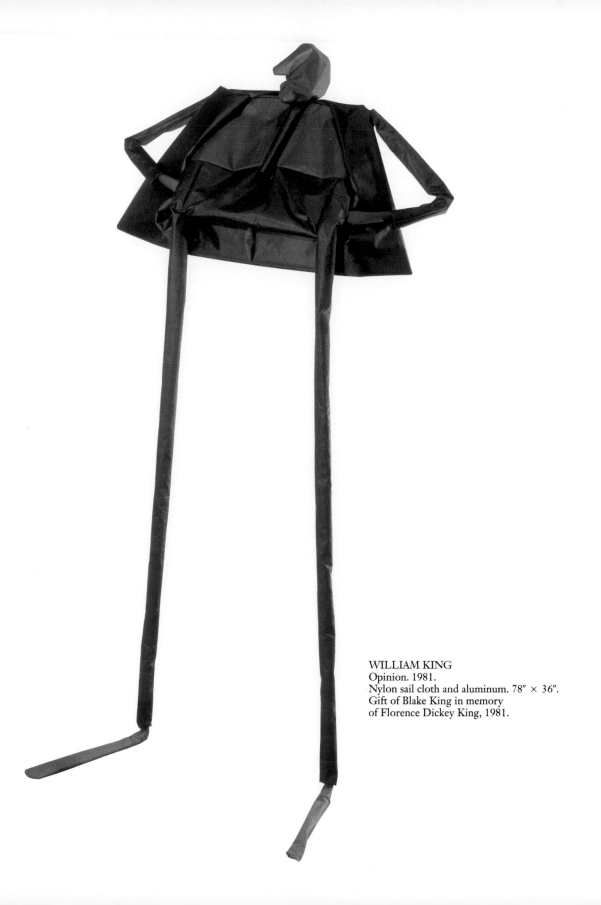

WILLIAM KING
Opinion. 1981.
Nylon sail cloth and aluminum. 78″ × 36″.
Gift of Blake King in memory
of Florence Dickey King, 1981.

THE
PHOTOGRAPHY COLLECTION

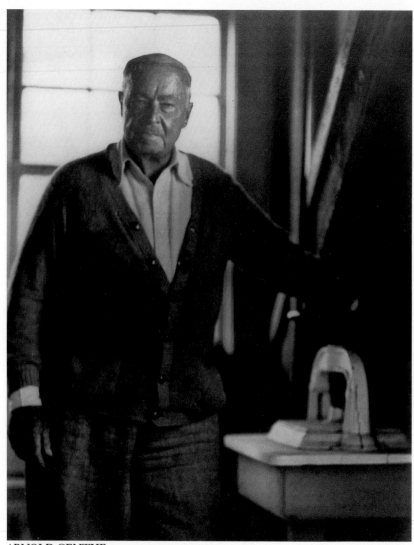

ARNOLD GENTHE
Childe Hassam. 1935. B/w. Gift of Robert Schey.

ROBERT GIARD
Windmill. 1981. B/w selenium-toned. Gift of Robert and Joyce Menschel, 1983.

ALFRED EISENSTAEDT
1798 House, Main Street, East Hampton. 1967. Color. Gift of the artist, 1977.

ANNE SAGER
IGA. 1988. Color. Gift of the artist, 1989.

JOHN REED
First Church c. 1950s. B/w. Gift of Jonathan Reed, 1991.

ELLIOTT ERWITT
On the Beach. 1970–77 series. B/w. Gift of the artist, 1977.

GJON MILI
Anita Zahn—Three Muses. 193?
B/w. Gift of the artist, 1977.

DAN WEINER
Marilyn Monroe and Friend, Dore Weiner. 1957. B/w. Gift of Sandra Weiner, 1978.

JILL KREMENTZ
Jean Stafford. 1961. B/w. Gift of the artist, 1981.

TOBA TUCKER
Karen Eleazar Smith and Her
Son Cheron. 1985.
(from "A Shinnecock Portrait")
Gift of Robert and Joyce
Menschel, 1986.

DOROTHY NORMAN
Alfred Stieglitz. c. 1930s. B/w. Gift of the artist, 1990.

VAL TELBERG
Portrait of Self (half in focus).
1950. Photomontage. Gift of the
artist, 1979.

DUANE MICHALS
Norman Dello Joio. B/w. Gift of the artist, 1981.

EDMUND ENGELMAN
Freud's Historic Couch
(from a series). 1938. B/w.
Gift of the artist, 1981.

JAY HOOPS
Beach House, Westhampton. 1971. B/w. Gift of the artist, 1977.

ANDRÉ KERTESZ
The Wave. 1950. B/w. Gift of the artist, 1981.

KATHRYN ABBE
Montauk Light. 1966. B/w. Gift of the artist, 1977.

Arnold Genthe. Greta Garbo.

PHOTOGRAPHY

Arnold Genthe was something of a fixture on the village green in East Hampton during the years he spent summers here, from 1912 until his death in 1942. Tall, almost gaunt, and with fine aristocratic bearing, he would often wander around the village, carrying his huge box camera and tripod, stopping here and there to capture a moment or scene that caught his unerring eye.

His reputation as one of the greatest innovative photographers of his generation and a passionate exponent of photography as art was international in scope. At the time of his death, *The New York Times* celebrated his career in an editorial, calling him "a master photographer ... who composed his pictures to catch from his subject the characteristic and revealing moment. Almost invariably, the result was a portrait John Sargent might have been proud of."

Much sought after by the photography salons springing up in big cities in America and throughout his native Europe, Genthe somehow preferred to show at Guild Hall. In his autobiography, *As I Remember*, he said he had often turned down invitations to show in the big international events "but I have never neglected an opportunity to exhibit my work in the Guild Hall where in ideal surroundings the pictures were shown to a sympathetic and intelligent audience."

Guild Hall presented the first of his exhibitions, "Fifty Photographs of the Dance," in 1932. He continued to solo annually up until his death. Most of the shows were premieres. In a time when photography was still considered a raffish stepchild of "real" art, Genthe's strong presence enabled Guild Hall to take an early stance on exhibiting photography as a legitimate art in its own right.

Nothing irritated Genthe more than the irreverent label "only a photograph." During Genthe's exhibition of Greek pictures at Guild Hall, the artist Childe Hassam stopped by and overheard a man admonishing his wife for admiring the photographs. "But remember," he said, "they are only photographs!" Hassam interrupted, "I suppose if it were an exhibition of Rembrandt's etchings, you would say, 'But they are only etchings!'"

"Only" photographs? Among the images in his first showing of portraits at Guild Hall was one from a series he'd taken of Greta Garbo upon her arrival in America, when he predicted that she'd become a great star. Hollywood didn't agree. They saw Garbo as a "type", and refused to offer her a contract. Defeated, Garbo stopped by Genthe's studio to say goodbye one day, explaining that there was no work for her in America and that she would be returning to Europe. Genthe asked her if she'd shown the photos he'd taken of her to the people at MGM. "No," she told him, "I wanted to keep those for myself." Genthe insisted she take them to some MGM directors who happened to be meeting in New York. Amazed at the way Genthe had illuminated her beauty, they gave her a contract on the spot.[9]

Genthe always credited his friend Hamilton King, an East Hampton painter/photographer, with arousing local interest in studying and exhibiting photography. King had started a camera club in which Genthe himself became involved, even occasionally judging competitions among local young people and lecturing on color photography, which he had pioneered in this country.

Photography at Guild Hall anticipated the directions photography was taking elsewhere. It was unusual for a small-town institution to take such a decisive stand about showing photography so early, when other, more influential institutions were still tentative. But from the beginning, there was a powerful community interest in the new art.

The Camera Club and workshops that King and Genthe had begun in the '30s were taken up in the late '40s by Dave Edwardes, a pho-

The Camera Club (1948).
Front row: Harry Parsons,
Elsie Parsons,
William Vail,
Vivian Parsons,
Betty Edwardes,
Dave Edwardes, club director.
Back row: Else Bridgeford,
(unidentified), John Pfund,
Margaret Nugent,
John F. Williams,
Mildred Reininger,
Terry Schey Maloney,
Eva McDonald.

tojournalist with a camera shop on Newtown Lane. Among the eager participants was Lawrence Larkin, whose state-of-the-art darkroom in a turn-of-the-century studio on Georgica Pond was the envy of every other photographer around.

Larkin liked to experiment in new techniques with color and showed his best efforts in "The Far East" at Guild Hall in 1957. He and his wife, ceramic artist Rosanne Roudebush Larkin, became friendly with a number of the artists who were settling in East Hampton in the '40s, and some of his photographs of such artists as Pollock and Krasner later turned up in books about their work.

Other professional photographers who carried on the teaching tradition for us were Richard Wood, Jay Hoops, Bran Ferren, Kenneth Robbins and Noel Rowe. During the early '70s, when we were circulating mini-shows throughout Long Island, Robbins developed one of the most frequently requested exhibitions, an artful panorama on the making of a photograph.

Hans Namuth's career as the leading photographic chronicler of America's artists began at Guild Hall by chance. He later recalled that in the summer of 1950 he and his family had rented a house in Water Mill. "I knew," he said, "that Pollock's work was to appear in a group show at Guild Hall. There was to be an opening on July 1, a Saturday, which I decided to attend. Someone pointed Pollock out to me. He was standing in a corner near his paintings, and no one was paying any attention to him. I went up to him and said, 'Mr. Pollock, my name is Hans Namuth and I have wanted to meet you.' He said, 'Yes, why?' 'I'm a student of Alexey Brodovitch and I also take photographs for *Harper's Bazaar*. I thought it might be a good idea if you let me come and photograph you while you are painting.' At first Pollock was reluctant, but at last he said, 'Well, why not?' "[10] The rest, as they say, is history.

The critic John Russell would later note that, "Before long, [Namuth] was the unofficial historian of le monde des arts in the South Fork. Almost invisibly, he took the photographs that by now are often the sole surviving undisputable record of who was where when."[11]

Namuth had a special affinity for Guild Hall. Almost from the time he first set foot in the place, we benefited from our association with him. He gave us previews of nearly all the films about artists that he made with Paul Falkenberg. He has had four one-person shows, including a memorial show of his portraits in 1991, and has been represented in innumerable group shows.

The night of his death in an automobile accident (October 13, 1990), Namuth had earlier attended the Guild Hall showing of what was to be his last film, *Jasper Johns: Take An Object*.

Hans Namuth:
Self-portrait (1966).
All Hans Namuth photographs
courtesy of Hans Namuth Estate.

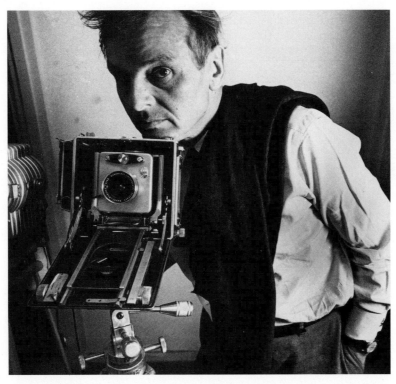

ON THE FOLLOWING PAGES

HANS NAMUTH'S PHOTOGRAPHS OF EAST END ARTISTS

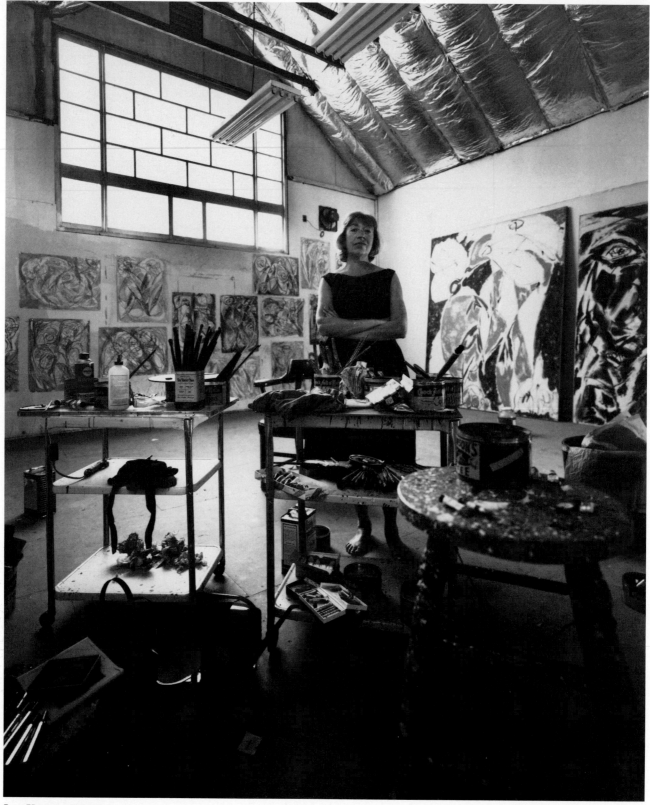

Lee Krasner (1962)

Elaine and Willem de Kooning (1953)

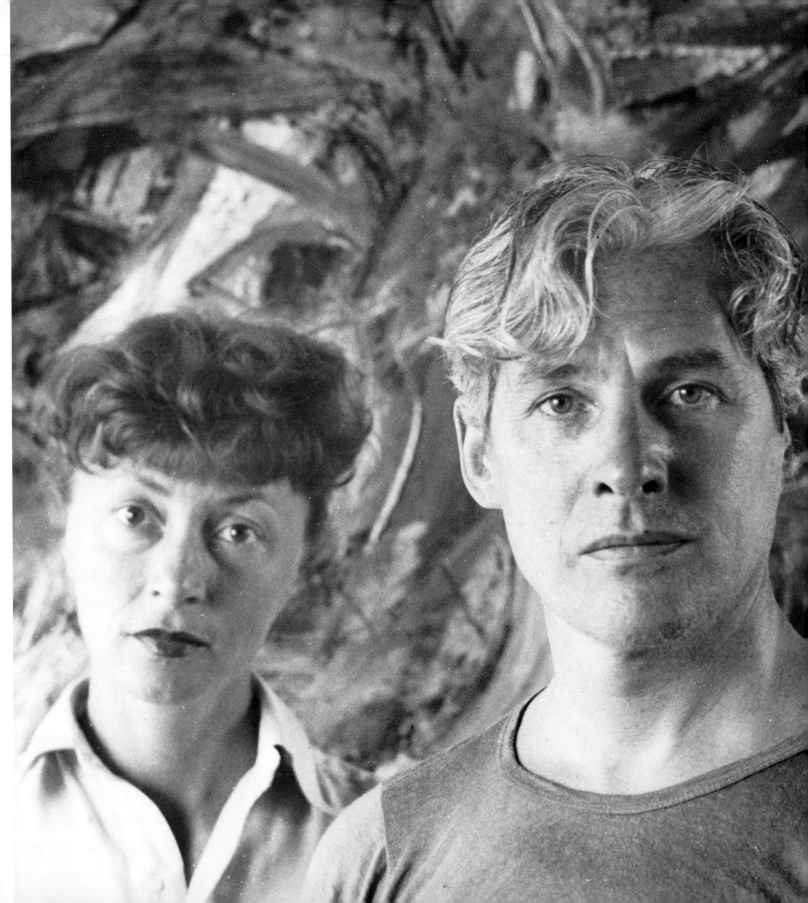

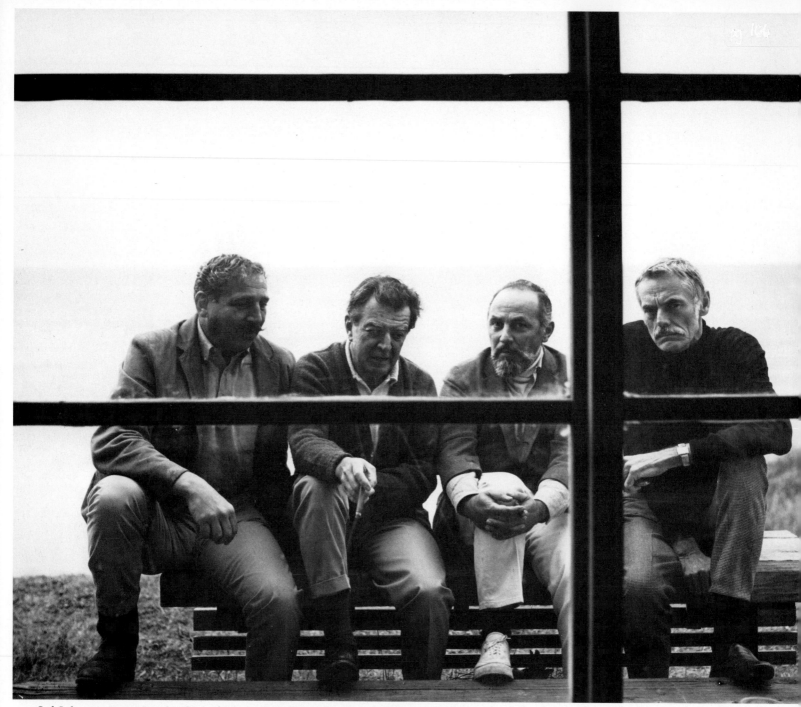

Syd Solomon, James Brooks, Conrad Marca-Relli, Balcomb Greene (1964)

Roy Lichtenstein (1980)

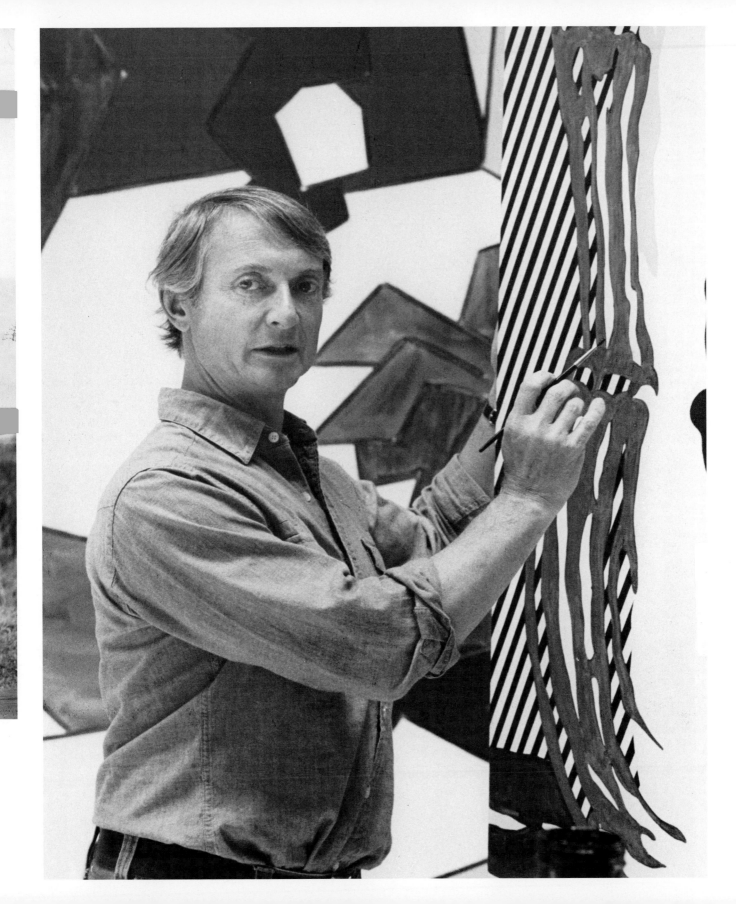

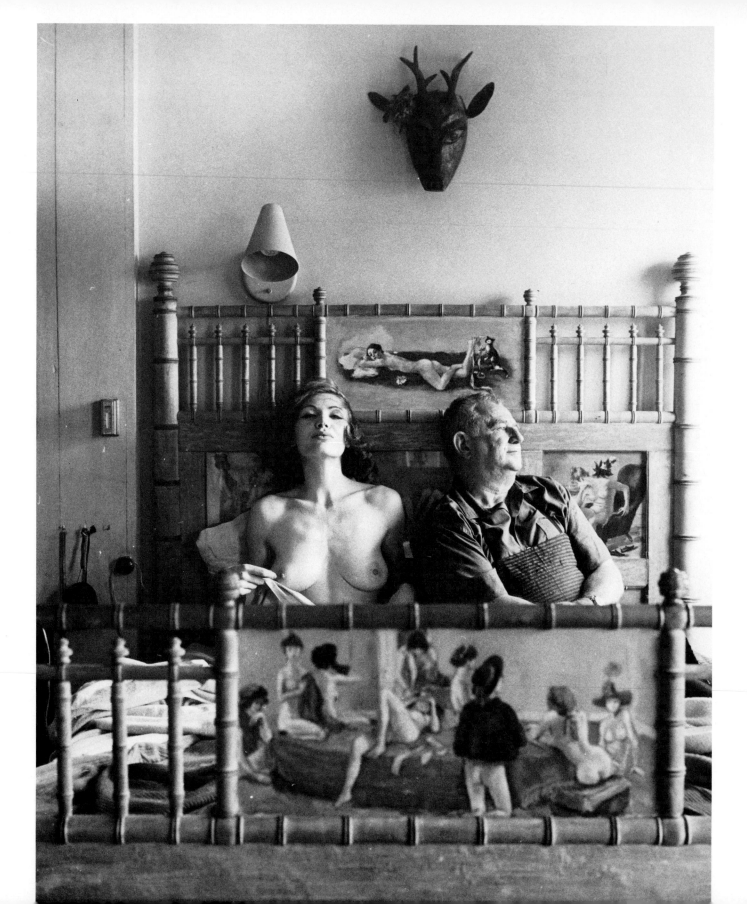

Jimmy Ernst and daughter, Amy (1958)

Alexander Brook
and friend in his famous
"brothel" bed (1962).

Alfonso Ossorio (1962)

Julian Schnabel (1985)

Saul Steinberg (1950)

Note: Saul Steinberg did the drawing upside down.

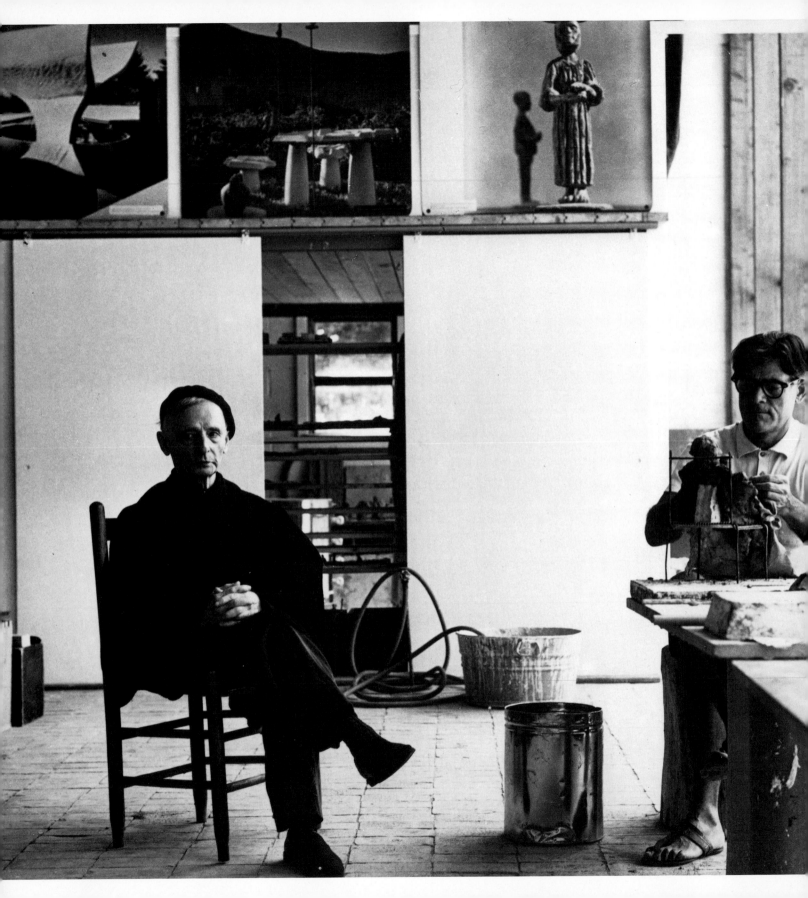

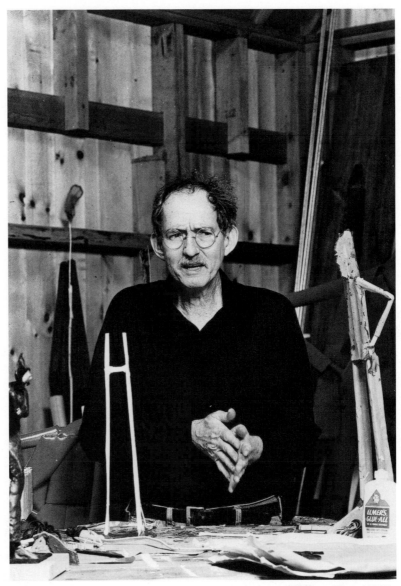

William King (1980)

Costantino Nivola and model,
Frederick Kiesler (1964)

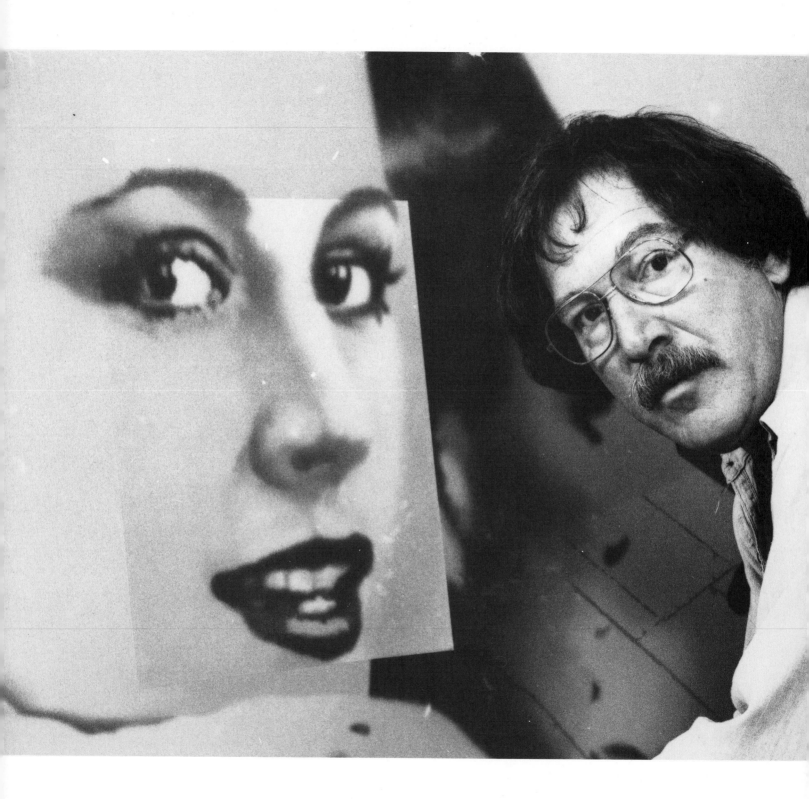

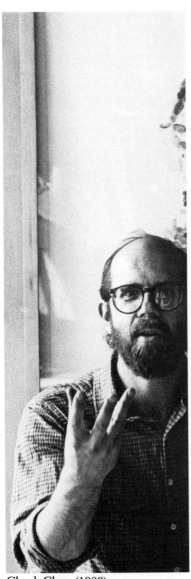

Chuck Close (1980)

Howard Kanovitz (1980)

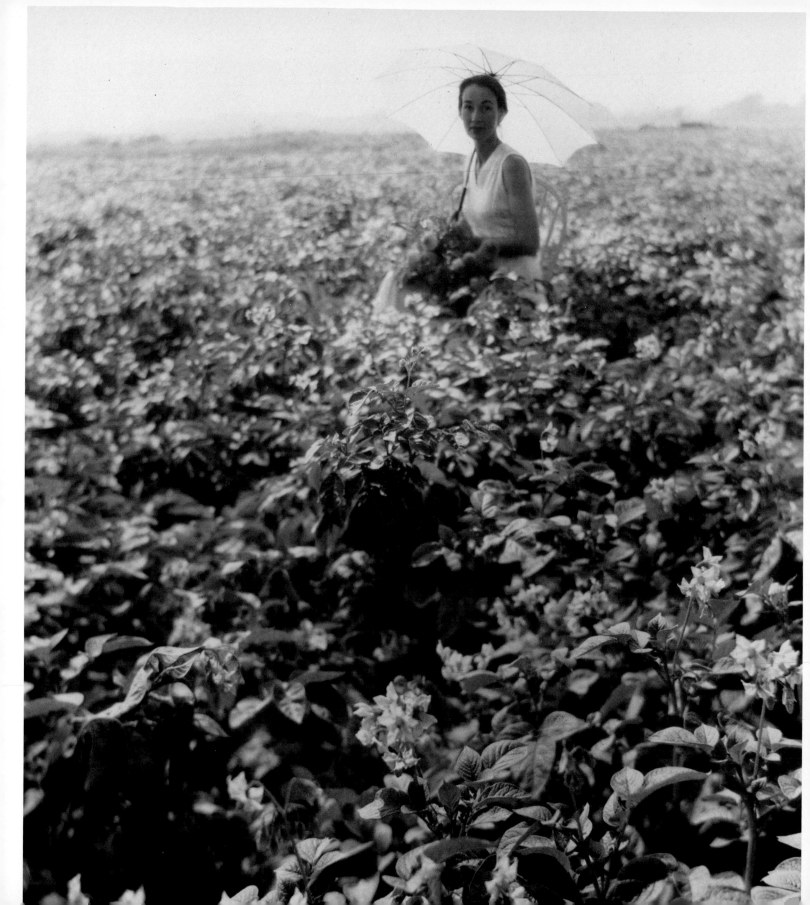

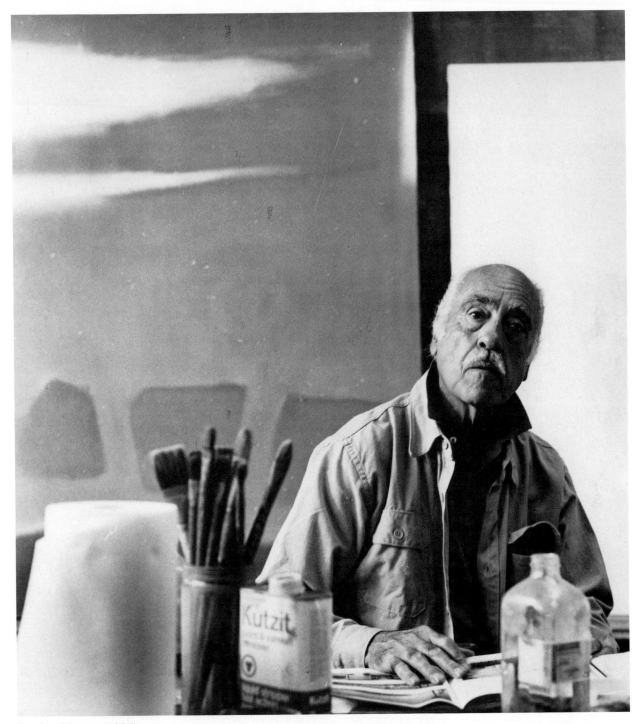

Esteban Vicente (1981)

Jane Wilson (1962)

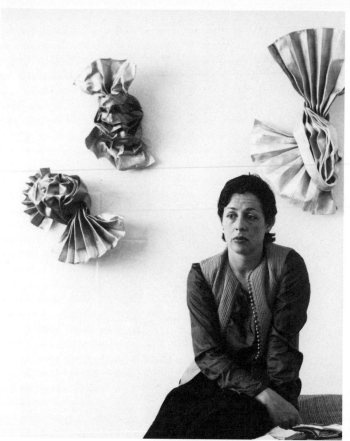

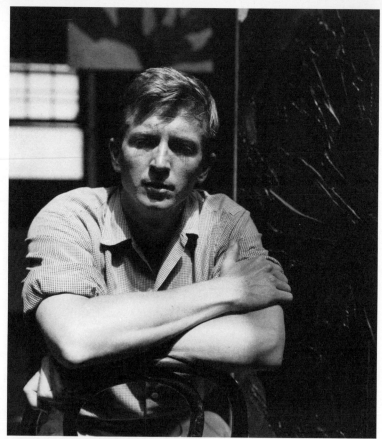

Lynda Benglis (1983)

Jack Youngerman (1959)

James Rosenquist (1965)

John Little (1973)

Eric Fischl (1988)

April Gornik (1990)

John Reed
photographed by his
son, Jonathan (1982).

PRECEDING PAGE

**Artists' Beach Party at
Two-Mile Hollow,
East Hampton (1962).**

Standing: Buffie Johnson,
Al Held, Lester Johnson,
Howard Kanovitz, Michael Goldberg,
Syd Solomon, Frederick Kiesler,
Norman Bluhm, Emanuel Navaretta,
Perle Fine (on the end).
Seated: unidentified, Lee Krasner,
Balcomb Greene, Sylvia Stone,
John Little (in back), Eleanor Hempstead,
David Porter, Rae Ferren, James Brooks,
Tania (in back), Arline Wingate (in front),
Louis Schanker, Adolph Gottlieb,
Lucia Wilcox, John Ferren,
Theodoros Stamos, Elizabeth Parker,
Jane Wilson, Jane Freilicher,
Robert Dash.

126

John Reed was another profound influence on our exhibition programming in the '60s and early '70s.

Originally a painter, Reed switched to photography when Alfred Leslie, an artist friend, needed money to buy canvas and sold him his first camera. After shooting a few rolls of film, Reed felt more comfortable "composing" with the camera than he did with his paintbrush. His first published work was an acclaimed book of photography, *The Hudson River Valley*. In 1961, he moved to East Hampton with his wife, Phyllis, and their young son, Jonathan.

Once settled, they bought what is now the Reed Photography Shop on Newtown Lane and were immediately attracted to Guild Hall and what it had to offer culturally.

Reed was soon appointed chairman of photography exhibitions, setting high standards for the shows. James Abbe, Jr., recalls, "The thing about John was that here was someone running a popular photo shop and yet he had a distinguished background in the arts. Guild Hall encouraged both sides; that is, he could commercially make a go of it and, at the same time, earn some recognition at Guild Hall—and at the newspaper, the *Star*, too. The *Star* was always encouraging to photography and for many years now has been featuring interpretations of the local scene on the front page." As a matter of fact, Reed's 1974 one-man show at Guild Hall, "A Decade of *Star* Photography," circulated to schools, universities and libraries throughout Long Island for two years.

In 1927, a young, talented and beautiful Dorothy Norman met photographer Alfred Stieglitz for the first time, marking what would become an intense personal and professional relationship; Norman later said, "Stieglitz liberated me to go my own way." In the foreword to the catalogue for "The Intimate Eye," Norman's 1986 exhibition at Guild Hall, Helen A. Harrison described how Norman expressed that freedom in her photography: "With Stieglitz's encouragement, Dorothy Norman developed a photographic style characterized by intimacy of mood, sensitivity to the nuances of light and a strong sense of emotional involvement. . . ." Norman was captivated by "moments of wonder." Included in her show, for instance, was her photograph *Mahatma Gandhi's Pillow*. "There was something so eloquent about the simplicity of how he lived," she explained. "There were many other things that I could have photographed, but that pillow caught my attention. It was something so perfect and simple that I loved it. It was a presence."

A photographer, author, editor, columnist and publisher, Norman befriended some of the leading figures of this century. In her first exhibition at Guild Hall, shortly after she had become a summer resident in East Hampton, she showed photographs of some of her renowned friends—Nehru, John Marin, Thomas Mann—along with her intimate studies of flowers and pastoral New England scenes.

In 1974, Norman arranged for an exhibition of photographs by Stieglitz based on material chosen by the Light Gallery for a show in honor of the publication of her book *Alfred Stieglitz—An American Seer*.

In 1938, when Austria became part of Nazi Germany, Sigmund Freud, after considerable harassment, was finally granted permission to leave Vienna for London. He was given ten days to get out. Edmund Engelman, at the request of his friend August Aichorn, agreed to undertake a photographic record of every detail of the place where psychoanalysis had been born.

The mission was clearly dangerous. The Gestapo had the quarters under constant surveillance, and the sessions would have to be held when Freud was out of the apartment, as, at eighty-two, he was ill and nervous about his departure.

Even so, Engelman set about his documentation, working clandestinely in the few days remaining before Freud would flee. As he later told it, "I wanted to see things the way Freud saw them with his own eyes during the long hours of treatment sessions and as he sat writing." One day, Engelman recalled, Freud had returned unexpectedly to discover the photographer at work. For a moment the atmosphere was tense, but after Engelman explained his mission, Freud was cordial, even permitting a photograph of him with his wife and daughter, Anna.

Not long afterwards, Engelman, who is Jewish, made his own hasty retreat from Austria. Knowing it would be too risky to take the precious negatives with him, he left them with Aichorn for sake keeping. After the war, Engelman learned that Aichorn had died and that the negatives had been sent to Anna Freud in London. She willingly returned them—the only record of how Freud's quarters had looked when he occupied them.

Engelman later said of the negatives: "The fact that the Austrians showed so little interest in Freud was probably the reason I did not expect great interest for him in the USA, and so my negatives just sat in my desk for years." Until 1972, that is, when Engelman, by then an East Hampton resident, met Helen Busch, then chairman of the Education Committee at Guild Hall, and mentioned them to her. She immediately recognized their worth and brought them to our attention.

The next year, as a part of a show called "The Photographic Eye: Four Points of View," organized and designed by Miki Denhof, Engelman's documentation of Freud's last days in Vienna shared the spotlight with the work of Elliott Erwitt, Leslie Gill and Sandra Weiner.

This Guild Hall "first" reverberated worldwide; the show traveled throughout the United States and in Europe to analytical societies, museums and galleries. The photographs were also published as a book, *Berggasse 19, Sigmund Freud's Home and Offices, Vienna 1938*. Gene Friedman made a film based on the photographs, which premiered in our theater and later won several awards, including a Ciné Golden Eagle.

Dorothy Norman
photographed by
Alfred Stieglitz (1931).

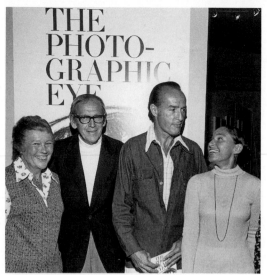

PHILIPPE MONTANT
Irene and Edmund Engelman
with Morton and Bernice Hunt at the opening
of "The Photographic Eye" (1973).

SANDRA WEINER
André Kertesz and Jay Hoops
at the opening of
"Photography in the Hamptons"
in which both were represented (1977).

The Austrian government's interest was revived, and Berggasse 19 was made into a museum, featuring Engelman's prints ("in poor quality enlargements," he maintained). But the original exhibition prints shown at Guild Hall are now part of the Guild Hall permanent art collection, a generous gift from the photographer.

Through her family, Helen Mann Wright has been involved in photography for many years. Her father, Henry Mann, headed E. Leitz & Co., the importers of Leica cameras. Wright herself was young when she began organizing exhibitions to tour nationally. The family had a summer home in East Hampton, and Wright naturally became interested in Guild Hall. Beginning in the 1960s she brought us a number of pretigious exhibitions drawing in both local and internationally known photographers. One was the 1960 show "Color" by Ernst Haas, an experimenter in color photography; this exhibition had its premiere at Guild Hall before touring museums throughout the country. Another was "Music Observed" (1964) in which W. Eugene Smith, Henri Cartier-Bresson, Bruce Davidson, Elliott Erwitt, Gjon Mili and other top photographers shot decisive moments when great music was made by, among others, Stravinsky, Serkin, Stokowski and Bernstein. With Kenneth Robbins, Wright also co-directed "Photography of the Hamptons: A Survey of Historical and Contemporary Camerawork" in 1977.

Jay Hoops's efforts on behalf of Guild Hall have never been fully recognized, because that's the way she wanted it. Throughout the '60s, '70s and '80s, this generous and modest professional was a familiar presence at Guild Hall as she recorded the panoply of events in our theater and museum and, with her assistant, Charlotte Jenkins, photographically documented the entire art collection.

In her work in various group and theme shows, she expressed a very personal vision of the East End scene. "My goal in many landscape photographs," she once said, "is to have the extraordinary light impose its quality on the image, taking over the picture so it becomes the main subject itself. . . . The soft, gentle light of a foggy day coming from everywhere and nowhere is the most difficult to translate onto film."[12]

Hoops's 1972 one-person show, "Under Long Island Skies," ran simultaneously with "It's Not Too Late," an extraordinary multimedia exhibition utilizing some twenty color slide projectors running continuously with several regional professional photographers providing the images, and together examining our changing attitudes toward the beauty and ecology of the South Fork. A show with a message, it was conceived and designed by Paul Friedberg with narration by the naturalist Roger Caras. Hoops was one of the contributing photographers.

Robert Giard is another photographer who likes to interpret the local scene. His 1984 exhibition, "Robert Giard's South Fork," ran concur-

rently with an exhibition based on Everett T. Rattray's book *The South Fork*, which Giard greatly admired: "To me," he said, "[the book's] significant quality is the intensity of the author's subjective responses to factual raw material. With similar intent, but through the medium of visual imagery rather than words, I endeavor . . . to uncover the drama latent in data, the poetry residing in fact."[13]

Other photographers find the people of eastern Long Island as compelling as the scene, maybe more so.

"I love documenting people, their way of life," photographer Sandra Weiner said recently. "I'm sensitive to what's going on around me and I record it in aesthetic terms with my camera." A good example was her 1977 exhibition "I Want To Be a Fisherman," which was based on her book of the same title, about twelve-year-old Christine Vorpahl; her bayman father, Stuart; their dog and pet crow; and documented their rigorous life on the water, and tending pound traps.

Weiner, like so many of the professional photographers in the area, has been represented in innumerable group shows, including two of the

GH ARCHIVES
Dorothy Beskind, Sandra Weiner, Anne Schwartz: Photographers represented in "Lifestyles East Hampton: 1630–1976" (1976).

Tom Abbe and son, Ethan at the opening of "Leslie Gill— a Classical Approach to Photography: 1935–1958" (1986).

KATHRYN ABBE

Frances McLaughlin Gill and Kathryn Abbe in double self-portrait, the back cover of their book *Twins on Twins*, on which their 1982 exhibition was based.

GH ARCHIVES
Paul Friedberg, director of the multimedia environmental exhibition "It's Not Too Late," with members of his committee: Suzanne Stephens, Judith Kress, Leslie Segal (1972).

Sandra Weiner's photograph of
Stuart Vorpahl and daughter Christine, subject of
Weiner's book and 1977 exhibition,
I Want To Be a Fisherman.

HELEN A. HARRISON
Debbie Silverblank-Neely,
education director, speaking to students
at the exhibition "Out of Bounds" (1989).

bicentennial exhibitions, "Lifestyles East Hampton," and "Photography in the Hamptons." Like her colleague Jay Hoops, she has been generous in giving her time to record Guild Hall history as it happened.

Weiner's husband, Dan, photojournalist for some of the most influential media of his time, was killed at the peak of his career in 1959 on assignment in Kentucky, when the plane piloted by the subject of his story slammed into a mountain during a freak snow storm. In 1990, Guild Hall presented "America Worked," Dan Weiner's photographs from the '50s; the show had originated at the Museum of Modern Art. The critic Ben Lifson had noted earlier in the *Village Voice*: "The smaller the gesture and the subtler the emotion, the more Weiner was engaged. . . . It is not absurd to speak of his powers of observation in terms of Daumier's."

Other photographers keenly interested in observing people have been Judy Tompkins in her 1974 show "The Other Hampton—A Portrait of the Black Community of Bridgehampton"; Richard Biegun, who examined the East End Polish-Americans in "Family, God and Country" (1985); Toba Tucker in her 1987 "Portrait of the Shinnecocks" (Indians); and Diane Gorodnitzki in studies of actors, "In Performance" (1976).

Kathryn Abbe, known as Fuffy, and her identical twin sister, Frances McLaughlin Gill, both became interested in photography as students at Pratt. After their graduation, they each pursued careers in the field, Abbe first apprenticing with Tony Frisell before going on to dramatize "human problems" in photographs for women's magazines, and Gill practicing fashion photography at Condé Nast.

The twins found that their careers didn't afford them the self-expression in photography that they'd hoped. Says Abbe, "Outside my career, I had a passion for documenting people and their life-styles—my studies of the Montauk fishermen, for example; I wanted to do something that would be meaningful to future generations."

Which is where Guild Hall came in. Offering an outlet through which the twins could stretch the parameters of their art, they returned to Guild Hall time and again, showing their work, helping to arrange other exhibits and offering their talents to document Guild Hall events behind the scenes.

Most recently, Guild Hall showed the twins coming full circle. Having started out in their photographic careers together, they published in 1982 a book called *Twins on Twins*. That same year, Guild Hall presented an exhibition under the same title, which included their photographs of twenty-nine sets of look-alike, same-sex twins, among them the Kondovs (Ringling Brothers Circus stars) and the Mahres (U.S. Olympic Ski Team).

Gill's husband, Leslie, who died in 1958, was nationally known for his classical approach to still-life photography. Like so many photographers, he was an artist first. Gill recalls that her husband used to photograph objects everyone had seen before—a feather, a shell, a fragment of

wallpaper—but juxtaposed them in such a way that the viewer feels he is seeing them for the first time. It seems fitting that "Leslie Gill: A Classical Approach to Photography—1935–1958," organized by the New Orleans Museum to travel nationwide, was presented at Guild Hall in 1986.

In *Out of Bounds* (1989), Guild Hall not only highlighted challenging new directions in photography, but it also expanded traditional boundaries to include all of Long Island. In her catalogue essay Ann Chwatsky, guest curator, referred to the exhibitors not as photographers but as artists, which surely would have pleased Arnold Genthe. Chwatsky wrote: "The artists were chosen because they have responded to photography's technical and aesthetic challenges with vigor and enthusiasm. They see not so much through the lens as in their own minds' eye." These tradition-breaking artists included Joan Harrison, Paul Ickovic collaborating with Anna Sergevna Ourusoff, and Laurence M. Gartel. Working in computer graphics, photomontage and unexpected mixed media, they came up with startling and unusual images that demonstrated how far photography has come over the past century and a half, and gave some clues as to where it may be headed.

Val Telberg photographed by his son Rurick (1975).

Val Telberg, one of the exhibitors, is especially well known to Guild Hall, where he and his wife, the dancer Lelia Katayen, have been involved in both visual and performing arts ever since they moved to Sag Harbor in 1956. Telberg came into international prominence for his innovative work in the '40s; his photomontages were first shown at the Museum of Modern Art in 1948. Widely reproduced, his work was used, for example, to illustrate Anäis Nin's *House of Incest* and *A Season in Hell*. Now in his seventies, he is still exhibiting nationwide. In 1982, he gave Guild Hall a selection of his finest photomontages. They form a part of the rapidly growing photography section of the art collection.

Is photography art or science? Have photography and art finally made their peace? These and other questions were discussed by a panel of experts at a lively all-day symposium that complemented the 1989 "Out of Bounds" exhibition. Meryl Spiegel concluded her review of the discussions in *The Southampton Press* this way:

> While the day's program offered a wide range of views on the old and the new in photography, and followed many avenues to explore where the medium has been and where it is now, there seemed to be general agreement on one point: Nobody knows where it is going next. That will be decided by individual photographers.

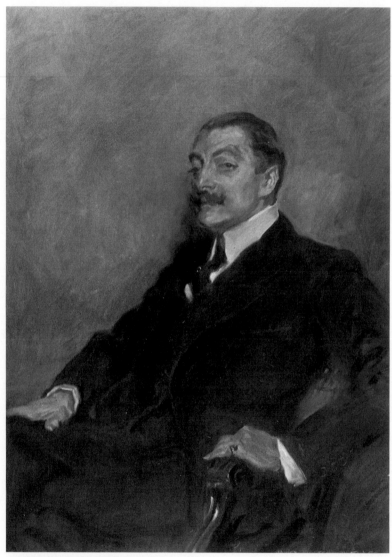

James Montgomery Flagg's
oil portrait of John Drew
(c. 1922).

THE JOHN DREW THEATER

When Katharine Cornell visited East Hampton in 1934, she was enchanted by the John Drew Theater—its octagonal shape, its blue and white striped tent-like ceiling, which swept up to a chandelier of multicolored glass balloons, its diamond-patterned walls, its rose-pink seats and six elegant little boxes at the rear. She thought it pure whimsy and proclaimed it "America's most beautiful summer theater." And that's how it has been known through the years.

Years later, in our 50th anniversary journal, Brendan Gill had some thoughts about the John Drew as well:

"The world of the theater is, among many other things, a world of ghosts, most of them happy. Even if we chance to be entering a theater for the first time, we cannot fail to sense innumerable benign presences hovering all around

us, seeking to strike up an acquaintance. The stage of any much-used playhouse is crammed with actors and actresses, only a few of whom are visible and at work in the play advertised as being the current attraction. Perhaps a score of plays out of a score of different pasts are being acted out on the same stage at the same time. Given that the traffic onstage is intense and uncontrollable, the wonder is that so few collisions occur between the living and the dead; but then, ghosts are nothing if not nimble!

"For half a century now, the John Drew Playhouse has been accumulating an army of attractive ghosts—actors, actresses, playwrights, producers, and directors. On a sunny summer's afternoon, they brush past us on the brick sidewalk outside the Playhouse; at night in the hushed Playhouse garden, they put us in mind of Gatsby's long-vanished blue gardens, where 'men and girls came and went like moths among the whisperings and the champagne and the stars.' They are picnicking on Georgica Beach, or they are huddled backstage, where a young playwright in ice-cream trousers has just arrived with several pages of revised script for them to get by heart before curtain-time. . . ."

Ludi Clair as Mother and Tom Ewell as Father in the 1966 production of *Life with Father*.

Frederick Stover and June Kelly with Ethel Barrymore Colt, star of *Hay Fever* (1973).

Although he never set foot on our stage, John Drew is among those ghosts. As his friend Otis Skinner said in dedicating the theater to "Uncle Jack" in 1931: "He died at age seventy-four, but his spirit is looking down on this scene today." Skinner went on to speak glowingly about his lifelong friend and America's celebrated actor, "charming the audience with a story about the time Drew's mother was running a company in Philadelphia, which was in rehearsal for a play that was to open the next night. The company was producing a different play each evening, and Mrs. Drew was in a quandary when her leading man walked out during rehearsal. But she knew her son John would be returning home late that evening from another engagement out of town. So she greeted him at the door with a candle in one hand and a playbook in the other." Skinner capped off his story by telling the audience what they had already guessed: With only a matter of hours to learn his part, Drew played it perfectly.

At the opening ceremonies, young John Drew Devereaux, the actor's ten-year-old grandson, accepted the dedication gracefully: "I wish to thank you, Mr. Skinner, for the beautiful tribute to my grandfather and the gracious ladies and gentleman of East Hampton who made this beautiful memorial possible."

Devereaux returned to our theater thirty-five years later as director of a revival of *Life with Father*. Playing the bombastic father, Tom Ewell lost his voice the third night of the run. Devereaux, true to the family tradition of handling theatrical crises with aplomb, stepped neatly into the role—book in hand—for Ewell. The audience cheered. "My grandfather," Devereaux told a *Newsday* reporter, "was hard to top in any facet of theatrical life. Even my cousins, the third-generation Barrymores, found it difficult to beat their parents or grandparents."

The only other member of the celebrated family to appear on the John Drew stage was Ethel Barrymore Colt, whose mother, Ethel, was John Drew's niece. She performed twice, most memorably in the lead in *Hay Fever* in 1973. Even so, all three Barrymores—Ethel, Lionel and John—often visited their aunt and uncle at their home on Lily Pond Lane. At one time, John Barrymore and Michael Strange rented a huge "cottage" in Georgica Woods; in 1936, after they were divorced, Strange presented dramatic poetry readings at the John Drew.

Skinner's daughter, Cornelia Otis Skinner, was the first star to grace the stage of the John Drew—September 4, 1931, in her one-woman show, *The Six Wives of Henry VIII*. A favorite of our summer audiences, she returned several times. Her *Lives of Empress Eugenie* (1932) was an American premiere, having come directly from London's Haymarket Theater. *The Southampton Press* described her as "a scrumptious beauty of the imposing and reserved type—eye-filling!"

Summer theater as we know it began at the John Drew in the 1930s. Two professional companies—the Hampton Players and the South Shore Players—both presented plays, mainly Broadway tryouts, from 1931 through 1935. Henry C. Potter and George Haight, producers for the Hampton Players, made their mark with *Double Door*, a murder mystery by Elizabeth McFadden, in 1933. With its original cast, it went directly on to become a big hit of the 1933–34 Broadway season, enjoying a long run. Another that went to Broadway some time later was *Goodbye Again*; Claire Trevor and Ann Revere were among the company members.

Ann Grosvenor Ayres presented the South Shore Players here in 1933–34. Her opener was Arnold Bennett's *Mr. Prohack*, in which Carol Stone made her debut. In the audience that night were Ring Lardner, Irving Berlin and Grantland Rice. That same season Ayres did *East River Romance* with Betty Bronson. In her second season she introduced all new plays. *I Married an Angel*, presented in association with John Golden, later became a successful musical in New York. Irene Rich starred here in *Any Woman*, and Ona Munson in *Hitch Your Wagon*. Ayres was, as Dorothy Quick wrote in the *Guild Hall News*, "a trailblazer for the drama in East Hampton." Harriet Helm (later Macy) and Alice Dowd, prominent in East Hampton social circles, were professional actresses as well and appeared with Ayres' company.

In 1937, Mrs. Woodhouse, whose largess was seemingly boundless, sponsored Leighton Rollins' Studio of Acting, giving Rollins the use of her second estate, Greycroft, on Huntting Lane; the school would include housing for the students and a carriage house for use as a laboratory theater. Greycroft adjoined Mrs. Woodhouse's Japanese water garden, which Rollins often used for such outdoor presentations as Aristophanes' *The Birds*. Workshops were held in the "lab" and polished plays, fully mounted, at the John Drew. Rollins had a distinguished roster of advi-

SUMMER THEATER

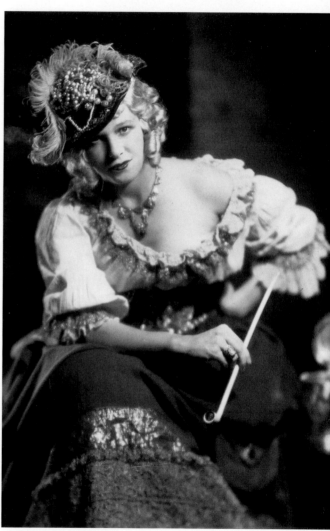

BEN PINCHOT. GH ARCHIVES
Cornelia Otis Skinner
as a Dutch trollop in
The Loves of Charles II (1934).

135

sers—Dame Sybil Thorndike, Josephine Hull; and directors—Frances Pole, Curtis Canfield, Eileen Thorndike, director of Embassy Theater and School in London, and guest director Margo Jones. Among the talent he attracted were Ernie Kovacs, Betty Comden, Conrad Janis, Martin Manulis and Patricia Weil.

Virginia York, a writer and long-time resident of the Hamptons, has memories of a long-ago Rollins production of *A Midsummer Night's Dream*: "I believe it was the fateful summer of 1939, shortly before Hitler marched into Poland," she says, "when the play was presented in the John Drew. With the help of Mrs. Nettie Rattray, a group of local children was assembled to play the fairies and elves attending Queen Titania and King Oberon—I recall among them Mary Orella Baerst, Gail Henderson, Paul Nugent, Bob Osborne, my brother Chuck Mann and myself. This lively troop of willing spirits was placed in charge of Miss Ingeborg Torrup, Rollins' director of dance; others will remember seeing her often in those years, an exotic figure in flowing scarves, pedaling her stately way to the Main Beach of an afternoon. This particular production was distinguished by having a tall, talented red-haired young Englishman named Henry Jesson (who later became Lord Audley), in the part of Oberon. Young though he was, he lent a commanding presence to the King of the Fairies, his actions thrillingly highlighted by flashing green sequins that were glued on his eyelids! And when it was all over, the principals took the fairy train to White's Drugstore for ice-cream cones!"[1]

For *Night of Stars*, the John Drew's salute to Guild Hall's 50th anniversary in 1981, Betty Comden and Adolph Green, the acting-writing team, talked about their associations with Guild Hall:

> BETTY: (speaking of her high school days in Brooklyn): "At Erasmus Hall, I wasn't interested in theater yet. I just loved poetry, and then later on, I was at this very theater—the John Drew—long before we were working together. I came out here one summer as part of the Rollins School. I won a scholarship for the summer by reading the letter scene from *Macbeth* and then that summer I played some big parts—as Julie in *Liliom* and in *First Lady*; but I do recall you came up to see me."
>
> ADOLPH: "I visited you one day very briefly. I was in awe of you in a way. I really thought of you as an important actress."
>
> BETTY: "Unemployed."
>
> ADOLPH: "Unemployed. Yet, three months later, there we were together at the Village Vanguard with Judy Holliday and our careers together began and we've been together ever since."
>
> BETTY: "And we have performed or taken part in something to do with Guild Hall many a time. . . ."

The Rollins productions ran the gamut from a tryout musical of *The Headless Horseman*, by Stephen Vincent Benet and Douglas Moore, to Shaw's *Pygmalion*. One of Rollins' most memorable productions here was Schnitzler's version of the early classic *Everyman*, which the company performed on the steps of St. Luke's Church. Sadly, the war wreaked havoc

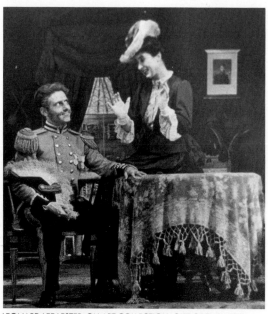

LEONARD LEE LESTER. GH ART COLLECTION. GIFT OF THE ARTIST
Betty Comden in a 1939
Rollins Studio of Acting production.

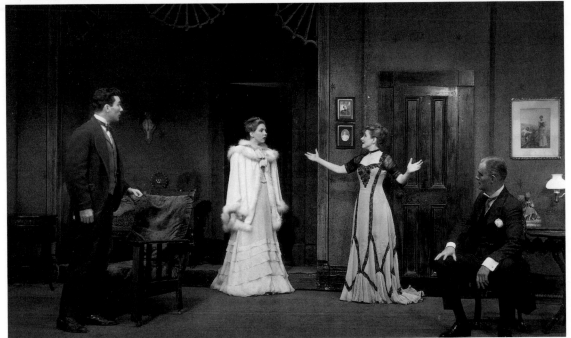

Helen Hayes and her daughter, Mary MacArthur, in
Alice Sit-by-the-Fire (1946). Charles Nevil (left); John Williams (right).

JOHN DREW THEATRE
EAST HAMPTON, LONG ISLAND
"America's Most Beautiful Summer Theatre"
Telephone: 706

WEEK OF JULY 29TH AT 8:45 P. M.

FRANCIS I. CURTIS

PRESENTS

Helen Hayes

IN

"ALICE SIT-BY-THE-FIRE"

BY JAMES M. BARRIE

WITH

JOHN WILLIAMS

Staged by JOSHUA LOGAN

Settings by　　　　　　　　*Costumes by*
FREDERICK STOVER　　　　LUCINDA BALLARD

Thornton Wilder played
the Stage Manager in his own play
Our Town (1946).

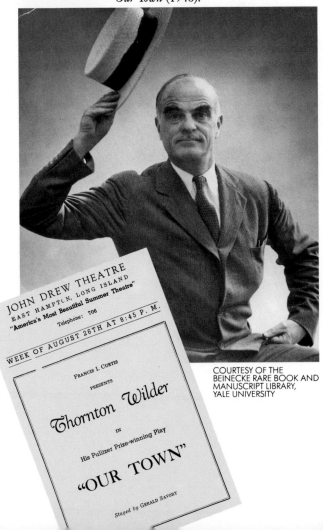

JOHN DREW THEATRE
EAST HAMPTON, LONG ISLAND
"America's Most Beautiful Summer Theatre"
Telephone: 706

WEEK OF AUGUST 26TH AT 8:45 P. M.

FRANCIS I. CURTIS

PRESENTS

Thornton Wilder

IN

His Pulitzer Prize-winning Play

"OUR TOWN"

Staged by GERALD SAVORY

COURTESY OF THE
BEINECKE RARE BOOK AND
MANUSCRIPT LIBRARY,
YALE UNIVERSITY

on the school, taking virtually all its male students. In 1945, Rollins
moved his operation to Lenox, Massachusetts.

If one scans the list of more than 350 summer theater productions pre-
sented at Guild Hall over the past sixty years, a pattern will emerge. Cu-
riously, even though different producers and companies were involved,
each season seemed to include, almost invariably, some old classics, some
modern classics, some popular "straw hat" fare and something new in the
way of an experiment or tryout for Broadway.

After the Rollins Studio of Acting departed, there followed thirteen
years of independent producers paying from $1000 to $3000 in rental for
the eight- to ten-week season. For us, this was a risk-free way to bring
entertainment to the community. But it proved, in the long run, to ob-
scure Guild Hall's image as a nonprofit cultural and educational center,
and after 1959, we took on the operation ourselves.

The first of the independent producers was Francis I. Curtis
(1946–48), who had previously been associated with David Belasco and
the Dennis Playhouse. Harriet (Happy) Macy, chairman of the Drama
Committee, and the staff helped launch the season with a subscription
drive, gave elegant parties on opening nights and generally made the ac-
tors feel welcome by arranging swimming parties, tennis and lunches.

During his three years at the John Drew, Curtis produced eight
plays a season with some of the great American stars. There were two

James Barrie classics—*Alice Sit-by-the-Fire* with Helen Hayes, and *What Every Woman Knows* with Olivia deHavilland, which also introduced an up-and-coming musical comedy and dramatic star, Elaine Stritch. Thornton Wilder himself appeared in his own *Our Town*, and Edward Everett Horton turned up in the perennial straw-hat favorite, *Spring Time for Henry*. There was a successful tryout, too: *Heaven Help the Angels* with Grace and Paul Hartman, which went on to score 308 performances on Broadway under the title *Angel in the Wings*.

Despite the imported talent, Guild Hall always remained home-based. Lawrence (Larry) Baker, Jr., a long-time East Hampton summer resident and theater "pro," was reminiscing recently about the old days, and recalled that he had played the milkman in *Our Town*. "It was a thrill to have the author himself there in person playing the stage manager," Baker recalls. "There was magic in his performance. And there were a number of East Hampton people in the cast. Louise Dowdney, a professional actress, played the ingenue, and Frank Dayton and several of the Guild Hall Players had parts. I'll never forget the party my family gave for the cast and crew after opening night. Thornton just took over. Everybody sat on the floor around him fascinated by his stories about theater and his career. He talked a lot about his long friendship with Gertrude Stein and his problems with Jed Harris, who produced the original *Our Town*."

With more and more theater luminaries finding their way to East Hampton, the theater world was watching with interest. At a dress rehearsal for Noel Coward's *The Marquise* in 1947 were Ethel Merman, Theresa Helburn of the Theater Guild, Philip Barry, Dorothy Gish, Helen Hayes and her husband, Charles MacArthur.

Hayes later recalled that she was very sentimental about playing at the theater named in memory of John Drew, who had helped her in her early career. Hayes had other reasons as well for remembering the John Drew. Her "darling young daughter" Mary MacArthur played with her in *Alice*, then returned the following summer to play with her godmother, Lillian Gish, in *The Marquise*. She died from polio a short time later.

While Frederick (Fred) Stover was designing and mounting a show a week at the John Drew in 1946, he was also designing *Man and Superman*, starring Maurice Evans, which was to open on Broadway in the fall. Nevertheless, Stover managed to turn out a new, and often elaborate, set a week without a trace of commotion and without a scene shop or barn to work in, building everything in the cramped wings backstage or, weather permitting, out in the back yard. Michael Smollin, a talented local high school boy who later became an advertising executive and illustrator, was Stover's assistant and remembers the problems they had with pigeon droppings ruining the pale blue and gilt paneled flats for *The Marquise*.

For the Curtis production of *Dracula* with Bella Lugosi playing the lead, Smollin learned that theater is all about group-effort illusion. He still remembers, "There were all these scenes in the drawing room with

the lights out and fog coming in wisps. We were using, I forget whether it was rose water and ammonia or something to create the mist, and we had little fans going to blow it into the room. And we had to create bats that would fly. So we carved out wood for the bodies and did black felt wings, put screw eyes into the top and fastened them with fishing rods. We would all stand on ladders in the wings and on cue we would let go as though we were casting for fish; we'd cast the bats and they'd flutter into the room. Then we'd reel them in quickly." (Smollin also recalls that unlike most actors, Lugosi liked to eat and drink rather extravagantly before his performances. To soothe his digestion, his wife would give him a great ladle of Italian bitters just as he was going onstage!)

Richard Barr, who directed the 1948 season, later recalled his production of *Romeo and Juliet*: "I had just begun to direct in the theater and I'd done work at the City Theater with José Ferrer. The next summer I was asked by Francis Curtis to direct the John Drew Theater. 'Well, Joe [Ferrer] said, 'I want to do Romeo. No one is ever going to let me do Romeo anywhere unless you do.' I said, 'Why not, we'll do it in a week, that's no big problem.' So Ferrer, Mary Anderson and Ray Walston, and quite a number of actors, rehearsed for a week and actually it came off very well. . . . It was the only time Juliet had to climb a ladder outside of the theater to get to her balcony. You know, the John Drew has two small, decorative balconies to the right and left of the proscenium, so I built the stage out a bit and Joe came down off the stage. Then Mary went outside and climbed a ladder, very often with an apprentice holding an umbrella over her head, because it was usually raining, and climbed into the balcony in time for her cue to do the balcony scene. Let me tell you, it was the first time that that's ever happened in the theater and it worked, believe it or not."[2]

Barr scored a coup with the proper Mrs. Woodhouse that season, too. She was known to walk out on a play of questionable propriety, and we were all a little worried when Brian Aherne and Maureen Stapleton appeared in *The Beaux Strategem*, which was billed as a bawdy Restoration comedy. Mrs. Woodhouse, elegantly dressed in a long, pale blue chiffon gown, in her usual seat in Box D on the center aisle, chuckled and applauded throughout the performance, all done in period costume, pompadour wigs and brocade breeches. When her guest, seated alongside her, questioned her acceptance—indeed, enjoyment—of the risqué scenes, she said, "Ah, but they do it with such elegance!"

Would East Hampton audiences respond to a company doing high-quality work—but without big names? That was the question asked by Forrest Haring, our next producer, who came aboard in 1949. We thought it was worth a try. Daga Bennett (now Ramsey) and her Drama Committee got busy with subscriptions and a telephone campaign. Even so, halfway through the season, poor attendance gave Haring his answer. Our audi-

GH ARCHIVES
Leo G. Carroll in
The Late George Apley (1949).

GH ARCHIVES
Forrest Haring, producer, with company members: Sally Brownback (later his wife) and Ray Walston, star of *The Male Animal* (1949).

ences wanted big names. Haring switched his approach the next season. Among his major attractions were Eva Le Gallienne in *The Corn Is Green*, Helen MacKellar in *The Glass Menagerie* and Jack Whiting and Carol Stone in *The Gay Divorceé*. Haring left, in failing health, after two seasons.

When Philip Barry, Jr., entered the scene in 1951 as producer, there were already rumblings in some sectors of the summer colony about too much commercialism at the John Drew—too many sign-boards, too many store-window posters, too much advertising. The theater, they said, was changing the community, attracting too many outsiders. Barry, son of the playwright, was a charming, bright young man steeped in the traditions of theater—and of East Hampton, where his family had spent summers for many years. His wife, Patricia, a stunning redhead, was an actress in both theater and film, and helped him out both onstage and behind the scenes; she appeared in such plays as *Old Acquaintance* with Ruth Chatterton and *The Hasty Heart* with John Dall and Darren McGavin.

In his first season, Barry tried out three new plays, stating his position in the *Guild Hall News* (November, 1951): "Summer theaters at their best are a proving ground for talent and plays; with production costs so high in New York, it is very difficult for an unknown author to get a hearing for his play." There was another element, too, he said: "Audiences, I think, take pleasure and pride in their own discovery of new faces, new plays—being part of the creative process." One of the new plays starred theater maverick Eddie Dowling, also a member of the community. It was *Border Be Damned*, a satire on Irish humor by Paul Vincent Carroll. Although it never went much further, it prompted Dowling to write a rapturous letter extolling the aims of our theater in daring to present new, untried works, and saying, "It could be the greatest place in America for playwrights to have their work seen."[3]

A hit of the 1951 season was *Pal Joey* starring Carol Bruce with Bob Fosse, who went on to become one of the great American choreographers. He and his wife, Gwen Verdon, the beloved musical comedy star and dancer, later lived in East Hampton and both contributed immeasurably by arranging and performing in benefits for Guild Hall. For the 50th anniversary *Night of Stars*, Fosse was asked, as were many other stars who appeared through the years on our stage, "Where were you in 1931 when Guild Hall opened?"

His answer was inspired: "In 1931, I was still in Chicago. I was three years old and I think by then I had learned how to wave 'bye bye' fairly well. Also I came from a very large family and it was very difficult to get attention, so I imagine in 1931 I was off dancing on some coffee table trying to get someone to say, 'Oh, who is that little kid over there?' And then twenty years later was the first time that I appeared here at the John Drew Theater. I was in a production of *Pal Joey* with Carol Bruce and I think then I danced on a coffee table once again. It was one of the most

DAVE EDWARDES
Philip Barry, Jr.,
producer (1951–52) with his wife,
Patricia Barry, actress.

pleasant experiences in my whole theatrical life. . . . But I think the proudest moment that I ever spent in an audience—and, of course, this is a father speaking—was last year, 1980, here at the John Drew when I saw a young dancer by the name of Nicole Fosse appear in a production of *The Nutcracker Suite*. That was wonderful."

Filmmaker and Guild Hall trustee Frank Perry also dates his love for East Hampton to the Barry days. "Under Barry," he says, "I was the advance stage manager for a production of *Candida* with Olivia deHavilland in 1951—she was such a big star, and I was only nineteen. My job was to come a week ahead of the production, supervise the set, get the props. For *Candida* we had to have a Victorian sofa, but the problem was that some actor had to leap onto the couch, so we had to honestly tell people we needed a sofa that could be jumped on! Anyway, we finally got it. Our budget for scenery and props was probably all of $200, but it was a very successful production. Then the following summer John Barry Ryan, the grandson of Thomas Fortune Ryan, was an apprentice here, and he had his sailboat moored in Sag Harbor. I lived on the boat for part of the summer. I just fell in love with the place."

Perry rented a house here in 1961, and bought one in 1975. "I kept my eye on Guild Hall all that time," he says, "and before I die, I'd like to see that theater restored. When I was first here, the colors were bright, circusy. And those balloons! It was like a jewel box. I'd like to see it made bigger—it's an awkward size from an economic point of view [400 seats]—but not at the expense of the charm of it. It should be restored to the beauty that it was. . . ."

Not everyone felt so sanguine about the John Drew. As the 1951 season wore on, the small and virulent group who opposed summer theater grew more aggressive, buttonholing board members and accusing them of ruining "their" village. Robert Vetault, a trustee during those years, remembers: "In the early '50s a sea change occurred in the summer population. You could see it on the street and in the boom of second homes in places like Amagansett-East. The status quo was being threatened and the establishment hated it. Guild Hall became the establishment's whipping boy.

"These people [they called themselves The East Hampton Protection Society] convinced themselves and others that the John Drew was a magnet, that the theater was a hangout of immoral people and the attractor of people who would not be acceptable in their clubs. The drumbeat grew and grew. Pedestrians were asked to sign anti–Guild Hall petitions. Doggerel about the trustees was recited in stores and on street corners.

"At last, in 1955, a meeting was held in which the trustees and the advisory trustees confronted the petitioners. John Boatwright was in the chair. Joseph Gunster was parliamentarian, and he did a good job preventing bloodshed. I can remember Robert Montgomery [the actor, an advi-

GH ARCHIVES
Bob Fosse and Gwen Verdon (mid-1950s). Fosse's first appearance at the John Drew was in the title role of *Pal Joey* (1951).

sory trustee] pointing his finger and saying, 'I want to know who you're talking about. Let's identify them!' Of course, they hemmed and hawed; said, 'Oh, you know. . . .' Montgomery said, 'I'll just say it for you. You're talking about Jews and fairies, it's as simple as that. That's what should be substituted every time you use the word "undesirable" all day long!'

"The moment was stunning. The trustees found their voices and rejected the petition. I don't think there really was a chance that they would have given in, but the moment brought the ugliness into focus for all to see."

By this time Ron Rawson was in his third year as producer (Barry, weary of the dissension among other reasons, had left at the end of 1952). A period of relative calm ensued after the 1955 confrontation, and Rawson went on about the business of presenting eight plays a season, assisted by his very capable wife, Ruth, who directed most of the major productions.

Rawson said recently in thinking back, "We strove to stay away from the often shoddy straw-hat productions of most summer theaters. We were always looking for new material that could conceivably transfer to Broadway. We did many English plays and aimed at a more knowing and sophisticated audience than is found in most summer theaters."

Several of the Rawson productions went on to successful runs elsewhere—among them, *Jimmy Potts Gets a Haircut* by George Panetta (1954). Recast, revised and renamed *Comic Strip*, it opened at the Barbizon Plaza Theatre in New York, where it enjoyed a run of eighteen months. Directed by Ruth Rawson, the play received an Obie as Best Play of the Year. Among others that had a future life were *You Never Know*, starring Bert Parks, and *Sticks and Stones*, a musical with Hermione Gingold.

When it comes to the plays of which Rawson was most proud, he singles out his 1953 production of *The Man Who Had All the Luck*, Arthur Miller's first play, which had failed on Broadway. As Rawson recalls, "Miller was very reluctant to release the rights, but with some intense finagling it was arranged. He came to watch a rehearsal and was very pleased with it. He said that if this production had been the one on Broadway it would have had a run. (Well, it was nice to hear, anyway.) It had a super cast and the lead was played by a young man in our company, William Daniels."

Rawson remembers, too, some of the distressing moments—like the time in 1954 when the John Drew was "dark," no lights, the result of a storm, when *On Approval* was playing. As he was scurrying around for candles and lanterns to light the stage, he heard a loud crash on Main Street. "As I looked toward town, I saw a pair of automobile headlights glowing among the leaves and branches of the fallen elm," he remembers. "I ran through the rain to the scene of the accident and while the car was a mess, the occupants were singing and laughing and having a high old time. The car was an old Packard roadster, and the driver was none other than Jackson Pollock."

WILLIAM BOONE
Gore Vidal, author of
A Visit to a Small Planet
and a former East Hampton resident;
with Bert Lahr, star of the
1958 production.

Ron Rawson (right), producer (1953–59);
with his wife, Ruth Rawson, director-actress
(second from left); with the stars of *Kind Sir*:
Scott McKay (left) and Ann Sheridan;
and the director, Gus Schirmer, Jr. (1958).

Or another weather-related near-disaster: As he tells it, "I had cast Tammy Grimes in a small part in a little comedy called *Quiet Wedding*. It was obvious to all that Tammy had that special star quality and was going to make it big; Tammy was also a very headstrong young lady. She was enamored of a young Canadian actor, Christopher Plummer, who, while she was playing in East Hampton, was performing Shakespeare across Long Island Sound at the Stratford Theatre in Connecticut.

"Tammy was determined somehow to get to Stratford after her performance at the John Drew. She got to the local airport and persuaded a pilot to fly her to Connecticut. It was a sultry summer night; the mist hung everywhere. On take-off the pilot's windshield fogged over and he reached out of the cockpit with his hand to wipe it off, lost control and crashed the plane. While the plane was badly damaged, Tammy and the pilot were only slightly shaken. Undaunted, she ordered another plane and this time successfully made the crossing.

"The next day she went to New York City. What she hadn't figured was that the sultry night was a prelude to a drenching rainstorm, causing flooding on all the main roads. A friend was to drive her out to East Hampton in time for the performance in his little MG sports car, built very low to the ground; but with all that water the trip took six hours. When she arrived, she was one chagrined young lady. Because it was a small part, we were able to cover for her and not lose the performance."

Candace Osborne played with Miriam Hopkins and Sylvia Sidney in *The Old Maid* (1957).

143

The story has a happy ending. Grimes could have been penalized, but wasn't, for breaking an Actors Equity ruling that says an actor can't go farther than ten miles from his place of employment without clearance from the producer. "In fact," Rawson says, "The story had a double happy ending, since Tammy and Christopher subsequently married and are the parents of Amanda Plummer, a very successful young actress in the mold of her mother and father."

Reminiscing about some of the people associated in one way or another with the theater during his time at the John Drew, Rawson mentioned Walter Matthau, Orson Beane, Cathleen Nesbitt, Dorothy Stickney, Leueen MacGrath, Martha Scott and Tom Helmore. "Also," he said, "there were stage designers—William Ritman, who went on to become one of the busiest and best designers on Broadway, and Peter Dohanos, who made his mark in television and film set designs; and Jac Venza, who did some designing for us and has for some time been overall production chief of Channel 13 in New York."

In 1960, Guild Hall took over the operation of its John Drew, and has managed it ever since. After thirteen years of leasing it to independent producers with disparate goals and interests, the board felt we could better fulfill our educational charter, and avoid an identity confusion in the minds of the public, by running the theater ourselves. This way, too, we hoped, we could make "summer" theater a more integral part of the overall Guild Hall operation.

It was Guild Hall's lucky day when, in 1960, Conrad Thibault offered to serve gratis as artistic director of the John Drew. He had recently retired from a successful career as a nationally known baritone concert artist, and in his earlier years had acquired some valuable experience in theater production. He lived just around the corner from Guild Hall and was an enthusiastic participant in its affairs. He served as director for nine years and, at his own expense, maintained an office in the New York theater district specifically for John Drew business.

Thibault was a gentleman in the old tradition, courteous and affable, yet capable of driving a hard theater-contract bargain; creative as well, he introduced some innovative ideas into the programming.

Under Thibault, we were the first theater to bring in productions from off-Broadway, most notably *The Fantasticks*, in 1960. At the suggestion of Larry Baker, we attended a performance of the little musical at the Sullivan Street Playhouse and found it enchanting. Limping into its third month, it hadn't yet had a profitable week and seemed destined to close. It was not surprising that Lore Noto, the producer, readily agreed to interrupt the run to bring *The Fantasticks* to the John Drew.

Noto and his company, disappointed by their shaky box-office business, looked upon the John Drew engagement as a respite at the seashore. With their swimsuits and tennis rackets, they were further disap-

ROBERT BENTON. COURTESY OF LORE NOTO
The original cast of *The Fantasticks* that played the John Drew in 1960. Top: Richard Stauffer, Jerry Orbach, Jay Hamilton. Middle: Thomas Bruce (author Tom Jones), Rita Gardner, Kenneth Nelson. Bottom: Hugh Thomas, George Curley, William Larsen.

TOP RIGHT: JAY HOOPS
The Fantasticks' cast of the 1981 production at the John Drew. George Curley (lower left) from the original cast.

Budd Schulberg; Frances Ann Dougherty,
chairman of the Drama Committee; and
Betsy Schulberg. At the opening night party for
The Fantasticks (1981).

February, 1981

Dear Tom & Harvey,

When the time comes to write the story of The Fantasticks' remarkable longevity, a separate chapter must include the John Drew experience in the Summer of 1960.

I often wonder if we could have survived at all had we not availed ourselves of their unusual offer to continue our original run and bring the show to East Hampton.

Our struggling production found not only the knowledgeable audience we had been seeking, but more, theatre-goers dedicated to the perpetuation of worthwhile theatre.

This was an audience which took an active role in spreading the word about our special merits. By the time we returned to Sullivan Street we were transformed from an endangered artistic success with an uncertain future to a commercial enterprise which has since endured.

I do not overstate their contribution to our survival. By the time we returned to our original playhouse we had a near sellout and it was the first profitable week we enjoyed since opening three months earlier, and all within a mere seven days. Our John Drew adventure was most fortuitous.

I shall always be grateful for their encouragement and support.

Best wishes,
Lore Noto
Lore Noto

pointed by the weather; it rained all week, and the actors spent most of their spare time playing cards at a table set up on the stage.

What a surprise when they met with enthusiastic audiences peppered with important theatrical figures like Elia Kazan, Jerome Robbins and others with valuable "word-of-mouth" power. *The Fantasticks* was a smash hit in East Hampton. When the company returned to the city, the box-office phone was ringing off the hook. It's still ringing, and *The Fantasticks* is enjoying the longest run in theater history.

When we presented a revival of *The Fantasticks* for the 50th anniversary of Guild Hall in 1981, Lore Noto wrote a letter about our role in the show's amazing history, which ended: "I do not overstate the John Drew Theater's contribution to our survival. I shall always be grateful."

The Fantasticks' author, Tom Jones;
and the composer, Harvey Schmidt; attended
the opening night performance (1981).

Conrad Thibault, artistic director
1960–69, with some of his
committee ladies (1968): Patricia Radway,
Marjorie Rice and Eloise McElhone.

Another Thibault innovation was bringing in a top-flight nonprofit repertory company, the Association of Producing Artists (APA), in their first engagement in this country. Headed by Ellis Rabb, the company was made up of a gifted group of actors, among them Rosemary Harris, George Grizzard, Paul Sparer and Keene Curtis. We hoped to provide them a permanent summer residency.

For limited engagements over a three-year period, they performed the classics: Shakespeare's *Twelfth Night*, Chekhov's *The Seagull*, Shaw's *Man and Superman*, Sheridan's *The School for Scandal*, as well as George M. Cohan's *The Tavern* and a tryout of John Whiting's *A Penny for a Song*.

For contrast, we invited the Phoenix Theatre Company, another nonprofit group, for a split season with APA in 1961. They performed modern classics—Fry's *The Lady's Not for Burning* and Ionesco's *The Chairs* and *The Bald Soprano*.

Sadly, however, vacation-oriented audiences were not eager to leave the beaches and cocktail parties for this type of serious theater, no matter how well produced, and we had to abandon what promised to be the ideal programming for the John Drew Theater.

In 1962, we returned to the old summer-theater formula—a theatrical mix of something old with something new, and stars whenever possible. Under Thibault, for example, we presented Viveca Lindfors and Luther Adler in *Brecht on Brecht*; Estelle Parsons in *A Taste of Honey*; George Grizzard in George Kelly's *The Show Off*; Vicki Cummings and Kendall Clark in Albee's *Who's Afraid of Virginia Woolf?*; and musicals such as *Stop the World, I Want to Get Off* with Joel Grey; *My Fair Lady*; and *The King and I*.

During those years, there were tryouts, too. Eddie Dowling, East Hampton resident, directed several. In 1962, he wrote and appeared in his own panoramic production, *In the Time of My Life—A Memoir*.

"I was supposed to direct this show," remembers Neil McKenzie, resident director for the season. "Eddie Dowling had come to the theater in 1962, offering to present excerpts from the plays he had produced and directed on Broadway (but glossing over discussions of the steep royalties the John Drew would have to pay to use a bit of each of the plays). So the show ended up being pretty much Eddie Dowling—amiable and witty," McKenzie recalls, with scenes from his successes, like *The Glass Menagerie*. The title piece, *In the Time of My Life* was, of course, Dowling's takeoff on William Saroyan's Pulitzer Prize-winning *The Time of Your Life*, which Dowling had produced and starred in.

"But what could I do?" McKenzie adds. "There was nothing to direct. Eddie would say, 'I need a trunk,' so I'd go out and get a trunk. But how are you going to direct a man who's going to talk about his life? Eddie's show was entirely Eddie's improvisation. Except for the scenes which Julie Haydon and Claire Luce performed, it varied every night with stories about Sarah Bernhardt, Lorette Taylor and playwrights whose reputations he had helped establish—Tennessee Williams, William Saroyan,

Eugene O'Neill. . . ." Still, the audiences found the evening enchanting (if a bit long).

McKenzie remembers, too, one time when everything worked brilliantly at Guild Hall for an outstanding new musical which should have gone on to success elsewhere, but didn't; McKenzie, who directed it, thinks of it to this day. Noel Weiss, who had been associated with *The Fantasticks*, brought *All Kinds of Giants* to the John Drew in 1961, sensing that he had another *Fantasticks* on the string. It was about a small five-foot giant whose bigness came from the heart. Ralph Carpentier did the sets— "caught the fairy-tale quality of it," says McKenzie. The casting was perfect, as was "the marvelous percussionist, whose instruments required a truck to bring out here." Billed as a musical on its way to off-Broadway, the show was a hit; both children and adults loved it. "If ever there was a show that was a collaborative effort, this was it," says McKenzie. It won a Long Island "best original script of the year" award. But in reworking the show for off-Broadway, the formula that proved so winning at the John Drew was abandoned; the show closed in a week. In its new staging, the magic simply did not carry well.

Joan Fontaine was a particular favorite during the Thibault years. "You could depend on her," Joseph (Joe) Dunn, the theater manager, observed. "You knew she'd be there and that she'd give a top-notch performance. No unusual demands, no temper tantrums."

So it was particularly satisfying to all the crew that it was Joan Fontaine who broke the theater's box-office record, both for attendance as well as gross receipts, when she appeared in Agatha Christie's *The Unexpected Guest* in 1965. She broke her own record in 1967 in another Agatha Christie and was rewarded with an engraved silver trophy. From that time on, she remained a good friend to the theater, returning from time to time to perform on special occasions.

James (Jim) Tilton, who has been associated with Guild Hall and the theater in various capacities for some thirty years, began designing sets for us in 1963—his first job—and later went on to design over thirty shows on Broadway, including some Albee plays and some for APA and Phoenix. His first production for us was *Finian's Rainbow*. He remembers putting together a season's scenery with a lumber budget in the neighborhood of $700. By season's end, as he tells it, the stage platforms simply got smaller and smaller. Everyone worked incredibly hard, including the starry-eyed apprentices who each summer learned that the glamour/hard work ratio in show business weighed heavily toward hard work.

He recalls one summer in the mid-70s, when one of his apprentices turned out to be fairly rambunctious. "All he wanted to do was have fun and play games; he just didn't seem to have his heart in it. Finally I had to sit him down and say, 'Look, I don't think you need to stay here, because obviously you're not enjoying this work in the theater.' " The next time that apprentice surfaced was as Griffin Dunne, the famous actor-producer. . . .

Luther Adler, Viveca Lindfors, Micki Grant,
Lou Antonio in *Brecht on Brecht* (1963).

1960s

Joel Grey in *Stop the World
I Want to Get Off* (1964).

Claire Luce, Eddie Dowling and Julie Haydon
starred in *The Time of My Life*, a new memoir
play by Eddie Dowling (1962).

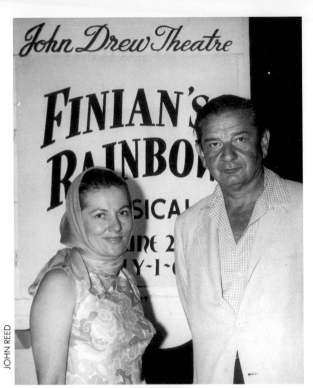

Joan Fontaine with Charles Addams,
New Yorker cartoonist,
during a theater intermission (1963).

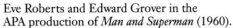

Eve Roberts and Edward Grover in the
APA production of *Man and Superman* (1960).

Actor Sam Levene and
playwright Murray Schisgal
at a cast party (1965).

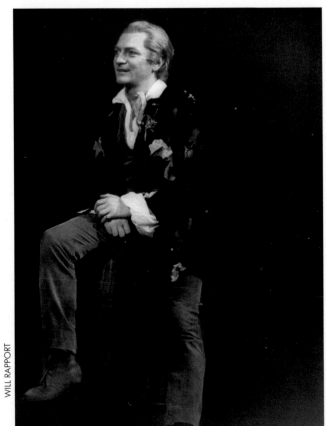

George Grizzard as the vagabond
in Association of Producing Artists (APA)
production of *The Tavern* (1961).

Another, and perhaps more eager, apprentice to serve was Parmalee (Pam) Bates (now Fletcher), whose first exposure to Guild Hall was watching her older brother and sister in the Village Vanities; she couldn't wait to join. She finally earned a part in one scene playing an Indian. "I was hooked; I just loved it," she says. "I was lucky enough in about my third year to be tapped for a genie. I had a solo. In Tampa today I still sing my song every morning when I'm walking my dog. And I wore a fabulous costume—all sequins, pointed hat, turned-up toes. It was wonderful."

Fletcher worked later as an apprentice during the summer seasons when there were eight different shows running for a week each. She can still recall building, painting, transporting and putting up a new set every week. But the spirit ran as high as the energy required to put on all those shows. "I remember how impressed I was with the good will of all the actors," she says. "Most of them seemed excited to be there; they enjoyed themselves. I remember, for example, that during the run of *Fiorello* (1962) my job was to push a platform with about five people on it onto the stage. I was about sixteen at the time, and fairly strong, but not strong enough to push that platform. So one of the actors jumped off the platform, helped me push it, then jumped back on in the nick of time.

"There was a spirit," she says. "It had to do with the hospitality Guild Hall offered, those wonderful parties. I was living and breathing theater the whole time I apprenticed. I have such warm feelings about those days. . . ."

All was not always serene, however. Actor Hurd Hatfield, a former Sag Harbor resident who had appeared on our stage before, recalled his 1968 Guild Hall run, when "I battled through J. Wiedman's *Ivory Tower* as a Fascist-minded American poet on trial for treason. There was some similarity to the distinguished Ezra Pound, who was never on trial and whose wife was not a waitress! (Had never been!) The publicity surrounding this production, which premiered at the Ann Arbor Festival in Michigan, persisted in this libelous association. Mrs. Pound (the poet by that time was deceased) threatened legal action. Somehow this was avoided. I pressed on—velvet jacket, Shavian-like iconoclasms and a thunderingly tough third act."[4] It was not a happy experience for Hatfield.

During Thibault's time and beyond (until 1974), Joe Dunn was our likeable and very efficient general manager for the summer theater. He can still recall the dizzying variety of duties: "First off, there's the handling of relationships with the union, sometimes prickly . . . and putting down 'fires' that would come up between performers and management—even to caring for pets, all those little problems that would surface in the course of putting on a show a week.

"We had big musical companies coming in in the early '60s consisting of maybe twenty-three people, including two or three musicians. Some of those chorus people were only getting $100 to $140 a week, and under the union rules we would have to provide a room for $25 a week. If we couldn't find one for that, we had to make up the difference.

JOSEPH ADAMS
Sag Harbor resident
Hurd Hatfield,
played leading roles in *Monique*
(1958) and *Ivory Tower* (1968).

"One thing that helped: We had a 'welcome aboard' newsletter that we gave to everyone when they arrived, told them where they could rent a bike, how to get to the beach, where to go for breakfast. And the Guild Hall hospitality committee would see that they sometimes got invited for lunch and a swimming party at a private home. Everyone was made to feel very welcome. I think that feeling carried over into their performances and to the general rapport we had with them.

"Of course there were exceptions—like when Hermione Gingold, star of *Oh Dad, Poor Dad*, was having an 'off' day. It was a union rule that we had to provide a hot meal for the company when we were running two performances on Saturday nights, at 6:00 and 9:30. We usually set it up in the garden or one of the galleries. Some local ladies were in charge of the food, and they always did a good job. But this particular night Miss Gingold didn't feel like coming out to the garden, so Kurt from the staff made up a tray and took it back to her. He knocked on the door, she opened it, grabbed the tray and slammed it on the floor, apparently in a fit of artistic temperament, for food, dishes, everything went flying all over the place."

Then there was the time the board had to intervene. Irving Markowitz, then a presiding officer, remembers: "It was a Saturday night, and I was having dinner when Joe Dunn called: 'Our star won't go on.' I asked, 'What do you mean, our star won't go on?' He said, 'Well, he says he wants a chauffeur-driven limousine to take him back after the show closes tonight, so what should I do? I told him it's not part of his contract and he's not getting it.' And I said, 'Joe, I admire what you're saying, but how late is the show now?' He said, 'A half hour.' I said, 'Is the house full?' He said, 'the house is full.' So I said, 'Joe, promise him anything, promise him a plane, promise him the sky. You tell him whatever he wants Mr. Markowitz says he will have.' Joe said, 'But that's not right.' I said, 'Joe, get him on the stage.' The next day I stopped by and said to the gentleman, who was still waiting for his limo, 'Mr. B., you're going back on the parlor car on the Long Island Railroad because that's what's in your contract and that's all you're going to get.' He said, 'But you promised me.' I said, 'I know I promised you, but you promised to set foot on that stage last night and you refused, so I don't consider what I had promised you to be valid.'" Mr. B. went back on the train.

Through the later years with Thibault we generally played to near-capacity. There was less experimentation. The peak year was 1966, when Thibault reported to the board, "This was our best season from the standpoint of box office. We had an excess of $21,000 over expenses, but I want to warn you that costs are rising sharply. We sold out for nearly every performance, and we feel the limitations of a 400-seat house. Touring shows of good quality are getting harder and harder to find."

By 1969 some patrons were beginning to grumble about "too much warmed-over Broadway," and Thibault concluded that we needed a whole new approach but that he was not the man to provide it. There was also serious illness in his family, making it necessary for him to move

JAY HOOPS
Bran Ferren, technical consultant during the '60s and '70s; and Joseph Dunn, theater manager (1961–1974).

151

Carmen de Lavallade and David Ackroyd in *In the Beginning*, first production directed by Larry Arrick for the John Drew Repertory Company (1971).

Josephine (Jo) Raymond, long-time chairman of the Drama Committee, and gracious hostess to innumerable cast parties.

permanently from East Hampton. For everyone concerned—the board, staff and committees—that era had been a happy one. Thibault had served Guild Hall and its theater admirably, giving it his almost undivided attention and best efforts for nine years.

Commenting on the status of summer theater (June 17, 1970) Leo Seligson of *Newsday* wrote:

> This summer, Long Island's straw-hat circuit looks as shrunken as a bonnet left out in the rain all year. But even though it's 'curtains' for the Mineola Playhouse, the Wedgewood Dinner Theater, the Greenport Summer Playhouse and the Southampton Cabaret Theater, there are a number of survivors and even a couple of signs of new life stirring. And one survivor, the John Drew Theater, is taking a leap into something wholly different. . . .

That "something wholly different" was the Yale Repertory Company. After considering ten proposals from various companies, we invited Robert Brustein, Dean of the Yale School of Drama, to bring his celebrated four-year-old company of professional actors in a season of Story Theater. It was a form of theater originally conceived by Paul Sills that broke down the barrier between narrative and drama through the spoken word, music and dance, as a way of bringing some of the best loved works of fiction to the stage. The company included Carmen DeLavallade, Alvin Epstein, David Ackroyd, Elizabeth Parrish and some then-unknowns—James Naughton and Henry Winkler. Larry Arrick, artistic director, presented four productions based on stories by Ovid, Flaubert, Philip Roth and others. The season, a huge hit, really caught our audience's imagination.

Josephine (Jo) Raymond, for many years chairman of the Drama Committee, says: "To this day, I get chills up my spine when I think of the opening night of *Olympian Games*. The applause at the end was something I'd never heard before at the John Drew—simply tremendous. I gave a party at my home afterwards. Somebody sat down at the piano and started playing the opening number from the show; first thing I knew, the cast was doing the whole show all over again. It went on until four A.M. It was so much fun that summer because we got to know all those actors and see them playing different roles. We had all hoped so much that the John Drew would be their summer home."

It was not to be. Owing to changes within the Yale company's structure, we were unable to negotiate a contract with Brustein. Nevertheless, individual members of the company were available, as was Larry Arrick, whom we engaged as artistic director to form the John Drew Repertory Company under the Guild Hall banner for the 1971 season.

In addition to the core company, Arrick added some distinguished new talent—Linda Lavin, Kathleen Widdoes and Ron Leibman, among others. All new works were presented, some in the Story Theater format.

There were tryouts such as Terrence McNally's *Bad Habits*, which went on to an off-Broadway run. In thinking back, McNally said: "The John Drew was kind of a goal for me because I love the summer. It's my favorite time to work, and when I started coming out here I thought it

would be wonderful to have a place here, because I could walk my dog along the beach, get some sun—and also be working. It happened very quickly, actually. I first came out here in the summer of 1969, when I wrote *Bad Habits*, two related one-act plays that were performed in the summer of 1971. . . . Linda Lavin was in it. I especially remember her and Rose Arrick—they were quite marvelous. Larry Arrick directed it, and it was a very good production. I remember thinking the sets [designed by John W. Taylor] were wonderful. The play was never set so well again."[5]

Another premiere was Joseph Heller's *Catch-22*, which Heller adapted for the stage. ("Larry Arrick," the author had said, "is the only director I would let do my script.")[6] *Catch-22* traveled thereafter to the Goodman Theater in Stamford, Connecticut, and other regional theaters.

In spite of good reviews, particularly for the charming Story Theater version of Goldoni's *A Servant of Two Masters*, attendance fell considerably below expectations, and the board considered it financially risky to go with the company the following year. All of us, disappointed, asked ourselves, "What happened?" We went over all possibilities; there was no economic slump, no new exciting competition, no roadblocks to the theater. "I guess," said Arrick, "we were yesterday's discothèque."

The following summer, 1972, playwright Edward Albee and director-producer Richard Barr offered their services gratis as artistic directors. Both were Montauk residents and long-time friends; Barr had discovered Albee and championed his career for decades. Barr said their intent was to appeal to the painters, sculptors, theater people, writers—intellectuals of the community. As their plans evolved, the board agreed to give them full artistic control; furthermore, for the first time in the history of the theater, the board raised a backing fund of $20,000 which, together with a New York State Council on the Arts grant and a successful subscription campaign, seemed for once to take the risk out of the venture.

The season opened brilliantly with a double billing: Thornton Wilder's *The Long Christmas Dinner* and Albee's *The American Dream*, with Albee offering a delightful, informal give-and-take with the audience after the performances. But—call it an aesthetic conflict, call it miscommunication between producers and the board, call it a mismatch between subject and audience—the season began to go downhill. Joe Orton's *What the Butler Saw* displeased many in the audience. But with *Dudes*, three new one-acts by Martin Duberman that was to close the season, Guild Hall faced a problem. As the new script began to circulate among the trustees, there were those who wanted to cancel it because of its "offensive" content; on the other hand, there were those who felt that censorship was far worse than presenting the play. Two valued trustees resigned from the board in protest over the 15–3 decision to run *Dudes* as scheduled. In the end the audience itself voted against the play; by the end of the two-week run there was only a handful of people who showed up to see it. It was a sad end to a well-intentioned effort.

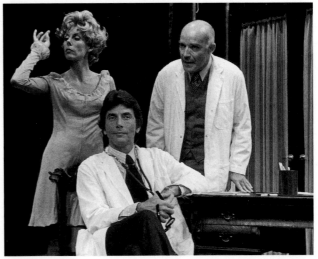

JAY HOOPS
Betsy von Furstenberg, Keene Curtis, Michael Lipton in *What the Butler Saw* (1972).

153

Edward Albee, Richard Barr,
artistic directors for the theater;
and Enez Whipple, executive director.
At a pre-season meeting
at Albee's Montauk home (1971).

Keene Curtis, Dee Victor and James Woods in *Dudes*,
Martin Duberman's one-act plays premiered in 1971.

Andre Gregory's production
of *Alice in Wonderland* (1973).

A *Star* editorial (August 3, 1972) commented:

> The management of Guild Hall had the courage to try something new—a season of mainly experimental plays . . . and the results were, to put it mildly, a disappointment at the box office. It was, no doubt, a calculated risk. There is only so much of an audience for this sort of theater, and it is obvious that not enough of that audience was in the Hamptons this summer. There should be no recriminations, only continued support for a community center with backbone enough to stick its neck out.

After a change of pace in 1973 by way of a Festival of the Performing Arts—music, chamber opera and theatrical presentations starring Joan Fontaine, Ethel Barrymore Colt and Viveca Lindfors, along with Andre Gregory's off-beat *Alice in Wonderland*—we again returned to a season of straight theater in 1974.

Jerome Minskoff, one of our board members, was instrumental in bringing our old friend The Phoenix Theatre, now referred to as "The New Phoenix," to the John Drew that year. Hailed for "inventive, poised and polished productions," they gave us their best in Giradoux's *Amphytrion 38*, Pinter's *The Birthday Party*, Anouilh's *The Rehearsal*, Coward's *Tonight at 8:30* and Barry's *The Animal Kingdom*, plus a new small-scale musical called *Pretzels*, by John Forster. John Cullum, Bill Moor, Swoosie Kurtz and Remak Ramsey were among the actors in the company, which remained with us for two seasons.

But even with a substantial grant from NYSCA, we couldn't make it financially. Further, we were unable to arrive at a mutually agreeable contract figure for the third season. Phoenix, too, was feeling the pressure of escalating costs and it would not be long before they, like APA, would close shop, another casualty in the American theater.

By 1978 we had come to a momentous decision: to engage a year-round managing director for the theater as a way of providing the kind of continuity in the operation that had been missing since Conrad Thibault's time. The decision was implemented by our new board chairman, Budd Levinson, a firm believer in long-range planning; and Frances Ann Dougherty, a theater professional serving on our board.

Anthony (Tony) Stimac was selected for the position. We knew his work from 1976, when Dougherty had recommended him to direct *America the Musical*, four musicals celebrating the bicentennial, which Stimac had adapted from rarely produced comedies of the eighteenth and nineteenth centuries, with music composed by Don Pippin and others.

Through Stimac's tenure, Dougherty played a strong guiding role in planning and developing the programming. The summer seasons combined tryouts and touring shows; during the winters, new scripts were tried out in staged readings. Two of these by East Hampton playwrights, James Kirkwood's *There Ought to Be a Pony* and Murray Schisgal's *The Downstairs Boys*, were considered worthy of full production in the summer; *Boys* was presented in 1980 and later toured regional theaters. *Pony* was presented in 1982.

JAY HOOPS

Jerome Minskoff (seated) and Irving Markowitz, (right) co-chairmen of the Drama Committee, with Dan Freudenberger, production director (left) and Marilyn Miller, executive director for the Phoenix Theatre season (1975).

JAY HOOPS

Jonathan Hogan and Swoosie Kurtz in *The Private Ear and the Public Eye* (1975).

1970s

Christopher Lloyd, Jacqueline Brookes and James Cahill
in Pinter's *The Birthday Party* (1974).

Remak Ramsey and John Lithgow
in *Tonight at 8:30* (1975).

John Cullum, Susan Clark (on platform)
and Paul Hecht in *Amphytrion 38* (1974).

Paul Hecht, Christopher Lloyd,
Susan Clark, Bill Moor and John Cullum
in *The Animal Kingdom* (1974).

Alfred de Liagre, New York producer of the original *Death Trap*.

Dick Cavett and Louis Edmonds re-creating their Broadway roles in *Otherwise Engaged* (1978).

James Coco and Lenny Baker, stars of Terrence McNally's play *Broadway, Broadway* in its premiere at the John Drew (1978).

Louis Jourdan and Carol Mayo Jenkins in *Present Laughter* (1979).

Paul Davis' 1979 theater poster.

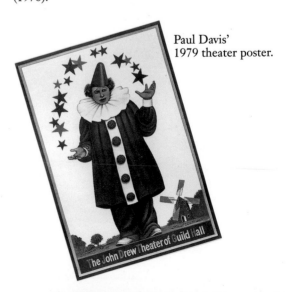

Dina Merrill, star of several John Drew productions through the years; with Tony Stimac, managing director (1978–82).

Scene from *The Unexpected Guest*. Dina Merrill, star of the play; with Dan Hannafin, Timothy Doyle, Patrick Farrelly (1980).

The 1978 season followed the balanced approach to programming that seemed to work best: revivals such as *Otherwise Engaged*, starring Dick Cavett, and premieres such as Terrence McNally's *Broadway, Broadway*, with Geraldine Page and James Coco. McNally, who bought a home in Bridgehampton after his first acquaintance with our theater in 1971, refers to the John Drew as "my home-town theater" and recalled later that his friends thought he was crazy to try out a play there: "They said, 'You're going to get the same audience you're supposed to go out of town to avoid. You'll have all those "in" people there the first night.' And they were right. It was a tough audience—but you're working for a tough audience in the New York theater. I think the John Drew can play a very important step in getting a show to New York, because what's the point of playing to a bunch of deadheads? You sure don't have that here, so I'd do it again."

"The only bad part," McNally continued, tongue-in-cheek, "was that when the play did not go as well as we'd all hoped, it made it very hard to drive by the John Drew Theater. I found myself coming up with wild excuses to shop in Southampton or wait 'til a movie got to Southampton just so I wouldn't have to go by the place so often. But that only lasted six months."[7]

The prime attraction of the 1979 season was George Grizzard in *Death Trap*, presented with special permission of its New York producer, Alfred de Liagre, a member of Guild Hall's advisory board. He told a *Star* reporter that he had produced and directed thirty-three shows in his career and, in all that time, had never had the pleasure of seeing one of them performed at the theater in his adopted summer home town.

The opener that season was Noel Coward's *Present Laughter*, starring the incomparable Louis Jourdan, whose wardrobe crisis Stimac still remembers. "All of Jourdan's wardrobe (and it was fantastic) was given to him by some famous French designer. He arrived in New York with trunks full of clothes, but he'd lost weight so he'd had them altered. When the clothes arrived in East Hampton, they were poorly altered and Jourdan was in a dither; he kept saying, 'Ah, these clothes, they were tailored by plumbers!' Finally we brought in a dear woman in East Hampton who was descended from a long line of German tailors—and who, on top of it, was in love with Jourdan. 'Ach, these clothes have been tailored by plumbers!' she said when she saw the wardrobe. He embraced her, and she worked seventy-two hours straight to fix every single one of his garments. And she was our costumer for the rest of the time I was here."

In 1980, we participated in a new experience: the videotaping for a summer TV series called "Summershow," which featured three East Hampton residents in *A party with Comden and Green* and *Madowman of Central Park West* with Phyllis Newman, a one-woman musical she wrote with Arthur Laurents. At Newman's suggestion, Arthur Cantor, executive producer of the Mobil Showcase, picked the John Drew for the taping. He told the *Star*'s Alan Kayes, "She hit the nail right on the head. It's an

absolutely perfect house. Its technical facilities are marvelous. . . . The audiences have been very warm and they are extremely sophisticated."

At this time Chester Hartwell was our year-round stage manager (our first). He wore a few other "hats" on the job as well. Producing scenery for a play, he found, can have its own tense, dramatic moments. He tells about how *The Downstairs Boys*, Schisgal's comedy, almost played on a bare stage in the summer of 1980. "It seems the set plans included movable walls, requiring a kind of construction our crew was unable to handle, so we used a shop in New Jersey to build it. The driver loaded it onto the truck late one afternoon, drove it to Manhattan, locked it and went to bed, expecting to make the delivery to us the next day—but the next day, no truck. We were in a panic; the scene shop had filled its contract once the truck was loaded. The show was to open in a couple of days. No money in the budget for mishaps like that. We called the scene shop: 'Put something, anything, together fast!' While we were sweating it out, the police called to say the truck had been found at the Brooklyn piers, ignition broken but cargo intact. We just barely got it in time to make the opening. That was a close one."

The John Drew has sometimes been criticized for bringing in shows directly from New York; East Hampton summer audiences, the argument goes, have already seen them. Stimac presented two, however— *Ain't Misbehavin'* and *Vanities*—that were standing-room only sellouts. East Hampton was the first stop for the *Vanities* national tour in 1980.

For Stimac, the 50th anniversary was a "killer." It combined plays, a dance festival, a film festival and dozens of one-night "specials." Opening the season were three one-acts involving local celebrities: "Margo Korda Schoeneman, who was on Frances Ann Dougherty's Drama Committee, had this idea to have writers of the region write a play for acting couples of the region," Stimac recalls. "I liked the idea and said Murray Schisgal might write a play for Eli Wallach and Anne Jackson. Frances Ann thought Jim Kirkwood might write one for Dina Merrill and Cliff Robertson, and somebody else thought Lanford Wilson might write one for Uta Hagen and Herbert Berghof. We were on Frances Ann's deck at the time. I drove back to the theater and one hour later all nine of them had said yes; we had our opener for the season. Later Wilson had to drop out because he got involved in a rewrite of one of his plays. So it was finally Murray's play, *A Need for Brussels Sprouts* with Eli and Annie; Jimmy's play, *Surprise* with Jimmy and Dina; and Cliff's play, *The V.I.P.s* with Cliff and Dina. And of course we sold every ticket there was. We did 104 percent business."

Wallach and Jackson have happy memories of *Brussels Sprouts*, in which Jackson played a tough policewoman and Wallach an over-the-hill actor she meets because he's playing music too loudly in his apartment. Wallach recently recalled, "Afterwards, Schisgal wrote a companion piece for it, and it kept us occupied for two years. We did it on Broadway under the title *Twice Around the Park*, even took it to Edinburgh." Jackson added, "We should have brought it back here where it started." Wallach quipped,

Betty Comden and Adolph Green in a videotaping of *A Party with Comden and Green* for a TV series, "Summershow," at the John Drew (1980).

Patricia Kennedy Lawford (left) and Ruth Carter Stapleton (third from left) pay a backstage visit to James Kirkwood, author of *There Must Be a Pony*; and its star, Joan Hackett (second from left). 1982.

"Not with *me*. I can't lift the policewoman anymore." Jackson had the solution: "Roberta [their daughter] will be in it and I'll direct it and we'll find a young man who can lift Roberta."

And Schisgal talked to a reporter about working with the Wallachs: "What's good about working with Eli and Anne is that they want more. I started out wanting to do just a parody of an actor and a policewoman, but when I showed them the first draft, they said, 'We love the basic idea, but we feel it could be more like this.' They gave Schisgal fifteen pages of suggestions and back he went to the typewriter. Eight drafts later, the play was ready for the stage of the John Drew. "That wanting *more* is really healthy. It turns a writer on."[8]

The climax of the 50th celebration was *Night of Stars*, a revue of memorable moments in the history of our theater. It was a gala homecoming for dozens of performers, composers and directors who had happy memories of the John Drew: Peter Stone, Gwen Verdon, George Grizzard, Carlos Montoya, Betsy von Furstenberg, Pat Barry, theater critic Martin Gottfried and dozens more. Clark Jones and Enid Roth produced it and Peter Dohanos designed the sets. "And for the finale," Brendan Gill wrote in the *Star*, ("Out came the most dazzling contemporary actress, Helen Hayes. . . . Erect, at ease with herself, her voice as gentle and strong as ever, she recalled playing at the John Drew Theater long ago with her daughter, Mary. The producer of the play had begged her to attend a certain fashionable party in Southampton on the night of the opening because her presence there would do much to 'weld the Hamptons.' [He was referring to the historic rivalry between East Hampton and Southampton.] Miss Hayes shook her head and marveled, 'Imagine my welding the Hamptons. Think of my learning to be a welder in such a cause!' And then in a final salute to the theater and to the joyful occasion that had brought her back to it, she quoted a few lines from a playwright who, she said, was an old friend of hers. And so he was, for his named turned out to be Shakespeare." The lines were from *Twelfth Night*, slightly revised:

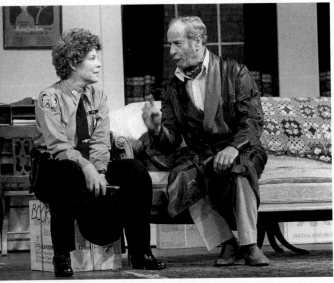

JAY HOOPS
Anne Jackson and Eli Wallach
in *A Need for Brussels Sprouts* (1981).

> *Make me a willow cabin at your gate,*
> *And call upon my soul within the house;*
> *Write loyal cantons of contemned love*
> *And sing them loud even in the dead of night;*
> *Halloo your name to the reverberate hills,*
> *And make the babbling gossip of the air*
> *Cry out, 'O! Beautiful East Hampton!'*

After six successful years as the John Drew's first year-round director, Stimac left East Hampton in 1983 to establish Musical Theater Works, Inc., in New York, an enterprise devoted to testing new musicals.

Wilson Stone, composer-lyricist for stage and film and producer of special muscial events, followed Stimac. Almost from the time he and his wife,

Dorothy, and their young daughter, Susanna, moved to East Hampton in 1970, he had been deeply involved at Guild Hall. He served as a trustee, organized a very successful youth theater program, was an active member of the Drama Committee, planned the Sunday night "theater specials" and, surprisingly, also headed the Building and Grounds Committee.

At the board's request to hold down costs, Stone turned to a festival season, which was considered less risky than a season of fully mounted plays. He would have preferred continuing the summer theater pattern of former years; however, he did manage to squeeze in a few plays along with the concerts, films and variety shows.

Speaking of his two years of running the theater, Stone said he was most proud of *The Importance of Being Earnest*. "It was an Ellis Rabb production; Ellis played Lady Bracknell in a dress. It was a wonderful cast, an artistic achievement, and it ran three weeks. It was something you wouldn't see anywhere else. I don't approve of bringing something right out from New York and plunking it on the stage at the John Drew, because everyone's just seen it in New York. Everybody worked for minimum—about $500 a week—even Ellis. That's how we were able to do it."

Stone remembers that Rabb "was terribly terribly artistic, and very demanding. Housing actors is always a difficult proposition, but we managed to find him a little house for $2500 dollars. It was really kind of a dump, but he thought it was all right, which was a great relief. I thought that problem was solved.

"He'd hardly moved in when I got a phone call, and he said, 'Wilson, I was driving in order to calm my nerves the other night and I passed Three Mile Harbor, where I saw lovely boats in the harbor with their lights twinkling. Obviously, people are living on these yachts out there, and that would be very tranquil for me with the pressure that I'm under. Could you arrange that someone else take my house and I could be on one of those yachts?'

"I decided that the only way to handle this was to say yes to everything. I said, 'Ellis, it's a wonderful idea. Why didn't I think of it? I will call tomorrow and see what I can find in the way of yachts.' Of course, he never brought it up again and, of course, I didn't, either.

"A little later on he called and said, 'Wilson, I am trying to sleep in my bedroom, and there are cars going up and down the road. Can't you do something to stop this traffic on this road?' I said, 'Oh, yes, Ellis, I will. I'll call about that right now.' Of course I never did anything and he never mentioned it again."

On the subject of why straight theater had been dropped, Stone was outspoken: "I am of the opinion that if the board wants theater, they should go out and raise the money as they do in other nonprofit operations like this. A third of the season's costs should be underwritten; costs can't be met by box office alone. I think the notion that the theater should be *making* money to support things like a new roof or furnace—and a maintenance crew, which is what had been suggested to me—is unrealis-

JAY HOOPS
Douglas Fairbanks, Jr., and his co-star, Meg Wynn-Owen, and cast of *Out on a Limb*, premiere of a musical from a Thurber story (1978).

SUSAN WOOD
Wilson Stone, artistic director of the John Drew (1983 and 1984).

tic. I don't know of a nonprofit theater in America that is supposed to carry the weight that the John Drew is supposed to carry."

Among the major productions that Stone wove into the festivals during his tenure were *Tallulah!*, a new work by Tony Land and Arthur Siegel, starring Helen Gallagher; and *Hail Thurber*, compiled by Peter Turgeon and directed by Barbara Bolton.

Stone also introduced, in 1983, the popular and lively Hot Topics panel discussions, conducted by Sherrye Henry of New York's WOR Radio, and balanced out the two seasons with a blend of classical music; and, on the lighter side, The Great Ladies of Song series with Jo Sullivan, Julie Wilson and others; and The Song Writers, featuring the music of Lerner and Lowe, Oscar Hammerstein, Burton Lane and Johnny Mercer.

At the end of the 1984 season, successful though it was, Stone resigned. He found the job "too encompassing," leaving him no time for his own career as a composer.

Amy and William McGrath followed Stone in 1985 as artistic directors. They, too, went along with festival programming, although their hearts were really in stock theater. Like Stone, they also managed to include a few plays. Of *The Cherry Orchard*, presented in 1985, Leo Seligson wrote in *Newsday*, "Considering the summer stock regimen under which it was assembled—a hectic two weeks of rehearsal and curtain up—it's a surprising treat—not easily forgotten."

Among other fully staged productions presented by the McGraths were a musical salute to Cheryl Crawford, Broadway producer since the early '30s and a resident of Bridgehampton, entitled *One Touch of Crawford*, written by Barry Harman and starring Patrice Munsel; and a new musical comedy–murder mystery, *The Case of the Dead Flamingo* by Dan Butler and Donald Oliver, with music by Donald Oliver.

The McGraths were committed to encouraging new talent and ran an ambitious nationwide search for new plays. They were deluged with 300 manuscripts, and out of them chose three for staged readings, using local professionals; and one, *Rainbow's Return* by Stephen Hanan, for full production. After two years, the McGraths left to run the Airport Theater in Bohemia, Long Island.

Kelly Patton's first association with Guild Hall was in 1969, when she taught an acting class. Among the things that drew her back years later to serve as artistic director from 1986–91 was the allure of the theater, which, she says, "had such a mystique . . . John Drew and all the people who had played there."

As the McGraths had been, Patton was deeply committed to fostering new playwriting talent. In addition to the major festival attractions in 1987, which included two fully staged tryouts arranged by Norman Kean (Bonnie Franklin in Judith Viorst's *Happy Birthday and Other Humiliations* and Uta Hagen in Donna DeMatteo's *The Silver Fox*), Patton staged a number of readings. "My dream was to make the John Drew a develop-

MARTHA SWOPE
Laila Robins, Kelly Wolf and Uta Hagen, stars of *The Silver Fox*, a new play by Donna de Matteo (1987).

162

ment center for new works, to bring talents together—a playwright with a writer, for example. That's what happened in the 1991 season; I brought the Sagaponack author Peter Matthiessen and the Sag Harbor playwright Joseph Pintauro together. Out of that came a dramatization of *Men's Lives*, which I put on the stage of the John Drew."

Patton enjoyed directing Budd Schulberg's *On the Waterfront* as a staged reading in 1991. "He had written the story and the movie and now was refining the play. I arranged it as sort of 'story theater.' I had someone reading the stage directions leading into the play's action, during which the actors would 'freeze' their positions. Budd Schulberg liked what we did so much that he wrote the 'story' part into the script. Our budget? A mere $1500. It costs so much less than mounting a full production."

Patton was proud of her full-blown production of a new concept for *Moving Targets* by Pintauro in 1988. "Bill King, the East Hampton sculptor, made wonderful props, and the artist Connie Fox did the costumes," she recalls. "It was a way of bringing the whole artistic community together creatively." The *Southampton Press* reviewer, Lee Davis, wrote: "Guild Hall had the imagination [and] foresight, as this area's only regional theater, to fulfill its truest calling—and present a new and therefore dangerous theater work. It was one of those treasurable theatrical moments when a multiplicity of extraordinary talents satisfyingly converged."

But everything was not a premiere under Patton. There was, for example, A. R. Gurney's *Love Letters*, presented in the summer of 1990.

Cliff Robertson tells how it came about:

"I had been playing it on Broadway with Elaine Stritch. The John Drew asked me for suggestions for their 1990 summer season, and I offered to do *Love Letters*. It had only two characters, no scenery, ideal for the theater. I played for 'minimum' for a two-week run. It just happened to work out right time-wise for me. Elaine was only available for the first week, so for the second I suggested Anne Jackson. Fortunately, she was available. I had worked with her eons ago in summer stock; in fact it was my very first summer in stock. Elaine's and Anne's performances were quite different, but they're both wonderful actresses. I didn't have to adjust to them; they adjusted to me. . . ." Stritch had played one of her first acting roles at the John Drew with Bella Lugosi in *Dracula* in 1947. Jackson has a home in East Hampton and is motivated, like Robertson, to help her hometown theater. "We all want to help Guild Hall and its theater," says Robertson. "I'll always help—on- or offstage."

At the end of the sixth decade, "summer theater" has evolved into a blend of all the performing arts. There are those who say it better reflects the tastes of its diverse audiences; there are others who long for a return of the traditional eight-week season of fully-mounted plays and musicals typical of the John Drew throughout most of its history.

Kelly Patton (second from right), director of *Moving Targets* (1988); with some of the East End talent involved in the production: Dr. Robert Shaughnessy, composer of the incidental music; Joseph Pintauro, the author; Connie Fox and William King, artists who created the sets and props.

RAMESHWAR DAS © 1988

The playbill for *Love Letters* starring Cliff Robertson, Elaine Stritch and Anne Jackson (1990).

Shakespeare's Ladies, a special benefit presented in 1966. Philip Burton, director and narrator; Dina Merrill, Joan Alexander, Lee Remick.

SPECIALS FOR "DARK" NIGHTS

Sunday night, the one night of the week during a normal summer theater season when the actors aren't performing onstage, has traditionally been our "dark" night. Ever since the early '30s, these nights have often been given over to Specials, usually benefits for Guild Hall. With their air of spontaneity and the wide range of talented people who participated, these Specials have often been the most memorable events of their season.

Take, for instance, the glorious night in the summer of 1974 when some of Broadway's most distinguished composers and performers, who came from as far away as London and Las Vegas, turned up on our stage to honor their friend, the lyricist Dorothy Fields.

As Cy Coleman explained it, a group of Fields' friends who had often gathered in Bridgehampton to celebrate her birthday came up with an idea for the perfect memorial: a show, taking place on what would have been her sixty-ninth birthday, a few months after her death, celebrating her great contribution to the American theater, and benefitting one of her favorite charities—Guild Hall and its John Drew Theater.

Kermit Bloomgarden and Cy Coleman produced the show, Cy Feurer directed it, Barbara Fried adapted the script and the performers were stellar: Gwen Verdon (after Fields, "the hit of the evening," Theodore Strongin proclaimed in his review in the *Star*), Richard Kiley, Donna McKechnie, Joshua Logan, Sheldon and Margery Harnick, Maureen Stapleton, Colleen Dewhurst. . . . As the curtain opened, the audience saw a line-up of four small, upright pianos and behind them the composers Cy Coleman, Burton Lane, Arthur Schwartz and Albert Hague. They began playing and singing the songs they'd written with Fields, from *Sweet Charity*, *Red Head*, *A Tree Grows in Brooklyn*, also including such long-time favorites as "Sunny Side of the Street" and "I'm in the Mood for Love."

JAY HOOPS

Sheldon Harnick and his wife, Margery Gray,
performed in several Specials
through the years.

JAY HOOPS

Cy Coleman, composer;
Dorothy Fields, lyricist;
with Joseph Weinstein, who hosted a party
after *An Evening with Dorothy Fields* (1971).

Sheldon Harnick, the lyricist for *Fiorello* and *Fiddler on the Roof*, remembers it all with pleasure. "I was supposed to sing 'The Cuban Love Song,'" he recalls now. "During rehearsal, as a joke, while singing it I took out a cigar, lit it and puffed on it during the rests. The scattered rehearsal audience liked my joke so much that Cy Feurer asked me to leave it in. . . . Also, I got to sing a duet with Colleen Dewhurst; I'm a great admirer of her work. What made it so amusing was that Colleen sounded as though she were singing in a bass range a full octave below me!"

Joseph (Joe) Weinstein, a member of our board, and his wife, Bobbi, were the conduit to much of the exceptional talent that inspired many of the Specials that took place in the '70s and '80s. They were, as Anne Jackson put it, "angels of the theater—wonderful people. They knew everyone and nobody could say no to their requests." And after most of the shows, they hosted big, informal get-togethers at their home, often with Coleman at their piano, surrounded by the stars and the guests joining in the singing. "There's never been anything like them," said Wilson Stone, who during those years served as chairman for the Specials. He, too, had a wide acquaintanceship in the world of musical theater, which he often tapped for those occasions.

The first Sunday Special dates back to 1932 when Jack Harkrider presented a series called Twilight Concerts, variety shows with such Broadway performers as Hal LeRoy, dancing sensation of the Ziegfeld Follies of 1931; Johnny Green, composer of *Body and Soul*; Fray and Braggiotti, duo pianists playing a Gershwin rhapsody; and Helen Morgan seated on the baby grand, singing her trademark "My Bill."

Among the special entertainments Mrs. Woodhouse hosted throughout the '30s was a lavish spread for the cast of *New Faces* at her Elizabethan playhouse after they appeared in the John Drew as a benefit for Guild Hall in 1934. Her friend Dorothy Quick Mayer had arranged with Leonard Sillman to bring the entire cast out from New York on their own "dark night." Imogene Coca, Henry Fonda, James Shelton and Sillman himself were among the *Faces*, and at the party afterward some of them sang to accompaniment on Mrs. Woodhouse's Skinner-Aeolian organ.

Lawrence (Larry) Baker usually had a hand in the string of informal variety shows, all professional, that took place in the '50s. "Much of that talent," Baker recalls, "came out of the Stage Managers' Club talent shows in New York with which I was connected. They were done to showcase promising new talent. Bob Fosse's choreographic ability was discovered in one of the shows; in fact, he did the choreography for "Dancer's Dilemma" in our *Headliners of '52* revue at the John Drew, with Phil Barry helping out on that one. Robert Montgomery was M.C. for those benefits."

Elaine Stritch, who became Baker's close friend and a frequent visitor to his East Hampton home, was in the 1953 revue. Baker remembers spotting her potential as a musical star when she was playing at the

John Drew back in the 1946 season: "At a cast party at our house, Erik Rhodes, one of the actors in the company, started playing the piano and Elaine sang some songs from *Oklahoma*. My mouth dropped open. I thought, 'She's not only a helluva good actress but she can really sell a song!' So the following year, when we were going to do a revue, *The Shape of Things*, out here, I recommended Stritch. They auditioned her, thought she was great. She was a smash hit. The producers Marjorie and Sherman Ewing, who were readying *Angel in the Wings*, a show starring the Hartmans for the following Broadway season, happened to be in the audience. They liked her so much they gave her a song, 'Civilization,' in it—and that's how she got into musicals."

The writer James Kirkwood, best known for *A Chorus Line*, was, according to Baker, another alumnus of the Stage Managers' shows who appeared in our theater in the 1953 *Gaieties*. Kirkwood later said, "I remember the first time I came to East Hampton; it was because of the John Drew Theater. I was working with a partner named Lee Goodman in night clubs in New York, and we were asked to come out here to do a benefit. So we hopped on the train and came on out. Well, I thought we had reached heaven, because at the time I was living in a cold-water flat in Hell's Kitchen. Five rooms, $28 a month. The toilet that you shared with the next apartment was in the hall and the bathtub was in the kitchen. So here I was in East Hampton, and not only that, I was asked to have dinner at Robert Montgomery's house—he was the M.C. for the show. Well, I mean I thought that was the end. . . . I thought if I ever make it, or even half make it, I'm going to buy a place and live here. It was like a magnet—still is; every time I come down that hill toward Town Pond, I just get a big thrill. So I finally bought a house here, even though I couldn't afford it. . . ."[9]

There has always been an unpredictable anything-can-happen excitement to the Specials, with each one coming alive in its own way. The composing team of Jerry Ross and Dick Adler turned up at the John Drew in the 1953 Special, for example, in a preview of compositions they had written for *John Murray Anderson's Almanac*, due on Broadway that fall. Baker remembers, too, other Specials in those years, with Swen Swenson, Dennis King, Jr., Kay Medford, opera star Jarmila Novotna and Kent Smith.

Later, in the '70s and '80s, when Wilson Stone was chairman of Specials, there were the Sunday evenings with Composers/Lyricists, featuring Charles Strouse, Burton Lane, Dorothy Fields, Sheldon Harnick, Sammy Cahn, Harold Rome—and the star-laden 1975 spectacular *Cy Coleman and Friends*.

Carolyn Tyson, a patron of the arts and personal friend of the poet Robinson Jeffers, sponsored in 1963 an excellent Special of his play *The Cretan Woman*. It starred Marian Seldes and was directed by Peter Turgeon, with area residents Gloria Nouri and Conrad Bain in supporting roles.

Sammy Cahn in *Words and Music* (1974).

Carolyn Tyson, sponsor of *The Cretan Woman* (1963).

Emily Cobb and Peter Turgeon
in *An Evening of Thurber* (1977),
one of several Thurber Specials
arranged by Turgeon.

The legendary Libby Holman
with musical arranger–accompanist Gerald
Cook in *Blues nd Ballads* (1967).

Turgeon has always felt warmly toward the John Drew, staging or acting in many of our benefits. His expertise on Thurber prompted several staged readings of the author's works. "I was in the original production of *Thurber Carnival* in 1960," he said recently, "which, to my amazement, turned into an enormous hit. I gave it three days, which shows you, I can't guess right, never could. I once turned down a part in *Death of a Salesman*, the original, because I thought it would never get out of Philadelphia."

Another of Turgeon's Specials was his one-man show *Charlie Chaplin: An Illustrated Memoir*. He's presented it twice at the John Drew, and at colleges and theaters all around the country. "I knew Chaplin when I was a young man," he recalls, "in the summer of 1942. The whole middle part of the show is slides from the pictures I took with a little box Brownie. It always works beautifully. There's been a real revival of interest in Chaplin—and I'm amazed at how young people respond to it."

When Libby Holman, the great torch singer of the golden era of musical comedy, presented a program in 1964 as a benefit for Guild Hall, she was married to the artist Louis Schanker and lived in a contemporary house on the beach. Spectacularly stylish and offbeat, she was also deeply involved with the cause of civil rights and loved singing "work" songs and other Black American music; *Blues, Ballads and Sin Songs* was her program entry. But audiences loved her best when she was singing the old familiars, and they weren't satisfied until she returned for encore after encore of requests, songs she'd made famous in the '20s and '30s, like "Moanin' Low" and "Body and Soul."

The superb Wallach-Jackson acting couple could always be counted on to give their talents for a Special. Memorable was *Bits and Pieces* (1970) in which they performed Calder Willingham's one-act comedy *How Tall Is Toscanini?*

Christophe deMenil provided another provocative Special in the summer of 1978, by sponsoring a performance of Robert Wilson's *Deafman's Glance*. One of the most innovative figures in the theater world, Wilson was nevertheless an enigma to many in our audience. Theodore Strongin, always pleased to see the John Drew dip into something new, approved of the experiment in his *Star* review, referring to it as "potent abstraction . . . exciting stage craft."

The most frequent Specials performer has been Carlos Montoya, the celebrated flamenco guitarist, who has played at Guild Hall more than twenty times since his first appearance in 1945, when his wife, Sally, danced to his guitar accompaniment. At that time, solo flamenco guitar was almost unheard of, yet Montoya would go on to play hundreds of concerts a year worldwide. Even so, he always found time for benefit concerts—sellouts all—at Guild Hall and also honored us with two of his premieres, "La Virgen de la Marcarena" and "Zambrilla." In 1989, at age eighty-six, and in poor health, he made a touching farewell appearance.

Tom Paxton, the renowned folk singer and recording artist, has been—and still is—another of our most generous performers, having appeared on our stage in a dozen or so concerts since he and his family moved to East Hampton in 1968. As with Montoya, his Guild Hall concerts have taken on the aura of a ritual. A particular quiet settles over the audience when he takes center stage; he has something important to sing about, and nobody wants to miss his message. "There's an absence of malice in his lyrics," wrote Alan Kayes in the *Star*, reviewing his 1981 performance, ". . . yet he wields a surgical scalpel with exquisite skill in his songs of social and political protest. . . ."

Where Montoya describes a "family" closeness in his feelings about his local cultural center, Paxton is more pragmatic, seeing us as a responsibility of the community as a whole. "We shouldn't just have something like Guild Hall handed to us on a platter," he says. "It's up to us, and it ought to be up to us, to keep it going." He believes it's healthy that Guild Hall wasn't endowed at the start, that we've had to struggle financially. "I admired the philosophy behind the Carnegie libraries," he says. "Andrew Carnegie said he'd build the libraries but the communities had to put the books in. He did it so that the people would feel involved. . . . Guild Hall is never going to have it easy. When that happens it's on its way to dying as an institution."

JOHN REED
Carlos Montoya, flamenco guitarist and frequent performer at the John Drew, accepting a rose from an admirer in the audience (1965).

GH ARCHIVES
Tom Paxton, folk singer–recording artist, has given his services for several benefits for Guild Hall.

Guild Hall Players production of *Life with Father* (1954). Standing: Miles Anderson, Anita Anderson, Ronnie Palmer, William Stowell, William Whyte.

eated: Kenneth Anderson.

COMMUNITY THEATER

Frank Dayton, a member of one of East Hampton's oldest families, still remembers Guild Hall's earliest days, when all of East Hampton was watching to see what this new cultural center would become. When our earliest community theater group, the Guild Hall Players, was formed in 1931, he signed up right away: "Betty Edwards started it," he remembers. "She called a few of us together and said that there was this beautiful new theater—didn't we think we should form some sort of dramatic club? Somebody wanted to know how often we should put on shows, and somebody else thought about three a month. Can you believe it? We found out we'd be lucky if we could put on three a year!"

Dayton recalls the thrill of building make-believe worlds to put on the stage of the John Drew during the lean years of the Depression when everybody had nothing but time on their hands. "The Players became the center of our lives. We used to stay there 'til two or three in the morning, building scenery. Oh, and it was such fun getting together at someone's house to read over our parts in a play for the first time. . . ."

"I remember Jack Devereaux," he continues, "who offered to be our first real director; he was married to John Drew's daughter Louise. He had a wonderful sense of humor, always telling us stories about his days in stock theater. Smoked constantly, Lord Salisbury's. He'd saunter up and down the center aisle, giving us directions, and occasionally would jump up on the stage and show us how *he* would do the scene. We thought the world of him."

Devereaux piloted the Players through some fine, polished productions, among them, *In Old Missouri*, by Augustus Thomas, a well known playwright, who then had a home in East Hampton's Georgica Woods.

The excitement of the new theater also attracted Ruth Moran, the painter Thomas Moran's daughter, who had an abiding love for great theater, matched by her love for great literature. A portly woman with a full, chesty voice, she'd often present readings from the classics, mostly Shakespeare, at the Players' workshop evenings.

Warren Whipple's poster
drawing of Frank Dayton as
Scrooge in the Players' production
of *A Christmas Carol* (1947).

Cast members of the Players'
production of *Good News* (1951):
Arthur Palmer, Pat McElroy (at the wheel),
James Reutershan, Pat Lester,
Richard Morrisey, Olive Clark.

Dayton remembers, too, that she liked to direct. Her first venture was a Guild Hall Players' production of *Romeo and Juliet*, complete with whatever Shakespearean get-ups the Players could assemble—an ambitious project, to say the least, for the fledgling troupe.

"We weren't exactly the best material for Shakespearean actors," he says now. "But she'd get us over there to the Moran studio—Darryl Parsons, Carl Reutershan—and give us elocution lessons, teach us how to make sweeping bows and all that. I was all right until the night of the show. She put me in some skin-tight pants that made me look like a skeleton, and got hold of an opera cape from somewhere. I was feeling pretty much like a real Shakespearean character as I got ready to make my entrance, when all of a sudden my wife, Jean, appeared, took one look at me and burst out laughing. With my skinny legs, I was so self-conscious that I wrapped the cape around me tight as I could to cover up the pants and made my embarrassed entrance. I think I ruined the act."

Besides being adept at set building, Dayton was an instinctive actor and played character parts in many plays over a period of some thirty years. His favorite role was that of Scrooge in Dickens' *A Christmas Carol*, in which Louis Edwards also made a perfect Bob Cratchit, and Ken Stowell, who taught music at the high school, composed a moody chant for Marley's ghost. Eastern Long Island accent notwithstanding, all the townsfolk agreed that Dayton made a better Scrooge than Lionel Barrymore.

Kenneth Anderson, a Sag Harbor attorney, and his wife, Anita, were prominent members of the Players throughout most of the forty-five years of its history. Both acted, and he directed as well. Anita made a lasting impression in *Mrs. Moonlight*, a play about an ethereal woman who never grows old. To this day, she remembers the borrowed Worth ballgown she wore.

Much later, Anderson directed himself playing the lead in *Life with Father*, while his wife played Mother and their young son, Miles, played one of the boys.

In those days, Anita recalls now, "We were in love with theater and went to all the summer plays. But the last time Ken and I went to the John Drew, everybody was in jeans and old sneakers. We couldn't help thinking of the old days when Mrs. Woodhouse and her friends were around. It was black tie and long evening gowns. Very gala—and very different from today."

Through the years of World War II, the Players earned a reputation for the shows they took weekly to bases and hospitals the length of Long Island, even making one appearance at the famous Stage Door Canteen in New York City. The best of these entertainments were eventually combined and presented in the John Drew in a grand, end-of-the-War finale under the title *Dear Mom*, based on letters the G.I.s wrote in thanks to the Players. After a performance at Camp Upton, Sgt. Milton Wine-

berg wrote: "I've been in this hospital almost four months and I've never seen anything like tonight's show. U.S.O., with their professionals, couldn't hold a candle to this bunch. . . ."

Another major triumph for the Players was the spectacular historical cavalcade on the village green in 1948 in commemoration of the 300th anniversary of the founding of East Hampton. It involved a year of research, a cast of more than 300 people, not to mention the livestock—horses, sheep, pigs, geese. Much of the action took place around the historic buildings overlooking the green, Home Sweet Home, the Mulford Farm, the old mill. Captain E. J. Edwards, the last of the offshore whalers, and some of his original crew brought their fully equipped boat out onto the green and carried out the ritual maneuvers used in catching a whale.

There were perhaps a dozen different directors during the history of the Players, including Joseph (Joe) Luciano, who discovered East Hampton and the drama club when he was stationed at the air base at Montauk. First thing he did was to bring an all–G.I. revue to the theater, as a benefit for Guild Hall. Next thing he knew he had the comedy lead in the musical *Oh Kay!* Although he left town briefly after his service at Montauk, he couldn't get the place out of his mind and returned with his bride, Gayle, to become a permanent member of the community. Among the plays and musicals he directed were *Mr. Roberts, Stalag 17* and a rousing production of *Guys and Dolls.*

"The sets for *Guys and Dolls* were marvelous," Luciano remembers. "Gabe Avalone and Frank Bologna did them and they got an ovation when the curtain opened. Charlotte Markowitz knocked them dead as Adelaide, and Jim Strong's Barbershoppers were great in '. . . Rockin' the Boat.' We did a repeat as a benefit and raised $5000 for Guild Hall."

By all accounts, the Players were one big happy family in those days. Luciano remembers that, after rehearsals, everyone would congregate across the street at Jack Williams' 1770 House in the Cupboard Room, actually the old cellar kitchen with its big bake-oven fireplace, in which Williams would have a blazing fire on cold nights. Williams himself was enticed into playing some roles with the Players, and never tired of telling about the hard time he had learning his lines for *Dear Ruth.* It was cause for celebration when he made it through the final performance without being prompted.

Trevor Kelsall, another longtime thespian, also remembers the good times: "We formed lifelong friendships, and you felt good about giving pleasure to the community." He recollects directing Moliere's *The Physician in Spite of Himself,* in which Nell Robinson played the wife. As he tells it, "She was an old English actress, known up and down Main Street for her eccentric dress. She figured she was a cut above the amateurs. She ended up by taking on part of the directing herself. As I was a bachelor, she took great delight in explaining to me the subtleties of the husband-wife relationship. Sexual politics was not part of my expertise."

Charter members of Guild Hall Players (formed in 1931) shown here in 1951. Seated: Evelyn Bradford, Jean Dayton, Betty Edwards, Louise Barnes. Standing: Donald Gould, Otis Barnes, Frank Dayton, Clifford Edwards.

EUNICE TELFER JUCKETT
William Costin and Louise Orlando, leading performers in the Players' production of Gershwin's *Oh Kay!* (1956).

Eddie Borkman at the John Drew lightboard with Allen Vail, his assistant (c. 1948).

Christian Johnson and Irene Kerzner in *Count Dracula*, presented by Maidstone Regional Theater (1979).

Carleton Kelsey, librarian at the Amagansett Library, appeared in almost forty of the Players' shows. "As a young man, I wanted to go into theater as a profession, but couldn't afford to take the risks," he says today. "I now realize that through volunteer acting, I've enjoyed all the pleasures of the profession without the financial heartaches." Now in his late seventies, Kelsey is still active in community theater.

For years, the eccentric Eddie Borkman served as electrician for the Players, and in the group he found his family. Known affectionately as "High Pockets," he was so tall he had to bend over to go through a normal doorway. He was also unfailingly generous with his time, and with his spotlights, which he'd pick up here and there and install gratis for use by the Players. (He was also touchy, however, and if something didn't please him, he would threaten to pick up his lights and go home.)

As lighting technician, he had one firm demand: that a pretty girl be enlisted for each production to give him his light cues—and this was a desirable post, as he'd give her a box of chocolates on opening night.

Borkman lived alone, and his only social life was with the Players. He took great pleasure in the cast parties, but always remained a little to the side. When he died, he left everything he had, including his small house, to Guild Hall and the Players. The estate amounted to $12,000. The Players presented a play in his memory, and Guild Hall, appropriately enough, bought a new stage lightboard—known from then on as "Eddie's Light Board."

There were many more high points for the Players—notably the ambitious 1971 production of Brecht's *Three Penny Opera*, directed by William (Bill) Sturges, which ran during the troupe's 40th-anniversary year. It was a sad day when the Players decided to disband in 1976, after 45 years of a mutually happy relationship between these actors and their audience. Their last production was Tennessee Williams' *Cat On a Hot Tin Roof*, directed by Willis Gould.

Richard LaFrance and his Maidstone Regional Theater, who had been performing at the Bridgehampton Community Center, stepped in to fill the vacancy, remaining through 1979.

LaFrance, utilizing some of the former Players, was an effective producer-manager. Barbara Johnson, a loyal member of the group, and George Caldwell played the leads in Maidstone's first production, *Dial M for Murder*, an auspicious start for the acting group. "But the real jewel under LaFrance," says Johnson, "was the musical *Oliver*, directed by Bill Sturges. "It was really a marvelous production. There were thirty children to play Fagin's gang, drawn from Westhampton all the way out to Montauk. It was community theater at its best. The whole town turned out for it." Among their other presentations were *Table Manners*, directed by Willis Gould and *The Little Foxes*, directed by John Albano.

Stage manager Chester Hartwell still shudders at the memory of Maidstone's 1979 production of *Count Dracula*, which was also directed by Gould. "In the final act," he says, "carbon dioxide fog was to come out of Chris Johnson's (Dracula's) coffin, and someone forgot to put the breathing tube into the coffin. Johnson, nearly blue from breathing carbon dioxide throughout the act, had to be propped up for his curtain call."

"Everyone said we'd never make it. Five women running a theater company? Can you imagine the in-fighting? But they were wrong," says Irene (Deede) Windust who, with Vaughan Allentuck, Margaret (Meg) Gage, Valerie Austin and Katie Meckert formed Community Theater Company (CTC) in 1983. Windust and Allentuck came with professional backgrounds, and the others with talent and a spirit of collaboration. As a board, unhampered by the often divisive directives of a membership organization, they've built a solid core of support for their series of four productions each year. "None of us ever felt motivated to outshine the others," Windust says. "We set our goals and stuck to them: no experiments, just good solid revivals." Except for a few additions to fill vacancies as they occurred, three of the original founders, Windust, Allentuck and Gage, are still the guiding lights.

The production directors are all professionals—Barbara Bolton, Kelly Patton and Serena Seacat. In contrast to the old days, there's a plethora of talent available which, together with the top-notch directing, results in first-rate productions. *Steel Magnolias*, *Gas Light*, *Ah Wilderness* and such big-scale musicals as *Oklahoma* and *Guys and Dolls* are among the troupe's well received highlights.

"At first we'd get only a handful for tryouts," Windust remembers, "but now we're getting as many as fifty auditioning, and some of them come from all the way down the Island." Still, casting hasn't always been easy. For *Peg o' My Heart*, the lead moved out of town at the last minute and Kelly Patton, the director, recast a talented Israeli girl, Orly Klausner, in the part. Patton had her hands full, making Orly believable in the part. "But," says Windust, "it worked."

Although they do not have a set company, CTC works with a core of old faithfuls—but always welcomes new talent. Robert Blaisdell and his wife, Barbara, have been with the group from the start, and recently their teenage daughter who, as a child of six, sat in the back of the theater watching her parents rehearse, appeared with her mother in *Kiss Me Kate*.

Some of CTC's admirers think the company could well be a solution to the needs of summer theater at the John Drew. Windust is against it. "We're in this for the pure joy of producing theater for the year-round community. Let's leave it that way."

Board of Community Theater Company (CTC) (1986). Standing: Margaret (Meg) Gage, Irene (Deede) Windust, Vaughan Allentuck. Seated: Charlotte Markowitz, Victoria Vega.

"Luck Be a Lady Tonight," the crap game scene from CTC's production of *Guys and Dolls* (1990).

Frank Borth's caricature of Hugh King and Mary Johnson in the CTC production of *Arsenic and Old Lace* (1986).

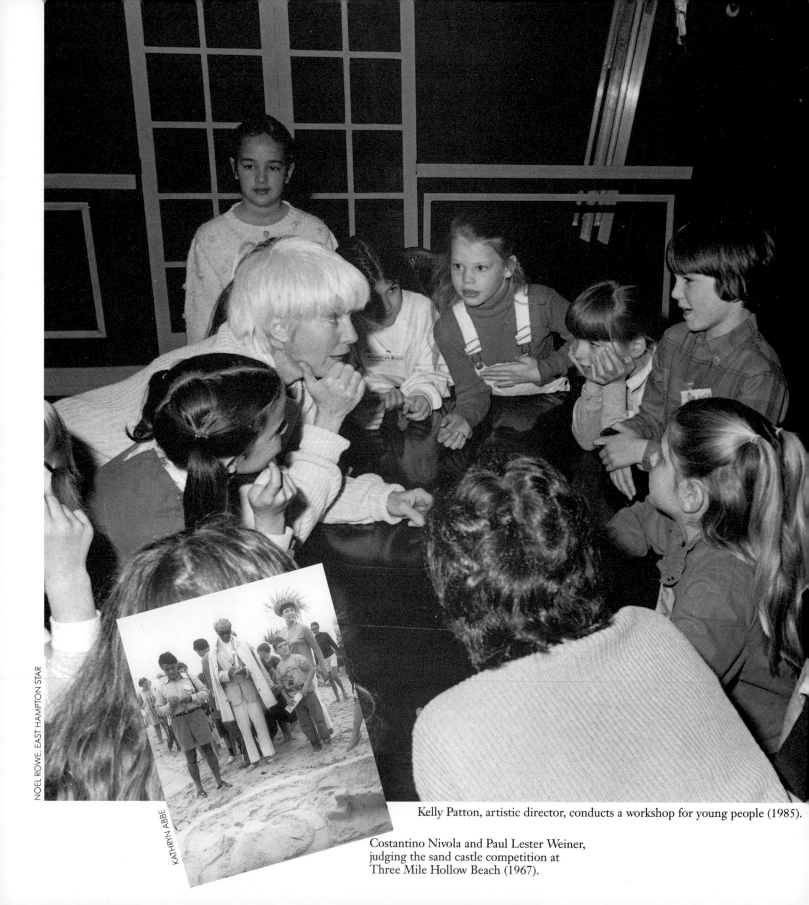

Kelly Patton, artistic director, conducts a workshop for young people (1985).

Costantino Nivola and Paul Lester Weiner,
judging the sand castle competition at
Three Mile Hollow Beach (1967).

THEATER
FOR YOUNG PEOPLE

The "nimble ghosts" inhabiting a theater to which Brendan Gill likes to refer would have had to be particularly agile at our children's theater presentations. Snakes, llamas, bears, monkeys and tigers have been among our live "performers," appearing in such offerings as *Straw Hat Circus of 1956* and *Snakes Alive*, when Carl Caulfield, director of the Staten Island Zoo, brought to us an alarming variety of serpents. Kids loved it, as presumably did Gill's ghosts.

Several generations into Guild Hall's history, parents are now bringing their children, and grandparents their grandchildren, to enjoy the perennial favorites they themselves saw at the John Drew.

Perhaps the most fondly remembered is Larry Berthelson's Pickwick Puppets, who have been brought back time and again. These are not ordinary puppets. They're "rod" puppets, four- to six-feet tall and so skillfully manipulated, so magnificently costumed that to audiences of *all* ages they seem almost preternaturally lifelike. Favorites in Berthelson's repertoire over the years included *The Mikado* and *Cinderella*.

Our children's shows were traditionally run by committees of parents and teachers—Tillie Delehanty, Judy Ackerman and many others. Anne Roarick, one of the chairmen, recalls that, "During the '60s and '70s (before the women were all out working), we had some wonderfully dedicated leaders in Janet Grossman, Lorelle Fallon, Joan Strong, Virginia York. We would book series combining plays and movies; the movies usually carried us financially so that we could afford higher priced plays. We made all our posters by hand. They were beautiful.

"We used to put the kids in the car and go out with the posters, talking to teachers and principals, selling tickets, getting people excited. That way we almost always had a full house. One of the most popular was *Mr. Jiggs: The World's Smartest Chimp*, who rode a motorcycle, shot cap pistols and took Polaroid pictures of the kids. We also did pet shows and, best of all, the sand castle–building competitions that Janet Grossman organized. The kids really loved those, and we had great judges like Alfonso Ossorio and Costantino Nivola. . . ."

Backstage after a performance of
Larry Berthelson's Pickwick Puppet Theater (1966):
Kate Mund, Sarah Vetault, Tracy Trenton,
Rosemary Cavagnaro, Robin Vetault.

JAY HOOPS

Jack Hannibal and Mark Johnson in the
Young People's Theater Workshop production
of *Broadway × 6* (1982).

As the years went on, the shows reflected children's changing tastes. There were fewer *Pinocchio*s and *Robin Hood*s. Instead, we presented *Petey and the Pogo Stick: The World's First Pogonaut* (who invents an atomic motor for his pogo stick), or *Geminima*, about, of all things, a space-age Cinderella. To answer the question once and for all, we once took children on an expedition under the sidewalks of Manhattan in a show called *Are There Alligators in the Sewers of the City of New York?* Another time, kids (and their parents) were treated to a mixed media show, *Dinosaurs, Puppets and Picasso*. Outstanding, too, was the Little Theater of the Deaf, with classic fairy tales told in beautiful visual language. For sheer ingenuity, nothing could top the Paper Bag Players, a company, sponsored at Guild Hall by Joanna Rose, that uses paper bags, boxes and the like to create characters and stages effects.

For young people, the most rewarding experience is being up on the stage themselves. They had their first chance at the John Drew in the mid-40s, when Nell Robinson imparted her stern British dramatic training to her Junior Drama and Reading Circle in the *Mad Tea Party* and *Pigs and Peppers* and, later, in the theater apprentice showcases. Many took place in the '60s when Constance Loux, one of the John Drew directors, was turning out about three shows a summer. Talented young people like Pam Bates, Pat Helier, Miles Anderson and John Osborne appeared in, among other productions, *Heidi*, *Red Shoes* and *Our Hearts Were Young and Gay* from the book by Cornelia Otis Skinner and Emily Kimbrough. Many children, now adults, also remember the poet and artist Rose Ignatow, whose imaginative approach to puppetry in the late '60s resulted in some magical productions with scripts written by the children themselves.

Memorable among acting workshops in the '70s were those that came through the O'Neill Theater Center in Waterford, Connecticut, about which Barbara Bologna, an English teacher from the local high school, wrote us in 1973: "The atmosphere at school was electric with excitement as students dashed from one theater workshop to another, eager to get in before the classes were filled up. It was the kind of day students and teachers will remember for a long time. And it all happened because the actors were here under the auspices of Guild Hall."

Unquestionably the most inventive work done with teenagers was in Lelia Katayen's Multimedia Experimental Youth Theater in the early '70s. Katayen, a modern dancer and choreographer, was assisted by her husband, avant garde photographer and filmmaker Val Telberg.

Using "open theater technique," Katayen guided the students in improvisations melding modern dance and acting, complemented by striking lighting, slide projections, unusual props and electronic music. After a year of experimenting through the workshops, the troupe produced *Versions* incorporating the best of their free-form creations. Funded by the New York State Council on the Arts, they toured high school auditoriums on Long Island as far west as Mineola.

One enthusiastic member of the company, Bruce Bromley, III, says, "The Multimedia Theater's confluence of the visual arts, music and dance reaffirmed my belief in a unity of structure which underlies all the arts. . . . My involvement pushed me out into the world. I have become a painter/writer/composer. . . . A play of mine, *Sound for Three Voices*, was performed at the 1986 Edinburgh Theater Festival by the Oxford Theater Group. . . ."

Following a more traditional approach, the Young People's Theater Workshop was founded in 1978 by Wilson Stone "to fill a gap," he says, "left when the East Hampton schools were on an austerity budget and had to cancel all dramatics." This much-appreciated community project brought together an enthusiastic and talented band of teenage thespians in such tried and true musicals and plays as *The Boyfriend*, *Our Town* and *Fiddler on the Roof*. Jack Graves wrote in the *Star*: "I'm here to tell you that as of Monday morning I'm still stunned. The YPTW performance of 'Fiddler' (directed by Scott Banfield) was astounding, incredible, unbelievable. Really, words cannot describe how good it was."

Tony Stimac, artistic director for the John Drew at the time, also directed some of the productions, notably *Speaking of Shakespeare* in 1981, with the young actors presenting scenes from the bard's plays and their contemporary counterparts—*Romeo and Juliet* with *West Side Story*, and *The Taming of the Shrew* with *Kiss Me Kate*.

Folk singer Tom Paxton looks back to the YPTW days with fond memories: "My children had a wonderful time at those workshops," he says, "with the Rattray kids and the Hannibal kids. My daughter Kate was one of the daughters in *Fiddler*, and later had to step in and take over the role of Emily in *Our Town*, which was a tremendous experience for her." As of 1991, he added that as her graduation present from college, she was given a chance to attend a summer theater workshop. "From her days in the Guild Hall workshops, she decided she would very much like to go into the theater."

Kelly Patton brought her special brand of creative children's theater—and sensitivity to the times—to the John Drew in the late '80s. "Children adore Kelly Patton and it's a mutual admiration," the *Sag Harbor Herald* wrote in acclaim. "She has the attraction of a modern day Pied Piper. She likes to deal with universal issues in her productions."

She did just that in 1988, in her Children of Dickens project, casting numerous local children along with professionals in the Israel Horovitz version of *A Christmas Carol*. "To bring out the point that what's going on today with the poor and homeless is comparable to Dickens' time," she said, "I had those children do a street scene on the homeless. They organized it, picked up money in the street and gave it to I. Cross, a group that helps the homeless. The children did it all, even to getting a permit from the Village to perform on the street. It was an experience they'll never forget."

PHILIPPE MONTANT
Judy Ackerman, chairman; Diane Braun and June Beckwith of the Children's Activities Committee, putting up posters for *Tom Jones* (1970).

GERRY GOODSTEIN
The Paper Bag Players in *No Problems* (1989).

179

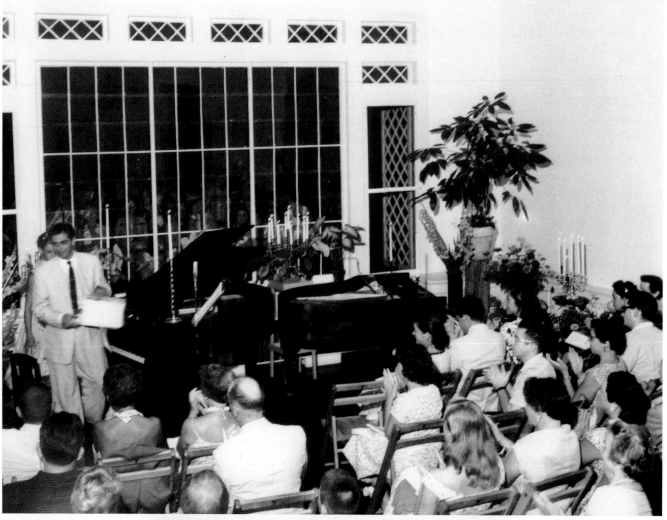

Norman Dello Joio, composer, at a Guild Hall concert at The Creeks (1955).

The audience enjoying refreshments on the terrace overlooking Georgica Pond.

MUSIC

After an initial spurt during the early 1930s when Victor Harris, a composer and resident of East Hampton, introduced some fine chamber groups, the Depression and the War precluded much in the way of live music at Guild Hall. Yet there were many musical evenings, perhaps all the more pleasant for their informal quality and the way they commanded anyone who wasn't tone deaf to become involved.

Early on, for example, Mrs. Woodhouse often lent her Victrola for music appreciation evenings in front of the fire in the Moran Gallery. There were some fine record collections among our residents. Kenneth Stowell, music director at the high school, conducted the programs, using his own considerable collection and occasionally inviting guest speakers to bring *their* collections—Berton Rouché on the

evolution of New Orleans jazz, Alan York with Haydn's "Lord Nelson," Evans Clark with his unique South American music and Francis Markoe with opera excerpts. These musical meetings took place three times a month over a period of several years.

Once, as a change of pace, Markoe, an elegant bachelor who lived in an exotic Oriental-style house near Southampton, invited everyone over to his place for an evening of music. It was St. Patrick's day, and the host was zealous in carrying out the theme—a buffet supper including green mashed potatoes, green gelatin salad, pistachio ice-cream and a cake with green icing. No one seems to remember how the lady soloist integrated "The Wearin' o' the Green" into her classical repertoire.

Joan Brill Kallmeyer, an accomplished pianist, moved to East Hampton in 1951, shortly after graduating from Juilliard and marrying Robert (Bob) Brill, proprietor of a local clothing store. She was drawn to Guild Hall and the Music Club almost at once, and remembers: "Bob's mother's warned me, 'You don't want to go there. Only the 400s go there.' 'What's the 400s?' 'The *rich*!' But I was a rebel and wouldn't take her advice. I went to Guild Hall anyhow. I suggested that they might like some live music, and said that Juilliard students would be thrilled to come out to play. I ended up being program chairman for the next twenty years."

Brill, who continued to study piano under Leonid Hambro and others, gave many recitals herself and later, with William and Judith Gaffney, formed the Brill-Gaffney Trio, which became well known throughout Long Island. "At Guild Hall, we tried to involve the community," she says, "inviting local singing groups and soloists to perform, and featuring student musicians from the schools." Philip Markowitz was one such young man who later became a composer and recording artist.

During the years Brill was active, the committees were headed at various times by Tsuya Matsuki, Harry Allaire and others, and among the musicians we presented were concert artist Jan de Gaetani, June Kelly of the Phildelphia Opera, duo-pianists Gold and Fizdale and the Kohon String Quartet.

Musical dramatizations were another specialty. One, in 1955, had a cast of forty talented residents and depicted episodes in the life of Mozart, under the direction of Harry Allaire. In 1966, the committee produced Menotti's *The Telephone*. That same year, Dr. Robert Shaughnessy presented Bach's Christmas Oratorio with the South Fork Orchestra.

Most memorable, perhaps, were the Guild Hall concerts held at The Creeks.

These took place during the three summers between 1955–57, and were arranged by Ted Dragon, a member of the Music Committee. Formerly the famous Herter estate, The Creeks, situated on Georgica Pond, had been bought by the artist Alfonso Ossorio, Dragon's companion, in

DAVE EDWARDES
Anne Wolf at the piano before her Chopin lecture-recital. With her, members of the Music Club: John F. Williams; Sybil Mulford; Kenneth Stowell, club director; and Margaret Nugent (1947).

The artist Lucia and her husband, Roger Wilcox;
Joan Brill and Harry Allaire, Music Committee chairmen;
planning a concert to take place at the
Wilcox home-studio (1958).

Arthur Gold and Robert Fizdale, duo-pianists,
appeared several times in Guild Hall benefits,
the last time in 1981.

Scenes from Mozart's Life performed by, among others,
Rosalie Wolf, Barbara Loris, George Schulte, Anthony Gordon
(young Mozart), Eleanor Tingley, Carleton Kelsey (1955).

Philip Markowitz,
pianist-composer, who
played at Guild Hall in concerts
as a young man in the 1960s
(c. 1980).

The Tokyo String Quartet,
a prime attraction on the Midsummer
Nights Concert Series (1982).

Shirley Verrett, soprano,
opened the concert series in 1982.

1952. Ossorio had stripped down the Italiante villa, formerly done in pastel colors, painting the walls pure white and furnishing the rooms sparingly with a few handsome white modern pieces. The walls were hung, also sparingly, with paintings by Pollock, Clyfford Still and others whose work Ossorio admired.

For the concerts, flaming torches lit the entryway, and the entire house glowed with hundreds of candles. In the sunken music room torchères flanked the playing area in front of a floor-to-ceiling window through which the softly lit garden could be seen. The place had been especially wired for sound so that an overflow crowd could sit on the terrace overlooking the pond and listen to the music.

Natalie Boshko, a well known figure in Long Island music, often brought in the concert groups. In the summer of 1955, one evening was devoted to the music of Norman Dello Joio, Pulitzer-Prize winning composer and East Hampton resident. Recently he recalled, "I had gotten the players together—Max Pollikoff, Sidney Forest, Joan Brill and Renan DeCamp. I was impressed with the setting; there was a big turnout. I remember Jackson Pollock was in the audience, and I was quite surprised at how much he liked music. . . ." Joan Brill remembers, too, that, "That night I played some of Dello Joio's music in manuscript form; it hadn't even been published yet."

Another Creeks concert took place on August 11, 1956, an evening that thereafter would resonate throughout the art world. Leonid Hambro, concert artist and official pianist for the New York Philharmonic, was the guest performer. The artists' community was well represented—Wilfrid Zogbaum, Frederick Kiesler, Lucia and Roger Wilcox, Clement Greenberg. Shortly before his death in December, 1990, Ossorio thought back to that evening: "As the introductory remarks were being made for Hambro," he said, "the phone rang. A maid answered. Pollock had called to say he would be late. During the concert—it was a very still night—I could hear the ambulances. Next thing I knew Conrad Marca-Relli called up, saying Jackson had been killed. I didn't make an announcement. I drove right over. I knew exactly where the accident had happened. When I got there Jackson was still lying where he had fallen. I took out my handkerchief and covered his face. . . . It was a double tragedy. That girl who had come out to 'chaperone' Ruth Kligman, Jackson's girlfriend, also lost her life. She had gotten away from Nazi Germany and got killed in Springs!"

Lee Bendheim was chairman of the Music Committee from 1976–82. Diversification was what he aimed for in his programming. He was assisted by a knowledgeable and eager committee that included Lee Walter, who had been closely associated with the famous Hurok organization; he created a long-lived series, a near sellout from the start, called Music for Everybody. As Bendheim tells it, "We had the R. K. Williams Singers, a terrific black group from Bridgehampton; and we had Dick Hyman playing jazz; John Hammond, folk; the superb Cantilena Chamber Players . . .

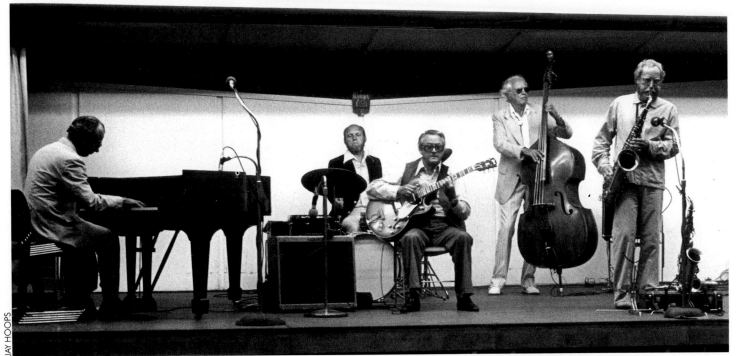

Jazz on a Summer Night—
the East End All-Stars: Dick Hyman,
Ron Traxler, Toots Thielmans,
Bob Haggart, Hal McKusick (1977).

We even did the first full opera ever presented on the John Drew stage, *Cossi fan tutti*, in 1978. We got hooked up with Opera on the Sound from the north shore, and invited them out. The whole thing was produced here. They rehearsed, built their scenery, made their costumes, everything. The whole production, complete with a welcoming reception afterwards, came off beautifully . . . In those days, we were the center of musical activity out here. People would come all the way from as far as Quogue. At that time there was just nothing musically on the East End—quite different from today . . ."

During the summers of 1980–83, Leonard Davis, through his Regional Arts Foundation, backed a music series, making it possible for us to offer artists we could not have afforded otherwise—the Emanuel Ax/Young-Uck-Kim/Yo-Yo-Ma Trio, Spanish pianist Alicia de Larrocha, the Soviet Emigré Orchestra, Shirley Verrett, the Metropolitan Opera star.

One time, Bendheim recollects, the Hungarian pianist Lili Kraus arrived for her concert to find that her wardrobe (sent on ahead) hadn't been delivered. "She had to play the first half in her rumpled traveling outfit," he says. "At intermission, she learned her luggage had finally arrived and dashed off to Heddy Baum's house, where she was staying as a guest, to make the change. The house was quite a distance from the theater and we had to hold the curtain, but the audience was patient. When she came on stage in her elegant gown and explained why she was late, the audience stood up and cheered."

More recently, Robert A. Becker, founder of the Beethoven Soci-

Lee Bendheim, Music Committee chairman;
with Lili Kraus, pianist; and Heddy Baum,
the pianist's friend and hostess for her
East Hampton stay (1977).

Interior of the Woodhouse Playhouse,
later the home of Mr. and Mrs. David D. Brockman,
where a 50th Anniversary tribute to
Mrs. Lorenzo E. Woodhouse, Guild Hall's founder,
took place in 1981.

ety, and his wife, Nancy, have funded for young people "Mr. Beethoven" and "Mr. Mozart," performed by Dennis Kobray, as well as several concert groups, including the Chamber Music Society of Lincoln Center and the Tokyo String Quartet.

David and Elizabeth Brockman bought Mrs. Woodhouse's Elizabethan-style playhouse on Huntting Lane in 1958. Even back then, Elizabeth, a Juilliard graduate, and her husband were deeply involved in the New York music world. Elizabeth is credited with helping to save Carnegie Hall from demolition and also with crusading to save Radio City Music Hall. They had a similar reverence for the playhouse, and continued the musical tradition Mrs. Woodhouse had started in her younger days, when Ruth St. Denis danced on the moonlit terrace, and John Drew and his friends performed informally in the 75-foot-long hall.

The Brockmans felt close to Guild Hall, too, and like Mrs. Woodhouse, often played hosts to our musical benefits. The most stunning of the playhouse events was *A Night for Remembering*, presented in the 50th anniversary year (1981) to honor Guild Hall's founder. The evening, hosted by the Brockmans and masterminded by Michael Smollin, co-chairman of the 50th anniversary committee, was a re-creation of a typical '20s gala as given by Mrs. Woodhouse in the heyday of the playhouse, even to an array of period cars parked in the driveway, such as a 1924 Stutz Bear-Cat, a 1922 Model T Ford Depot Hack . . .

The terraces were set with candlelit dining tables for a sumptuous Chinese banquet. Our musical host was Karl Haas, well-known conductor and commentator, who introduced such celebrities as concert pianist Rosalyn Tureck; Gene Boucher of the Metropolitan Opera singing to Charlotte Rogers' organ accompaniment; Michael Moriarty, Shakesperean actor; composer Norman Dello Joio. For an authentic touch, the Westminster Choir, which had sung in that very playhouse for a Guild Hall benefit in the early '30s, appeared to celebrate the anniversary. But

Flyer for the Westminster Choir's 1934 appearance at the playhouse. The choir re-created its program for the 1981 tribute.

David Brockman, host for the tribute, greeting the audience. To the right, his wife, Elizabeth, and special guests, Marjorie Douglas Woodhouse Mason and Olivia Mason, great grand-daughters of Mrs. Woodhouse. On the wall, William Whittemore's portrait of the founder's daughter, Marjorie Woodhouse Leidy.

NOEL ROWE

GH ARCHIVES

the hit of the evening was Dello Joio and his son, Justin, playing *Family Album*, pieces the composer had created for his children when they were growing up.

When Barbara Mahoney (later Brooks) joined the staff as publicity director and assistant to the executive director in 1969, she found herself working, she says, in a whirlwind. Like everyone else on our small staff of four, she was expected to wear several hats. In 1972, for example, she took on the job of coordinating a three-day visit by the American Waterways Wind Orchestra. This waterborne company of fifty musicians under the direction of Robert Boudreau had given concerts on the Thames and various U.S. rivers and now, under the sponsorship of Guild Hall, would bring its barge into Boys' Harbor, performing evenings on the barge and daytimes in small combos at various gardens around town.

The evening concerts on deck, with the audience sitting on blankets on the shore, always started with a display of fireworks over the water. Opening night, a severe thunderstorm erupted just as the skyrockets were set off and, as the lightning competed with the fireworks, the audience scrambled for cover 'til the storm passed. "It took a lot of orchestration, so to speak," Mahoney says, "to pull this three-day production together, and a major challenge was finding free housing for the musicians, but it was fun—a real air of excitement. At that time Ted Strongin was critic for the *Star* and Boudreau, his good friend the musical director, was staying at my house. After the concert a number of us came back to my house. Nobody had eaten anything, and I hadn't had time to go to the grocery store. I had bread, a dozen eggs and some tomatoes from the garden. So I said to Hattie Strongin, a wonderful cook, 'This is all I've got. What can we do?' She looked at me and said, 'Dinner will be ready in fifteen minutes.' She made delicious omelettes and tomato salad. The community participation was a wonderful thing."

It was in Amagansett, at the studio of his friend Tsuya Matsuki in 1954, that Max Pollikoff conceived the idea for his Music in Our Time series, in which he introduced, over the years, over 250 composers, including Leonard Bernstein and John Cage, to American audiences. It was a brilliant experiment, and achieved decades of success at Town Hall and the 92nd Street YMHA in New York. "Contemporary music," Pollikoff proclaimed, "is only avant garde because it takes us so long to catch up with it." His words were prophetic.

In 1974 Pollikoff, with a grant from NYSCA, approached us about moving Music in Our Time out of New York, with the hope of making Guild Hall its permanent home. Encouraged by the solid audience base we were building for music and by Pollikoff's conviction that his experimental music would appeal to the ever-growing number of people in the arts who were settling in East Hampton, we agreed to give it a try, with three concerts in the spring of 1975. Enticed by the idea of hearing new music by Stuart Diamond and John Danser, played by some of New York's

PHILIPPE MONTANT
Max Pollikoff (right),
founder of "Music in Our Time," with
Beatrice and Harris Danziger (c. 1974).

Chico Hamilton, jazz drummer, and his band, at a student performance, one of several he presented during the '70s.

Andrea Marcovicci, a star of the Cabaret Series in 1991.

finest musicians, a good-sized crowd attended the first concert but, even with rave reviews, attendance dropped off drastically for the remaining two. Only a handful of people seemed to understand or like what they heard and, reluctantly, Pollikoff decided that the series could not survive in East Hampton.

This came as no surprise to Theodore Strongin, who served as a music critic for several publications, including *The New York Times*, before embarking on his much admired Previews and Postscripts column for the *Star*. "Music is the most backward of the arts in the sense of doing new things," he said recently, "because of the terrible nostalgia. People want to hear tunes they have associations with, those same old familiar hundred pieces. I was hoping, of course, that it would catch on. In New York they had a good audience, but then, in a city of several million, there are enough people to be interested in any particular thing."

As the year-round staff grew in size during the mid-80s, the Music Committee became advisory only and the staff took on the responsibility for the programming, opting for a balance between nationally known artists like Dave Brubeck, the Cleveland String Quartet with Walter Trampler, the Empire Brass and, of course, performers associated with the Hamptons. For example, the 1989 East End Music Festival brought a dozen or more musicians to the spotlight—Caroline Doctorow, The Syndicate, Phil Noble, Nancy Remkus and others. Tom Clavin, the organizer, said that these shows were specifically for the musicians who were here year-round, "the ones who play a tavern with three people in January."

Still, there's always room for a variety of programming. In recent years Cabaret evenings, for instance, have been successfully introduced into the summer festivals with such singers as Steve Ross, Ann Hampton Calloway, Anita Ellis and Andrea Marcovicci. As for the experimental, Strongin advises that we keep trying. "Sneak it in," he says.

Composer Stephen Dickman and librettist Gary Glickman, who premiered their new opera *Tibetan Dreams* in 1988.

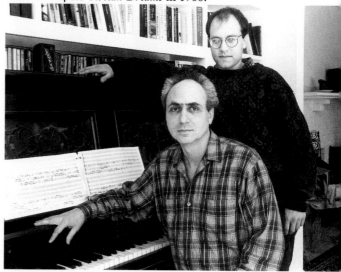

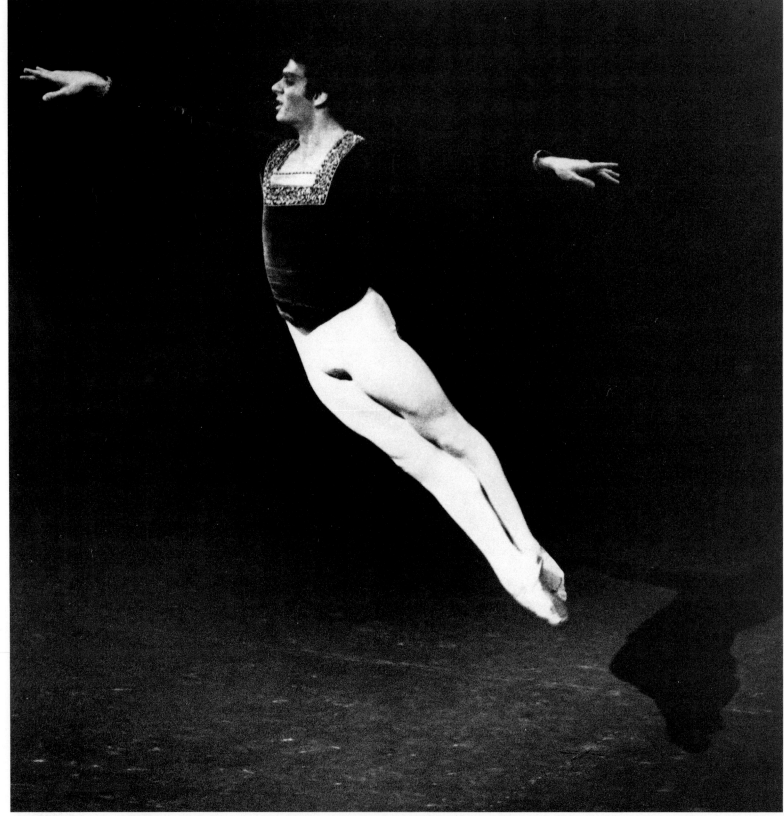

Fernando Bujones performed in James Lipton's *Dance Divertissement* (1974).

DANCE

When Gwen Verdon, "the reigning queen of American musical comedy" and long-time resident of our town, heard we were having some financial problems during the early '70s, she said she wanted to help. A woman of her word, this red-headed star *(Damn Yankees, Sweet Charity)* characteristically jumped in with both her dancing feet and, as she told a reporter for *Hamptons Magazine*, "I started doing benefits with Jim Lipton. We did everything but take off our clothes and walk down Montauk Highway to save the place.[10]

Out of that spirited liaison came several benefits that helped fill the Guild Hall coffers and, at the same time, gave us some of the best dance theater ever seen in the John Drew. The first event, in the summer of 1973, was *Gwen Verdon and Friends—A Dance Divertissement*, which Verdon herself calls "an evening that rivaled anything being done

then or now in New York."[11] All her friends—among them Cy Coleman, Peter Gennaro, Ben Vereen, Geoffrey Holder—pitched in to help. The highlight of the evening was the American premiere of Norman Walker's new ballet, "Psalm," performed by stars of the Joffrey company. James (Jim) Lipton, playwright, director, choreographer, best-selling novelist and all-around dynamo, wrote, produced and directed the evening as his personal gift to Guild Hall. Like the others involved, he never forgot the excitement: "The ticket demand was so great we had to give not only one but two performances and in the end, had to turn away hundreds." *Star* critic Theodore Strongin was also ebullient: "The usually staid Guild Hall audiences whistled and cheered through the evening. The theater sounded like a ball park."

Later, in the summer of 1977, when we broke away temporarily from stock theater and presented the ambitious Festival of the Performing Arts, Verdon was again pivotal. She provided a feast of dance programs by Ballet Hispanico, the Murray Louis Company, the Dance Collection and, spectacularly, the first performance of Lee Theodore's brand new American Dance Machine, the living archive of Broadway dance theater which re-created twenty great numbers choreographed by DeMille, Fosse, Gennaro, Kidd and others.

Verdon's Christmas gift to the community in 1980 was an original version of *The Nutcracker*, described by *Newsday* as "a tiny tiger of a show." Produced with Peter Diggins, it was ingeniously created especially for our small stage. Kirk Peterson of the American Ballet Theater and Denise Jackson of the Joffrey took on the leading roles, but the minor characters and, of course, the children were drawn from the community. Verdon's daughter, Nicole Fosse, danced, while Verdon herself played Mother Ginger, with her children rolling out from under her big hoop skirt to perform amazing backflips and cartwheels. The production was a magnificent and hugely successful community effort. Jim Tilton designed the sets gratis and, as before, Verdon's friends chipped in, this time to cover the show's expenses.

For Lipton's second dance festival in 1974, the demand for tickets was so great that we had to move our operation to the high school, which seats 900, more than double the capacity of the John Drew. Lipton outdid even himself, promising "the unmatched thrill of seeing a stageful of the world's greatest dancers, not in one company's work, or even one kind of dance, but in brilliant exciting works from every major dance form: ballet, modern, ethnic, jazz and Broadway musical theater."[12] And he delivered it "right into our laps," as one critic put it. "We feel as though we were in it." This rare sense of immersion had to do with the rapport Lipton established with the audience through his impassioned introductions that created an electrifying air of anticipation. When he said that we in the audience were about to see a dazzling dancer on the threshold of becoming one of the world's greatest ballet stars, he delivered Fernando Bujones who, in a brilliant "first" performance of "Gopak" from *Taras Bulba*, left

JAY HOOPS
Scene from *The Nutcracker*, produced
especially for the John Drew by
Gwen Verdon and Peter Diggins (1980).

192

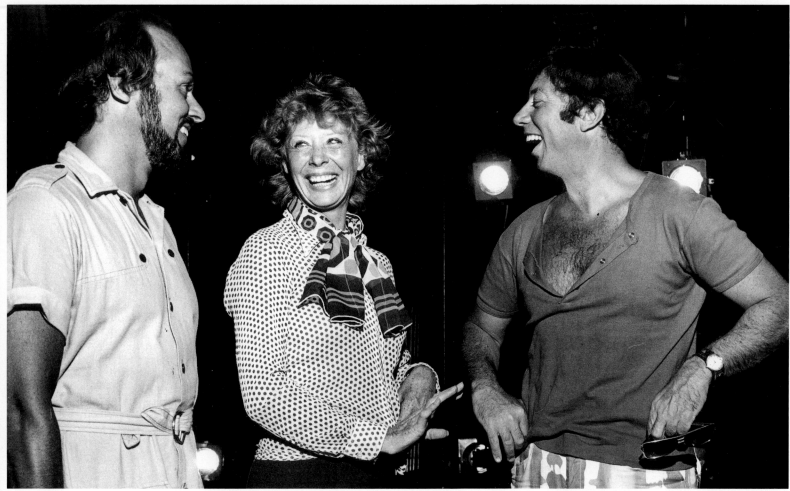

PHILIPPE MONTANT
James Lipton, producer; with
Gwen Verdon and Cy Coleman, discussing
plans for *Gwen Verdon and Friends*, first
of the dance festivals (1973).

no doubt in our minds that Lipton's prophecy would come true, as it did. We saw, too, the unveiling of a new company led by the modern dancer Lar Lubovitch, along with such major soloists as Martine Van Hamel and Violette Vardy.

But it was a contingent of the Alvin Ailey dancers who brought down the house, prompting Lipton to bring back the entire company the following year (1975) for two full evenings. The high point was "Cry," Ailey's masterpiece danced in heart-rending fashion by Judith Jamison, for whom it was created.

By this time, Lipton's reputation as a creative entrepreneur had spread way beyond East Hampton, and he was being engaged to produce shows at Lincoln Center in New York and the Kennedy Center in Washington. He had given us three superb dance benefits. We could hardly expect more.

The dance festival mantle fell on John Goldman in 1976. Lipton was a hard act to follow: "I think everyone thought we'd fall on our faces," Goldman says, "but we worked extremely hard. A lot of people helped.

193

Judith Jamison of the
Alvin Ailey Company was
the show-stopper of the
1975 festival.

Martine Van Hamel and Clark Tippet
in Ballet Theater's "The Sleeping Beauty"
pas de deux (1980).

Naomi Rosenbloom was our committee chairman. We had soloists from the New York City Ballet, Boston Ballet, Cliff Keuter's and Dennis Wayne's companies . . . It was an artistic success and we made some money for Guild Hall."

Goldman also helped produce the weeklong 50th Anniversary Festival, Fifty Years of American Dance, in 1981. He remembers with special pleasure the opening event, an informal free dance concert at Main Beach. "We wanted the whole community to come, and it did, hundreds and hundreds with their picnic baskets. The weather was perfect, great rollers coming in, clear blue sky. We had some modern, some jazz, but when the

NOEL ROWE
John Goldman and Gwen Verdon (right),
producers of the six-day 50th Anniversary
Dance Festival (1981); with Chita Rivera,
star of "The Great White Way Cabaret,"
a festival highlight.

CAROLYN GEORGE D'AMBOISE
Kay Mazzo and Helgi Tomasson
of New York City Ballet performed
in the 1980 festival.

Isadora Duncan dancers floated along to the music against nature's back-drop, it was positively ethereal. Everybody had a marvelous time. We should have made an annual event out of it."

The 50th festival continued with evenings at the theater featuring classical ballet (Eleanor D'Antuono); the May O'Donnell Company with a look of the '40s through the eyes of the '80s; and the experimental, comedic David Gordon Pick-Up Company. "That company," Goldman explains, "has since made quite a name for itself, even if they weren't appreciated by everyone in *our* audience. Some people walked out when they did the number with the folding chairs, sliding in and out of them, folding themselves up in them, pushing them here and there. But we were trying to give a full picture of the different forms dance can take."

Gwen Verdon and choreographer Christopher Chadman produced the final two nights: first *The Great White Way Cabaret* with Chita Rivera and Sylvia Syms, followed by *Broadway Baby*, an "affectionate" look at the evolution of the American musical. Martin Gottfried wrote in his review for the *Star*, "The John Drew Theater's audience Sunday evening saw not only one of the most inventive musicals ever put together for a single performance but had a surprise preview of what could, with enough work, be a future Broadway hit. . . . The company was extremely admirable, gifted and polished. . . . They gave the John Drew audience their every-thing, and just for a one-night stand. In that respect as much as any they presented the heart of Broadway musicals. . . ."

Although some detractors think Guild Hall has been too conserva-tive in its programming, dancer-choreographer Lelia Katayen thinks of us as in the avant garde in the dance we have sponsored; she's been involved in workshops and concerts at the John Drew since the early '60s.

For many years Katayen had her own professional modern dance company, trying out all of her programs at the John Drew before taking them on nationwide tours. As time went on, Katayen combined profes-sionals with local dancers she had trained through the workshops, a for-mula that worked especially well with East Hampton audiences in dances with such indigenous themes as "Widow's Walk" or "A Whaling Ballet."

"I was always interested in interrelating the arts," Katayen says, "and the galleries were perfect for this. I remember bringing my dance students over from Southampton College to work with local children in an unusual experiment for the times—the mid-60s. I had them create dance segments based on their emotional responses to the line, form, color of the paintings and sculptures."

Dancing classes at Guild Hall have been popular since the late '40s when Maria Motherwell, Mexican wife of the artist Robert Motherwell, taught the dances of South America—the rumba, the tango—most exotic at the time. Throughout the '50s, Dionne Farrelle, exhibition dancer and former Radio City Music Hall Rockette, conducted classes regularly for both young people and adults, in ballet, tap and ballroom. Ever since the early '60s, modern dance seems to be the dance class of choice.

When Alwin (Nik) Nikolais, once called the "silver-haired magician of light and space," took a look at our small stage one day in 1965, he wondered "how in the world" he would mount his grand-scale multimedia Abstract Dance Theater on it. In the first place, the proscenium opening is only fifteen feet wide and the stage depth only nineteen feet. What is more, the lightboard couldn't possibly handle the demands of his elaborate lighting effects. Our hearts sank. We had counted on this event as the blockbuster of the arts festival we were planning jointly with Southampton College. But after a few minutes of silent observation, Nikolais said crisply, "We'll do it! Don't you worry!" He did it by bringing in a whole truckload of equipment from his own New York studio—auxiliary light board, projectors, dozens of lights, a sound system.

When the curtain opened on the performance, the audience was stunned by the choreographer's all-encompassing "total" theater, something new to most of us. Strange electronic music crackled as amorphous shapes from outer space danced through the dazzling lights, creating patterns that seemed to have been lifted off the abstract paintings on our galleries' walls. By the end, even the skeptics were on their feet applauding.

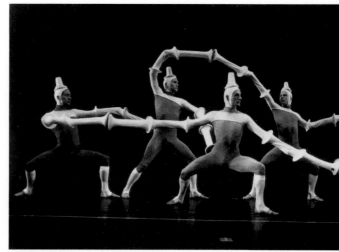

JOHAN ELBERS
Alwin Nikolais' "Imago" was previewed at the John Drew in 1968 prior to a European tour.

On a return engagement in 1968, Nikolais honored us with the preview, including the full work *Imago*, of a production he was readying for an extended European tour to, among other cities, Venice, Berlin and Warsaw. "It turned out to be one of the most important tours we ever made, Nikolais observed recently. "It ended with the big Paris international festival and we took every prize—choreography, costuming, everything. They decided to include all the awards in one trophy, a huge crystal vase. It was so heavy that when they presented it to me, I almost fell into the orchestra pit!"

Murray Louis, Nikolais' partner and a critically acclaimed solo dancer and choreographer, has his own distinguished small company, quite different from his partner's, a form of expressive modern dance closer to human emotion and threaded with humor. He too has brought his company to our theater, once, in 1967, for an all-out benefit in support of Guild Hall, in which he premiered a new work.

A surprising number of companies, apart from those mentioned, have appeared at the John Drew. Among the first were the Anita Zahn School of the Dance (based in East Hampton) in the '40s, and Ballet Theater Dancers with Nora Kaye and John Kriza, which played a full week's engagement in 1956. Most, however, have appeared since 1960: the Long Island Ballet, the Ohio Ballet, Edward Villella Dancers, American Ballet Theater, Eglevsky Ballet, and Frances Alenikoff's multi-media company.

MASASHI OHTSU
Women of the Calabash,
a hit of the 1989 season.

And so, in spite of an inadequate stage for dance (one critic said the ballet performers looked as though they were trying to dance in a living room with the chairs pushed back), dance clearly has its niche at the John Drew. Where there are audiences for dance, it seems, most dancers will triumph over the "inadequate."

Frank Perry, producer/director; and
Truman Capote on location for the filming
of Capote's *Trilogy*, opener of the first
Filmmakers of the Hamptons Festival (1969).

FILM

As Robert Montgomery stepped out onto the stage in front of the screen, a hush fell over the audience. Every seat in the house was filled. It was the first night of Guild Hall's first Film Club showing. The year was 1952; the film, *Night Must Fall*. And there was the star himself up there, relating the behind-the-scenes excitement of playing the role of a killer who carried his victim's head around in a hat-box. The film, Montgomery told the crowd, was a turning point in his career. MGM, he said, was reluctant to cast him as a horrific murderer; they feared it would endanger his box-office popularity. Even at the Hollywood premiere, some insiders had predicted a flop. Nevertheless, the film had triumphed, and the star was a bigger draw than ever before.

Night Must Fall was an auspicious start to over forty

Film star Robert Montgomery
greets Happy Macy, Guild Hall trustee,
as Mrs. Montgomery looks on (c. 1952).

years of films running the gamut from the early classics to the avant garde and including many national and world premieres.

When Robert Dowling, a prominent figure in theater and film, became involved as a board adviser in 1953, he brought us two American premieres. Memorable was *The Captain's Paradise*, starring Alec Guinness. Dowling decided that our tired-out 16mm projector, a borrowed one at that, wouldn't do and brought in professional equipment from New York. Heralded by bold banners across the front of the building, Guinness' comic masterpiece attracted an overflow crowd.

The writers Gerald Sykes and Berton Roueché were the prime forces behind the Film Club during its early years; their combined expertise brought us memorable classics, many from the Museum of Modern Art Film Library: Garbo in *Camille*, Dietrich in *The Blue Angel*, Flaherty's *Man of Aran*, De Sica's *The Bicycle Thief* and others.

In 1958 we showed the Academy Award–winning documentary *Helen Keller in Her Story*, with long-time East Hampton resident Richard Wood on hand to tell how he'd made this extraordinary film with Keller, who was born deaf and blind. "Solving the problems of directing a blind and deaf person," he said, "was a real challenge. Considering her handicap, I found her very responsive. I've tried to tell the story of how this remarkable woman became an inspiration to handicapped people all over the world." One such person was Yves de Kerellis, a handsome young Frenchman living in Water Mill, who had studied with Keller. He and his wife, both deaf, learned to speak both English and French without ever having heard the spoken word. Inspired by the great pantomimist Marcel Marceau, they developed their own pantomimes and presented them publicly for the first time in our theater in 1969.

From 1962–68, John Reed chose the films with a discerning eye for quality. Some years after John's death, Phyllis, his wife, recalled that when they'd lived in New York, her husband, an artist turned photographer, practically lived at the Museum of Modern Art's film theater. At Guild Hall, he opened one season with a premiere of *Jane*, a documentary about Jane Fonda made by D. A. Pennebaker, the innovative filmmaker who lived in Sag Harbor and whose work has since been screened many times at the John Drew. That was followed by another premiere, this one of the Namuth-Falkenberg film about Springs sculptor Costantino Nivola.

East Hampton was hungry for film in those days. The one movie house in town, the old Edwards Theater, confined itself to week-long runs of prime attractions. There was definitely an audience for alternatives— the foreign films and revivals being offered at Guild Hall. Fortunately, those audiences forgave us if we weren't up to snuff technically or sometimes had to cope with worn-out, brittle celluloid prints that ripped at the most embarrassing moments.

Alan York, later chairman of films, remembers, "We were still using the lone 16mm projector in those days. We were lucky to have John Reed there, running the programs. If anything went wrong, he could fix it."

Until one night, when York had taken over from Reed, and something went wrong. "I had made an arrangement with a few people around town who had projectors," says York, "that if ours broke down we could borrow theirs. This night I ran out and borrowed Bob Plitt's while the audience waited. People were patient. They knew our problems."

Until then, the screenings were all informal, with easy chairs set up in the Moran Gallery. It was not long, however, before we outgrew the space and moved into the theater. York, whose taste ran to the great world classics, assumed the film duties in 1968, continuing devotedly through 1976.

In 1968, thanks to the energetic efforts of our board chairman, Charles (Bud) Dewey, we were able to build a projection booth in the balcony and install state-of-the-art equipment under the professional supervision of Bob Gruen and Bran Ferren. From then on, film began to assume a greater role at Guild Hall. "We had acclaim in the Sunday *Times* for one of our 35mm series, the early films of René Clair," York remembers. "That put Guild Hall's film showings on the map."

When it came to drawing in new audiences, York showed imagination. Once he premiered a film about St. Francis of Assisi as a benefit for the Catholic church; another time, he showed Leonard Bernstein's *Journey to Jerusalem* as a benefit for the Jewish Center of the Hamptons. He also arranged for Milos Forman to introduce his film *Firemen's Ball* and invited the local fire department to attend. With a project in conjunction with the NAACP called American Negro History and Culture, York showed *The Weapons of Gordon Parks* with Parks there to speak.

JAY HOOPS

Bran Ferren and Robert Gruen with the state-of-the-art movie projector they selected and installed in 1968.

Films were utilized in dozens of other ways during those years, complementing such interdisciplinary theme presentations as the Polish Festival of the Arts, Five Faiths of Mankind, and Chinese Culture. And for a "Member Bring a Member" evening run by the Membership Committee, for example, there was an unforgettable showing of Lillian Gish in the silent classic, *Way Down East*, with a rousing, improvised piano accompaniment by composer Wilson Stone that brought down the house.

York had discovered along the way that East Hampton's wealth of residents connected with the film industry could enrich Guild Hall's film programming, something that Trudy Golden, a former film publicist, took full advantage of as chairman of the Filmmakers of the Hamptons Festival. Beginning in 1969, she masterminded the festival for almost two decades and ritualized it into a spectacular annual event.

The concept was as simple as it was innovative—to say nothing of effective: showing films but with the important addition of appearances by filmmakers living in the Hamptons. Golden's criterion was broad. Those who spoke ranged from producer to script-girl. This immediate and intimate approach to showcasing films became so successful, and so well respected, that an invitation to participate was an honor.

PHILIPPE MONTANT
Members of the first committee for
Filmmakers of the Hamptons Festival (1969):
Hans Namuth; Trudy Golden, chairman;
Roger Caras; Alan York; Robert Alan Aurthur.

The first festival, in 1969, began with Truman Capote's *Trilogy*, a film by Frank Perry, starring Geraldine Page, Maureen Stapleton, Martin Balsam and Mildred Natwick. Capote and Perry were there in person to discuss the film.

Before her death in 1988, Golden reminisced about a few of the highlights of her years with the Festival:

"Peter Stone was the most creative participant we ever had; he was our constant adviser. Peter is a screenwriter with many Academy Award winners to his credit. In 1978 we put together a special program, The Art of Screenwriting, as a salute to him. We included all his Academy Award–winning films, beginning with *Father Goose* with Cary Grant and Leslie Caron, and following with *Mirage, Arabesque* and *Skin Game*. The last was *Charade*, made in 1963, with Cary Grant and Audrey Hepburn.

"Each night Peter invited a couple of his screenwriting friends from this area to come up on the stage with him, and before the film went on they'd talk shop. It was marvelous, like leaning over their shoulders while they were sitting in the commissary. . . .

PHILIPPE MONTANT
Participants in the 1975 festival. Standing: Peter Stone, George Silano, Robert Alan Aurthur, David Opatoshu, Bran Ferren. Seated: Eli Wallach, Anne Jackson, Dina Merrill, Cliff Robertson.

Evan Frankel, Guild Hall trustee and producer of Menotti's *The Medium*, spoke at the festival screening of his film (1970s).

SUSAN WOOD

"Arthur Laurents wrote *Time of the Cuckoo*, the play on which the film *Summertime* with Katharine Hepburn and that glorious-looking Rosano Brazzi was based. We all loved that film—a Venetian tour de force—and we included it in the 1974 Festival with Arthur Laurents presenting it. But then he gets up on stage and says he doesn't think much of the film, refers to it as a pretty travelogue with no theme or point of view and, in his words, 'an almost complete evisceration of the play. And instead of a fairly sophisticated New York secretary, Katharine Hepburn plays a terrified forty-year-old virgin from Akron, Ohio, with a mid-Atlantic accent, a fancy wardrobe and all the Hepburn mannerisms. There is little reality to her performance or the picture.' Never had we had an introduction quite like that before. . . .

"In 1975 we had a film called *The World's Best Commercials*, a compilation of the prize-winning commercials on film from an international festival. We programmed it for the festival with George Plimpton, who was then making commercials, introducing it. It was great.

"That showing was on a Thursday. Friday night, we were supposed

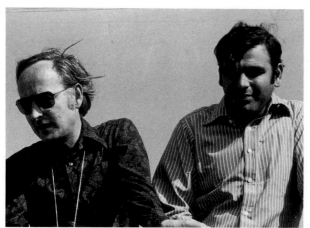

James Ivory and Ismail Merchant, frequent festival participants, first appeared in person to introduce their film *Bombay Talkie* in 1971.

Ruth Tonkonogy, hostess for the festival receptions; with writer James Kirkwood (left) and actor Michael Tolan, who were featured in the 1974 festival.

to have a night with Cliff Robertson, but we learned that his plane wouldn't get him back from Texas in time—and we were sold out. So I asked George if he'd be available for a repeat performance. George is very social; he had about three parties that night—but he knocked them off, just came over to Guild Hall to do *The World's Best Commercials* again. When people arrived we told them we were terribly sorry about Cliff Robertson, but if they'd like to stay for *Commercials*, fine. Everyone (even those who had been there the night before) stayed to see it, so it all worked out fine.

"An aftermath: I was hanging around until everything had been tucked away. I finally walked out onto a rather lonely Main Street, and there was a car with Cliff Robertson leaping out of it, saying 'Where is everybody?' He'd done everything he could to make it. . . .

"I had seen the new film *From Mao to Mozart: Isaac Stern in China* in New York, and I thought it was one of the greatest films of its kind that I had ever seen. The artistic supervisor of the film, a youngish man named Allan Miller, was an area resident. He said he would be delighted to present the film, so we decided to use it as the opener to the festival for the 50th anniversary year in 1981.

"As luck would have it, we were able to arrange for Isaac Stern and his wife to make their annual visit to the Adolph Greens the weekend the festival would open. And one day, I was on Georgica Beach and met a young woman working for the Chinese Inter-Cultural American Exchange. One of her assignments was to put together an itinerary for a delegation of five important Chinese officials who were coming to the United States. So she wrote a letter suggesting that the delegation visit East Hampton, while we wrote it off as a pipe dream. Much to the surprise of all of us, the authorities said yes. From then on, we had to think of our showing of the film in diplomatic terms—how to address our guests, where to house them, transportation to lunches and dinners, but mainly a reception, where they'd meet many people in the community, particularly those with a special interest in China.

"The event itself was oversold. The movie was brilliant, and members of the delegation spoke eloquently, through translators. Then, when we discovered that the Chinese hors d'oeuvres kindly donated by Mrs. Martin Morrow hadn't yet arrived for the reception, Isaac Stern came up on stage and just ad libbed 'til the food arrived. He was so charming and entertaining that the audience would have been happy sitting there for another hour or two.

"The entire 50th Anniversary Film Festival was just as exciting. We had *All That Jazz*, with Bob Fosse introducing it, and the preview of the film about de Kooning, produced by Charlotte Zwerin and Courtney Sale. We also premiered the film on the history of Guild Hall, which Carolyn Tyson funded. The last film in the program that year was *All the President's Men*, introduced by the director, Alan Pakula, and Carl Bernstein, who co-wrote the book, both of whom were residents here.

"And let's not forget our volunteer behind-the-scene professionals who were integral to our success—people like Sue Oscar, a film distributor who kept her eye open for unusual films, Bran Ferren, a genius in everything technical; and that wonderful Leon Laufer, a retired New York projectionist who was only a phone call away when we needed his advice and help—and it was often."

In one of the earlier festivals (1972), Cliff Robertson "talked" the rapt audience through the genesis and making of his recently released *J. W. Coop*. He wore four hats in this movie that Vincent Canby had called "Robertson's triumph"—those of writer, producer, director and star. In reminiscing about it, he said, "My uncle had ranches in Colorado and New Mexico. I was visiting him and, as we sat around the fireplace talking, he said, 'Why don't you do a film about a rodeo cowboy—not a Marlboro type, but a real dimensional person?' So I did *J. W. Coop*." On the stage of the John Drew, the filmmaker brought the film to life in a transcendent way that exemplified Golden's "personalized" approach to presenting films at Guild Hall.

Frank Perry also added luster to the cinema scene, with his roots in East Hampton going back to the '50s. Some fifteen successful feature films later, Perry remembers that it was theater that first brought him to the John Drew, as stage manager in 1951. "Paul Heller (who would go on to make such films as *My Left Foot*) was the scenic designer at the time; that's how we met. I co-produced my first film, *David and Lisa*, with him. My then-wife and I wrote it, in the first house we rented out here, in Amagansett. And Keir Dullea, who'd been an apprentice at Guild Hall, played the lead."

Perry made it possible to show *David and Lisa* as a benefit for Guild Hall and later gave us the world premieres of *Diary of a Mad Housewife* (made with the late Peter Dohanos, a close friend he had also met at Guild Hall) and *Compromising Positions*. He remembers the "very elegant" party, open to the entire audience, held at Mrs. Harry Watts' historic Main Street house, to celebrate *Diary*. Craig Claiborne and Pierre Franey were the celebrity bartenders.

As for *Compromising Positions*, Perry said recently, "We shot a great portion of that film right here in East Hampton on David's Lane, with the cast and crew having their meals catered at the Presbyterian session house across the way. We'd been looking for a suburban home. We worked our way out on Long Island, and found ourselves forty miles from East Hampton. I was working with the art director Peter Larkin, who has a home out here, and we finally said, 'Let's shoot it at home. . . .'"

Which reminds Perry of his favorite story about Woody Allen's *Annie Hall*, a film shown in the 1983 Filmmakers of the Hamptons Festival. "It was shot partially on the East End," Perry said. "Remember the classic scene where Diane Keaton is cooking lobster? It was shot in Helen and Everett Rattray's summer home in Amagansett. Woody said, 'I want

Cliff Robertson talked about the making of his film, *J. W. Coop* at the 1972 festival.

the kitchen floor painted green, dark green.' Someone asked why. 'Never mind,' he said, 'I just want it green.' So they went to elaborate lengths to paint the Rattray's floor green. In the scene, Keaton was afraid to drop the live lobster in the pot, so the lobster was to fall on the kitchen floor. Naturally, when the green lobster dropped on the now dark green kitchen floor, you couldn't see it. Woody was confused—he thought lobsters were red, till someone explained that they only turn red once they're cooked. Woody said, 'You mean they're not red all the time?' Woody was such a New York City kid that he thought lobsters were born red, lived red and died red!"

Hilva Landsman, a Guild Hall trustee who has been film chairman almost continuously since 1976, has always had a keen interest in cinema. "I started early," she says. "I was only five or six years old when my father started taking me to the movies. I can't tell you how many times I saw *It Happened One Night*." Later she took courses in film history and was chairman of the Film Committee for the American Federation of Arts. She is now a director of the Lincoln Center Film Society.

"The first film I booked for Guild Hall," she remembers, "was a Dickens classic at Christmas time. There were only nine people in the audience so I knew I had to rethink things. I decided to build series around themes such as Goddesses, Youth and the Rites of Passage, Distinguished Foreign Directors, James Dean. . . . I found themes really captured the audiences. I also learned the importance of marketing. We did 'flood mailings,' formed a film society with special incentives, and before long we were filling the theater in the dead of winter.

"One of the most popular summer showings (and I didn't expect it would be) was *Running Fences* in 1978. It was a documentary about the artist Christo, who draped something like twenty-four miles of California landscape in a swath of fabric. The Maysles brothers and Charlotte Zwerin, who made the film, were there for the screening and so were Christo and his wife. It played to standing room, and afterwards we had a nice reception for them in the garden. It was a terrific evening."

For the 50th anniversary year (1981), the theme Landsman picked was The Barrymores—A Royal Family, featuring the films of Lionel, Ethel and John, all of whom frequently visited their uncle, John Drew, in East Hampton. It was a great moment for the audience when Landsman escorted the legendary Myrna Loy out onto the stage to talk about *Topaze*, a 1933 film in which she starred with John Barrymore. It was this film that revealed Loy's flair for comedy and took her once and for all out of the oriental "vamp" roles. It also earned Barrymore critical acclaim for the finest performance of his screen career, even if he did have some trouble, as Myrna Loy recalled, remembering his lines.

"In the mid-80s," Landsman says, "I realized that the end was in sight for the kind of series that had been successful for so many years. VCRs were taking movies into the home, and so we gave up the regular

COURTESY OF JOHN HUSZAR
Virgil Thomson, subject of *Virgil Thomson: Composer*, a film previewed in the 1980 film festival through its producer-director, John Huszar, an area resident.

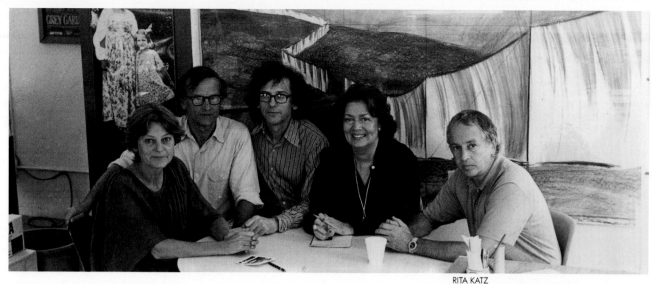

Hilva Landsman, chairman of the
Film Committee (second from right),
discussing the special showing
of *Running Fences* with the artist Cristo
(center) and the film's makers,
Charlotte Zwerin (left),
David Maysles and Albert Maysles (1978).

showings; I didn't become involved with films at Guild Hall again until 1991, when we tried an international film festival with Richard Peña, program director for the Lincoln Center Film Society, as moderator. It went so well that we've planned to continue."

Besides selecting the films all those years, Landsman also took special pride in improving our screening capabilities, the wherewithal being provided through contributions from Clifford Ross and Steve Ross. "Those were the great years," Landsman recalls. "I can honestly say that running the Guild Hall film program was the most satisfying board work I have ever done."

A unique event took place in the fall of 1981: the Directors' Week-End, which honored the distinguished film director Sidney Lumet, another East Hampton luminary. Presented by the Directors Guild of America in association with Guild Hall, it brought together more than 100 professional movie directors to meet and share ideas; the public was invited to eavesdrop. Six films by Lumet were screened, all preceded by talks by Lumet himself.

Guild Hall still continues its tradition of bringing unusual cinematic events to moviegoers. Outstanding in recent years were Richard Brown's Private Screenings for which he had become famous in New York (they featured interviews with such stars as James Earl Jones and Robert Duvall); The Movie Makers Series, organized by Theodora Sklover; the presentation of the award-winning films of the Suffolk County Film Festival; and recent Russian documentaries in the only Long Island showing of the Glasnost Film Festival.

Though we've had to shift our approach to adjust to changing times, as first television and later the VCR decimated traditional film audiences, Guild Hall's film programming has kept its strength and audience by creatively meeting the needs of the times.

Hilva Landsman, James Kotsilibas-Davis
and screen star Myrna Loy
who introduced the showing
of her early film *Topaze*. (1981).

207

PARLOR READINGS
BY
Miss RUTH BEDFORD MORAN.
WILL BE GIVEN AT THE COTTAGES OF
Mʳˢ GEO. A. STRONG --·---·--- On TUESDAY, JULY, 15ᵗʰ
Mʳˢ GEO. P. CAMMANN --·-·-- On TUESDAY, AUGUST, 5
Mʳˢ EVERETT HERRICK--·-- On TUESDAY, AUGUST, 26
Readings Begin Promptly At Four O'Clock. Tea At Five O'Clock.
TICKETS FOR THE COURSE ~·-~ $5⁰⁰
Can Be Obtained From SINGLE READINGS ~·~ $2⁰⁰

Mʳˢ W.E.Wheelock. -- Mʳˢ Geo. A. Strong. AND AT

Mʳˢ E. Herrick. -- Mʳˢ Geo. P. Cammann. EDWARDS' DRUG STORE

Thomas Moran's watercolor and tempera poster
announcing his daughter Ruth's parlor readings, 1920.

POETS
AND WRITERS

Berton Roueché, *New Yorker* writer (Annals of Medicine), prize-winning author of several books and Guild Hall trustee for twenty-three years, was instrumental in organizing our first tribute to the writers of the region in 1958. "I liked the idea," he says, "because I felt that while we had an internationally known art community here, we also were beginning to get a lot of writers and I felt that they should be represented at Guild Hall, or at least acknowledged."

Our plan was to show the development of each writer's work from sample manuscript to proof, jacket design, original illustrations, to finished product. Robert Keene, proprietor of a Southampton bookshop, gathered the materials, and artists Fred Hurdman and Marland Stone saw to it that the show was mounted as if it were an art exhibition,

with a little niche given over to each writer. Called Writers of the South Fork, the tribute took place in the early spring—a tricky time, in those days, for attracting large crowds—and was packed. Roueché remembers, "There were some thirty writers, all of whom had had more than one book published by a major publishing house. There was P. G. Wodehouse, Robert Coughlan of *Life*, A. J. Liebling of *The New Yorker*, Peter Matthiessen, John O'Hara, John Steinbeck. . . ." Not bad for a first tribute.

Some of the writers joined in panel discussions and talks in the theater. One such was What Travel Means to the Writer, with Gilbert Highet and Helen MacInness, his wife, describing how "place" served as an inspirational backdrop for each of them in entirely different ways. A visit to Italy, for instance, resulted in Highet's classic, *Poets in a Landscape*, and MacInness' novel of intrigue, *North From Rome*.

How to Get a Book Published was the subject of another panel with legendary avant garde publisher Barney Rosset, among others, offering a primer for aspiring writers. Roueché remembers John Brooks, author of *The Man Who Broke Things* and other books, saying that it was like a human pregnancy, nine months from the time the book was accepted by the publisher and the time it was out in the bookstores.

From then on, until the present, writers have shared the Guild Hall limelight with others in the arts. Mary Maguire, a member of the Education Committee, ran several series of talks by writers of the South Fork beginning in 1966. Peter Matthiessen, who has had a fifty-year association with Guild Hall, dating back to his boyhood when he often visited his friend Peter Scott who lived across from Guild Hall, has spoken several times, first in 1963, when he talked about his book *Under the Mountain Wall*; we presented at the same time an exhibition of his photographs of primitive life in New Guinea, taken when he participated in the Harvard-Peabody Expedition. John Brooks too has appeared many times.

Among the many others who have spoken are Dwight Macdonald, Willie Morris, Jean Stafford, Nora Ephron, William Safire, Betty Friedan and Shana Alexander.

The writers' events have often taken on unusual aspects. In 1975, rather than make a speech about one of his cookbooks, the noted food writer Craig Claiborne, with his friend Pierre Franey, himself an internationally known chef and food columnist, gave a tour-de-force demonstration on the presentation of local fish and produce, then invited the audience to sample the results at the reception afterwards.

Everett T. Rattray, the late editor and publisher of the *Star*, was honored in 1979 at a signing party, along with an exhibition of the illustrations by Peter Dohanos, for his new book, *The South Fork*.

Jeannette Rattray, Everett's mother and a former publisher of the *Star*, was in her day thought of as East Hampton's First Lady—and for good reason. She served numerous local organizations, and for forty years held forth in her column for the paper over the signature *One of Ours*. In

RAMESHWAR DAS © 1989

Berton Roueché, writer and long-time Guild Hall trustee (1989).

PHILIPPE MONTANT

COURTESY OF RANDOM HOUSE
Peter Matthiessen's book about the baymen of the South Fork was dramatized by Joseph Pintauro and staged at the John Drew in 1991.

Writers Helen MacInness (center) and her husband, Gilbert Highet, (second from right) spoke on "What Travel Means to the Writer" in 1958. With them: Thomas Burns, publisher; John L. Boatwright, Guild Hall board chairman; and Anne Washburn.

Among the writers of the region who have appeared at Guild Hall is Dwight Macdonald, seen here with Sammy, outside his East Hampton study (1976).

Willie Morris, novelist and editor, at the podium. Writers of the Region series (1975).

Craig Claiborne (right), noted food writer; and Pierre Franey, internationally known chef and food columnist, have twice demonstrated their artistry on the stage of the John Drew.

Everett T. Rattray was honored at
a signing party for his new book
The South Fork in 1979.

Jeannette Edwards Rattray,
author of *Up and Down Main Street*
and other books, receives an honorary
degree of Doctor of Humane Letters from
Chancellor R. Gordon Hoxie
at Southampton College, 1968.

1968, having just published, among her other books on local history, *Up and Down Main Street*, she received an honorary degree of Doctor of Humane Letters from Southampton College. Guild Hall and the East Hampton Library (where they named a wing for her) gave a book party in her honor, with the author reading from her book about Main Street's historic homes to a group of friends and family large enough to fill the Moran Gallery.

Thanks to Dorothy Quick, poet, novelist and Guild Hall trustee, poetry resonated early in Guild Hall's history.

An invalid most of her adult life, Quick suffered the disabling effects of diabetes, which, nonetheless, couldn't dampen her enthusiasm for the arts; she frequently presided over salons for a wide circle of friends in the literary arts at her summer home, Mostly Dunes. A love of the written word had been instilled in her by her mother, Mrs. Thomas Jefferson Mumford, a pillar of culture in both New York and East Hampton. Mark Twain was a close family friend, and Quick liked to recall being bounced on his knee when she was a child. He encouraged her to write; among her published works was *Enchantment*, her memories of Twain.

Despite her fragile health, including near-blindness, Quick was a woman of ideas—and action. In September, 1947, she announced in the *Guild Hall News*: "Having come to the conclusion that one branch of the arts has been neglected, we have decided to inaugurate a poetry contest. Anyone who is a poet at heart can enter. John Hall Wheelock, our dearly loved and most distinguished poet, will act as judge. . . ."

The first poem submitted was a whimsical entry by Dorothy Hamilton Brush; it appeared prominently in the next issue:

HAIL TO GUILD HALL

Oh mechanistic Atom Age
of our United States,
Where soul is nix and sonnets not
And only Bizness rates,
Pray take a look at Japanese
Before they fell a victim
To Western ways of war-craft
Until we had to lick them.

So vital to their life was
The art of poetry,
That it was a department
By Government decree.
But here? It sill might happen!
Take heart, ye poets all,
Rejoice, for we've been recognized
By derring-do Guild Hall.

Quick's poetry contest caught fire and over the next few years produced some works of "real quality," as Wheelock expressed it in a congratulatory letter in the February, 1948 *News*. Elizabeth Bogart, Jack Small, Barbara Leslie Jordan and May D. Rogers were among the contest winners.

John Hall Wheelock was widely known as the dean of American Poets, but locally he was considered East Hampton's poet laureate. A familiar figure on his daily walks along the beaches, he wrote some of his most

celebrated poems about "Bonac" and his beloved old shingled house, tucked into the inner dunes. One memorable afternoon in 1966 he was honored by Guild Hall on his eightieth birthday. Sparked by his neighbor Julie Hays and planned by Lynn Chase, the party and reading took place in the Moran Gallery. The birthday cake was borne up the aisle by Jean Stafford, one of America's most prestigious writers and a resident of Springs. Standing before the fireplace, Wheelock read several poems to the rapt capacity audience. Then the cake, and Conrad Thibault leading the audience in singing "Happy Birthday to You."

Some time later the David Tyson Foundation funded for us a film about Wheelock made by Robert Blaisdell, which would go on to win national awards. It was premiered as a special tribute to the poet in 1977. The program included a concert of Wheelock poems set to music by Pulitzer Prize–winning composer Norman Dello Joio. "I was very fond of Wheelock," Dello Joio said recently, "and when the Philadelphia Symphony commissioned me to write something, I chose to compose the Wheelock songs as a way of expressing my homage to a great poet. I remember his calling me up to tell me how pleased he was with my title: *Songs of Remembrance.*"

Wheelock's birthday party in 1966 had reawakened an interest in poetry readings, which is still very much alive today.

H. R. Hays, poet, novelist and playwright, spearheaded the new wave of poets reading at Guild Hall. His wife, Julie, described the new

GH ART COLLECTION GIFT OF THE DAVID TYSON FOUNDATION, 1982
John Hall Wheelock, celebrated poet, in a pencil portrait by Victoria Fensterer, part of a collaborative work with the poet, shown in the "Poets and Writers" exhibition.

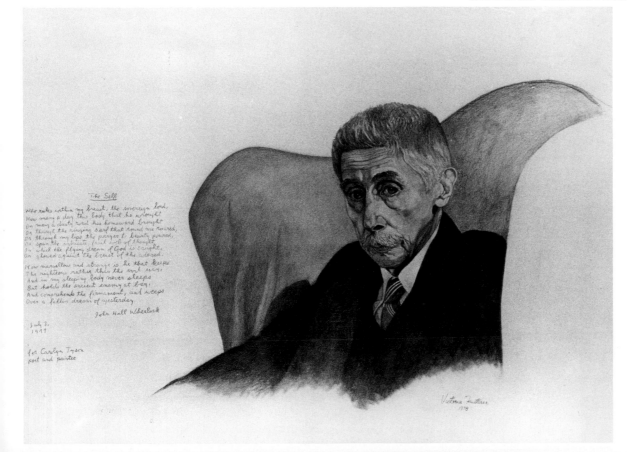

213

program: "Hoffman had unbounded enthusiasm. He wanted people to savor the language and ideas of poetry, to be able to hear the different voices just as you go to the opera to hear the arias done by different voices. We were getting quite a few poets out here in the late '60s, and then, when David Ignatow came along, he was as enthusiastic as Hoffman. That was where it all began."

Like Hays, Ignatow had published several books of poetry and prose, taught at several universities and was the recipient of numerous literary awards. With the energies of the two of them in our favor, we were able to maintain an average of eight to ten readings a year and, in addition, sponsor Poets in the Schools with poets Sandy MacIntosh, Kenneth Koch, Allen Planz and others conducting the student workshops.

Hays died in 1980. Julie remembers that at his memorial at Guild Hall, "All the poets came and read one of their own poems and then one by Hoffman. Mordecai Bauman sang 'Sweet land-a-shining, glory glory be/If a man has nothing, nothing at all/How can a man be free? . . . ,' which Hoffman had written for a pageant, and then Michael and Lillian Braude, always generous, held an open house afterwards." To commemorate her husband, Hays, with the help of the Braudes and other friends, established the H. R. Hays Memorial Poetry Fund at Guild Hall which further insures the continuity of the readings.

In 1970, we held the premiere showing of drawings of poets that Rose Graubart, Ignatow's wife, had sketched for her new book, *Portraits of Poets*. Several of the area poets were included, among them Armand Schwerner, Norman Rosten and Harvey Shapiro, all of whom read from their work during the run of the exhibition.

Looking back over the years, Ignatow mentions several poets whose readings he found particularly memorable: "Alan Dugan for his powers of observation; Stanley Kunitz for his depth of insight and compassion; Harvey Shapiro for his incisive city poems; Michael Braude for his grand sense of humor; Derek Wolcott for his strong sense of place (the Caribbean); Kenneth Koch for his rich comical vein; and June Jordan for her powerful portrayal of racial bias. . . ."

Budding young writers have also had their day at Guild Hall.

In 1967, Eunice Juckett (now Meeker), an English teacher and writer, inaugurated Sunday afternoon programs with East Hampton High School students reading from work that had appeared in their literary magazine, *Beachplums*. These programs were later directed by Barbara Bologna, an English teacher. Imaginatively staged and often combined with original music, these twice-a-year events continued for almost a decade.

The Three Muses: An Experience in Poetry, Music and Art epitomized Guild Hall's dedication to cross-fertilization of the arts. It took place as a series in the early '70s at artists' studios—Arline Wingate's converted coach-house, the loft of Sydney Butchkes' potato barn-studio, Cile Lord's

ROBERT TURNEY
Poet David Ignatow, long active in celebrating poetry at Guild Hall, has frequently read from his works.

ADRIENNE KITAEFF
Poet Laureate Howard Nemerov read from his works in 1990.

214

Kenneth Koch. poet and educator, conducted poetry workshops for Guild Hall at East Hampton High School in 1974. Barbara Bologna (left) served as coordinator for the project.

High school students in a program of readings from *Beachplums*, student literary magazine, at the John Drew (1977).

Michael Braude's multimedia poetry play was presented in the theater in 1979.

JAY HOOPS
First in the series, The Three Muses
took place in the studio of sculptor
Arline Wingate (center). Poets Allan Planz
and H. R. Hays read from their works,
and Judith and William Gaffney
performed music for flute and oboe (1973).

harbor-view studio—with readings by Armand Schwerner, Allen Planz
and R. B. Weber, and music by Jon Tooker, William and Judith Gaffney
and others.

This was one of the many events funded through the years by Poets
and Writers, Inc., a New York State agency founded in 1970 by Galen
Williams, who still serves as its chairman. She says now in looking back,
"The Three Muses was exemplary. Poetry shouldn't be put in a little box.
Interweaving it with the other arts makes it come alive—closer to what it
was originally, in the caves, where chanting, dancing and painting were all
part of one satisfying life experience."

Artists Howard Kanovitz, Jim Brooks and Kyle Morris all thought
it was a terrible idea when they were asked to help plan talks by artists for
the Monday night slots during the 1977 Summer Festival season at Guild
Hall. "Instead," Kanovitz recalls, "we wanted to do something creative—
a performance kind of thing with poets and artists collaborating. With
Guild Hall approval, we went ahead. The poet Kenneth Koch wrote a play,
the *Red Robins*, especially for this festival, and Arnold Weinstein already
had a play, *The Party—A Play with a Piano*, he wanted to try out. We
figured the artists were 'hams' and would like to act—plus, as artists we
could create the scenery. We called our project Poets and Artists Theater,
a continuation of an earlier one."

Koch entered into the collaborative spirit, calling upon artist Kyle
Morris to create the set pieces, and a number of others in the arts to be
in the cast. Larry Rivers, for instance, played a dog. Taylor Mead, an Andy
Warhol star, played six parts, including The Slimy Green Thing and the
Chinese Philosopher. Christophe deMenil, designer and philanthropist,
created the costumes. *The Party*, however, almost got out of hand when

KATHRYN ABBE

Christophe de Menil, cast member and designer of costumes for Kenneth Koch's *The Red Robbins*, during a rehearsal break.

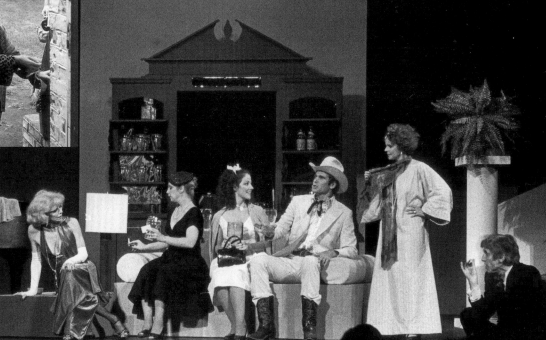

JAY HOOPS

Scene from Arnold Weinstein's *The Party: A Play with a Piano*, second offering in Poets and Artists Theater.

PHILIPPE MONTANT

Larry Rivers played The Dog in *Red Robbins*.

KATHRYN ABBE

FAR LEFT

Some of the key "players" in Poets and Artists Theater: Howard Kanovitz, designer of sets for *The Party*; Kenneth Koch (in the cockpit) with his *Red Robbins'* set designer, Kyle Morris (second from left) one of his actors, Larry Rivers; and his director, Donald Sanders.

Weinstein, for whom Kanovitz had pledged to design the sets, decided he had to have professional Equity actors for his play, thus stretching the small budget beyond its limit. It looked as though we might have to cancel until Christophe deMenil came to the rescue, donating enough money to see the production through.

"Rehearsals for the two plays took place simultaneously," Kanovitz says with amusement, "one on stage and the other in the basement of the new wing, and from the first, the difference in style was apparent. "We—*The Party*—would send out for sandwiches and Cokes from the Chicken House, whereas the *Red Robins*, with Christophe's help, would have the 'déjeuner célèbre' with elegant picnic baskets, real linen napkins, fine wines, cold chicken with little sauces and salads. Two different scenes were going on, one in the lap of elegance, the other decidedly more proletarian."

The whole artists' community turned out to view both plays. The opening receptions were particularly spirited, with various artists donating their culinary specialties. *The Party*, a more conventional play, and with a professional cast, was the better received. "Even so," Kanovitz commented much later, "Ken's play was in a way more in the spirit of the poet's theater. The challenge was in the poetic aspects of his language and what the actors would do."

Robins was later produced in New York, with Red Grooms, Roy Lichtenstein and others designing the sets, some of which were donated to the Guild Hall art collection, along with Kanovitz's set piece for *The Party*.

Through the late '80s and into the '90s, Guild Hall has responded to a revived interest in poetry readings and talks by authors. Among the poets who have appeared in recent years: Poet laureate Howard Nemerov, Pulitzer Prize–winner Carolyn Kizer, Amy Clampit, Lynn Emanuel, Philip Appelman, Siv Cedering and Stanley Moss. Among the writers: Gail Sheehy, Martin Gottfried, John Gruen and Faith Popcorn.

KATHRYN ABBE
Guild Hall trustee Emilie Kilgore
and Willem de Kooning at a performance
of Poets and Artists Theater (1977).

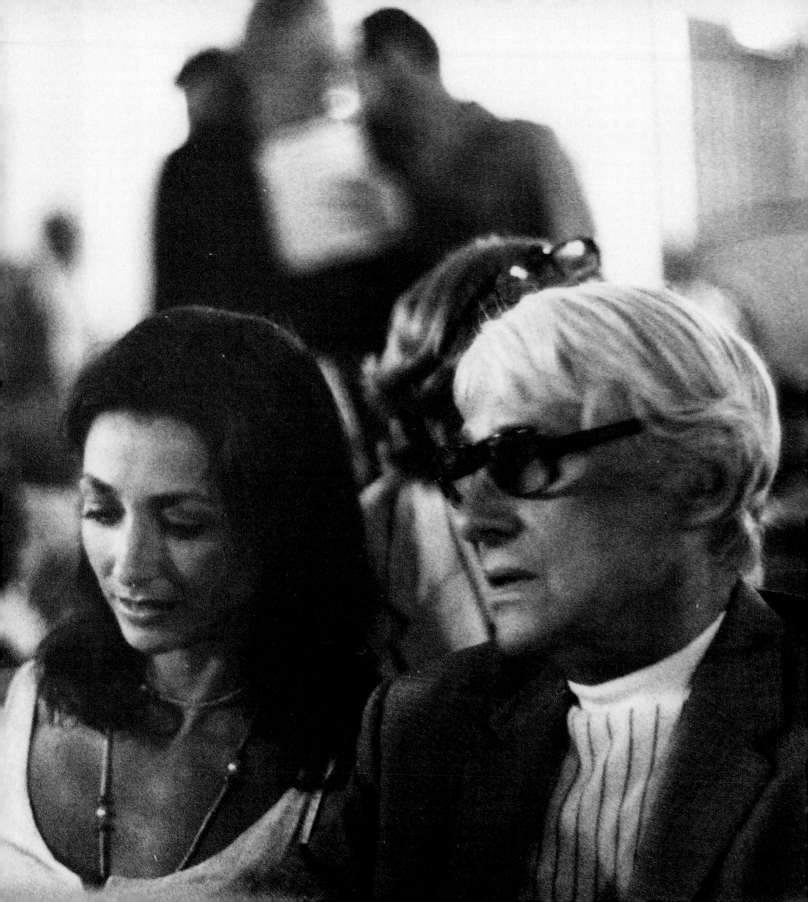

FOR THE COMMUNITY

Guild Hall's essentially open mandate—"to encourage a finer type of citizenship"—has challenged us from the beginning, as we've worked toward achieving a balance between educational-community events and those considered cultural in a broader sense. It's a fine balance, however; cultural and community events frequently, and effectively, overlap in an institution that aspires to interweave disciplines.

By 1935, according to the *Star*, Guild Hall was the meeting place of many civic organizations—the East Hampton Taxpayers' Association, the Women's Republican Club, the Young Men's Republican Club, the Ladies Village Improvement Society, the Women's Auxiliary of St. Luke's Church, the Ramblers and the East Hampton members of Daughters of the American Revolution. Early

JAY HOOPS

Bruce Collins, superintendent of public works;
and Ronald Rioux, mayor of East Hampton, put Hook Mill in working order
for the historical tour, Up and Down Main Street (1974).

on, too, the Mothers Club held a reception every year at Guild Hall for the new teachers. And from the '40s on, trail-blazing education programs and community-service functions were instituted to fulfill the dictates of the New York State Educational Charter. To put it another way, Guild Hall is perhaps best used in a mix-and-match way: Choose what you want to take, and give, to make it your own community cultural center.

Taken together, says David G. Rattray, for example, who first became aware of Guild Hall when he was "five or six" years old, the scope of events he experienced here were tantamount to an education or an awakening: "I hate to think of how lopsided my education would have been without Guild Hall." He took advantage of everything Guild Hall had to offer.

And what an education! "I was in the first grade when I was drafted to be the midshipman's 'mite' in *Pinafore*. I used to walk to school the back way, cutting through back yards and potato fields, singing the songs and reciting the lines. I can remember learning my lines, which were modest, indeed. By the end of the rehearsals, I knew every line in the show." After this introduction to theater, he attended subsequent productions, along with films, mostly foreign, that were presented during the winter. He took ballroom dance classes, attending meetings of the Camera Club, and played an all-Beethoven piano recital; much later, as a poet and dictionary editor for *American Heritage*, he would return some of Guild Hall's favors by lecturing on lexicography.

What he remembers most, perhaps, is visiting Guild Hall during his most impressionable years—ten, eleven, and twelve. "I was there when there was a really major break in our visual sensibilities—to see Genthe and Steichen." As for the first artists of the region shown in 1949, and seeing Pollock's huge canvas for the first time, Rattray says, "It made the biggest impression on me of any exhibition I have ever seen in my life. I went back every day that show was there."

Nor was his civic education at Guild Hall ignored. As a member of an old East Hampton family (his parents were Arnold and Jeannette Edwards Rattray, publishers of the *Star*), our local heritage has always been important to him, and he can remember the Guild Hall Players re-enacting the history of East Hampton in the *Calvalcade* on the village green to commemorate the village's 300th anniversary. The highlight for him was his grandfather and his off-shore whaling boat.

Rattray remembers lectures like Buffie Johnson's "Images of the Great Mother," and his own entry in the *Walls* exhibition in the mid-80s, where he contributed a poem called "To the Blue Wall," later revised and included in his latest book of poetry, *Opening the Eyelid*.

Rattray even received something of a sartorial education at Guild Hall when as a boy of about twelve he won first prize for the most imaginative costume at a Guild Hall party—a kind of safari outfit, with pith helmet, a short-sleeved khaki shirt, short pants and boots, accessorized by a crocodile his grandmother had made for him!

Capt. E. J. Edwards and his old off-shore whaleboat crew, in a demonstration for East Hampton's 300th Anniversary Cavalcade presented by Guild Hall Players on the village green (1948).

222

"The reason I wanted to do it," says Michael Smollin, referring to his having accepted the daunting position of co-chairman with Clyde Matthews of the big, year-long 50th anniversary celebration of Guild Hall in 1981, "was because Guild Hall had provided me with so much inspiration, help and joy in a lot of things in my life, and the chairmanship job was something I wanted to do to say thank you a little bit."

Smollin's extensive reminiscences seem to inform every aspect of his life; Guild Hall seems to have provided a cultural, civic and educational refrain to his life. He credits Mrs. Woodhouse with encouraging his interest in art back in the late '30s; in fact he went on to become an illustrator and advertising executive. "I remember the first time she took notice of me. There weren't too many people my age who came to the art exhibitions, and on one occasion she asked me what my interest was. I said I had hopes of becoming an artist. I can't remember her words or how they were framed, but what she said was very supportive of my going off to do whatever I wanted."

Smollin feels Guild Hall truly nurtured his work. He was on the Junior Art Committee, which taught him about organizing and hanging exhibitions and enabled him to meet our community of artists. He learned the fine points of set design by working summers with Frederick Stover. "I was really a little nervous about going to work there with a professional who had such a reputation in Broadway theater, but Fred was an incredibly nice person and made me feel very much at home.

"I have a strong feeling about what Guild Hall does for the community. I know with my own children I was able to expose them to lots of experiences from which, perhaps, they could make up their minds about what's going to interest them and what they're going to do in life. . . . How wonderful for *any* child to be able to go to Guild Hall, experience a play, hear a concert, see an exhibition, watch a painter actually work."

JAY HOOPS
Clyde Matthews and Michael Smollin, co-chairmen of the 50th anniversary celebration (1981).

Doubtless the most talented, exuberant and tireless volunteer ever to turn up at Guild Hall was Bran Ferren. He and his parents, John, an abstract painter, and Rae, also an artist and later associate curator at Guild Hall, moved to East Hampton year-round in the '60s. Bran was only thirteen and already an electronics whiz kid when he found himself "gravitating toward Guild Hall."

We were actually the lucky ones! Now president of Associates and Ferren, an innovative design and research company, and an acknowledged master of special effects for stage (*Evita, Cats, Sunday in the Park with George*) and film (*Altered States, Little Shop of Horrors, Death Trap*), Ferren thinks back on his fifteen years of helping out at Guild Hall with special fondness. "For me," he says, "Guild Hall was like a large laboratory in that I could experiment with a whole collection of things—whether it was opening a jammed lock on the front door or building a theater set, anything that I hadn't done before. At the same time it was, still is, an inter-

esting exposure to the performing arts and the art world. I made contacts I've maintained to this day: Sidney Lumet, the film director, Tony Walton, the scene designer. . . ."

During his years of volunteering, Ferren selected, and often ran, a new movie projection system to replace the antiquated one that had been in the booth for years. (Sometimes, he says, this job included "repairing prints that often arrived patched up with chewing gum and staples.") He started a program to train stage technicians after renovating the rigging and lighting; presented experimental films of his own, including the premiere of his first feature-length film, *Funny*, which won a "gold" at the Houston International Film Festival; and designed a new grid track-lighting system for the exhibitions galleries. "That was fun," he says. "It gave me an opportunity to learn about exhibition lighting that has been useful to me to this day. . . .

"What's special about Guild Hall is its collaborative atmosphere. One of the things that impressed me was that you did not necessarily do what was the safe and obvious, but took chances. There was some very innovative theater. Guild Hall was alive with many things. I liked being part of it. What it did for a great number of people, myself included, was to be a vehicle which enabled you to learn about and hone your skills. It's just a generally warm feeling I have about the place."

Besides providing such broad educational experiences, we have also maintained a structured program of classes and workshops, with as many as twenty different subjects covered in a given year. Most consistently scheduled were the art classes in all their variations—painting, sculpture, drawing, print-making, art appreciation, as well as photography and crafts, from ceramics to bookbinding. In the performing arts, acting classes and stagecraft have been popular. As for the literary arts, courses in poetry have been among the most popular.

Attracting a particularly devoted group of followers, the Great Books Discussions, under joint sponsorship with the East Hampton Library, were started in the '50s and were still going strong some twenty years later.

Education chairman Kelsey Mansir and, later, Betty Marmon, were attuned to Guild Hall's community center role. As Marmon described it, "Every time a handful of people requested a class, no matter what the subject, we tried to set it up—courses in foreign langauges, speed-reading, bridge, chess, yoga, safe driving and so on." We did stop, though, at a request for a dog obedience class.

Guild Hall has also developed a broad outreach program to the schools. In addition to encouraging teachers to bring students to its cultural events, we have taken exhibitions, artists, actors and poets to the schools as well, and throughout the '70s and early '80s had as many as fifteen mini exhibitions circulating to schools and libraries throughout eastern Long Island. What is more, since 1971, Guild Hall has presented

GH ARCHIVES
Harold Webber (standing)
with his bridge class (1960s).

224

annual awards to outstanding high school seniors in art, drama, music and literature.

The whole village cooperated to make the living history outreach project, Up and Down Main Street, a success in 1974. Based on Jeannette Edwards Rattray's book of that title, it featured visits to historic homes and sites with costumed residents enacting scenes from life in earlier times. Then-mayor Ronald Rioux put the historic Hook Mill windmill, which had been idle for thirty years, in operation especially for the occasion. Mark Hall played schoolmaster in the Historical Society's little one-room schoolhouse, community women held a quilting bee at the Lyman Beecher House, Elbert Edwards shod horses at Mulford Farm, a fisherman's family mended nets in the yard of the old Huntting homestead. There were dozens of events, including maypole dancing on the green. Well over a thousand young people were bussed in from area schools. The event was so popular it was repeated the next year, this time with the students themselves portraying the village characters. Jean Dayton and Judy Ackerman were the organizers.

Interaction with the schools has continued to the present in other imaginative ways—school vacation creative workshops, special classes for parents and children to discover art together and talks for young people by professionals about exploring careers in the arts, for example.

The Education Committee (1966):
Ruth Wolkowska; Mary Maguire;
Carlo Grossman; Margaret Young, chairman;
Janet Grossman.

WILLIAM BOONE

DAVE EDWARDES
Dr. Wayne Barker conducting one
of the Great Books discussions (1958).

COURTESY OF THE EAST HAMPTON STAR
Jack Ramsey and his painting class (1972).

A PLATFORM
FOR THE
EXCHANGE
OF IDEAS

To William Dreher, a recent board chairman, "The answer to reducing the gap between the different segments of the community is education. We've made, over the last several years, a large effort to strengthen the education function. For that we have to thank Lillian Braude, trustee and former chairman of education, who was a persistent voice in urging access to the local schools, coordinating with the schools to broaden the aesthetic spectrum and to get their parents interested."

As early as 1932, Gilmore Clark, a parkway designer for historic Williamsburg, talked to a rapt Guild Hall audience about routing the Main Street through-traffic *around* instead of *through* the village. A couple of years later, Marvin Shiebler was delivering another urgent message about safeguarding Suffolk County's water supply. Not long afterwards the subject was "The Future of the East End Fishing Industry." By the '60s, the AAUW and Guild Hall were jointly conducting regular panel discussions on such subjects as women's rights and narcotics use among the young, topics that are as relevant today as they were thirty or sixty years ago.

Of special importance to Guild Hall's "town meeting" role were the AAUW's annual Meet the Candidates nights initiated in the early '60s. Roma Martin, who has been active with the AAUW for many years, recently observed, "We were the only organization on the East End to present two sides of the political issues. We did the forums every year up to the early '80s. We gave all parties, on the town, state and national levels, a crack at explaining their platforms, and the audience a chance to question the speakers. There was some pretty hot give and take. It was a real community service."

Newsday led off its October 19, 1974, story about the debate between candidates for State Assembly and Congressional seats this way: "The 400-seat John Drew Theater was full to overflowing last night for a show that offered humor, anger and enlightenment, and led one spectator to observe that it was almost better than going to the theater." The audience became so boisterous at one point that the moderator had to call for no further comments from the floor.

Some of our symposiums had their lighter sides, too. There was, for instance, the night in 1969 when Bill King, a sculptor with a mischievous sense of humor, picketed the Guild Hall panel discussion "Is American Art Chauvinistic?" for which the critic Harold Rosenberg was moderator, and artists Warren Brandt, Adolph Gottlieb, Lee Krasner and others were panelists. King remembers: "It was such an idiotic subject and panels are a blight! Dwight and Gloria Macdonald, my wife, Annie, and I got all dressed up. I wore my Greek silk suit and the girls wore evening gowns. I went to Dreesen's and got a whole bologna and a knife. Then I printed up paper napkins in red that said, 'This is the real baloney.' So we stood outside of Guild Hall and, as the people went filing in, we'd put the bologna on a napkin and hand it to them, saying, 'This is just a sample of

what you're gonna get inside, folks.' They'd laugh, you know. But it was a wonderful protest. Lee Krasner ate hers like a real trooper."

Some of the lectures appealed to a whole different crowd. Nature was a favorite subject. The *Star* (August 8, 1935) reported on a garden talk in that year, noting that "to see an oxalis plant going to bed at 5:30 P.M., turning over in its sleep at 2:30 A.M. and waking for the day at 8:30 A.M. was something nobody in the audience will ever forget."

The Guild Hall Education Committee has sponsored countless discussions on serious issues. One, planned by Howard Barry, chairman in the early '60s, was "The Future of East Hampton Town," which caused such excitement that we expanded it to three nights, with panelists representing a broad spectrum of the community—Abe Katz, owner of Dune Alpin Dairy Farm; Milton Miller, president of the Baymen's Association; John Ecker, Town Justice of the Peace; Perry Duryea, State Assemblyman; Hester Cheney, head of the East Hampton Library. . . .

Barbara Delatiner, *New York Times* reporter and member of Betty Marmon's Education Committee in the early '70s, also planned several series of symposiums. One was called "The Quality of Life" and covered such subjects as "A Look at Ex-Urban vs. Urban Living," "Art and Pornography" and "Sex and the Teenager." Her panelists included David Osborn of the Town Planning Board; Robert A. M. Stern, architect; Martin Gottfried, theater critic; and Dr. Stephen Sigler, physician. "It was a way of bringing in the local people and giving them some insights into the problems facing us all," Delatiner said later. As to the coincidence that the same issues have been discussed all through Guild Hall's history, "There are certain constants," she says. "That's the answer."

Some years later Sherrye Henry, trustee and WOR Radio interviewer, gave the symposiums her own twist. "It all started in 1983," she recalls, "when Wilson Stone, who was in charge of the theater at the time, came to me and said, 'We have four empty Tuesdays in July. If you had four empty Tuesdays in July, what would you do with them?' I said, 'I would probably do something that wouldn't be of great interest to you. I would probably go into some subjects that concerned moral values and ethics. It seems to me that people are hungry to talk about that sort of thing.' He said, 'Well, go ahead and do it!'

"So I came up with a plan of talking about morality—morality that touches American lives in four different ways: morality in business, in the press, in the movies, in politics. We would find the best authorities on the subjects who happened to live here and let the town come and talk to them. Everybody had to feel they had a part in it. One aim was to make the residents feel more comfortable with each other. We wanted them to feel that it was like coming into a living room. People were urged to come dressed as they wanted to—blue jeans, jackets, no tie, sneakers. I remember Don Marron was one of the panelists. Some of the others were William Safire, Ed Bleier, John Lindsay, Don Hewitt, William Simon, Ken

RAMESHWAR DAS. © 1988
Sherrye Henry (second from left) with her Hot Topics panelists for "Corruption in Government": Stanley Fink, Judith Hope, Richard Emery (1988).

Auletta. . . . It took off in a really wonderful way. We played to standing room."

The programs, which continued for several years, received excellent feedback, which gave Henry the greatest satisfaction of all: "I would meet people all over town, in the A&P checkout line, the post office. One shopkeeper said, 'Our study group is going to take up the discussion on morality.' I loved that. It meant Hot Topics had another life. People seemed grateful that Guild Hall offered them the chance to be thoughtful."

FRIENDS AND VOLUNTEERS

GH ARCHIVES
Anne O'Rourke, volunteer head usher for over 20 years (1950s–70s).

What motivates people to make extraordinary gifts of talent, time and energy to a center like Guild Hall? There are as many different answers as there are volunteers. Helen Hoie, a trustee whose dedication encompassed just about every branch of Guild Hall's activities, expresses it this way: "It was what Guild Hall did for me. It brought me recognition as an artist, and I will never forget it.

"In the late '60s, Guild Hall had a Young Collectors Gallery, organized by Merrill Lake and showed rotating works by artists, most of them relatively unknown, for under $500. I was invited to be a part of it. One day Werner Kramarsky, an important collector, stopped in to have a look. He asked to see more of my work, came to the studio, bought some of my paintings and then recommended me for a show at a local gallery. One show led to another and, before long, I had Babcock as a New York dealer and was on my way. I just feel that the exposure at Guild Hall was a great stimulation to my career."

Hoie has worked tirelessly for Guild Hall ever since that first show, twenty years in all.

It was Hoie, for example, who early on recognized the need for an auxiliary support group for Guild Hall and with Dorothy Stone, Alice Mund and Helen Busch, formed the Friends of Guild Hall in 1973. Mary Steen Johnson joined forces and drafted the bylaws.

Busch remembers the first organizational meeting. "We were very enthusiastic," she says. "The first thing we did was determine Guild Hall's needs and set up the support divisions: clerical assistance to the staff, docents for conducting student tours through the exhibitions, hospitality at openings, sales personnel for the museum shop, ushers for the theater. I've been a member ever since and have found great personal satisfaction in heading the docents' program."

Stone, the first president, saw the Friends as a public relations arm to Guild Hall. "I thought we could help bring the local community closer to us," she comments. "We put together a slide show about what Guild Hall has to offer and presented it to the various village organizations—Lions Club, Rotary, the Ladies Village Improvement Society, even the Baymen. We encouraged schoolchildren to bring their parents to the exhibitions and served refreshments. We had a wonderful response."

Alice Mund, who followed Stone as president, adds that, "As time

PHILIPPE MONTANT
Walter Fried, board chairman,
presenting the Friend of the Year award
to Alice Mund (1974).

SANDRA WEINER
Helen Hoie presenting
Miki Denhof with an award
for her volunteer work
as graphics designer (1975).

NOEL ROWE
Oscar Weinberger (center), Guild Hall's
long-time treasurer and a host for the party
honoring volunteers (1981). With him,
benefactor A. R. Landsman (left)
and volunteer Saul Levinson.

NOEL ROWE
Budd Levinson, board chairman,
congratulating Edith Parsons
for personally bringing in 150 new
memberships in a single year (1981).

ADRIENNE KITAEFF
Joe Gorsuch with his citation (1990).

PHILIPPE MONTANT
Fred Echevvaria, Friend of the Year (1977)
and Sally Armbruster who served on
exhibition committees.

RISING TO THE CHALLENGE

went on, we decided that with all the hours these volunteers were giving, we should try to make the meetings very special. Jeanette Saget came up with the idea of meetings at artists' studios and asking the artists to talk about their work. We've since visited the studios of Audrey Flack, Howard Kanovitz, Elaine de Kooning and many others. Another thing we did was to establish the Friend of the Year Award to recognize outstanding volunteers. (NOTE: Award winners are listed in an Appendix.)

The Friends do not consider themselves fund-raisers, yet through the efforts of past presidents Florence Kulick and Dora Masoff, they made enough money on their monthly bus trips to New York (sometimes with visits to the museums) to renovate the Guild Hall kitchen and provide $15,000 toward a Steinway concert grand piano.

The board now includes one trusteeship specifically for a representative of Friends, thus creating an even closer bond with this dedicated group of volunteers.

"Because our services are so varied," Beatrice Mathes, a recent president, says, "it requires much careful planning to properly channel the talents of 200 members. The secret is in finding the job that will be a rewarding experience for each person."

It became obvious early on in Guild Hall's history that, except for Mrs. Woodhouse, there were no large donors coming forward to help keep the doors open. Until 1940, Mrs. Woodhouse covered most of the operating expenses singlehandedly. Beginning to feel the strain, she told the board and members at the annual meeting that year that somehow they would have to find a way to make Guild Hall self-sustaining. The community rose to the challenge and from that time on has presented several fund-raising events a year. From the $50 bake sale to the $100,000 auction, all are important because they draw people together for a common purpose.

As Rosemary Sheehan expresses it (and she should know, as she was chairman of Guild Hall's benefits for ten years beginning in 1973), "I loved planning those big community fundraisers, the kind where you meet new people, move around, talk, laugh, dance and maybe even do a little flirting. I've met half the town. If I wanted to run for mayor, I probably could. Everyone likes to feel they're helped.

"My favorite of all was *Who Is Killing the Great Chefs of Europe?* It was Peter Stone's film, and he had given us the premiere, klieg lights, stars and all. We had a party afterwards in the galleries, with twenty-four fabulous desserts by twenty-four caterers and restaurants in our area. Most of the chefs were present, too. From Miriam and Sidney Perle's 1770 House there'd be their double chocolate cake and from Gordons, their luscious pecan pie. From Anna Pump, pears poached in wine—each dessert more beautiful than the next. It was the funniest and gayest party I think we ever had at Guild Hall."

Many of the benefits stretched beyond our Main Street headquar-

ters—the benefit fireworks, for example, that clearly couldn't be held in the John Drew.

George Plimpton, well-known fireworks maven and Guild Hall trustee, agreed to put together a Grucci Brothers spectacular as his contribution. "We had a real problem finding a location," Sheehan remembers. "We tried the schools, some of the big estates, but everyone was scared to death of the idea. Then finally the police suggested putting them on the water. Boys Harbor seemed right and Tony Duke, who runs it, right away said, 'Here's the lawn and there's the water: perfect!' We hired a barge and, just as the show was about to start, the rear end of the barge sank! We lost a few fireworks; that was really something. But even from the beginning, the event really took off—five hundred people in 1980 (the first year), and up to a thousand only a couple of years later. It was beautiful, with people setting up elegant picnic suppers on the shore and on their boats."

Sheehan never ran out of ideas and grand gestures. Evelyn (Evie) Wechsler and she organized the first big New York auction, for instance, to take place at the Union Club, and somehow produced spectacular items from every direction, as if by magic. At the last minute, though, someone suggested that there be a door prize. Sheehan sprang into action, literally stealing a great old door from Grey Gardens, the legendary estate that Ben Bradlee, then editor of the *Washington Post*, and writer Sally Quinn had just bought from the estate of Edith Beale. To make the stolen door even more of a collector's item, the artist Paul Davis painted a cat on it (the Beales had loved cats, which in their time could be seen in large numbers most any day sunning themselves on the roof).

The event was a huge success, capped by the announcement of the winner of the door prize. "The woman whose name was called came forward," Sheehan laughs, "hoping to collect a little chinchilla wrap or something, and being absolutely horrified that she won a door for a door prize."

The postscript was Bradlee's surprise when he read the story in *The New York Times*. He wrote Sheehan a letter that said, "Only you would have taken my door. I'm glad it was for a good cause."

During the '70s and early '80s, the staff coordinator for the benefits was Mary Frayher whose efficient help (often including her husband as a volunteer) kept the events flowing smoothly.

The New York City theater benefits have been steady fund raisers, beginning in 1970 with *Applause* starring Lauren Bacall. Jo Raymond, who organized many of them, observed: "Beside raising money, they were a nice way of getting people involved. We had many addressing sessions in my home—people sitting around mounds of envelopes—using all the little kids to help lick stamps."

Involvement was characteristic of community benefits in the earlier

COURTESY *EAST HAMPTON STAR*
Rosemary Sheehan,
Special Benefits chairman,
as the Statue of Liberty
at a party in 1986.

PHILIPPE MONTANT
Committee for fireworks benefit at Boys' Harbor:
Anthony D. Duke; Freddie Plimpton; Elaine Dannheisser,
chairman; and George Plimpton (1980).

JOHN REED
Village Vanities committee (1963). Mildred Granitz, chairman (later Guild Hall publicity director); Ione Stoddard, Marjorie Kennard.

years, too. New Year's Eve night club parties, based on themes such as the "Roarin' Twenties" were highlights in the '50s and '60s. They were bring-your-own-bottle affairs in the glamourously decorated galleries with the committees, under the direction of board vice-chairman Ralph Frood, local innkeeper, furnishing the food, and Guild Hall Players providing the floor shows. There were always high-kicking "Rockettes" and such comedy specials as Andrew (Drew) Lawrie's rapid-fire impersonations of famous people done by switching dozens of different hats.

We also held candlelight tours to view the Christmas trees and decorations in the homes and inns around town. One of the most unusual benefits was "Exotic Birds in Garden Settings," arranged by Marie Olssen, aviculturist and mother of June Dunnet, Guild Hall's secretary. One artist took exception to the framed yarn "painting" labeled "Abstract Art by the African Weaver Birds." He didn't think it at all funny.

GH ARCHIVES
Frederick Stover's cover for Vanities playbill.

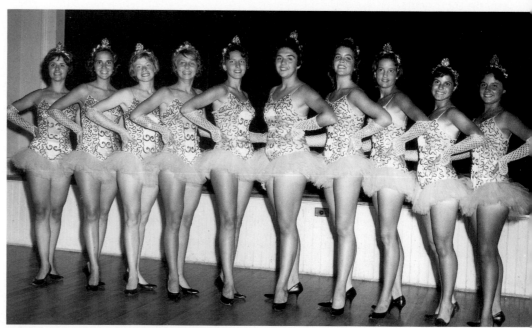

WILLIAM BOONE
Village Vanities "Rockettes" (mid-'50s).

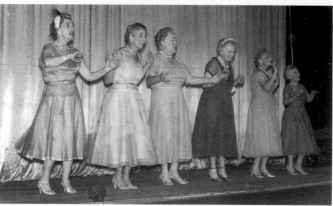

GH ARCHIVES
"We're the Girls You Used to Know," Village Vanities (1957): Monica Barns, Esther Bromley, Marian Myrick, Edith Siter, Louise James, Maude Taylor.

For total community involvement there was perhaps nothing to equal the Village Vanities, in which the summer and year-round residents joined together to kick up their heels in lavishly costumed, professionally directed variety shows where everyone was a star. Beginning in 1954, the Vanities lasted a decade. In addition to all the fun, they also changed a few lives.

Heddie Bates Edwards remembers only too well that it was at the very first Vanities that Robert Montgomery, the movie star who was master of ceremonies, recognized her talents and guided her toward a career in theater. "Besides telling me to get my teeth fixed, introducing me to Helen Menken, who got me into her theater program, and suggesting that I study drama (which I did), he also said, 'Be sure you maintain your weight, keep your health, never listen to an audience, be a businesswoman first and use your "theater" to benefit your own life.' And that's exactly what I did. I've had a wonderful life, and all because of the Vanities." She used Montgomery's advice to go on to become a top model.

Taking the limelight in more recent times, "Joys of Summer" was initiated in 1984 by Joanna Rose and Clorinda Gorman, and featured up to forty lunch and dinner parties, most with entertainment, over one summer weekend, a program continuing to 1989. Gorman says the secret to "Joys" was that, "People love meeting others outside their own little group of friends. They love exploring the diversity of architectural styles of the homes. They love good food and entertainment. To this day Guild Hall gets calls wanting to know when we're going to bring back 'Joys.' "

And no wonder, the choices were endless. Ballerina Sono Osato and Victor Elmaleh served lunch on their porch overlooking the water, and Sono herself danced for the guests. Joanna and Daniel Rose brought up a jazz band from New Orleans for their lawn party buffet. Jack Lenor Larsen, the fabric designer, had a champagne croquet party at his Round House. Famous cookbook writers Craig Claiborne, Pierre Franey and Florence Fabricant prepared special gourmet meals. Some parties, like Marion and David Porter's Moroccan evening, had ethnic themes. Al and Hilva Landsman took their guests by plane over to Block Island for lunch. The children had their day, too, with a Big Apple Circus hosted by Virginia and Alan Slifka, and a hayride given by Mary Jane Brock and Diane Van Amerongen. Celebrity Tennis, for which Suzanne and John Cartier were largely responsible, was so popular that it finally spun off into an event on its own, continuing through 1991.
"Plants and Trees in Art" was conceived by Ruth Widder, a trustee admired for her inventiveness, and David Seeler of the Bayberry Nurseries as chairman. It involved the community in an entirely different way.

From 1986–90, nursery owners donated rare specimens and provided breathtaking landscaped settings on which to hold the auctions. Judith Sneddon, then Guild Hall director, observed that drawing in the

Planning a fund-raiser: Lynda Miller chairman; Joan Brill; Marian Ely, co-chairman; Mary Horne, Beth Gardiner, Adelaide Osborne (c. 1963).

MORGAN MCGIVERN, *EAST HAMPTON STAR*
Among the generous hosts who entertained at their homes for the 1989 Joys of Summer benefit: Jerry Della Femina (left) and his wife, Judy Licht (extreme right) shown here with daughter Jody Della Femina and Andrew Saffir.

businesspeople expanded Guild Hall's circle of friends and supporters. "There's an old saying, 'Your heart is where your time is.' You're going to love a place that you've done something to help."

Filmmaker Frank Perry, the driving force behind our Lifetime Achievement in the Arts Awards, which has turned into Guild Hall's biggest fundraiser of all time ($236,000 in 1991 alone), says the award was not originally conceived as a money-maker but as a way to honor the artists in our area.

"It was originally an idea of Sherrye Henry's," Frank Perry recalls. "She was then on the board, in charge of special events. She had once observed that acre for acre, this place has more talent than anywhere in America. We got together with Budd Levinson, who was then chairman of the board, and worked out the plan; that was in 1985. There were to be three categories of awards: visual arts, performing arts and literary arts. The criteria were that the winner must live on the South Fork east of the Shinnecock Canal and have done a body of work worthy of recognition in his field.

"That first day we put together a jury that would decide on the winners: Peter Stone, Peter Jennings, Sydney Gruson, Joseph Cullman, Roy Lichtenstein . . . eleven of us in all. We met at my house, voted in secret and counted the ballots right then and there. We decided to ask the winners to join the eleven of us and become the Guild Hall Academy of the Arts. In 1991, we were up to fifty-five members. At the time, we thought if the awards dinner broke even, it would be all right. I think the first year it made something like $29,000, and it's been going up ever since."

"It would never have happened if it hadn't been for Frank Perry," Levinson says. "He had the concept of how to honor the talent and how to carry it out, a concept that has created a meaningful association with the artistic community, one that can go on indefinitely."

The black-tie dinners have been masterfully orchestrated at such places as Tavern on the Green, and the Pierre and Plaza hotels in New York. "Karen Karp is extraordinary," says Perry. "She's been the engine for three years." And Peter Stone, who was honored with a special award in 1988, has played stellar host as the incomparable master of ceremonies.

The list of recipients of the awards given in the few short years since 1985 reads like a Who's Who in American Arts and Letters:

1985	Kurt Vonnegut, Willem de Kooning, Alan Alda
1986	E. L. Doctorow, Saul Steinberg, Sidney Lumet
1987	Joseph Heller, Roy Lichtenstein, Jerome Robbins
1988	Tom Wolfe, Larry Rivers, Itzhak Perlman
1989	Peter Matthiessen, Charles Gwathmey, Paul Simon
1990	John Irving, Paul Davis, Lauren Bacall
1991	Edward Albee, Richaed Meier and Frank Perry himself

Frank Perry, Academy chairman; with Karen Karp and Luly Duke, co-chairmen for the 1989 Awards Dinner.

NOEL ROWE

PAMELA CAMHE. *EAST HAMPTON STAR*
Four white beards at the Lifetime Achievements in the Arts Awards Dinner, Tavern on the Green (1987): Jerome Robbins, award winner in the performing arts; Lee Bailey; Sydney Butchkes; Marshall De Bruhl.

234

Members of the Guild Hall
Academy of the Arts
who served as jurors for the
Lifetime Achievement in the Arts
Awards (1985): Roy Lichtenstein,
Frank Perry, Joseph Cullman III,
Peter Jennings, Sydney Gruson,
Wilfrid Sheed. (seated) Elaine Steinbeck,
Henry Geldzahler, Sherrye Henry.

Daniel Rose and Joanna Rose,
Guild Hall trustee, at the 1990
Celebrity Bash honoring Frank Perry
and the Guild Hall Academy of the Arts.

In accepting his award, de Kooning, through his wife, Elaine, said he
didn't ordinarily accept awards anymore, but that "Guild Hall is different.
That's family."

THE DECADES
AN OVERVIEW

There are still a number of people who can remember life in East Hampton in the years just before Guild Hall opened, when bootlegging took up the headlines in the *Star* ("Three Slain in Dry Raid on Rum Runners"), and when one of the local controversies was whether or not the village should install cement sidewalks (the Ladies Village Improvement Society said no). At the same time, the Depression was deepening; the unemployed were put to work building new roads for the town. But from the time of its celebratory opening in 1931, Guild Hall served as a local antidote to the nationwide despair, providing an instant gathering place for the community. Now residents could enjoy singing together in a chorus,

George Plimpton's fireworks at Boys' Harbor (1982).

1930s

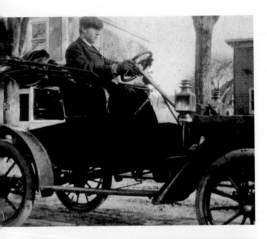

Nelson C. Osborne, Guild Hall's longest serving trustee (1931–67) shown above as a dashing young man about town, and below in his office in the '30s when he served as Guild Hall treasurer.

seeing a play or exhibition, helping to build a stage set. It was all there for free—or at most a dollar or two for a ticket.

The genteel East Hampton ways were coming up against the harsher, new Depression realities. At Guild Hall, however, a tempered elegance prevailed. Mrs. Woodhouse presided over the early tea party exhibition openings with a beautiful silver tea service and always one of Edie Parsons' huge coconut cakes that were, at the time, locally and justifably famous. It was all so beautiful. Guild Hall was furnished then in rose-colored rugs and very handsome, if not terribly practical, furniture covered in floral prints. In a sense, it was almost too beautiful to touch.

In those days, opening nights in the theater were very special events. Mrs. Woodhouse could always be found in Box D on the aisle dressed to the nines in a beautiful evening gown as were the other grande dames who set the early tone for Guild Hall. Even the ushers wore long dresses.

Kennell Schenck, whose father, Percy, and mother, Hallie, were avid Guild Hall participants (Percy played the piano for parties and variety shows on stage) remembers as a young boy that his family insisted he attend just about everything that was going on there. "I remember those Sunday night shows—the duo-pianists and Helen Morgan sitting on the piano. I didn't like to wear a hat. I remember my mother saying, 'I want to tell you, you're not old enough to make those decisions. If you're going with your father and me to an affair at Guild Hall and I tell you to wear a hat, you're going to wear it.' And I did." Those were standards to maintain.

Every event that took place in the first few years was a "first," as Guild Hall in effect "auditioned" for the roles it would occupy in the community. As for the financing of all this, the fourteen-member board, headed in the first two years by William C. Dickerman, had its hands full. Dickerman tapped five people at a thousand dollars each to see them through the first year but warned that they had to find a long-term way to make Guild Hall self-supporting. They talked about building an endowment fund, but the time wasn't right.

They were fortunate that Nelson C. Osborne, treasurer, who would go on to serve as a valued trustee until his death in 1967, turned

over his office, gratis, to Guild Hall business, particularly the bookkeeping, for the next twenty years or more. Still, no matter how tight the financial squeeze, on the surface everything remained very elegant.

In the first year, Mrs. Woodhouse's daughter, Marjorie (Mrs. Carter Leidy), an artist and, like her mother, a firm devotee of all the arts, arranged exhibitions and art classes for young people. Mrs. Woodhouse was obviously grooming her to carry on the Woodhouse tradition at Guild Hall. Tragically, Marjorie was killed in an automobile accident in 1933 at age thirty-two. As a suitable memorial, the small gallery adjacent to the theater was named for her.

Theater fare in 1931 was kept light, in large part to distract audiences from their Depression troubles. Typical was *The East Hampton Revels* put on by the Maidstone Club's Women's Committee, with song-and-dance routines and skits with titles like "Dream Couples," "Dancin' to Heaven with You," "High Hat," and "Bit o' Tropics." The newly named Guild Hall Players also put on their first performances. Guild Hall was on its way.

The following year (1932) saw even more of the community becoming involved. There were meetings of the Ramblers (a ladies' discussion group), the Young Men's Republican Club, the Daughters of the American Revolution—meetings of almost every organization in town, it seemed. Guild Hall was clearly becoming at home in East Hampton—if perhaps not exactly as planned.

For example, the original Guild Hall incorporators had envisioned "the little theater" as "intimate, cozy, for amateur productions or musicals," but by the second and third year, two professional companies—Hampton Players and South Shore Players—were fixtures on the stage of the John Drew. It was inevitable perhaps that in a summer resort community, lines would be drawn: summer for glamour, and winter for community-oriented events.

In any case, Robert Schey, board chairman in 1935, stated in a piece he wrote for the *Star*: "Guild Hall occupies a unique position in being open through the entire year for community affairs as well as cultural activities. There is no place in the United States where the problem of combining both has been at-

tempted and solved as in Guild Hall. There are community houses but not art centers, and there are art centers but not community houses, but to offer both in one building is only achieved by Guild Hall."

On January 24, 1935, the *Star* reported the death, after a long illness, of Lorenzo E. Woodhouse, long-time president of the Merchant National Bank of Burlington, Vermont. He and his wife, Mary, had been East Hampton's greatest philanthropists and founders of Guild Hall. The *Star* also noted that Mr. Woodhouse was mechanically minded and drove several of the first Stanley Steamer cars in the days when it required a real engineer to operate one. That same month, Welby E. Boughton, editor of the *Star*, died. In April, Arnold and Jeannette Rattray bought the paper, beginning the Rattray's long association with chronicling East Hampton affairs, including those of Guild Hall. In 1940, the paper moved to its present location, completing the Guild Hall/Library/Clinton Academy/*Star* quadrant, and anchoring that end of Main Street.

At the same time, Guild Hall continued to appeal to its two different audiences. The winter of 1935 marked the first and last time Guild Hall ever ran a sports event—a ping pong tournament (in the Moran Gallery) in which James (Dick) Strong won the Suffolk County championship. By contrast, in the summer, the Hampton Players presented a season of all new plays that they hoped were Broadway-bound. An *Art Digest* headline that summer read: "East Hampton, America's Oldest Art Colony, Exchanges Shows with Newport."

A February flood, the worst ever recorded in East Hampton, was the big news in 1936. Caused by a sudden thaw, it inundated parts of the village. Guild Hall suffered the most severe damage, with the stage under a foot of water and all but the last five rows of seats covered as well. The high-water mark along the wall could be seen for years thereafter. The trustees wondered, as they scurried to raise funds for the emergency repairs, if that old-timer who called them "damn fools" for building in a swale wasn't right after all.

By spring the theater was back in order for the presentation of *Historic Tableaux*, directed by Miss Georgia Todd and Mrs. Winthrop Gardiner, and featuring such local historic

highlights as Lion Gardiner returning Wyandanch's daughter after her abduction by the Naragansett Indians.

The summer of 1936 was the Rollins Studio of Acting's first of nine seasons of performances in the John Drew; and in the galleries, visitors saw such exhibitions as "A Retrospective of Flower Paintings" under the auspices of the East Hampton Garden Club.

In spite of all this activity, by 1939 Mrs. Woodhouse began to feel abandoned by her circle of supporters, who were increasingly complaining of hard times. No one seemed willing to accept the board chairmanship that year, so she herself stepped into the position, one she held, reluctantly, for six years, until 1945. During that time she covered most of the operating costs. The annual budget in those years averaged $6000.

As time went on, it was increasingly apparent that the all-important summer activities were essentially designed for the social elite of the summer colony. Anyone looking back, in fact, would find that Guild Hall news was covered alongside the society news in the New York press.

As Guild Hall neared the end of its first decade, Mrs. Woodhouse expressed disappointment that the year-round residents had not fully embraced Guild Hall. There was, as Madeline Edwards Potter—a member of one of the old families, who remembers the '30s—said recently, a difference between Clinton Academy and Guild Hall which was built to replace it. "Guild Hall was a little overpowering, whereas at Clinton 'Hall' everything was so casual that you could sort of kick up your heels and let go." Not that Madeline didn't enjoy and admire Guild Hall. She attended the plays, both amateur and professional, and sang with the Choral Society, but she sensed a "better than thou" attitude that she thinks put off many of the local people.

It was clear to the trustees that the boundaries between summer and winter residents would have to be broken down. History would, at least in a temporary way, intervene to that end. As the world edged toward World War II, a common bond would develop between the two groups as they joined in making bandages for the Red Cross and entertaining the hundreds of servicemen stationed in the vicinity.

The Village Fire Department pumping out backstage after a flood.

COURTESY OF THE EAST HAMPTON STAR

The front of Guild Hall after the devastating hurricane of 1938.

1940s

Guild Hall operated in subdued counterpoint to the war in the early '40s. Nearly 900 men would leave the East End to serve in the armed forces. In July 1942 Nazi saboteurs landed off Amagansett and buried explosives.

Against all odds, Guild Hall at first tried to keep its traditions together; still the formal teas with thin, watercress sandwiches, and the dressy theater openings with Will Whittemore, the elderly and courtly artist, making his imposing entrance in his opera cape.

Henry Leggett, chairman of the Art Committee, in an effort to present a "business as usual" atmosphere amid the anxieties of the war, organized sixteen exhibitions for the 1940 summer season, including one honoring Guild Hall's architect, Aymar Embury, II, which featured his architectural drawings of some of his major accomplishments—the Triboro, Henry Hudson and Bronx-Whitestone bridges.

Rollins presented Jimmy Savo's one-man show, *Mum's the Word*, to benefit Belgian, French and English children.

Over the next couple of years, the war put nearly all normal activities on hold, especially during the winter, when fuel rationing made use of the facilities almost impossible. To make matters worse, the furnace broke down and the fireplaces in the galleries were the only source of heat one winter.

Warren Whipple, then summer director, remembers that most of the activity occurred in the warmer months. There were air raid drills given by the Civil Defense Council; and there were appropriate exhibitions such as William and Helen Whittemore's "Paintings Reminiscent of Europe in Happier Times," and Cecil Beaton's photographs—"London's Honorable Scars."

The following summer (1942), Whipple remembers that one gallery was temporarily turned into a registration center for the Selective Service.

In the early '40s, the playwright Philip Barry helped the war effort by bringing out from New York–American Theater Wing variety shows for which the men stationed at the East End were bussed in to the John Drew. When transportation became logistically difficult, the Guild Hall Players filled the bill by taking their own entertainments directly to the bases, all the way from Montauk Point to

GH ARCHIVES
Warren Whipple, director (summers of 1941–42) with Henry T. Leggett, chairman of the Art Committee.

Camp Upton at Yaphank. The local Red Cross furnished a rickety old van, dubbed the Black Mariah, for carrying cast, props and scenery. A favorite in the Players' repertoire was Wilder's *The Happy Journey to Camden and Trenton*. A girls' vocal trio took music to the hospital wards. The accompanist played on a little portable organ borrowed from St. Luke's Church.

On Blood Donors' Day at Guild Hall in 1943, the Red Cross collected 240 pints from 350 donors, the largest amount taken anywhere in Suffolk County. During the war years, one gallery at Guild Hall was given over for an officers' lounge. Under Eleanor Osborne's direction, young women, from debutantes to school teachers, joined together to give regularly scheduled dances for servicemen.

By 1946, with the depression and the war behind us, we entered a new phase. Much to Mrs. Woodhouse's relief, Guild Hall had a new and energetic board chairman, Joseph F. Gunster, as well as a director who would guide the organization for many years to come. The building was now open an average of five nights a week year-round, and membership doubled to 174 families. "Guild Hall is now known and used by the community in general as never before," the *Star* reported on March 28, 1946.

That summer, for the first time, through the efforts of Philip Barry, an independent producer, Francis I. Curtis, was brought in to stage ten plays in a ten-week period, opening with Estelle Winwood in *The Royal Family*. Rental for the summer was $1000. Tickets were $1.20 and $3.00. Curtis had brought along with him the elderly Healy sisters—Madeline (Maddy), Broadway's first female theater treasurer; and Kathryn (Kitty)—to run the box office, jobs they held for fourteen years. They became beloved East Hampton summer fixtures, taking in (and imparting) all the backstage theater gossip from their post in the box office. Every night, before returning to their rooming house and without a worry about security, they carried the evening's receipts over to Jack and Queenie Williams at the 1770 House, leaving it in their little safe overnight.

In 1947 Nelson C. Osborne tried his best to convince the board to purchase the several acres of Mulford property (now Pondview) be-

hind Guild Hall, which had become available for about $9000. He foresaw possible future expansion and parking. Unfortunately, his proposal fell on deaf ears and empty pocketbooks; it was a lost opportunity the board would come to regret in later years.

Edward E. Bartlett, formerly chairman of the board of the New York Stock Exchange, headed the Guild Hall board in 1948 and immediately set about raising an emergency building repair fund. The theater had suffered another flood!

The summer of 1949 is best remembered for our having introduced Guild Hall audiences to Jackson Pollock and other Abstract Expressionists in the show, "Seventeen Artists of Eastern Long Island." Ever since, invitational regional exhibitions have been held annually. Rosanne Larkin, organizer of the show, told the board, "The coming of so many prominent artists gives Guild Hall an opportunity to lead in the renaissance of art in this neighbourhood."

In covering the landmark exhibition, the *Star* wrote:

> *"Artists, we always thought, were a happy, dreamy sort of people who could see the beautiful; but the overall impression of this show seems to be that life is sordid and scrambled; that nothing you paint is supposed to look anything like the subject. . . . It was our happy experience to hear an art lover exclaim again and again over what he found in gazing upon a combination of colors that to us did not seem to hold possibilities for even a fourth-rate linoleum pattern . . . If you have not seen the show, it would be a good idea to stop in and take a look. You will go home a raving enthusiast for the new expression, or leave the galleries perplexed and disappointed. The pictures are for sale and business has been brisk."*

Sales totaled $4000.

As if to protest further the encroachment of modern times, the *Star* also published that year a letter to the editor criticizing the Guild Hall Players for their profanity; an actor had said "God damn" repeatedly during the performance of *Room Service*.

Forrest Haring, replacing Francis Curtis, had leased the theater for the summer of 1949, enjoying his biggest success with the Hartmans in their new satirical revue, *Up to Now*.

Guild Hall was livelier than ever before at the close of the decade. The Home Demonstration Unit established by Mary Ingalls, was drawing in a whole new segment of the community by offering instruction in dozens of "home arts" from cooking to upholstering furniture. Membership had reached 700, with 276 additional junior members. It seemed that almost all of the adult membership, year-round and summer alike, attended the successful New Year's Eve party that year. A Roaring Twenties theme saw in the new decade.

By the early '50s, a few summer people were keeping their houses open for spring and autumn weekends. More artists, writers and retirees who did not depend on New York City day to day, were making their permanent homes here. We now had a small full-time year-round staff and a fair-sized audience all year for concerts, plays, films and lectures. By 1957, exhibitions were presented throughout the year. We became increasingly aware of our educational charter and were integrating our programs with the curriculums of the schools. This would be the decade during which Mrs. Woodhouse saw all her dreams for Guild Hall fulfilled.

In 1950 Forrest Haring returned for his second and last season with such favorites as *Finian's Rainbow* and *Born Yesterday*. The actor Lee Marvin, still a relative unknown, but definitely a presence, was a fixture that summer, appearing in *The Spider* with Victor Jory, and appearing even more often before his circle of admirers at Main Beach.

The year 1951 was Eloise Spaeth's first as chairman of the Art Committee. Her first triumph was "A Historical Survey of American Art." The following year we received national press acclaim for her "Nineteenth Century Influences in French Painting" in which Justin Thannhauser's great van Gogh landscape, *Mountains at St. Remy*, was shown publicly for the first time.

The invitational regional exhibitions in the '50s were impressive not only for their rosters of distinguished artists but for their buying opportunities. For example, anyone attending the 1951 regional could have purchased a work by Pollock for $250 or by James Brooks for $350. The 1952 regional had works by Robert Motherwell beginning at $200.

COURTESY OF ELLEN BARRY
Playwright Philip Barry, chairman of the Drama Committee in the '40s, seen here in a portrait by his wife, Ellen.

1950s

WILLIAM BOONE
Daga Bennett (later Ramsey), chairman of the Drama Committee; with Philip Barry, Jr., producer for the theater in 1951–52.

At a 1951 meeting of the Membership Committee (all served as trustees at one time or another): Helen Gay; Joseph F. Gunster, former board chairman; Helen Anderson and Essie Vetault, co-chairmen of membership; John L. Boatwright, later, a board chairman; Enez Whipple, director; and Harriet (Happy) Macy.

Philip Barry, Jr., leased the theater the summers of 1951 and 1952, introducing several new plays along with such standards as Shaw's *Heart-Break House*, with Beatrice Straight and Philip Bourneuf—a stunning critical success, but a box-office disaster. *An Evening with Bea Lillie*, better suited to a vacation audience, broke the box office record. Meanwhile, the board was busy putting out fires set by the self-declared East Hampton Protection Society, which was spreading dissension by insisting that summer theater was calling too much attention to East Hampton and attracting all the wrong "types."

In 1953 Denise Delaney (later Mrs. David Hare), succeeded Spaeth as chairman of the Art Committee. Among the shows she organized was "A Selection from Twelve East Hampton Collections," which included a Pollock from the collection of Daniel T. Miller, owner of the Springs General Store, where Pollock used to pay for his groceries with paintings.

In 1954, Ron Rawson was in his second of seven years of producing summer theater, opening with Lucille Manners in *Song of Norway*. That year, in preparation for a coast-to-coast tour, Jessica Tandy and Hume Cronyn, who were in residence in East Hampton that summer, presented *Face to Face* (dramatic readings) especially for Guild Hall members.

During the mid-50s Guild Hall remained as active in the winter as in the high summer season. The Guild Hall Players presented *The Importance of Being Earnest* and Gershwin's *Girl Crazy*. Penelope Potter taught drama (Chekhov method), and there were art lectures, bridge, children's events and informal concerts, where you were invited to "toast your own marshmallows over the fire afterwards." The much beloved Robert (Bob) Reutershan was now chairman of the Winter Committee and later served as vice-chairman of the board. He continued his important work until the time of his tragic death in 1964, when he was struck by a car while crossing the street in Amagansett.

Among the various benefits conducted to raise money in 1956 was a big furniture auction, everything from grand pianos to Spanish lanterns, held in front of the school on Newtown Lane, and organized by Audrey Hurdman. People still remember Truman Capote bidding frantically for a huge fan-backed wicker chair in which he looked positively diminutive; even so, he was delighted with his purchase.

Robert Reutershan. chairman of the Winter Committee in the '50s and later vice-chairman of the board of trustees.

The 1956 exhibition, "Thirteen Artists of the Region," which included works by Jackson Pollock, had just opened when Pollock was killed in an automobile accident on August 11. With the Pollock tragedy still fresh, the atmos-

phere of the next annual regional show in 1957, organized by Boots Lamb, was lightened by the tone of the catalogue introduction by the writer Gerald Sykes, who confronted the old-guard sentiments head-on: "There are those who speak of the art wars of East Hampton as if they should be indicated on road maps with crossed swords. Seven years ago, at the time of the fighting in Korea, when one school of painters hung in one wing of Guild Hall, and an opposing school in another wing, the space between them was referred to locally as the Thirty-Eighth Parallel . . . so far at least, all the bloodshed has been verbal . . . Guild Hall authorities, I am told, do not expect to have to call in the special police. There will be violence, but it will exhaust itself in a few well-worn phrases, such as every museum guard knows by heart . . ."

The abstract painter Franz Kline was in residence the summer of 1957 and working in a section of artist John Little's barn. Both men opened their studio spaces for the artists' studio tour to benefit the Art Acquisition Fund. Kline set up his space as an artist's still life, down to a partially filled coffee mug, a half-eaten piece of toast, some just-completed sketches scattered about, and his jeans and socks draped over the bed.

In 1959, Mrs. Woodhouse, now over ninety, was delighted that at last Guild Hall had found its place in the community. She chose one of her favorite quotes (she had them for all occasions) to express how she felt. "Julia Ward Howe," she said, "was asked once if it was not pretty hard to grow old, and she said, 'No. The deeper I drink of the cup, the sweeter it tastes, all the sugar at the bottom.'" That year, had she been able, Mrs. Woodhouse would have enjoyed seeing the Players' *Petticoat Fever*, directed by Robert Vetault . . . or perhaps partaking of turkey Brunswick at Audrey Hurdman's benefit dinner dance for the Repair Fund, listening to the rousing singing of the Orpheus Club (that was the night the leg of the grand piano gave way!) and, surely, attending the Candlelight Christmas Home tour.

As if to herald a new era, Everett T. Rattray had become editor of *The East Hampton Star* in 1958. His father had died in 1954, and his mother had served in the interim. Over the next decades, he would report many changes at Guild Hall, just across the street.

There was a classic small-town power struggle taking place at Guild Hall as the decade turned, with the Garden Committee at war with the Exhibition Committee. The Ruth Dean Garden with its formal plantings and lovely wall fountain was conceived as a "reflecting place," but in recent years had taken on a more important role as a place to show sculpture. The Garden Committee didn't approve (especially when the space was given over to "ugly" modern pieces made of such unorthodox materials as crushed automobile parts), and set out to thwart the Exhibition Committee by planting shrubs in the sculpture nooks. No sooner done, however, than the Exhibition Committee would surreptitiously remove them. It took an administrative dictum to stop the nonsense. Like it or not, the garden was for sculpture.

Like the rest of the country, East Hampton would find the '60s unsettling. Russian trawlers were on our doorstep, flying saucers were reported at Nappeague and a short-shorts ordinance was passed, prompting the *Star* to comment that if it were replaced by a mirror, some shorts wearers would head for home and a Mother Hubbard (a long, shapeless housedress). Guild Hall was taken to task for holding its benefit fashion show at the exclusive Maidstone Club, and the *Star*, responding to the winds of change, did away with its "Summer Colony" news heading, declaring "East Hampton is now all one!"[1]

Having declared our independence from outside producers in 1959, we were in 1960 running our own summer theater with Conrad Thibault as artistic director. Despite some residual bitterness over the change in management, membership doubled that year. Our small staff of three, aided by committees, worked harder than ever before to fulfill our educational charter. We collaborated with the American Association of University Women on an unusual multimedia presentation, "Knowing Africa." A special crowd pleaser for the community that year was the exhibition "Crafts of Eastern Long Island—Then and Now," organized by George Schulte, assisted by the artist Marland Stone. Interest in it led to the formation of the South Fork craftsmen's Guild, which flourished under Guild Hall sponsorship into the '80s.

Mrs. Woodhouse died on December 3,

1961 in Florida, at age ninety-six and was mourned by the whole community. The trustees' tribute to her included this statement: "Guild Hall, enshrined in the hearts of all East Hampton, stands as a living memorial to the generosity and vision of a truly great woman. For thirty years art, drama and music have been fostered and have enriched our lives. Mrs. Woodhouse's beauty, grace and understanding were qualities that glowed and inspired. Her prayerful interest in a purposeful Guild Hall has given strength to others to be worthy of the trust."

Paul Montgomery, our new board chairman in 1961, a businessman as well as an artist, was sensitive to the social complexities of the community. He soon implemented a change in the bylaws to increase the number of trustees to eighteen in order to bring "new blood" into what was essentially a self-perpetuating board. During his five years as chairman, he introduced the custom of year-end giving as a way to provide a dependable flow of additional money into the treasury. More importantly, he recognized the need for expanding the physical plant and laid the groundwork for the new wing that would open in 1970.

By 1962, one saw more paper cups than fine china teacups, more sandals than high heels at the art openings. Informality was the new keynote, although one of the few remaining grande dames did try, unsuccessfully, to persuade the board to set dress codes for the openings.

Several summer art shows drew special attention in 1962 because they tapped the resources of the community. One was "Photographs of Old East Hampton"; another was "East Hampton Collectors," which drew attention from as far away as London. In the "New York News" column of the London *Art Review*,[2] M. L. D'Otrange Mastai wrote of the show:

East Hampton . . . on the whole . . . tackles the cultural aspects of its activities very seriously indeed and very discriminatingly. The Guild Hall and its John Drew Theater . . . are run on truly democratic lines. No wealthy patron, or group of patrons, is allowed to dictate its policies, or in more senses than one, run the show . The present show is indicative of the intellectual level and catholicity of taste. Mrs. Otto L.

Spaeth, chairman of the exhibition and a noted collector in her own right, has stated in her introduction to the catalogue that 'some of the finest works of art in the country are today in the collections of East Hampton'."

Summer theater in 1962 continued to flourish with a mix of tryouts and standards. Those were the days when $3 bought one a good orchestra seat for the matinee plus lunch, and actors could expect to spend $15 a week for a room, $1.25 to $2 for dinner at a modest restaurant and about $5 at one of the quality establishments. It cost $5581 to present a week of the package musical *Fiorello* that season and $3484 for *Critics' Choice*, starring Jeffrey Lynn and produced "in-house."

Theater attendance in 1963 topped the preceding year. Jo Raymond figured prominently on the scene as chairman of the Drama Committee, working closely with Conrad Thibault, a position she held throughout the decade. By this time, the long-popular *Village Vanities* had run its course. The 1963 revue, *Hit the Road*, was to be its last.

There was an old saying around town that after Labor Day you could shoot a cannon down Main Street. Not so by 1963, when we had audiences for art exhibitions beyond the peripheries of the summer season. Early that spring, for example, we presented the first of the juried "Long Island Painters" exhibitions organized by John Reed with Harold Rosenberg heading the jury. Attendance equalled a typical summer show.

The dream of adding a new wing first seemed possible in 1964, when Paul Montgomery arranged to acquire the needed adjoining property through the generosity of the owner, the elderly Myrtle Shepherd. However, the building project was held up because of problems about an access driveway that bisected the property. Although the new wing wouldn't open for several years, we were already envisioning its many uses—for offices, a storage vault for the art collection, an arts and crafts center.

From his arrival on the board in 1964, Irving Markowitz was a welcome and spirited presence. A certified public accountant, civic-minded and well liked, he was the perfect liaison to the business community, shooting down misconceptions about Guild Hall's "elitism"

PHILIPPE MONTANT
Paul Montgomery (right), chairman of the board (1961–66) with Robert T. Elson, trustee and later vice-chairman of the board, at an exhibition opening in 1975.

244

with deadly aim. During his years as a trustee, he served in many capacities—among them, vice-chairman of the board and co-chairman of the Drama Committee. He said recently: "I got as much out of Guild Hall as I put in; it was a tremendous satisfaction; I was a trustee for ten years. It was when I originated a resolution that a board member may not succeed himself for more than two three-year terms that I, in a sense, voted myself off the board. I think that ruling has helped greatly to widen the participation of the people in our community." His wife, Charlotte, who was as deeply involved as her husband, added: "I loved those years when Irving was on the board. I had great fun—even standing in the kitchen scraping celery sticks for an opening night party. It was a wonderful, warm time meeting new people . . . opening up a whole new world for me."

We noted with concern in 1964 that the cost of producing theater had doubled in four years, meaning we had to maintain eighty percent capacity to break even. We couldn't afford many errors in judgment. One, however, was the tryout of a new play, *The Glass Rooster*, which earned this *Newsday* headline: "The Glass Rooster Lays an Egg." Fortunately, we made up for it with *My Fair Lady*, the first show to enjoy a two-week run at the John Drew.

The outstanding offering of the 1965 spring Festival of the Arts, co-sponsored with Southampton College, was an exhibition of the work of theatrical stage and costume designers who had been associated at one time with the John Drew. Models of sets for Broadway, such as William Ritman's for Edward Albee's *Tiny Alice*, and Peter Dohanos' for *Kataki*, were included.

At the 1965 annual meeting, Paul Montgomery stated his intent to start a fund-raising campaign for the new wing, confident that he could resolve the nagging driveway problem. Soon thereafter, he suffered a heart attack and gave up the chairmanship, leaving the project in abeyance for the time being.

In 1966, John Ahlquist, House and Grounds chairman, proudly announced that at long last, after years of complaints about the oppressive heat in the theater, air-conditioning would be installed in time for the opening of the summer season. Our excessive zeal to keep the audiences cool that summer prompted Barbara Delatiner, in *Newsday*, to refer to one show as "a good ticket, especially on a hot night. The air-conditioning is set at freezing." That year the summer exhibitions were memorable for two fine retrospectives—memorials to Niles Spencer, who had lived in Sag Harbor, and Wilfrid Zogbaum, who had lived in Springs.

In 1966 the board paid tribute to Nelson C. Osborne, now in his thirty-fifth year as a trustee. He had helped form the original concept of Guild Hall and had served at various times as vice-chairman and treasurer. Osborne died the following year, thus breaking one of the last links to Guild Hall's beginnings. His son Robert, an attorney, was elected to fill his father's unexpired term. Later that year, the board noted with sadness the death of Guild Hall's architect, Aymar Embury, II.

Coming through the theater fire escape off the balcony, burglars broke into Guild Hall in the summer of 1967. This was our first break-in and a disheartening sign of a new era. As luck would have it, however, they entered the Moran Gallery which was empty except for a few display screens. Had they chosen the Woodhouse, they would have had their pick of more than a hundred paintings by some of the best known artists of our region, stacked and waiting to be hung the next day for "The Little Show." We reacted swiftly by installing a burglar alarm system, and, for the first time, employing part-time gallery guards. (Changes were noted around town, too, during these years. Along with the land boom, the town experienced its first narcotics raid, as well as its first bank robbery.)

Charles S. (Bud) Dewey, Jr., our new board chairman in 1966, had the enthusiasm of a schoolboy. "You're as young as your curiosity," he once told June Dunnet, staff secretary, and then proceeded to quiz her about each and every event listed on the big wall calendar over her desk. He observed how crowded we were for space—staff and committee people working in the kitchen, halls and even in the basement under the stage. He was determined to carry on where Montgomery had left off with plans for the new wing. Almost immediately he initiated a fund drive, engaged the architect Arthur Newman of Bridgehampton to draw up plans and set the spring of 1970 as the goal for completion of the work.

Bud Dewey's first priority as chairman: restrooms. Robert Elson noted somewhat later

Charles S. Dewey, chairman of the board (1966–74)

with amusement, "The first thing Bud said to me when he welcomed me as vice-chairman of the board was, 'Can you believe it—only one toilet for the women and one for the men? That's the first thing I want to correct as chairman. The other day I came into the building just before the matinee was about to begin. The ladies were lined up clear out into the front foyer! They'd all been to the pre-matinee luncheon special (all that iced tea!). I just felt I had to do something about it.'"

The year 1969 was a momentous one. It was, much to everyone's regret, Conrad Thibault's last of nine years as artistic director of the John Drew. And it was Trudy Golden's first of nineteen years as chairman of the Filmmakers of the Hamptons Festival. Also, among the new board members that year was Frances Ann Dougherty, who would later play an important role in theater programming.

On October 11, 1969, we broke ground for the new wing. Pat Trunzo was the building contractor, coming in with the low bid of $109,073.

By now the permanent staff had increased to six; one of the new members was Barbara Mahoney, serving as publicity director and assistant to the director. The programming was unusually varied that year—A Celebration of American Negro History Week, combining an exhibition with music, dance, lectures, films and arranged by Alan York; a new class, yoga for health; Mabel Mercer in a rare theater concert; and a panel discussion on "Sex and Censorship in the Theater."

Barbara Delatiner in *Newsday* (August 12, 1969) summed it all up in a story headlined "In East End, Guild Hall Fills the Cultural Bill." She referred to Guild Hall as "a cultural center that is the envy of cities and suburbs ten times larger" and expressed amazement that it could all be done "without government or foundation subsidy, and save for an initial benefactor, without any big donors . . . it has a loyal following that makes it not any empty shell of a museum or a seasonal home for theatrical retreads, but a year-round oasis for the performing and visual arts . . ."

The main excitement in 1970 was the long-awaited spring opening of the new wing that would later be named for Charles Dewey.

1970s

Called A Day in the Life of Guild Hall and organized by Gina Beadle, the opening lasted all day, drawing over 2000 people in all. There was continuous entertainment (to say nothing of continuous refreshments provided by Craig Claiborne and Pierre Franey) in every nook and cranny of the building: in the theater—Eric Hahn's light shows and rehearsal scenes of the Guild Hall Players' *Guys and Dolls*; in the galleries and garden, singers, musicians Max Pollikoff and his orchestra, and concert pianist William Macellos; dancers, sketching classes, exhibitions and tours through the new wing. Held on June 6, the opening seemed to set a pitch of excitement that lasted the entire year and beyond.

Almost without exception, everything presented that year was top-notch quality. Robert Brustein's Yale Repertory Theater, in four two-week runs of Story Theater, was probably the most favorably received season in the history of the theater. That summer Christophe deMenil, with Calvert Cogeshall, arranged an outstanding exhibition, "Nineteenth-Century Country Art"; and Milos Forman and Ivan Passer, noted Czechoslovakian directors, personally introduced scenes from their award-winning films for the festival.

An important element contributing to the quality of over-all programming through this decade was government funding, a source of support new to Guild Hall. We received our first New York State Council on the Arts grant ($29,500) in 1970 and would soon be receiving Suffolk County and National Endowment for the Arts grants as well.

For all our successes, it was also axiomatic that we could count on at least one crisis a year, and 1970 was no exception. When the Village of East Hampton voted to restrict parking at Georgica Beach, the artists, who had come to consider it *their* beach, were enraged, and Guild Hall was caught uncomfortably in the middle of the battle. The effect of the ordinance was to sweep the beach clean of its former occupants for the benefit of the village residents. The artist Herman Cherry said the problem started when a group of Lily Pond Lane residents got up a petition to restrict the parking. "I think the whole thing was aimed directly at us—the artists," said Cherry. "They didn't like to sit there with all that hoi polloi."

Things came to a head when the artists asked Guild Hall to try to persuade Village Hall to rescind the ruling.

Although in sympathy with the artists, the board issued this statement: "Our purpose is to serve as a cultural center for the whole community. It is not our function to be involved in civic and political affairs."[3] This angered the artists even more, and the *Star*, in a front page story on the subject, reported how the artists felt about it: "De Kooning says he'll exhibit in Ashawagh Hall in his 'own village' (Springs) from now on and Guild Hall can like it or lump it."

Dan's Papers covered the story, too, and wrote: "The attacks on Guild Hall, which so desperately needs all our support, seem particularly senseless . . . for the issue lies in Village Hall, not in our cultural center . . ." However, a former member of the East Hampton Village Board said recently, in looking back, that the artists had it all wrong: "The board decided there should be one 'protected' beach in the village (meaning one with life guards and lavatories), where village residents who pay taxes to maintain guards, etc., should be able to park exclusively. We picked Georgica because there was an empty Coast Guard station building there—ideal for lockers and rest rooms. I saw no reason why the artists couldn't move to another beach; instead they chose to make a case out of it. They were unfair. And speaking of being unfair, it was the artists who usurped Guild Hall from the local people. They just took over. Did they ever think of that? The village people don't feel at home there any more . . . Heck, all you had to do was put a frame around a house painter's drop cloth and you had what they were showing at Guild Hall . . . I remember the old days—all kinds of fun get-togethers. Now I never go near the place."

The fall after the Georgica Beach crisis, artist Jimmy Ernst was elected to the Guild Hall Board. Ernst had an almost missionary concern for artists' rights and great respect for the feelings of permanent residents.

It was Ernst's custom every morning to don his Greek fisherman's cap and take a walk downtown to pick up his daily paper at Marley's, where everyone gathered to swap the latest gossip and opinions. Thus Ernst became a sounding board for public sentiments. Board decisions were often tempered by his balanced appraisals, and a more relaxed relationship developed between the artistic community and Guild Hall.

The trustees would often be seen mingling happily with artists at the traditional "artists'" Thanksgiving dinner that Jimmy and Dallas hosted annually at their home. The event, attended by upwards of a hundred people, was a manifestation of Jimmy's "sense of community." "They were warm, wonderful parties," Dallas said recently. "Everybody brought their own specialty, and we provided the turkeys and the bar. I remember one year there were a lot of poets present, and after the party we found all these poems they had left for us, scattered about the house. It was very touching."

In 1971, audiences responded warmly to the retrospective of the work of John Ferren, a much-respected member of the art community. He and his family (wife, Rae, and son, Bran) had for some time been associated with Guild Hall. The show covered the years from 1933, his Paris days, up to his death in 1970. That year, too, Guild Hall was one of sixteen museums out of 1309 to receive a National Endowment for the Arts grant for purchases for the art collection. It pleased us that Donald Norton, a local man of modest means, was the first to contribute toward the $10,000 match.

William King's drawing of one of the annual artists' Thanksgiving parties at Jimmy and Dallas Ernst's East Hampton home.

JOHN REED
Artists working on the mural
to be auctioned for the benefit
of the McGovern for President Fund
(1972). It was later given anonymously
to the Guild Hall Art Collection.

In 1972 Edward Albee and Richard Barr produced a controversial summer season of four plays for us; Alan York, still chairman of films, continued to introduce exciting variety into the programming—everything from *The Trojan Women* to *Malcolm X*—and that year we paid tribute to a long-time artist of the Hamptons in "Moses Soyer—A Human Approach." Local school students were treated to a visit to Arnold Hoffmann's print workshop in connection with his exhibition, "How Screen Prints Are Made."

Everyone then involved with Guild Hall remembers the year 1973, when we were first accredited by the American Association of Museums—quite an achievement for a small museum with a staff of only seven and without a full-time curator. At that time, out of 5600 museums in the country, only 223 had been so accredited. For months in advance, as if for final exams, we had studied the stringent criteria for the collection, organizational procedures, the physical plant. The special certificate was hung proudly in the front foyer.

Attendance set a record in 1973—at 80,000 visitors. Even so, financial problems loomed. The addition to the building, as might be expected, created a need for more help and more money for maintenance. The public thought we were affluent because we were receiving some substantial government grants, but as former trustee Irving Markowitz pointed out recently in recalling those days, "Government grants were great but they were usually for specific programs. We needed money for nitty-gritty—for overhead. Most of our trustees and other supporters had divided loyalties. Their roots and principal residences were elsewhere and so were their major charity commitments." Where in the past we had always finished the year in the black, we were now showing our first deficits.

At the 1973 annual meeting, chairman Dewey noted that a national survey had shown that cultural centers such as ours were receiving eighteen percent of their income from tax-based sources. "On the other hand," he said, "Guild Hall has not up to this time received any support from Town or Village—in spite of the fact that much of our work is aimed at broadening the cultural horizons of East Hampton children." He regretted that Guild

Hall's request to be included in the school budget for $25,000 was defeated by a narrow margin of only fifty-three votes. The opposition was led by a strong block of senior citizens fearful of higher taxes.

Turning to another possible solution, Dewey, with Helen Hoie as chairman of the Development Committee, brought in a professional fund-raising agency with the aim of building a substantial endowment fund. However, it was not long thereafter that Dewey became gravely ill and resigned from the board, the stock market went into a serious slump and the plan was scrapped.

Among the 1973 winter season exhibitions, "The Romance of Maritime Long Island" captured the interest of just about everyone in town. In theatrical style settings, stories of shipwrecks, whaling adventures and other marine lore were told through authentic artifacts and paintings. Jeannette Rattray drew a full house for her talk on her new book, *Perils of the Port of New York: Maritime Disasters from Sandy Hook to Execution Rocks*, and afterwards wrote in the *Star*:

> *I have never felt more at home in my own home town . . . speaking before a friendly audience in the John Drew Theater on how the sea has influenced our lives from the time the first settlers, mostly farmers from around Maidstone in Kent, England arrived here . . . That audience was, perhaps composed three-quarters of 'natives' like me, and one-quarter of newcomers to eastern Long Island (that is, people who have been here only fifty years or so), who sometimes appreciate East Hampton even more than we do.*

The tranquil edifice of Guild Hall, on one of the prettiest Main Streets in America, has, perhaps inevitably, been the center of more small-town debates and controversies than the casual passerby could ever imagine. Trying to be all things to all people invokes the classic principle that you can never please all of the people all of the time. The conservative old guard used to shudder at the mention of introducing the experimental. The experimental faction feels pretty much the same way about the tried and true. Even the size and role of the board has been subject to challenge.

Then there was the Bridge Club, a casu-

alty of 1974. For years, regular as clockwork, the Bridge Club met in the Moran Gallery during the winter months; they loved that gallery. The first sign of trouble came when they began to complain about the paintings. When Guild Hall showed abstract art, the club (at least the vocal element) simply didn't approve. It made them nervous. They even went so far as to request that we hang something else on the walls, "something we can enjoy when we play bridge." Even worse, once we achieved museum status through accreditation, smoking was no longer permitted in the galleries, not even for the Bridge Club.

Once the new wing was built, we thought we had the answer: Move the Bridge Club down to the Crafts Center, a pleasant room where smoking was permitted. Wrong again. The club didn't like climbing the stairs; what was more, they felt they were being "put in the cellar." It all came to a head in 1974 when a delegation from the board tried, diplomatically, to explain Guild Hall's position: "They didn't even stop playing cards long enough to listen," said one of the delegates. "They just moved their club elsewhere."

That was a good-news-bad-news year. On the one hand, we received the largest New York State Council on the Arts grant of any organization on Long Island; on the other hand, we were faced with heavy unexpected expenses to comply with new state building codes—an asbestos fire curtain for the stage, additional emergency exits and so on. That was also the year Bud Dewey died, after learning just days before of the board's decision to name the new wing in his honor. Walter Fried, senior partner in a prestigious New York City law firm and East Hampton summer resident for over twenty years, had previously been elected to take his place. In reminiscing about the '70s, Fried said, "When Bud first talked to me about the chairmanship, I told him I knew nothing about running Guild Hall and he assured me that he would be at my elbow and be helpful in any way that was needed, but he died within a couple of months and I was left to swim on my own." Chairman Fried swam his way through admirably and along the way helped to arrange for the first East Coast showing of "The Sculpture of Black Africa" through his friendship with the collectors, Paul and Ruth Tish-

man, and later brought Geraldine Fitzgerald to Guild Hall for a benefit evening of her *Songs of the Street.*

In 1974 the Phoenix Theatre, a company with an enviable twenty-year reputation for high quality productions, signed on as resident company for a summer season of modern classics.

In the galleries there were such unusual exhibitions as Jack Lenor Larsen's fabric designs, which Theodore Strongin, writing in the *Star*, said was "like walking through some exotic potentate's chamber"; and "Reflections from the *Star*: East Hampton in Its Newspaper 1885–1975," which revealed in ingenious ways how a village newspaper can reflect the issues, events and personalities that shape the history and development of its town. Averill Geus and Jonathan Foster organized the *Star* exhibition, with help from Everett Rattray, the editor.

Financially, 1974 was again a worrisome year. The country was in a recession, affecting charitable giving, and the state-mandated building changes were running to more than $80,000. Fortunately, the artists came to the rescue with the big Parke-Bernet auction of donated works. NYSCA gave us a vote of confidence by doubling its support for another season of Phoenix Theatre, and the Town of East Hampton came through with financial help through its Federal Revenue Sharing fund. Bob Gibson, membership chairman, ran two special member-bring-a-member events to boost revenues, and an ad hoc committee produced a substantial fund for building renovations.

In 1975, Mildred Granitz replaced Barbara Mahoney (who moved back to New York) as publicity director and assistant to the executive director. Following the high standards set by Mahoney, Granitz went on to serve with skill and distinction for nearly a decade.

Bicentennial fever naturally set the tone for 1976 and Guild Hall celebrated it through both the visual and performing arts. By way of announcing the Bicentennial, we installed a large silhouette sculpture of the Liberty Bell by William King, lent by David and Astrid Meyers.

The summer season began early (in April) and featured two appropriate and highly acclaimed shows, both locally oriented: "Life-

PHILIPPE MONTANT
Walter Fried, chairman
of the board (1974–78).

styles East Hampton: 1630–1976" and "Artists in East Hampton—A 100-Year Perspective," the first such survey done on East Hampton artists.

Art critic David L. Shirey paid us a warm compliment in his April 11, 1976, *New York Times* review of selections from our collection: "The collection, like the museum . . . is a product of community effort, an admirable model of what can be done when different forces in a community merge in harmonious action. They are the museum—an inseparable entity that gives Guild Hall its particular vigor. Unlike many museums in the country that treat themselves reverently, like religious institutions, and their visitors like parishioners who must behave with stiff decorum within their venerable walls, Guild Hall has the intimate spirit of an open club . . ."

Also in 1976, the permanent staff grew to ten in number and the board to twenty-four. Alan York received an engraved trophy in gratitude for his ten years as chairman of films; June Dunnet, our beloved secretary–office manager, retired after seventeen years of superior service and was replaced soon thereafter by Billie Kalbacher, who would run the office with efficiency and good humor for the next several years. That year Rosemary Sheehan ran a delightful benefit trip to London. And Leon Q. Brooks, one of Guild Hall's original incorporators, died at age eighty-eight, leaving $10,000 to Guild Hall for a flower fund to continue a tradition he had started many years before—providing bouquets of roses for the actresses' dressing rooms from his locally famous garden.

At a 1977 board meeting, A. Chauncey (Chan) Newlin, a new trustee whose background included board positions at the Solomon R. Guggenheim Museum and the Metropolitan Opera, forcefully emphasized the need of trustee-giving and then and there started a tradition of annual trustee gifts of $5000 by making the first one himself.

Walter Fried resigned as board chairman in June, 1978. When asked some time later what he considered his major accomplishment, he answered, with a smile, "I think it was to persuade Budd Levinson to take over as chairman. It wasn't easy. I remember we went to the Guild Hall office and went over everything

with the director. Budd said, 'My God, this is a huge undertaking. This is many businesses in one.' Budd had retired. He was an able executive. He finally agreed to take on the chairmanship and I think he did a bang-up job."

At one of his first board meetings in 1978, Levinson told the trustees that he was committed to seeing that there was a balanced budget: "As a board we *must* be responsible for seeing that the necessary funds are provided for the budget we approve." He also made it clear that those who were unable to follow Chan Newlin's lead and contribute $5000 a year, would be expected to raise a like amount through some benefit activity. Beyond that, he also observed that there was a need "for a better cross-section of the community on the board." It was a turning point in Guild Hall's history. That year ended "in the black" as did others during his several years at the helm.

With Guild Hall now nearing its 50th anniversary, Chan Newlin headed a Half Century Drive for the endowment fund. Although he made a good start, he had to abandon it because of ill health. Levinson and fellow trustee Robert Menschel picked up the drive later and carried it through to successful completion in 1981.

Frances Ann Dougherty was by then chairman of the Drama Committee, and it was on her recommendation that Tony Stimac was engaged as Guild Hall's first full-time theater managing director in 1978. The summer season, called Summer of Stars, was a resounding success and played to eighty-six percent capacity.

The summer exhibitions included the well-received "Balcomb Green: A Retrospective (1937–1978)" and "Aspects of Realism," which gave representational artists of the area a chance to shine. Hilva Landsman, in her role as films chairman, turned in some imaginative programming around themes, the Music Committee hung out the SRO sign for several concerts, the Lions Club raised money for some handsome glass doors for the outer lobby, and the combined voices of the Whalers and Sweet Adelines wound up the year with a rousing concert of holiday music.

"East Hampton Architecture: the Message of Its History" opened the 1979 summer exhibitions. Guest-curated by Eraine Albin, it docu-

NOEL ROWE
Budd Levinson, chairman of the board (1978–83 and 1984–87).

mented the rich architectural heritage of the six villages and hamlets of East Hampton Town. One of the most remarkable documents was Anne Sager's photographic composite view of East Hampton's Main Street, which was mounted on two sides of a narrow corridor so it seemed one was walking down Main Street.

A major addition to the art collection in 1979 was "Our America," an extensive portfolio of Abraham Rattner's sketches and diary notes made on a trip through the American South with Henry Miller in a 1932 Buick. Having recently returned home from Paris just ahead of Hitler's armies, Rattner embarked on the trip with Miller in 1940, in essence, "to be put in touch again" with their country. Widely exhibited, his notebooks graphically portraying the ugliest sides of Southern poverty, as well as the most beautiful corners of America, were turned down as too expensive to publish as a book. Rattner was now at an age when he was concerned about where his work would eventually reside. As he considered East Hampton his home, he chose Guild Hall, offering it to us at an arbitrarily low figure. The work remains an important part of the collection.

Guild Hall's annual report of 1979 looked forward to the next decade: "We have exciting plans ahead, particularly for the 50th anniversary celebration, which will take place in 1981 . . ."

1980s

Although the main concentration in 1980 was on refining those plans, the year itself stood on its own merits. The summer theater was a near sell-out and included the world premiere of a "new kind of musical," *An April Song*, from a story by Anouilh. Helen Hayes came out to see Glynis Johns play the duchess, a role she herself had played twenty-three years before with Richard Burton in a nonmusical adaptation of the story.

Of the summer exhibitions, "Alfonso Ossorio: 1940–1980" was a stand-out. Curated by Judith Wolfe, it occupied all three galleries as

well as the garden, for which the artist created a spectacular eighteen-foot-high sculpture. The work of Athos Zacharias, Hans Hokanson and Arnold Hoffmann, Jr., was also seen in one-man shows that year.

Financially, 1980 was a strong year. Budd Levinson's efforts to create a sense of fiscal responsibility among the trustees had paid off. The year ended with a surplus; and besides the usual government subsidies, we received a $35,000 matching grant for air-conditioning from the Kresge Foundation.

The museum shop, now in its tenth year, cleared a record $60,000 and received the certificate-of-excellence award from the American Institute of Graphics for its Paul Davis poster, *Still Life with Fish*. During 1980, Robert Menschel, chairman of development, and Budd Levinson were already vigorously pursuing their goal of a half-million-dollar anniversary fund to be raised by the end of 1981. And to kick off the anniversary year, Page Moyer and her committee presented the Golden Jubilee Ball in the late fall of 1980.

One of the main features of the anniversary celebration was to be the series of four major exhibitions honoring artists influential in Guild Hall's history—and the first of these, "Thomas Moran, A Search for the Scenic," saw in the new year.

The annual operating and programming budget for Guild Hall averaged $6000 in the first decade; by 1981 it was nearly $800,000, which, given the events that took place over the anniversary year, seems almost modest.

In one sense, it was business as usual. Visual and performing arts and educational programs all rolled along without a hitch. In a larger sense, however, it was our year to transcend ourselves—and we did. Clyde Matthews and Michael Smollin, co-chairmen of the anniversay committee, worked closely with staff and standing committees to choreograph the commemorative year. The celebration was heralded by a special Golden Jubilee Journal edited by Rosemary Sheehan. In all, over fifty events, all stamped with the 50th logo specially designed by Miki Denhof, celebrated Guild Hall throughout the year. Smollin said recently, "In looking through the two huge photographic scrapbooks that document the year, I'm stunned with the magnitude of it all—one fantastic event after another."

CAL NORRIS

James Marcus, trustee (right) with The Honorable Desmond Guinness head of the Irish Georgian Society; Josephine Raymond, trustee; and Mary Mader at the 50th Anniversary kick-off party (1980).

NOEL ROWE

Connie Parr, development director; and Ken Topping, building superintendent; install a marker on a theater seat for Sheldon Harnick in recognition of his gift to the 50th Anniversary Fund (1981).

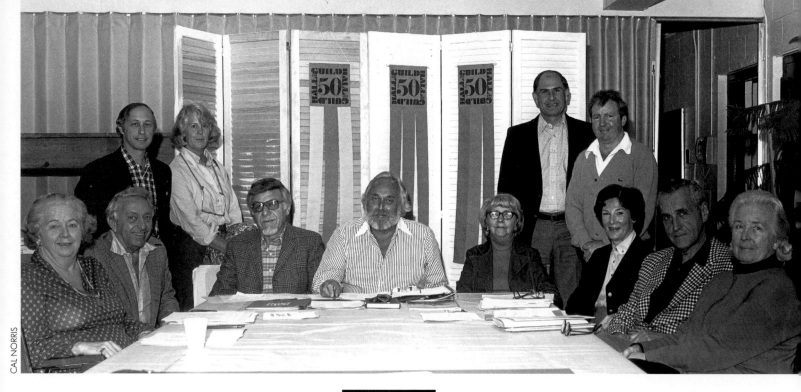

Eleanor Edelman talks with Robert MacNeil of the "MacNeil/Lehrer Newshour" at "New York Museums Salute Guild Hall" (a 50th anniversary event) (1981).

1981: THE 50TH ANNIVERSARY YEAR

Following the format of the Moran show—enlarging the exhibition with talks, films, music, receptions—the three remaining shows were hailed by press and public alike, and broke all attendance records. They were centered on the artists Childe Hassam, Willem de Kooning, Jackson Pollock and Lee Krasner.

With her usual zeal, trustee Helen Hoie threw herself wholeheartedly into the 50th celebration. At her instigation, Larry Rivers created a huge birthday cake sculpture in the likeness of Guild Hall, which was displayed in the foyer. Hoie also produced three commemorative posters by Fernando Botero, Jane Freilicher and Larry Rivers; an edition of pheasant weathervanes by William King; and, with Jean Mallet, a limited edition portfolio, "10 by 10"—photographs of prominent East End people in the arts by well-known East End photographers.

As a special tribute, four of the major museums in New York, the Solomon R. Guggenheim, the Metropolitan Museum of Art, the Museum of Modern Art and the Whitney Museum of American Art participated in an exhibition, "East Hampton/New York: New York Museums Salute Guild Hall." Held at M. Knoedler & Co., it featured the work of fourteen internationally known artists associated with the East Hampton art community, all from the collections of the four museums. The planners were June Larkin, Patricia McCulloch, Eloise Spaeth and Albert Edelman. East End galleries and museums honored us too—some twenty of them—each in its own way in appropriate exhibitions. Doris Lerman planned this month-long celebration.

Helen Rattray, publisher-editor of *The East Hampton Star*, that faithful chronicler of Guild Hall activities from its inception in 1931, paid homage to us also, in a special 50th anniversary supplement devoted to Guild Hall's accomplishments. The David Tyson Foundation funded a 20-minute color film on the history of Guild Hall.

The summer theater season, planned by Frances Ann Dougherty and Tony Stimac,

Members of the 50th Anniversary Committee (1981): Rosemary Sheehan; Lee Bendheim; Peter Wolf; Nan Orshefsky; Clyde Matthews and Michael Smollin, co-chairmen; Helen Busch; Dr. Donald Wilson, Southampton College president; Robert Denny; Page Moyer; Budd Levinson, Guild Hall board chairman; Frances Ann Dougherty.

opened with three one-act plays especially to mark the golden anniversary. The jewel of the season, *Night of Stars*, brought back performers associated with the history of the theater.

The events seemed almost endless; among them, the dazzling anniversary ball at the East Hampton Aire hangar, the Students' Art Festival and a Thanksgiving dance to round out the festivities.

By the close of the year, Budd Levinson and Robert Menschel had surpassed the half-million mark in their Anniversary Fund Drive—a remarkable achievement.

In December, 1981, the writer of this book retired from the directorship of Guild Hall after thirty-eight years. This transition was noted with appropriate celebrations and leave-taking, including an Honorary Doctor of Fine Arts degree from Southampton College of Long Island University and a new Guild Hall title, director emeritus; but an extraordinary tribute, much appreciated, followed in 1982 when more than a hundred artists presented prints and drawings under the title of The Enez Whipple Print and Drawing Collection. This generous gift (shaped by Eloise Spaeth and Doris Lerman) became a permanent part of Guild Hall's art collection.

Anabelle Hebert, formerly director of the Provincetown Art Association and Museum, assumed her new duties as executive director in May, 1982. As was perhaps to be expected following a long administration under one director, there were changes in personnel; in fact, by the end of the year there had been an almost complete turnover of staff. Nevertheless, the high spirits generated by the whirl of anniversary events continued on the stage and in the galleries throughout 1982.

The Music Committee, still under the leadership of Lee Bendheim, presented seventeen musical events, opening the year-long series with the Eglevsky Ballet. Tony Stimac, in

his final summer season at the John Drew, presented two tryouts. One was James Kirkwood's *There Must Be a Pony*. Joan Hackett starred, and two East Hampton professionals were featured—Barbara Bolton and Joanne Bonn.

As for the museum, the whole artist community turned out to honor John Little in his first retrospective (1934–1982), curated by Judith Wolfe and presented in the summer of 1982. One of the early abstract expressionists, Little was introduced to the area by his friends Jackson and Lee Pollock in the early '40s and in 1948 settled into an eighteenth-century farmhouse at Duck Creek on Three Mile Harbor, where he and his wife, Josephine, soon became important members of the artist colony.

A delightful but hard-to-keep secret that year was the 80th birthday surprise for Eloise Spaeth on June 19th planned by Rosemary Sheehan and Anabelle Hebert. Spaeth received greetings from eight museum heads including Richard Oldenburg of the Museum of Modern Art and Thomas M. Messer of the Solomon R. Guggenheim Museum, as well as from Governor Hugh Carey, but the cake was local; sculptor William King decorated it with a flourish. Ninety-three artists expressed their admiration for Spaeth and her outstanding contribution to the arts at Guild Hall with illustrated greetings (small works of art restricted in size), which lined the gallery walls. Later they were assembled into a handsome album, which to this day occupies a place of honor on a special display stand in her living room.

It was in 1983 that Guild Hall first learned it would be the recipient of a gift from the estate of the artist Alice Baber amounting to $138,000 and used to establish the Alice Baber Library in the Leidy Gallery. It opened in 1986 with the artist's fine collection of art books as its core.

Budd Levinson finished his fifth year as board chairman in 1983, and Robert Menschel, his fund-raising collaborator, took his place. Menschel said one of his goals was "to stress quality year-round programming." One example of quality programming that year was the retrospective exhibition "Larry Rivers Performing for the Family (1951–1982)," one of Helen A. Harrison's first as the new curator.

Wilson Stone, who became theater direc-

NOEL ROWE

Eloise Spaeth (right) admiring the cake decorated by artist William King for her eightieth birthday celebration at Guild Hall (1982). With her, Anabelle Hebert, executive director (1982–83).

BOB SERATING PHOTO
Robert Menschel, chairman of the board (1983–84).

tor in 1983, following Stimac, produced an impressive summer festival that included plays, a series called The Song Writers, and Sherrye Henry's Hot Topics.

With respect to films, Hilva Landsman continued her appealing series under such titles as Four Masterworks by Jean Renoir, and A Tribute to Tennessee Williams. The program throughout the year lived up to Menschel's objectives, but he found the job too time-consuming, given his personal business commitments, and so he chose not to continue another year. Meanwhile, Anabelle Hebert had resigned, and Budd Levinson, to provide continuity that might be lost in the unsettling round of musical chairs, accepted the chairmanship in 1984.

That year began on a somber note with the death of Jimmy Ernst on February 6, following a heart attack during a radio interview in New York about his new book, an autobiography, *A Not-So-Still-Life*. Two nights before, many of us had celebrated with him at a book-signing party in Manhattan. Shortly after his death there was a memorial service at Guild Hall. One speaker described Ernst as "great artist, great philosopher, compassionate human being—a man who approached life with open arms and an open heart." His dedication to artists' rights led to another memorial tribute, the formation of the Jimmy Ernst Art Alliance, an organization now grown to over 300 artists, dedicated "to addressing the social, economic and political needs of the visual artists who live, work and vote in the Town of East Hampton." The following year (1985) Guild Hall presented the first exhibition to cover the artist's entire career, "Jimmy Ernst: A Survey, 1942–1983." It was curated by Helen A. Harrision.

The new director in 1984 was Judith Sneddon. She was already familiar with Guild Hall through her work as director of the Suffolk County Office of Cultural Affairs, a grants-giving agency. Commenting recently on how she happened to take the position, she said, "I always used to say Guild Hall was the gem of the Island. I was particularly fascinated because it had both a theater and a museum with the possibility of interdisciplinary projects. That was the beauty and strength of the place. Yet it may also be its nemesis. It's diffi-

cult with a small staff to maintain the best quality programming in all areas." During her five years as director, she used her skills in grants-getting procedures to advantage and was justly proud of the $75,000 Advancement II Challenge Grant from the National Endowment for the Arts which required a three-to-one match. The funds were used for the renovation of the galleries and improvements in the building's heating and cooling systems.

Strong programming continued through 1984. "Robert Gwathmey: Works from 1941–1983" was a major retrospective and fitting tribute to the eighty-one-year-old area artist who, as noted by Barbara Delatiner in *The New York Times*, was at the ferment that brought forth the Abstract Expressionist movement but chose to follow a different drummer, often using socially conscious themes—for example, in his paintings of the rural farm workers of his native South. He told the writer, "My artistic point of view has not been prevalent these last forty years, but I've never compromised. Come hell or high water, I have painted what I want to paint. And now there are many signs of a return to the 'image'—I guess if you hang around long enough, everything happens—like this retrospective."

Wilson Stone scored another successful summer of variety fare in the theater in 1984 but resigned at the end of the season. He was followed by Amy and William McGrath who, like Stone, would remain for only two years.

The 1985 season planned by the McGrath's was typical of the pattern of mixed events already set in previous years to minimize the chances of loss. That summer included three plays, a Bach Aria Festival complemented by a symposium, "The Influences of Bach on Contemporary Composers," with Norman Dello Joio, among others, on the panel; and the seventeenth Filmmakers of the Hamptons Festival, with such entries as *Spaces: The Architecture of Paul Rudolph*.

Hamptons Newspapers Magazine (May 21, 1985) reported a "brouhala" in the local arts scene:

Artists seldom agree on anything, and nowhere do they disagree more than on the purpose and function of the Parrish Museum [in Southampton] and Guild Hall A general conclusion that can be drawn is that the

NOEL ROWE

Judith Sneddon, executive director (1984–88) celebrating the opening of the renovated galleries, with David Griffiths, general contractor (left) and Jim Field, painting contractor (1987).

Parrish and Guild Hall are approved of by the older, more established artists whose works may be in the museum's collections or are regularly featured. Many of the younger, lessknown artists wish the museums were more open to people trying to get a leg up.

It is interesting to note that with every passing generation from Pollock and his contemporaries on, this complaint has a more familiar ring, as every director or curator in Guild Hall history has soon learned.

In 1985 Guild Hall could hardly have been accused of not showing the wide spectrum of artists working in the area. More than 200 were represented in the annual "Artist Members Exhibition" (still dedicated to its "open entry" policy), and fifty-two contemporary artists of the region were featured in "The East Hampton Star's 100th Anniversary Portfolio."

A heralded event of 1985 was the launching of the first annual Lifetime Achievement in the Arts Awards which Budd Levinson called "the most important association Guild Hall has ever had in the cultural community."

In 1986 Eloise Spaeth, in an expression of pleasure in her long association with Guild Hall, established the Spaeth Award, a $10,000 grant to be given annually to an artist who "in the unanimous judgment of the jury has created a substantial body of work which merits recognition on the basis of its distinction." First to receive the Spaeth Award (in 1986) was James Brooks. In subsequent years (through 1991) the award went to Ibram Lassaw, Jane Wilson, John Opper and Jane Freilicher. This was also the year the Alice Baber Library opened with a dedication and an exhibition of the artist's work.

In 1986, the press took note of the condition of theater in general. In an article in the *Southampton Press* (October 9, 1986) entitled "East End Theater Season Had Its Ups and Downs," Lee Davis posed a question to representatives of theaters, all of whom had reported "lousy business" in July: "Is the Fabulous Invalid alive and well on the East End or is it suffering from the same rigor mortis that's reported—with some exaggeration—to be afflicting its cousin in Manhattan?" He wondered if perhaps the slow beginning might be traced to "the new Video Generation?" William McGrath, speaking for the John Drew, observed that the only two entertainment businesses that did well in East Hampton in July were the movie theater and video stores. The John Drew had felt the downturn. In announcing the McGrath's resignation at the close of the season, Judith Sneddon mentioned their general frustration with the spasmodic audience for drama and music programs. Kelly Patton was next to step in as artistic director for the John Drew.

Guild Hall remembered its commitment as a community center that year by making space, as usual, for November election polling; also for the Jimmy Ernst Alliance Dance and the Chamber of Commerce's season-end party. And in a show of camaraderie, the Guild Hall staff played softball with its friendly competitor, the Parrish Museum; Guild Hall was the winner.

In the fall of 1986 board chairman Budd Levinson and treasurer Oscar Weinberger stepped down after several years of almost undivided and caring attention to their duties as board officers. William A. Dreher was elected to take Levinson's place. In accepting the chairmanship, he said, "It is a culmination of my association with Guild Hall . . . The existence of Guild Hall was an important factor in my decision to buy a home in East Hampton eighteen years ago." He said he hoped to strengthen ties to the community.[4]

The major accomplishment of 1987 was the completion of the renovations of the galleries. It was celebrated at a formal dinner in May along with the opening of a major exhibition, "American Masters." Dreher called it "a tribute to Judith Sneddon's administration." She had secured the NEA grant that made it possible and supervised the work from start to finish.

One of the most appealing exhibitions of the year was "Long Island Modern," organized by Alastair Gordon. *New York Times* critic Paul Goldberger wrote: "Unlike most architectural exhibitions organized around local themes, this one has genuine national significance . . . it stands to remind us that Long Island was one of the country's major incubators of modern architecture."

The Guild Hall Art Collection of well over a thousand works continued to grow

NOEL ROWE
William A. Dreher, chairman of the board (1987–90).

through the '80s. In 1987, through monies realized from deaccessioning works irrelevant to a regional collection, Guild Hall made several new purchases, including a de Kooning. Further, Ruth F. Emmet left a fund to be used specifically for purchases of art by young artists, and the Institute of Museum Services awarded Guild Hall a substantial grant for art conservation.

The year 1987 marked the last of the annual Filmmakers of the Hamptons festivals, which Trudy Golden had produced so successfully for nearly twenty years. In failing health, she reluctantly gave up what she said was "the thing I love to do best." What distinguished the festivals was the "live" element—key people in person to talk about their work. Trudy Golden died in 1988.

The 1987 summer season proceeded smoothly, offering its usual pleasant combination of performing arts, including two tryouts for Broadway; further, it showed, surprisingly, an almost twenty-eight-percent increase in attendance over the preceding year. This led one to wonder if the box office was being affected by the invasion of "Wall Street's young Turks" described by David Behrens in *Newsday* as "a new breed of big spender . . . high rollers all" who have "made a killing in the bull market . . . and their money is changing the Hamptons dramatically." Perhaps "the big spenders" were helping to support some of the very successful benefits that year, too—the Clothesline Art Sale and The Joys of Summer—the proceeds of which were helping to cover Guild Hall's operating costs, now running close to a million dollars a year.

Under Dreher's leadership in 1987, Guild Hall was repositioning itself to accommodate new goals. In his annual report Dreher said, "The board was brought up to full strength by the addition of nine community leaders with a variety of backgrounds and individual talents. Less visible but still important developments were a completely revised set of organizational bylaws, a new structure of our Museum Advisory Committee and a fresh definition of acquisition policy."

After these years of struggling to define Guild Hall's future, a *Star* "Connections" piece by Helen Rattray (April 9, 1987) perhaps reminded us of the raison d'être for Guild Hall, no matter what the circumstances of the era. Rattray described how on a gloomy April day (and not being a "musicologist") she nonetheless wandered over from the paper's office to attend a young pianist's warm-up performance for Alice Tully Hall. "I had gone to the concert almost as therapy," she wrote. "I left not only having been lifted out of myself, but deeply touched."

In 1988, Tito Spiga (artist, designer and collector) died, leaving his estate, worth close to $500,000, to Guild Hall. It was the largest single bequest in our history. Spiga stipulated that the money be used specifically for a gallery for showing the permanent art collection; further, that it be completed within two years of his death or the money would go elsewhere. The trustees thought first of adding a wing to the building but because of the time factor decided to create a suitable space in what was then the collection storage vault adjoining the Moran Gallery.

With Kelly Patton as theater artistic director, programming for the year won its share of accolades. Virtuoso piano music took center stage with recitals by Misha Dichter, Gregory Slag and Robert Taub, and jazz pianists Dick Hyman and Derek Smith. A Margaret Mead Film Festival and Richard Brown's Private Screenings replaced the Filmmakers of the Hamptons Festival, and there was a premiere of a musical, *Jacques Brel Blues*.

In 1988 the museum presented fourteen exhibitions highlighted by "Ibram Lassaw: Space Explorations," curated by Helen A. Harrison. Rose Slivka in a *Star* review called it "a pacemaking event revealing Mr. Lassaw to be a major artist who, like Jackson Pollock, forged a unique form of spatial exploration that broke new ground."

Meantime, Judith Sneddon had announced her intention to retire at the end of the year, thus completing her five-year employment agreement. At a December party at the home of board vice-chairman, Jo Raymond, and her husband, Dana, trustees and colleagues joined in a tribute to Sneddon.

In her opening statement in the 1989 annual report, Joy Gordon, Guild Hall's new executive director, said: "Perhaps nothing was more rewarding during my first year than the sight of children proudly accepting their student membership cards. Our student member-

SELF-PORTRAIT
Tito Spiga
for whom the new
gallery was named.

ship program—the distribution of free memberships to more than 2500 local school children—was a vivid manifestation of our determination to respond to the needs of the community."

Gordon had come from a successful eleven-year directorship at the Danforth Museum outside Boston and had been a part-time resident of East Hampton for many years. She said recently, "When I used to come down from Boston to East Hampton, my first stop, with suitcase and bags in the car, was Guild Hall . . . As a professional I admired it and as I passed through and observed it with its galleries and beautiful theater, I thought it would be a cinch to run, but I soon changed my mind. It's complicated because of the multi-faceted community here . . . so many different interests . . . Trying to involve the people that come out from New York for the week-end to relax is very different from trying to serve the year-round community."

MONTE FARBER
Joy Gordon,
executive director (1989–).

Programming in 1989 reflected Gordon's commitment to community involvement. The theater, under Kelly Patton's direction, responded to the oft-repeated cries of "more attention to our local playwrights" with a Circle Repertory production of *Fifth of July*, by Sag

Harbor resident Lanford Wilson, and staged readings of four new plays including one by Kurt Vonnegut.

Some memorable events of 1989 were the sold-out art lecture by celebrated Rosamund Bernier, the memorial tribute to Elaine de Kooning on the occasion of an opening of an exhibition of her portrait drawings, Carlos Montoya's farewell flamenco guitar recital, and the New York City theater benefit, *Jerome Robbins' Broadway*, organized by Hilva Landsman and Dorothy Stone.

During these years, the financing of the Guild Hall operation was covered mainly by membership fees and special benefits, but Dreher was pleased to note as his tenure as board chairman came to an end in December 1989 that trustees themselves had that year contributed $150,000.

The decade too, came to an end with a rapidly growing and changing community. As Joy Gordon observed, "It's not so much a question of in season and out of season any more. People are here for long weekends all year-round. It's always been hard to convince an artist to show in the fall or winter. They think they're only going to get an audience in the summertime. That's not true any more." The same can be said of theater. The Community Theater Company, which had been presenting about four plays a year during the fall-to-spring period, was now drawing near-capacity audiences for as many as nine weekend performances for each production.

In compliance with Tito Spiga's will, Guild Hall met its deadline for completing the permanent collection gallery within two years of the artist's death, thanks mainly to trustee James Marcus' successful handling of the complicated negotiations regarding the estate. To open the new gallery on October 13, 1990, fifty works from the collection were spread through the four galleries. Charles Brock, the new board chairman, presided over the inauguration celebration and announced that in gratitude of the bequest, the gallery had been named for Tito Spiga. Among the speakers was architect Lee Skolnick, who described how he had linked the new space to the Moran Gallery to preserve the integrity of Aymar Embury's original building design.

1990s

COURTESY OF ELIZABETH LAMB.
Elizabeth (Boots) and
Condie Lamb with son,
Commander David Lamb (1983)

COURTESY OF THE EAST HAMPTON STAR
Charles Brock,
chairman of the board
(1990–)

1991: THE 60TH ANNIVERSARY YEAR

Guild Hall had further reason to rejoice, for 1990 was the year that Elizabeth (Boots) Lamb and her son, Commander David Lamb, deeded the historic landmark studio of Thomas Moran to Guild Hall, "reserving life estate in favor of Mrs. Lamb, who would pay all expenses and upkeep so long as she continues in occupancy." A hundred-thousand-dollar fund to help with maintenance was provided in the will. "Our hope," Mrs. Lamb and her son wrote to the board, "is that the premises would be used by gifted children in painting. Since Thomas Moran and Condie Lamb were both painters, that would seem a good place to start. Such other arts as music, drama and sculpture could be added in coming years as the trustees might see fit."

Helen A. Harrison resigned as curator early in 1990 to take the directorship of the Pollock/Krasner House and Study Center in Springs and was replaced by her assistant, Christina Mossaides Strassfield. Kelly Patton continued as artistic director of the theater with Pamela Calvert as general manager.

As a prelude to the 60th anniversary year coming up in 1991, there was a Celebrity Bash, planned by Mary Jane Brock and Douglas Leeds, at the polo field of Dune Alpin Farm, honoring Frank Perry and Guild Hall's Academy of the Arts.

Board chairman Brock noted that the year was significant for the emphasis on long-range planning, the consistently high level of programming and the extraordinary financial results showing a surplus—and accomplished without the usual need for trustees to cover an anticipated deficit. Brock added that the impressive financial results were in no small part due to trustee Ruth Widder's zeal and effectiveness in planning the successful special benefits and theater programs that year.

For Guild Hall, the decade of the '90s really began in 1991, the 60th anniversary year. As with any anniversary, this was a time to lay claim to the past and to confront the challenges ahead. Guild Hall tried to do both while scheduling programming for every segment of the community. Even the devastating Hurricane Bob, which flooded the basement under the stage as well as the lower level of the Dewey Wing, didn't halt progress.

In order to cope with the greatly increased activity for the 60th anniversary year, the office of president of the board was created as a way of sharing the burden with the chairman, Charles Brock. Jo Raymond, long-time trustee and officer, was elected to the position. She and chairman Brock worked with director Joy Gordon; her able assistant, Sandra Beckman Morell, and the staff and volunteers to keep the packed schedule of events flowing smoothly.

It seemed apt to go back to the beginnings, and two exhibitons succeeded in bringing history up close: "The Montauk: Native Americans of Eastern Long Island" and "East Hampton: The 19th Century Artists' Paradise." Bringing the artistic cavalcade full circle, there were one-man shows of such contemporary artists of the region as Eric Fischl, Chuck Close, Robert Dash and Philip Pavia. Memorable too was the exhibition, "View From the Sixties: Selections from the Leo Castelli and the Michael and Ileana Sonnabend Collection"; and that year Guild Hall remembered its friend Hans Namuth, who died in 1990, with a memorial tribute and an exhibition of his photographs.

The series of play readings which Kelly Patton arranged that year enabled the audiences to get closer to the creative process. Sam Schact, director of *Men's Lives*, commented that attending a staged reading was like sitting in the kitchen with the cook. Also well received that summer were *Closer Than Ever*, starring Karen Akers, and Spalding Gray's monologue, *Monster in a Box*.

There were seventeen concerts in all that year—something for everyone: the Beaux Arts trio, the Shanghai Quartet, jazz concerts and the annual Messiah sing-in. Hilva Landsman came through again with a splendid International Film Festival and, in association with the New York Foundation for Art, AIDS awareness videos were screened on A Day Without Art. The Community Theater Company celebrated with productions of *Our Town*, *Wait Until Dark* and *Guys and Dolls*.

To help finance the year of celebratory activities, the benefit committees, those indispensable angels of financial deliverance, came through with flying colors, setting all-time records. Michael Garstin and Luly Duke cochaired a benefit performance of *Miss Saigon* in New York, raising $100,000. The Lifetime

Achievements Awards Dinner, in the able hands of Karen Karp, brought in $235,000; the Celebrity Tennis Tournament with Suzanne and John Cartier as honorary chairmen, made $21,000; and the 45th Clothesline Art Sale, headed by Margot Dowling, hit an all-time high net of $56,580.

As the twenty-first century approaches, Guild Hall is adapting to its role in a changing community. Although it recognizes its symbiotic relationship to New York, it also recognizes its unique regional characteristics. The challenge is in keeping the two forces in balance.

Karen Karp, chairman, at the seventh annual Lifetime Achievement in the Arts Dinner, the most successful fund raising event in Guild Hall's history (1991).

APPENDIX

THE ORIGINAL GUILD HALL INCORPORATORS

Mary L. Woodhouse
Hildreth King
Mary T. Dayton
Julia F. Ethridge
Mary P. Hamlin
Alice C. Dickerman
Elizabeth E. Lockwood
Dr. David Edwards
I. Y. Halsey
Nelson C. Osborne
F. Raymond Dominy
Nathan N. Tiffany
Leon Q. Brooks
Clifford C. Edwards

GUILD HALL BOARD CHAIRMEN

YEAR ELECTED	
1931	William C. Dickerman
1933	Robert Schey
1937	Mrs. Thomas Jefferson Mumford
1938	Mrs. Lorenzo E. Woodhouse
1945	Joseph F. Gunster
1948	Edward E. Bartlett
1952	Foster Millikin
1954	Harold W. Nichols
1955	Frank H. Cornell
1955	Roy S. Durstine
1957	John L. Boatwright
1961	Paul Montgomery
1966	Charles S. Dewey, Jr.
1974	Walter J. Fried
1978	Budd Levinson
1983	Robert B. Menschel
1984	Budd Levinson
1987	William A. Dreher
1990	Charles L. Brock
1992	Josephine Raymond
1993	Robert S. Greenbaum

GUILD HALL DIRECTORS

SUMMER DIRECTORS

1939–40	Anne Poeller
1941–42	Warren Whipple
1943–46	Enez Whipple

YEAR-ROUND EXECUTIVE DIRECTORS

1947–81	Enez Whipple
1982–83	Annabelle Hebert
1984–88	Judith Sneddon
1989–93	Joy Gordon
1993–	Henry Korn

NOTE: From 1931 through 1938, Guild Hall affairs were managed by resident secretaries: Miriam Shaw (1931), Harriet Tyler (1932), Miriam Shaw (1933–36), Mary Alshire (1937–38).

FRIEND OF THE YEAR AWARD WINNERS

The award is presented annually by Friends of Guild Hall to a member of the organization for outstanding service.

1973	Frederick Stover	1985	Jeanette Saget
1974	Alice Mund	1986	Florence Kulick
1975	Miki Denhof	1987	Beatrice Mathes
1976	Rosemary Sheehan	1988	Edith Seabury
1977	Fred Echevvaria		Ida Keats
1978	Jobette Reed	1989	Rose Meinken
1979	Mabel Daly	1990	Joe Gorsuch
1980	Helen Busch	1991	Helen Martino
1981	Eugenie Nadelman		Marguerite Martino
1982	Edith Parsons	1992	Helen Lowry
1983	Dora Masoff	1993	Rosemary Buchman
1984	(no recipient)		

Unless otherwise stated, quotes are from audiotaped interviews made by Enez Whipple in preparation for writing this book, and from telephone interviews and correspondence.

FRONTISPIECE
1. John Russell, "The Many Roles of Guild Hall," *New York Times*, 26 September, 1976. Copyright © 1976 by The New York Times Company. Reprinted by permission.

INTRODUCTION
1. Elizabeth H. Cartwright, "Old Days and Memories of East Hampton and Montauk," *East Hampton Star*, 28 August 1931.
2. Courtesy of Print Collection, Miriam and Ira D. Wallach Division of Arts, Prints and Photographs. New York Public Library. Astor, Lenox and Tilden Foundations.
3. James Farias in *The Sun*, 4 June 1981.
4. Jeannette Edwards Rattray, "East Hampton Literary Group," *Long Island Forum*, August–September–October 1963.
5. Guild Hall Archives.
6. Michiko Kakutani, "Guild Hall and the Greening of East Hampton," *New York Times*, 7 June 1981. Copyright © 1981 New York Times Company. Reprinted by permission.

VISUAL ARTS
GUILD HALL MUSEUM
1. Details re. Childe Hassam are mainly from "Childe Hassam in East Hampton—a Note" by Judith Wolfe in the catalogue for the exhibition, "Childe Hassam: 1859–1935."
2. Exhibition co-organized by Guild Hall and Grey Gallery and Study Center, New York University, New York, NY.
3. Harold Rosenberg, Interview with Willem de Kooning, *Art News*, September 1972.
4. Virginia Seward, "The Big Splash for Little Squirts," *Newsday*, 7 August 1968. Reprinted by permission.
5. Russell, "The Many Roles."
6. Victor D'Amico, in exhibition catalogue.
7. A. Penny, exhibition catalogue preface.
8. Conceived and run by Eloise Spaeth as fund-raisers for the Archives of American Art, a department of the Smithsonian Institution, dedicated to preserving the records of American artists. For many years Josephine Raymond has served as Spaeth's co-chairman.
9. Hassam and Garbo quotes from Arnold Genthe, *As I Remember*, Reynal & Hitchcock, NY, 1936.

10. Hans Namuth, "Photographing Pollock" in *Pollock Painting*, ed. and intro. by Barbara Rose, photographs by Hans Namuth, Agrinde Publications Ltd., NY, 1978. Reprinted by permission.
11. John Russell in *Connaissance des Arts*, August–September 1988.
12. Jay Hoops in catalogue for "Light of the South Fork," 1979.
13. Robert Giard in exhibition catalogue for "Robert Giard's South Fork," 1984.

PERFORMING ARTS
THE JOHN DREW THEATER
Introduction. Quotes re. John Drew are from *East Hampton Star*, 2 August 1931.
1. Virginia York in a letter to the editor, *East Hampton Star*, 28 June 1990.
2. *Night of Stars* videotape, prod. Clark Jones and Enid Roth, 21 August 1981. Interviews taped by East Coast Omnivision.
3. Eddie Dowling in a letter to Dorothy Quick, in "What's New in New York," *East Hampton Star*, 20 September 1951.
4. From "Hurd Maguire Hatfield Reminisces," *Guild Hall Golden Jubilee Journal*, 1981. Ed. Rosemary Sheehan.
5. *Night of Stars.*
6. *East Hampton Star*, 28 July 1971.
7. *Night of Stars.*
8. Christine Lyons, *The Sun*, 3 July 1981.
9. *Night of Stars.*
10. Christine Lyons, "Gwen Verdon: Hampton Mover-Shaker," *Hamptons Magazine*, May 1983.
11. *Ibid.*
12. James Lipton's remarks are from promotional flyers prepared by Guild Hall.

DECADES
1. Details from Jeannette Edwards Rattray in catalogue essay for exhibition, "Reflections from the *Star*: East Hampton in Its Newspaper, 1885–1975" (1974).
2. M. L. D'Otrange Mastai. *The Arts Review.* "New York News": SUMMER AND ART IN THE U.S.A. "What East Hampton Collects" 8–22 September 1962. Permission granted.
3. Guild Hall board meeting minutes, 22 June, 1970.
4. Guild Hall board meeting minutes, 8 November, 1986.

Note: Several people who contributed comments to this book have died since the manuscript was completed.

INDEX

Note: References to photographs are not included in this index.